Chefs' Kitchens

Written by
Stephen Crafti

Photos by
Catherine Sutherland

Chefs' Kitchens

Inside the Homes of Australia's Culinary Connoisseurs

Foreword by
Matt Preston

Contents

- 6 Foreword Matt Preston
- 10 Introduction Stephen Crafti

- 14 Adam D'Sylva Streamlined Machine
- 26 Annie Smithers From the Farm to the Table
- 40 Brigitte Hafner Working in Idyllic Surrounds
- 54 Daniel Vaughan Having Grown up with Great Food
- 66 Frank Camorra Bringing a Taste of Spain Down Under
- 78 Ian Curley An Oasis
- 90 Jacques Reymond Keeping it Simple
- 102 Javier Codina A Kitchen with Space and Light
- 114 Jesse Gerner The Garth
- 126 Karena Armstrong A Kitchen to Share with Friends
- 138 Martin Benn A Celebrity Chef
- 152 Matt Breen Cooking with the Right Music
- 164 Michael Lambie Trained with the Finest
- 176 Michelle Crawford Surrounded by Vintage Finds
- 188 Peter Orr At Home with His New Kitchen
- 200 Rita Macali From Being a Fussy Eater to a Great Chef
- 212 Rodney Dunn Once a Classroom
- 224 Ronnen Goren A Sustainable Kitchen
- 236 Ross Lusted Multifaceted
- 248 Scott Pickett Fit for a Chef
- 260 Tony Nicolini The Italian Touch
- 272 Xinyi Lim A Love of Cooking

- 284 Author & Photographer
- 285 Credits
- 286 Index
- 288 Weights & Measurement Conversions

Foreword

I'm not sure when the kitchen reclaimed its place as the centre of the home. I suspect it was when the home theatre – with its giant screens, bass so deep and rumbling that it shakes loose cornices and older amalgam fillings, and fleecy recliners with a fully stocked bar fridge – lost its relevance in a new world of multiscreen homes and multistreamer access.

The proliferation of food television shows helped, as suddenly cooking was a legitimate hobby, a lofty pursuit, rather than just drudgery. I'm not sure how long that glamour lasted – a few weeks maybe. Suddenly we were back in the kitchen, snapping dishes for Instagram, and glossy magazines were full of features of well-coiffed people from the North Shore, Portsea or the Goldie in Camilla kaftans flashing dazzling capped smiles and sipping Cosmos in kitchens that could have been in the Hamptons, a Miami drug dealer's palace or a high-end New York loft.

The kitchen suddenly had status and demanded the same attention as the botox, hair extensions and ornate mani-pedis of those 'beautiful people' in the photos. It also was back at the centre of entertaining at home, wrestling back control from the pool, the spa, and the 'outside room' with its coloured feature wall, architectural plantings and a barbecue big enough for a medium-sized rhinoceros sold by the previous generation of television lifestyle and home reno shows.

More than any other part of your house, and more than just a mere expression of status, the kitchen became a statement of who you are, or who you want to be seen as. That is perhaps one of the reasons why this book is so fascinating – not only is it a sticky-beak into the private lives of some of our best-known and most-loved cooks but it is also a window into their individual aesthetics.

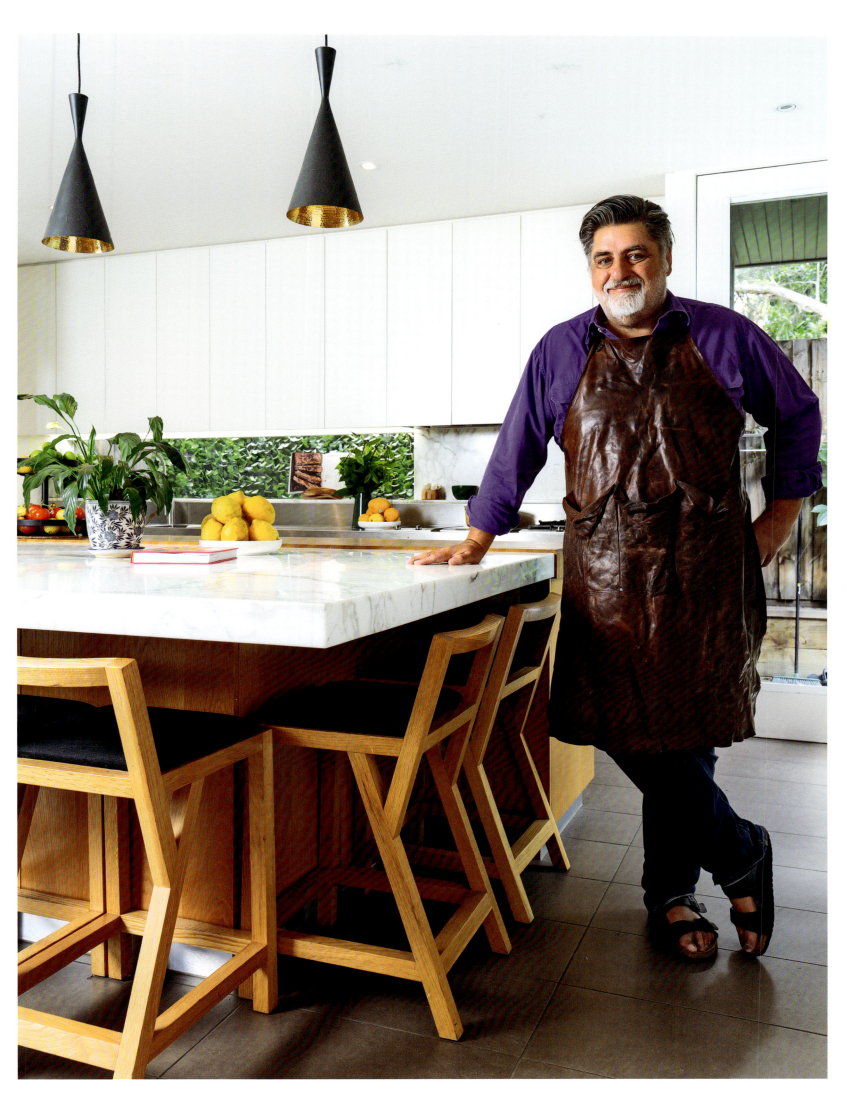

Annie Smithers and Brigitte Hafner's kitchens both scream cosy rustic functionality executed with style. Scott Pickett's is sleeker and has darker urban tones. It's fascinating to see who's picked marble and who wood, and, needless to say, natural materials, stainless-steel appliances and tiles abound here (often those long subway tiles – OK, I think they are really known as French urinal tiles, but I'm too delicate to say that when in such close proximity to food …). I'm a particular fan of Frank Camorra's blue floor tiles, which bring a smile of Spain to his CBD family kitchen.

As well as the perving into private spaces, there's also inspiration aplenty for your next kitchen and more than enough to covet in these pages, from Karena Armstrong's sunshine-yellow glass splashback and her tamarind chopping board to Xinyi Lim's use of orange tiles and a striking gooseneck orange tap to match the orange slides on her feet. These splashes of colour when so many contemporary kitchens take a timeless approach – minimalist clean lines, lots of white two-pack and warm wood – add some character that's easily swapped out for more conservative options by a new owner.

While we are at it, I am also a little jealous of Matt Breen's vinyl collection so close to the kitchen and his goat ragu. Luckily that's one of the delicious recipes supplied here. Likewise, I lust after Tony Nicolini (and his wife Marcella's) polenta board to serve their sausage polenta recipe on. And I don't just think it's Catherine Sutherland's lush photography that's doing that!

While Rita Macali's inspired idea of a dedicated wine draw? That's also something to add when we remodel our kitchen again! As is an open fire like Rodney Dunn has in his Tassie home kitchen, which makes his kitchen look like a place you could hang out drinking tea and cooking all day.

I do have a few questions remaining however: how do all these chefs keep their kitchens looking so uncluttered? What's in all those cupboards? How many of them are crammed with the pie maker, the table-top pizza oven, the slow cooker, the sausage-roll maker, the rice cooker, the waffle maker, the quesadilla maker, electric quesadilla press, the sandwich press and jaffle maker (just in case you do need both), the air fryer and pasta maker?

Or maybe top chefs don't fall for these home kitchen appliance innovations as heavily I do! Being a shameless slave to every fad appliance was a major reason we had to knock down the wall of our own kitchen to add on a pantry with wall-to-ceiling cupboards that could store all these dust gatherers ... And is it wrong that I want to peer into every pantry, open every fridge, and learn even more about the people behind the big names you are about to meet?

Matt Preston
food writer, cookbook author and radio host

Introduction

The idea for this book first came to me after vising the home of Tony Nicolini and his wife, Marcella. While the house, which was renovated by architect Domenic Ridolfi, was impressive, the kitchen in the new wing was far from being a traditional kitchen. There was not only a marble-clad island bench, but also a separate bench or 'station' used for preparing coffee or other drinks. And while a butler's kitchen now forms part of many kitchens, this was a serious preparation area brimming with kitchen utensils and every imaginable bowl and dish.

It was the kitchen in the Nicolini house that spurred me to write this book, focusing as much on the kitchens as on the food prepared. With the invaluable assistance from photographer Catherine Sutherland, this book has become a journey for someone far more in sync with architecture and design rather than food; in particular, food prepared by some of Australia's chefs at the forefront of hospitality.

The chefs featured in this book exemplify enormous culinary talent, with each one providing a recipe of the meal or dessert prepared for this book. But unlike many cookbooks that purely provide lists of ingredients and how to use them, this book shows where these great meals are created – from the simple yet highly functional kitchens to those that are endowed with every possible appliance.

But what makes for a great kitchen? Is it the amount of bench space to allow for several dishes to be worked on at the same time? Or is it the endless amount of storage the kitchens featured in this book appear to have – with deep drawers located below sinks to store large pots and pans. What type of surfaces do these leading chefs prefer to have in their kitchens at home? Is it similar to the type of bench that's used in their restaurants? In the case of chef Frank Camorra, owner of MoVida, he prefers working on timber benches in his own home, renovated

by architect Adam Dettrick. According to Camorra, each burn or knife mark simply adds to the patina of the bench, with each mark carrying a story or a moment in time when a certain dish was prepared, and even who the meals were served to around his dining table. Chef Xinyi Lim, who works in a kitchen with wrap-around stainless-steel benches that was designed with her sister, architect Qianyi Lim of Sibling Architecture, prefers the ease of wiping down the benches rather than leaving her mark. In her case, the dining table is used as additional space for preparing meals, with her extended family assisting.

For some chefs, such as Peter Orr, chef at Adelaide's Leigh Street Wine Room, the abundant natural light that streams through his large picture windows is essential. It was also important for Orr to have commercial appliances to cook with at home, including his 900-millimetre-wide Falcon stove shipped from the United Kingdom. And as with some of the kitchens featured in this book, there are specific zones in his home, one for preparing coffee and another dedicated to washing up. Other chefs, such as Ross Lusted, owner of Woodcut in Sydney, makes do with a considerably smaller kitchen. In a Victorian terrace that's been completely renovated, Lusted uses the adjacent courtyard both to cook and entertain family and friends. And while using the outdoors so frequently may not be as common in cities such as Melbourne or Hobart, Sydney's more Mediterranean-like climate certainly allows for alfresco dining for most of the year. Lusted also enjoys cooking on his outdoor barbeque. Chef Adam D'Sylva, from Melbourne, has a number of barbeques in his back garden, of different levels of sophistication and sizes.

The kitchen garden is also a focus of many of the kitchens featured in this book, from the smaller vegetable plots and herb gardens to the substantial properties where entire tracts are dedicated to one plant, be it a fruit tree or a type of vegetable. Chef Annie Smithers, who runs du Fermier in Lyonville, central Victoria, is surrounded by serious acreage that allows produce from the farm to be brought to the table. And while her kitchen, in what was once a church, is simple, the joy it brought this writer to see her in action was memorable! Chef Jesse Gerner, who owns a number of restaurants in Melbourne, has transformed his front garden into a large vegetable plot.

Seeing what chefs prepare in their own kitchens is as fascinating as seeing how they work. Chef Matt Breen, for example, loves cooking to the sound of music, with his vinyl records and turntables nearby. Others prefer a quieter ambience, both in sound and in the way their kitchens are designed – simple yet highly functional. And then there is Daniel Vaughan, who literally has all his machinery displayed below his glass floor in the kitchen. Instead of bottles of wine as one would expect, there are a number of chainsaws dating from the mid-twentieth century.

For those who love food, design or both or simply want to see how some of our great Australian chefs work in their own homes, I hope you enjoy, find inspiration, and perhaps think about ideas for your own kitchen!

Stephen Crafti

Adam D'Sylva
Streamlined Machine

At the time this book went to press, Adam D'Sylva had just moved on after a fourteen-year stint as co-owner and executive chef of Coda, and then Tonka, both in Flinders Lane, Melbourne. Adam continues his run with other projects, currently the gelateria Boca, in Ivanhoe, Melbourne. A chef for more than two-and-a-half decades, his venues capture his mixed heritage. "I'm half Italian and half Indian," says D'Sylva, who grew up surrounded by food, in particular meat. "My father used to have a butcher's shop and my mother worked alongside him." Even before graduating from school, he was working part-time in a pizza store. "I still enjoy making pizzas, particularly for the children," says D'Sylva, who lives in his house in Thornbury with his wife and their three children.

When the couple purchased the 1960s cream-brick home, it had enough bedrooms, but lacked a great kitchen. "It was more of a galley-style kitchen that was poorly tacked onto the back," says D'Sylva. There was also a garage at the rear that was too difficult to access, and has been incorporated into a new living wing that now includes the informal living area and an additional bedroom. "We literally doubled the size of this house, including a new dining area, which can accommodate up to twenty-five people with a couple of additional tables," he adds.

As D'Sylva designed the new kitchen, he was clear on what he wanted and also what he didn't want. He wanted a long island bench, plenty of storage and a butler's pantry where he could store many of the kitchen appliances. So unlike other kitchens, where there's at least a coffee machine or food blender on the benchtop, here one of the few items is a container with a variety of oils, salts and soy sauce. "They're a permanent fixture, with at least one of these ingredients going into every dish," says D'Sylva.

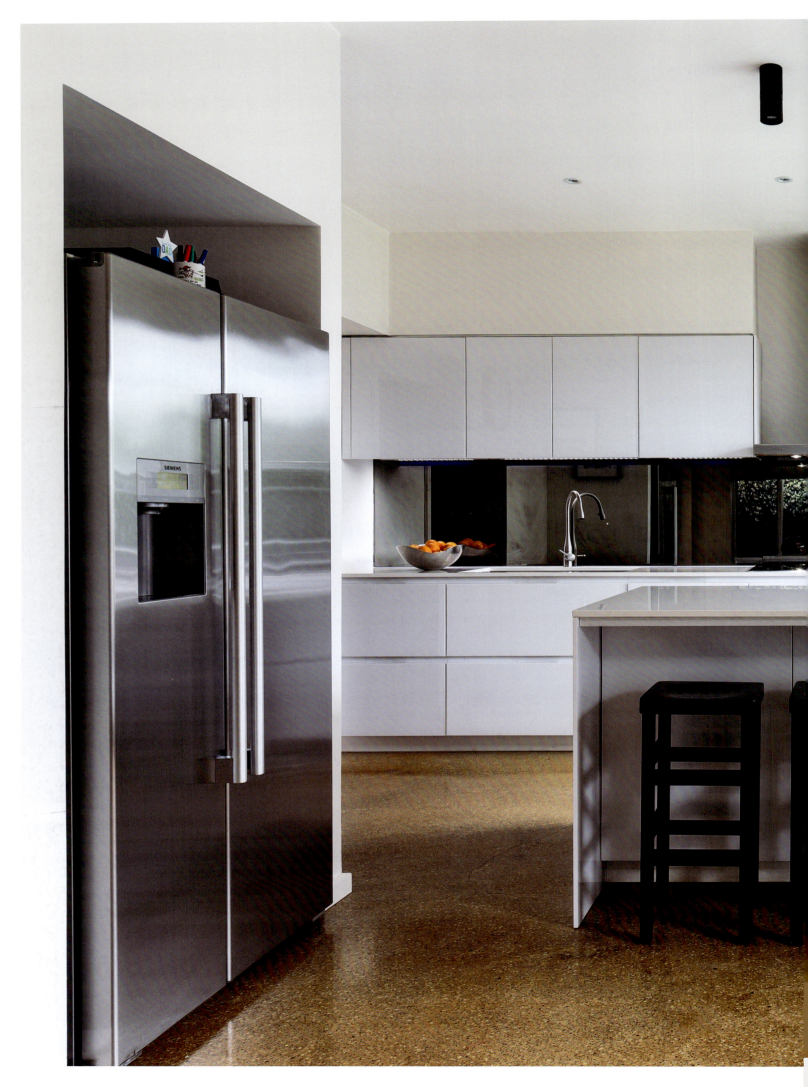

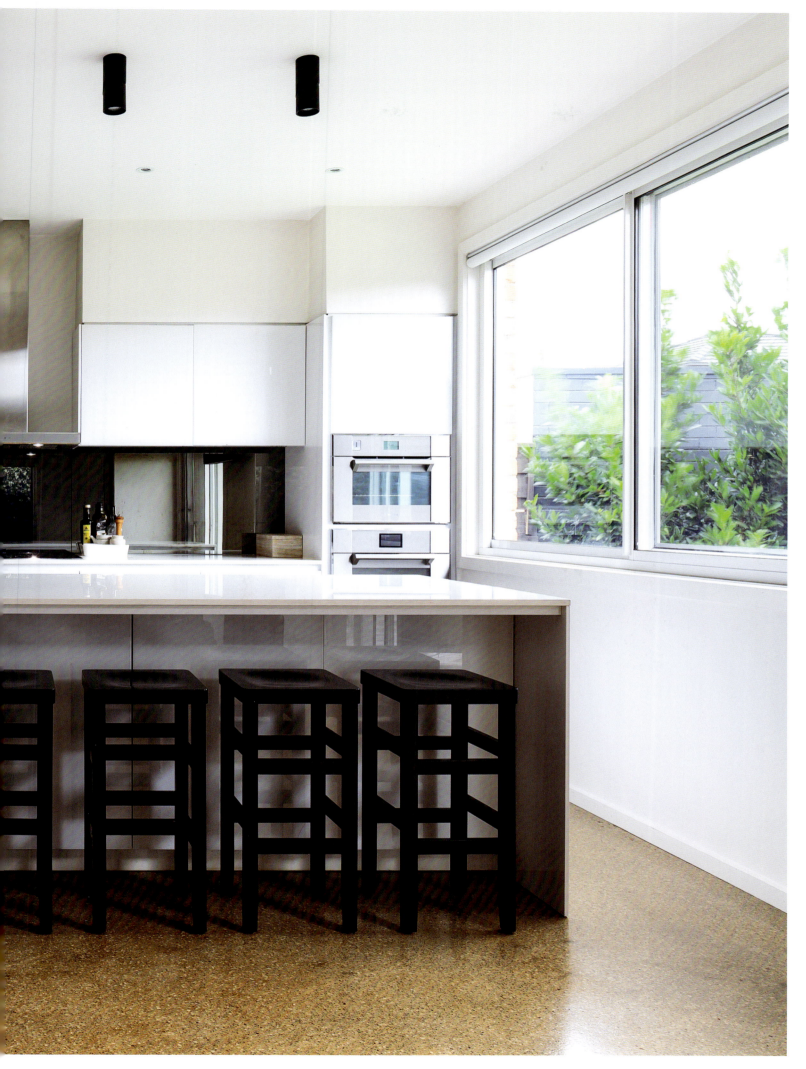

Although D'Sylva designed this kitchen and also advises a number of people, including property developers, on kitchen design, this one was manufactured by Snaidero in Italy. Some of the appliances, such as the wall ovens and steamer, are by De Dietrich. One of D'Sylva's favourite appliances is the free individual hotplates, also by De Dietrich. This was designed to allow for up to fifteen different settings and programed to allow for pots of any size to be heated up, with the heat following it rather than the pot following the heat. "My eldest daughter knows instinctively how to prepare pastries," says D'Sylva, who has allocated one entire drawer to her cooking implements.

With a dislike for sinks on island benches, as they 'cut up the island bench and water is splattered everywhere', D'Sylva located his twin steel basins and tap on the bench, adjacent to the dishwasher. A mirrored splashback extends across the entire length of the kitchen bench, magnifying the kitchen and adjacent dining room. "[The mirror] is one of the things I regret to be quite honest. You regularly have to clean it and, in my field, that time could have been spent doing something else," says D'Sylva. However, there are far more plusses in this kitchen, with many practical features that he suggests for clients. There's the drying rack in one of the overhead kitchen cupboards that's ideal for draining plastic containers and bottles. Storage is also generous, with large glass-fronted drawers containing everything from pots and pans to crockery, the latter including his own range, Salt & Pepper. Having storage on either side of the island bench also allows both frequently used and occasional items to have their own home. On the dining side, the five timber stools (one for each family member) restrict direct access to these cupboards. "But it's great to have this extra storage space for things you only need to use occasionally."

One of the features of the kitchen is the three ovens, one above the other forming an entire wall. At the bottom is a warming drawer, then an oven and at the top a team oven, all self-cleaning. "There's no build-up of grease and it's easy for the children to use," says D'Sylva. Just as generous is the double Siemens fridge, complete with ice-water dispenser. And although this fridge is full to the brim, there's a second fridge in the shed, relied on for entertaining friends and family.

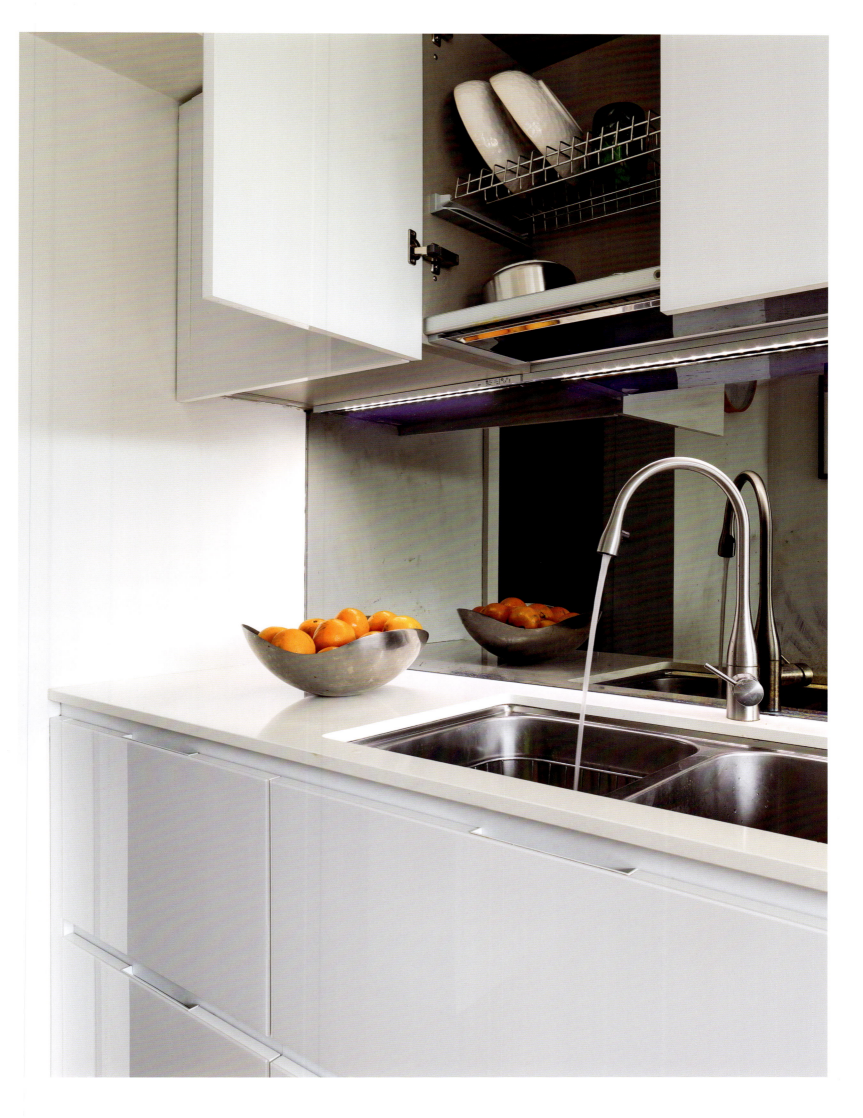

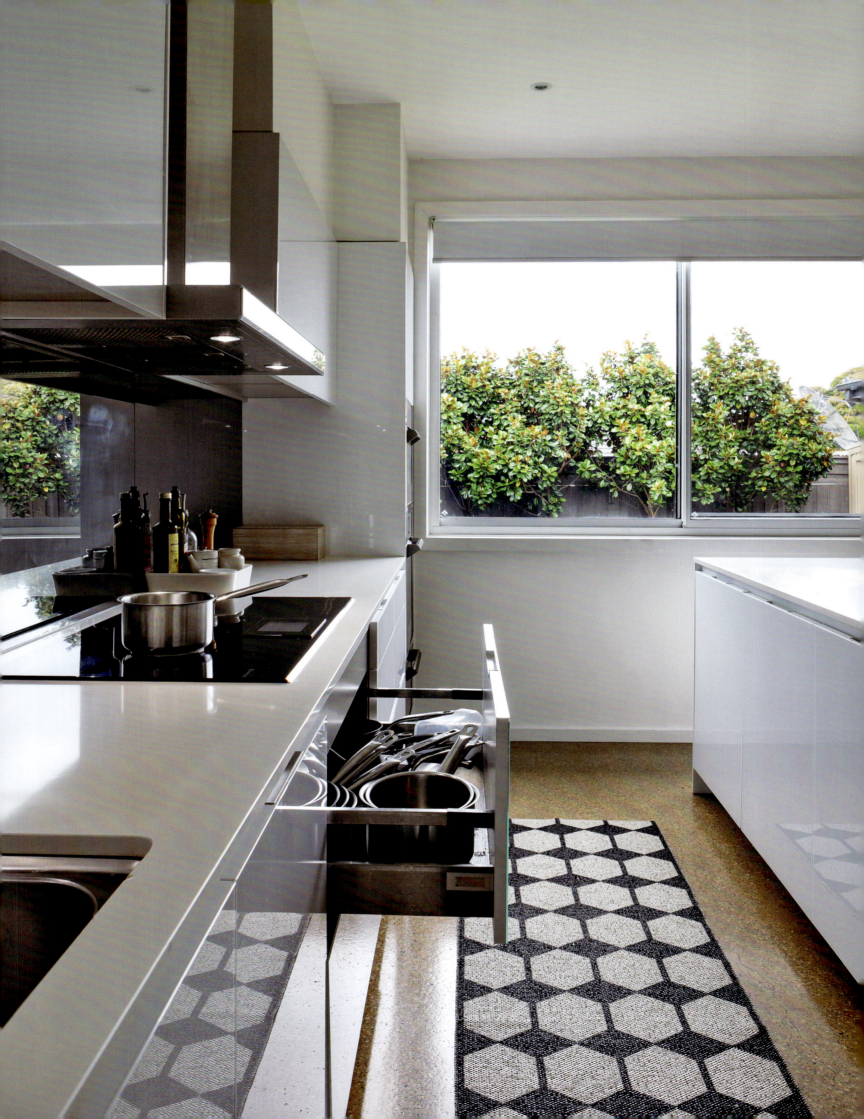

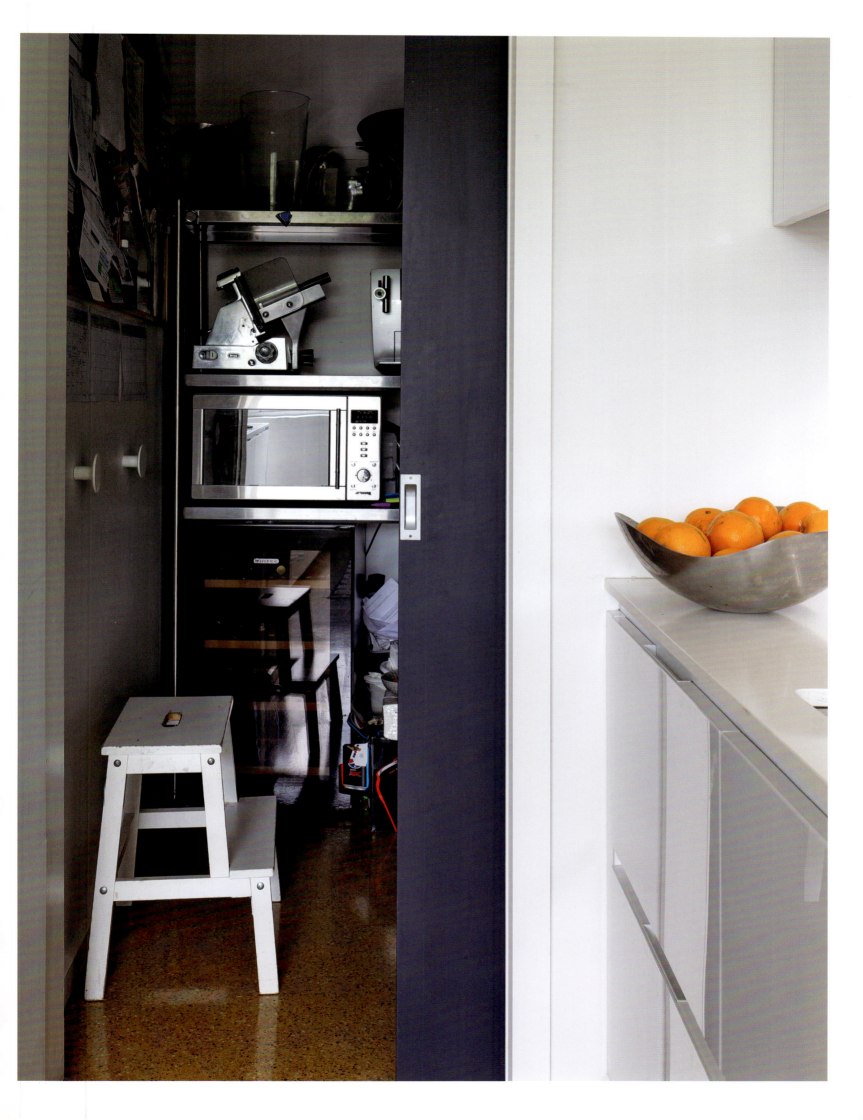

The butler's pantry is also an important arm of the kitchen, containing everything from a coffee machine, a microwave oven, a meat slicer and a juice presser, all carefully arranged on a steel shelf. A second bench, clad in stainless steel and complete with a sink, means considerable time is spent here. And unlike most kitchens that conceal the rubbish bin, here, the bin is tucked into one corner of the kitchen as a freestanding object. "When I cook, I like to be able to put scraps straight into a bin rather than finding myself working on part of a bench where the bin is below. This way I can just move the bin around, wherever I'm working," he adds.

With three young children, all with healthy appetites, D'Sylva often prepares two meals every day for the family. There's usually a small pasta dish that awaits the children when they arrive home from school soon after 4.00 pm, and then a larger meal that's prepared for the entire family. Weekends are often spent cooking in his back garden on one of his four barbecues. There's the little steel fold-up barbecue (pictured) as well as the Big Green Egg that sits alongside the Everdure Churrosco, a combo of gas and charcoal. Pizzas are generally prepared in the Big Green, while smaller meat dishes are prepared on the pint-size barbecue, an inexpensive item that cost less than $40. "This one has a great heat and is easy to clean," D'Sylva says.

However, for dinner or for entertaining inside, there's the dining table with George Nelson lights above creating a soft ambience. In the warmer months, the windows framing the dining area are wound out to allow the sweet scent from the star jasmine to permeate. "I've got a few herbs planted in the garden, and one of my tasks going forward is to transform the sandpit in the front garden into a herb garden."

For D'Sylva, this kitchen is the heart of the house. It's literally at the core and the place where everyone gravitates. And although it has a minimal aesthetic, it's a 'machine' when it comes to preparing food. "Everything is out of sight, but I know where everything is. I don't have to see it to be reminded," adds D'Sylva.

Prawn and zucchini spaghettini

250 g good-quality spaghettini
150 ml olive oil
5 garlic cloves, chopped
4 bird's-eye chillies, finely sliced
100 ml white wine
2 zucchini, grated
1 sprig thyme
24 large prawn cutlets
½ bunch flat leaf parsley, finely chopped
Salt & pepper

Salt a large pot of water to taste like the sea, then bring to boil. Add spaghettini and boil until three-quarter cooked – so still quite underdone. Reserve 2 cups of pasta water before straining pasta.

Meanwhile, place a heavy-based pot over a medium heat and add the olive oil. Sauté the garlic and chilli until aromatic. Deglaze with the white wine. Add the zucchini, thyme and 1 cup of pasta water. Cook the zucchini until it becomes tender and breaks down.

Add more pasta water, then the prawns, spaghettini and parsley.

Stir constantly, until the prawns are cooked and pasta is coated in sauce.

Check the seasoning (there should be enough salt from the pasta water), add freshly cracked pepper and serve.

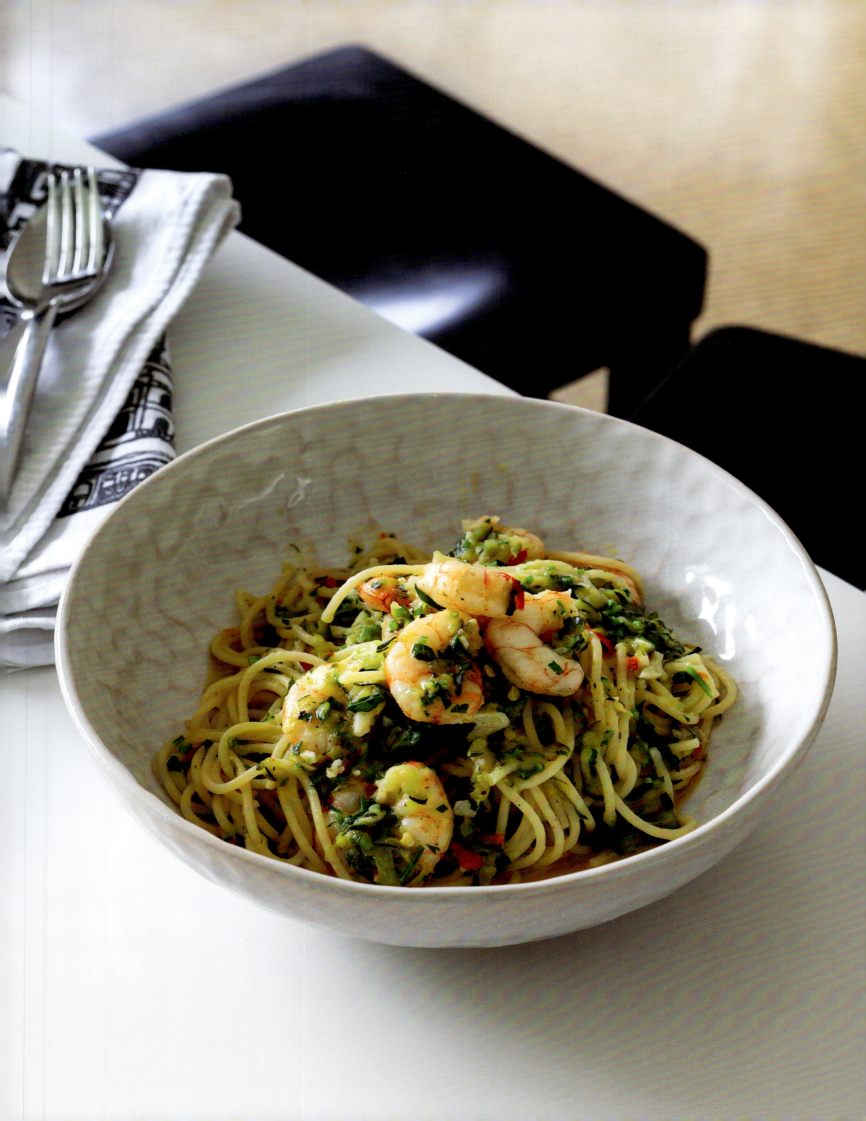

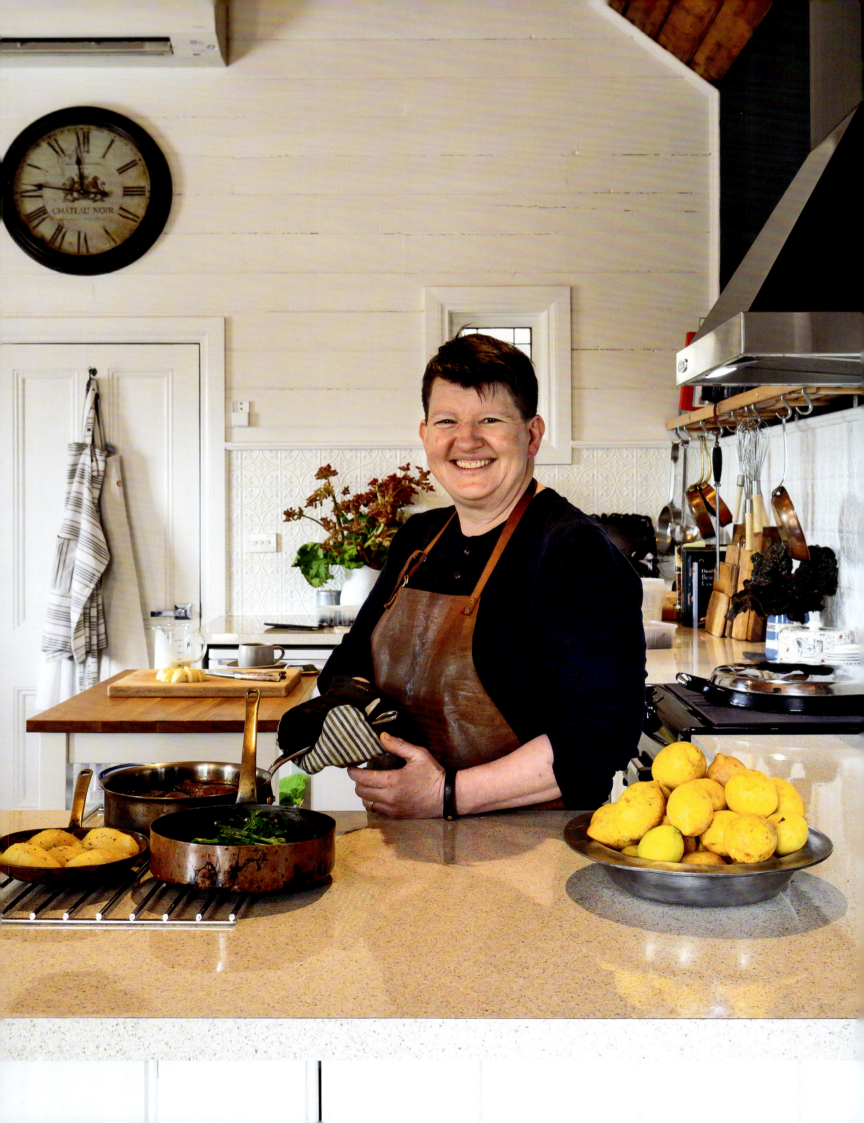

Annie Smithers
From the Farm to the Table

Babbington Park in Lyonville, Central Victoria, provides a sanctuary for chef Annie Smithers, who runs du Fermier. Three years ago, she purchased the 9-hectare property with her wife Susan and their two daughters, where they live along with their cats, geese and chooks. Situated at the head of the Loddon River, it draws one's eye immediately into the landscape, with its rolling hills framed by mature hedges. The couple's early-twentieth-century cottage is flanked by a series of outhouses, including an 1870s shearing shed, currently being restored, and a delightful church, thought to have been moved onto the property seventy years ago. It's here where Smithers does most of her cooking, along with her cooking classes, booked out for months ahead.

The church, a short walk from the main house, includes two bedrooms, a bathroom, the open-plan kitchen and living area, together with an annex that's used for students attending classes to sample the fare, as well as for entertaining friends and family. "I was initially thinking of using this building as a B&B, but it's perfect for cooking and holding classes." Simply furnished with a French country-style dining table, it only needed a few minor adjustments from Smithers. There was the addition of the Enzo Catalani pendant light in the living area and in the kitchen, an AGA 60 stove, pivotal to Smithers' way of cooking with ingredients brought from the farm to the table. With just one large hotplate and two deep ovens below, it provides everything she needs. "I can sauté potatoes, while keeping my soup or sauces warm on the side." The oven has two speeds, and it's perfect for the preparation of confit duck. After using AGAs for many years, she knows exactly what heat is required for any dish or even pastries. "Using an AGA is intuitive. It's like a dancing partner," says Smithers, who regularly braises certain dishes overnight.

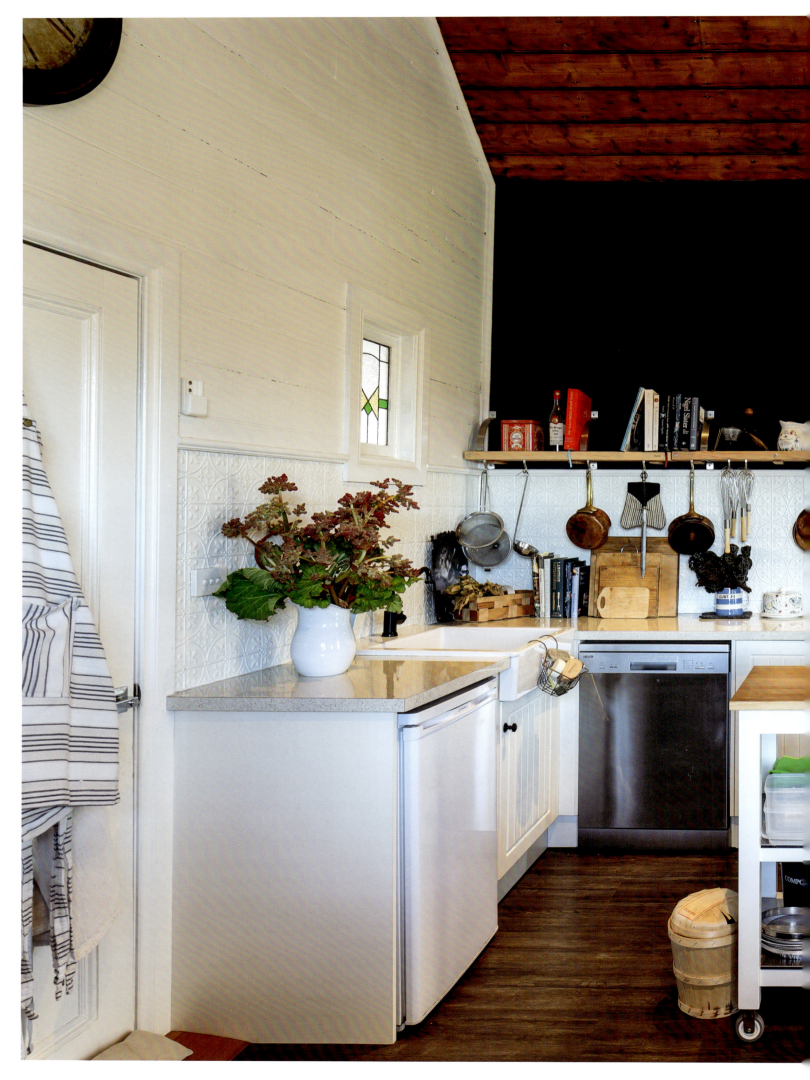

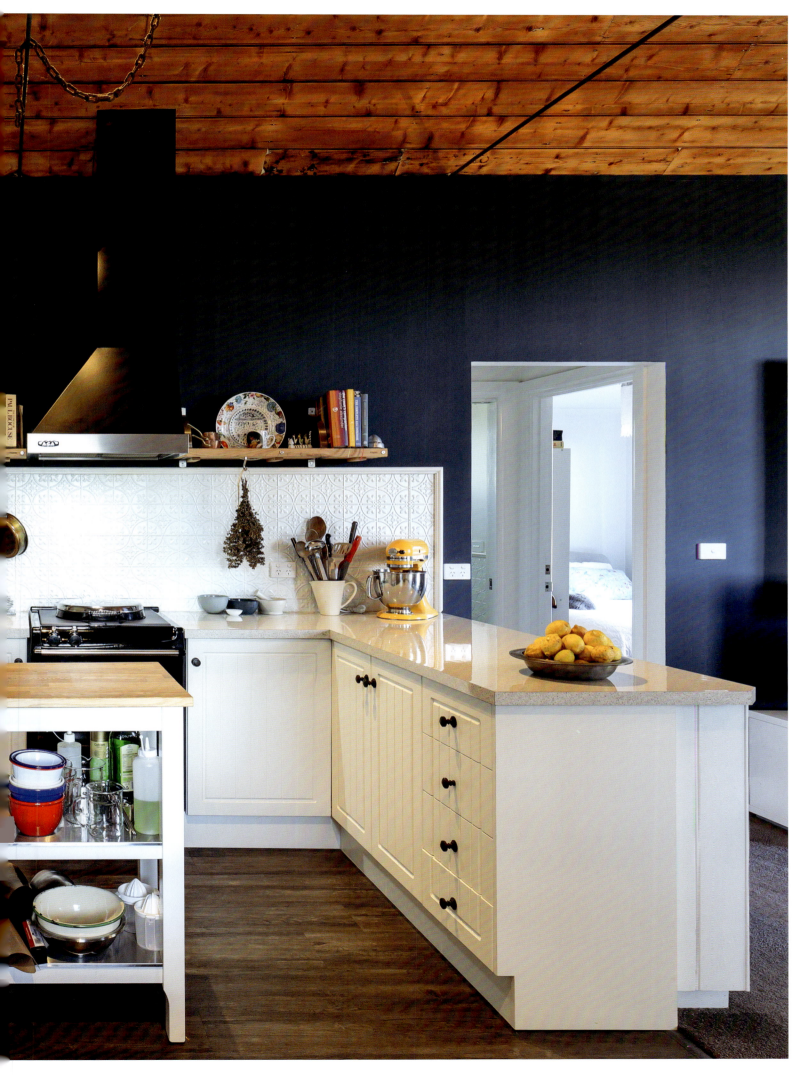

The C-shaped kitchen is simply appointed. There are laminate benchtops with tongue-and-groove joinery below, with one of the cupboards concealing a microwave. There's only a small bar fridge (a second larger fridge is in the adjacent annex), and copper pots and pans are hung from a timber shelf. Mauviel cookware is her preferred choice, considered to last the distance. "It's multi-generational." Whisks, wooden spoons and knives are tightly squeezed into a ceramic jug on the bench. "I'm a firm believer that you need to teach people in a domestic environment rather than in a commercial kitchen, so they can then produce these meals in their own homes," says Smithers. Although she works intuitively, there are a few cookbooks on the shelf, including two of her own. Her latest is *Annie's Farmhouse Kitchen*, including illustrations of her British Blue cats. A moveable trolley in the kitchen rarely strays far, with containers and vessels. "I believe that 'less is definitely more'. You shouldn't get sidetracked with the need for too many appliances," says Smithers. However, a well-loved KitchenAid on the bench is used on a daily basis. A series of timber chopping blocks stand permanently on the kitchen bench. "I like the feel of a knife on a wooden surface," says Smithers.

The deep ceramic sink was essential for Smithers, with an attached wire dish brimming with soaps and a variety of fingernail brushes. "As many of the ingredients come directly from the land, it's essential to be vigilant with scrubbing," says Smithers, who has added edible plants to the garden since moving here: rhubarb, quinces, almonds, walnuts and a number of fruit trees. There are also potatoes (originally this farm produced mainly potatoes). "We try and grow everything that we can, including all our salad greens," she adds.

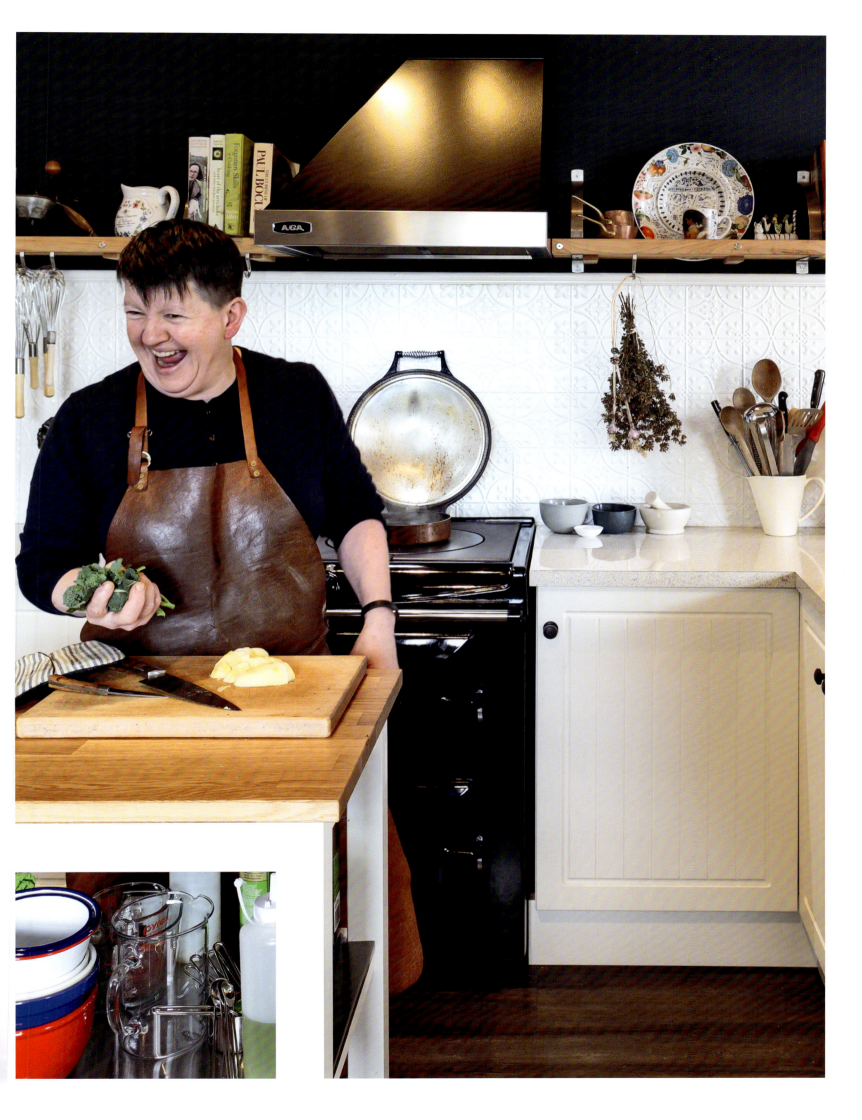

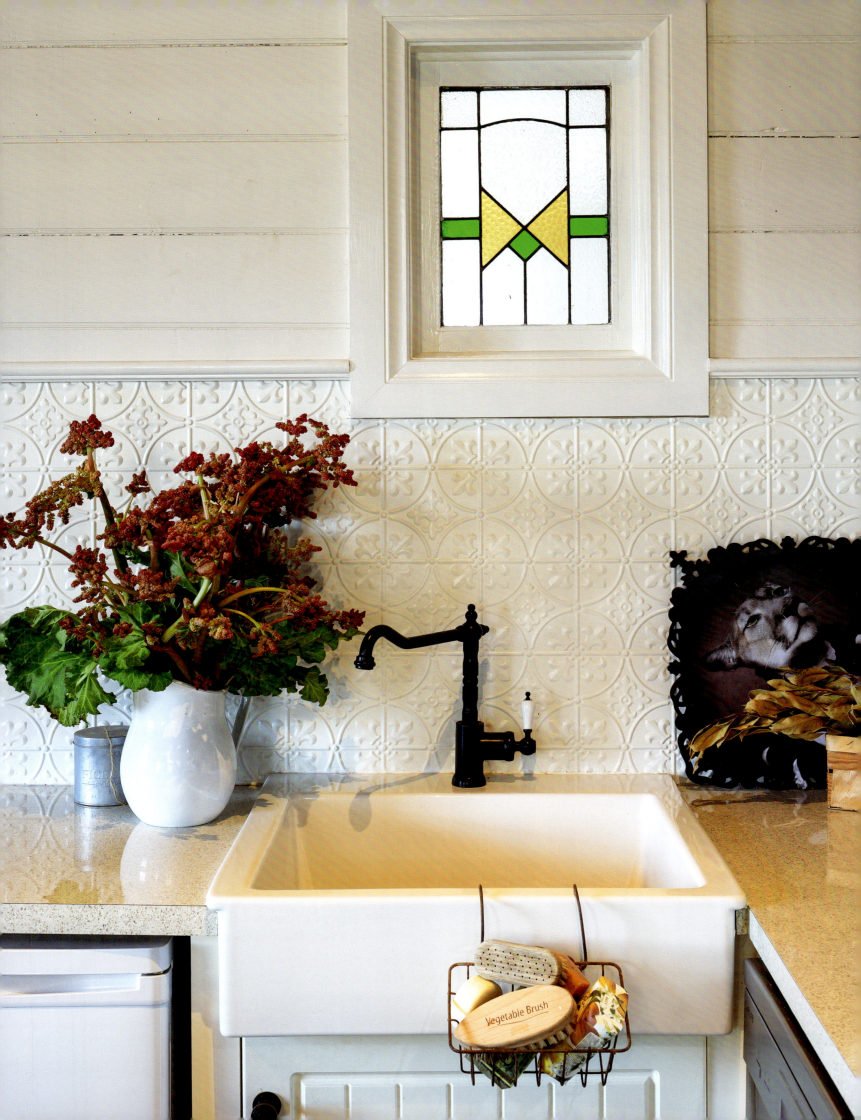

The annex was previously used to slaughter livestock. But now it's used as a second dining area, with its elongated window framing views of the property, including a magnificent 400-year-old gum tree. One of the few changes made to this space was the insertion of timber-style farm doors. It's in the annex where vegetables are washed and the vintage crockery is kept (Susan has been collecting vintage crockery for many years). There's a rustic charm here, with the old trestle-style table coming from a school nearby, and timber folding chairs with a rich and worn patina. Shaker-style coat hooks, and leadlight windows inserted between the two spaces, add to the charm. And as with the honesty that comes from living on the land, the annex features concrete floors dotted with Persian carpets. "This space was fairly rudimentary when we first moved in. It's been touched lightly," says Smithers.

This kitchen captures the essence of Smithers' food: simple and lovingly prepared, with many of the ingredients literally grown outside her front door. The French farmhouse-style food has not been 'tricked up' and is extremely nurturing. For Annie and her family, sitting down for a meal in what used to be a church comes with a sense of peacefulness and contentment. "We're 760 metres above sea level here, so it's considerably colder than in Melbourne. We do get snow, hence the need for this pot-belly fireplace," says Susan who likes the stillness of being at Babbington Park. The artwork, including a sculpture of a dog by artist Georgina Hilditch, adds to the sense of being outdoors, along with the artwork of morphed farm animals by Ibride displayed on the walls. "But you're always connected to the farm and the animals. The geese greet people upon arrival," adds Susan.

Although the kitchen brings in people from the cold, the grounds are continually explored by those privileged to visit. Hot houses are lined with vegetables and everywhere you look, there are projects on the horizon. Some of the land is left fallow over the colder months while other areas are showing signs of being 'close to the table'. But wherever one gazes, there's the sense of the land, including the recycled farm gate and partial timber fence marking out a new crop. "The place is slowly evolving. We've been working on restoring the shearer's shed since we've arrived," says Smithers, whose connection to the land is as formidable as the food served on her plates.

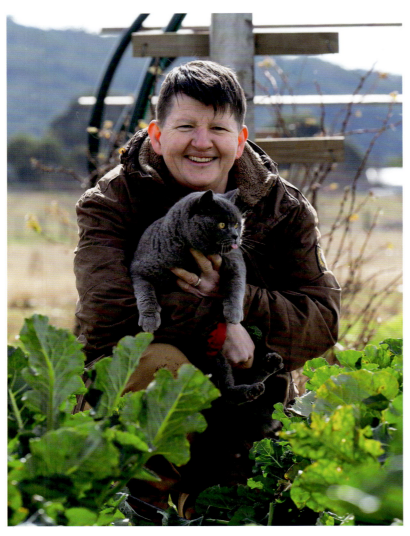

Duck legs braised with cider and prunes

6 duck legs
Salt & pepper, to season
1 tbsp olive oil
600 ml apple cider
1 tbsp Calvados
1 sprig thyme leaves
6 prunes

Preheat oven to 160°C. Season duck legs with salt and pepper.

In a heavy-based saucepan, heat the oil over a medium heat and brown the duck legs well on all sides for 4–5 minutes. Remove and set aside in a baking tray in which the legs will fit snugly in a single layer.

Deglaze the pan with apple cider and Calvados. Pour over the duck, sprinkle with thyme and add the prunes.

Bring to boil, cover with foil. Place in oven and braise covered for 1½ hours or until the duck legs are tender. Check occasionally to make sure the liquid has not evaporated too much. Remove the foil, turn the heat up to 180°C and colour the legs for 10 minutes, if necessary.

Apple purée

2 Granny Smith apples
20 g butter
Salt & pepper, to season

Peel and chop the apples. Melt butter in a heavy-based saucepan, add apples, season.

Cook covered until soft. Purée in blender. Check seasoning.

Final assembly
Potatoes
Broccolini, or green beans

Swirl a little apple purée on the plate and carefully place a duck leg, some prunes and some sauce on top.

Serve with potatoes in a gratin dish on the side with a large bowl of just-cooked broccolini (or green beans).

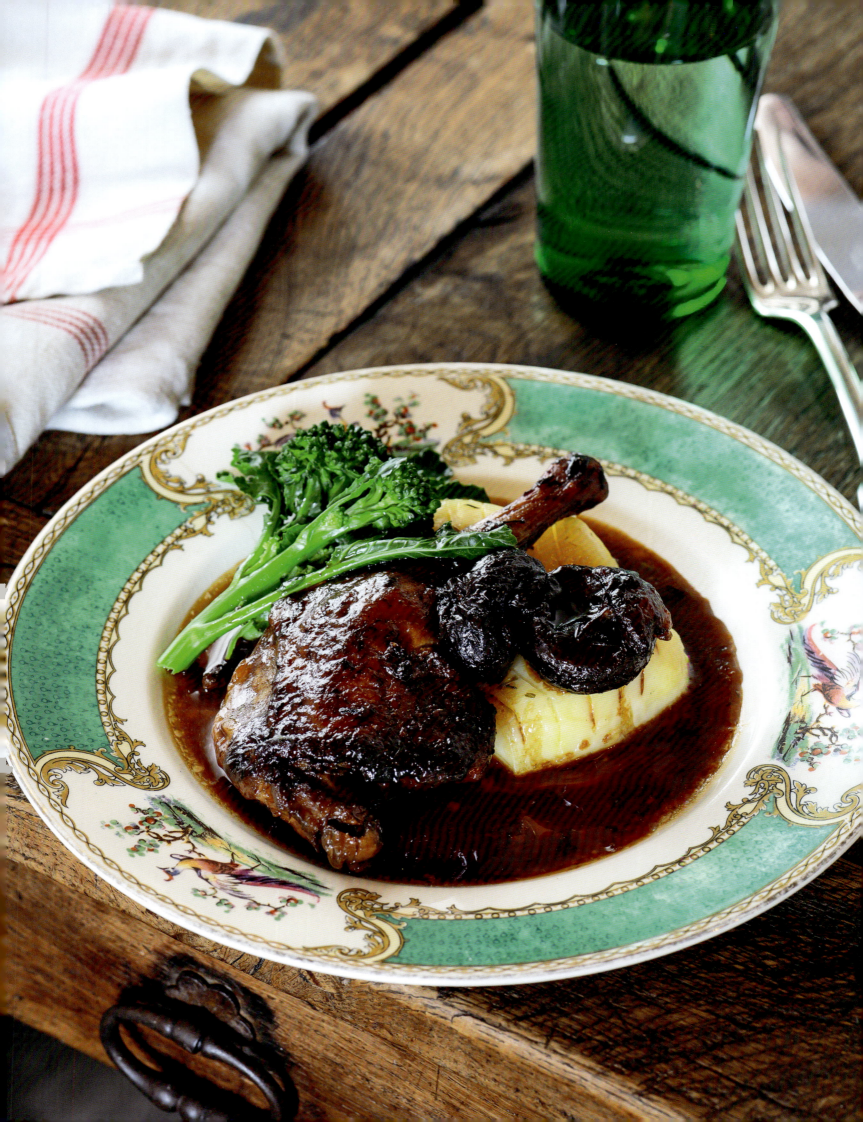

Brigitte Hafner
Working in Idyllic Surrounds

Brigitte Hafner, who owns Graceburn House & Tedesca Osteria in Red Hill on Victoria's Mornington Peninsula, has several projects going at the one time. As well as establishing an orchard on her Red Hill property, there's a new restaurant and B&B nearby. With her husband architect Patrick Ness, design director at Cox Architecture, and their daughter Vivienne, how they find time to prepare a great meal at home, let alone get through each day, is extraordinary. However, Hafner is as content being in the kitchen as she is in the garden, which she worked on with her father. "We've just planted thirty-six different types of fruit trees, plums, pears, cherries and apples," says Hafner, who loves retrieving the eggs from the chook house (a miniature Edwardian-style structure) at the top of the embankment. "Just listen to the sound of those chooks," she says.

The couple purchased the 12-hectare property, a one-and-a-half hour's drive from Melbourne, five years ago. Originally built in the 1970s, the low-slung mud-brick house had no architectural pedigree. However, the house enjoyed unimpeded views over rolling hills and came with great 'bones', including 50-millimetre-thick Oregon floors and chunky messmate tree trunks used as structural columns. "It gets extremely cold down here, with wind and rain lashing the windows on extreme days, and it can be hot in summer," says Ness, who slowly transformed the house, including a new kitchen, together with modifying some of the previously orange features (orange-stained floor boards and lots of pine joinery). Other changes have been the addition of a separate studio and work sheds.

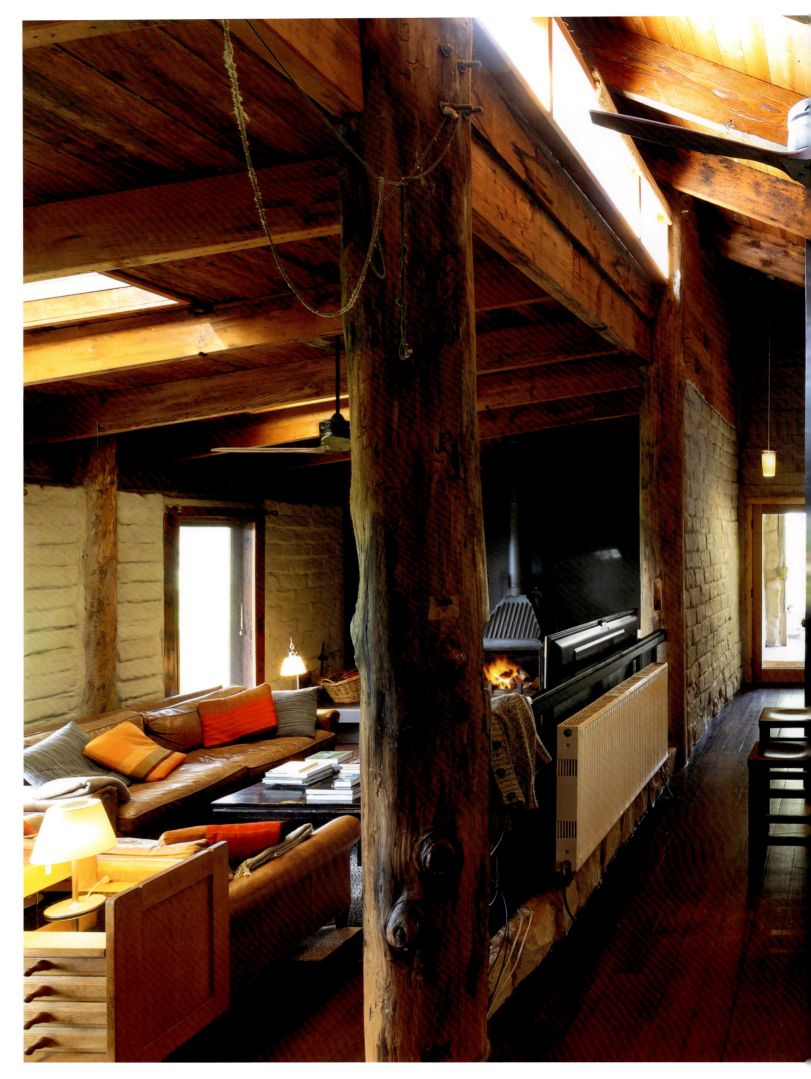

Originally the kitchen was horseshoe-shaped, lacking a central island bench. Virtually, the only prized feature was the Rayburn wood burning stove, used for baking and roasting. "I wanted a central area where my family and friends could be part of the cooking process, whether it's handing over peas to shell, or just opening a bottle of wine," says Hafner, whose brief to her husband also included generous bench space, something the former kitchen lacked. Although this kitchen appears to be original, the hearth/alcove is new, including the Japanese tiles framing the alcove, along with the Bertazzoni commercial oven. A worn red-gum beam conceals the kitchen flue.

As with Hafner's brief, pivotal to the design is an old sorting table from the 1960s that would have once been in a wood shed. The table, measuring 3 x 1.2 metres, and with its well-worn patina, came with large deep drawers for storing pots and pans. Ness also modified the undercroft to allow for additional storage. The rudimentary pine cupboards were removed and replaced with a Carrara marble benchtop that extends from one end of the kitchen through to a new pantry, the latter containing a fridge and an additional storage area. A generous sink from the English Tapware Company, referred to as a 'butler's sink' is cut into the bench, allowing Hafner to enjoy views of her garden and the soft western light.

Hafner readily admits she could work on a camp stove but was keen to see the kitchen complete before Ness got distracted with other projects on the property. "When you marry an architect, you get used to things not being complete!" Admitting to being a 'messy cook' and that rarely are things ready when guests arrive, the regime is often to plan things just a few hours before. "At home, I certainly don't spend days thinking about what will be served," says Hafner, who often rushes out to the garden just moments before to pick herbs. Although Hafner has a number of kitchen appliances, including two KitchenAids, one used for cakes and a larger one for making dough or bread, it's the knives she sees as one of her most important appliances. "I have quite an extensive collection of Japanese knives, rather than surrounding myself with too many gadgets."

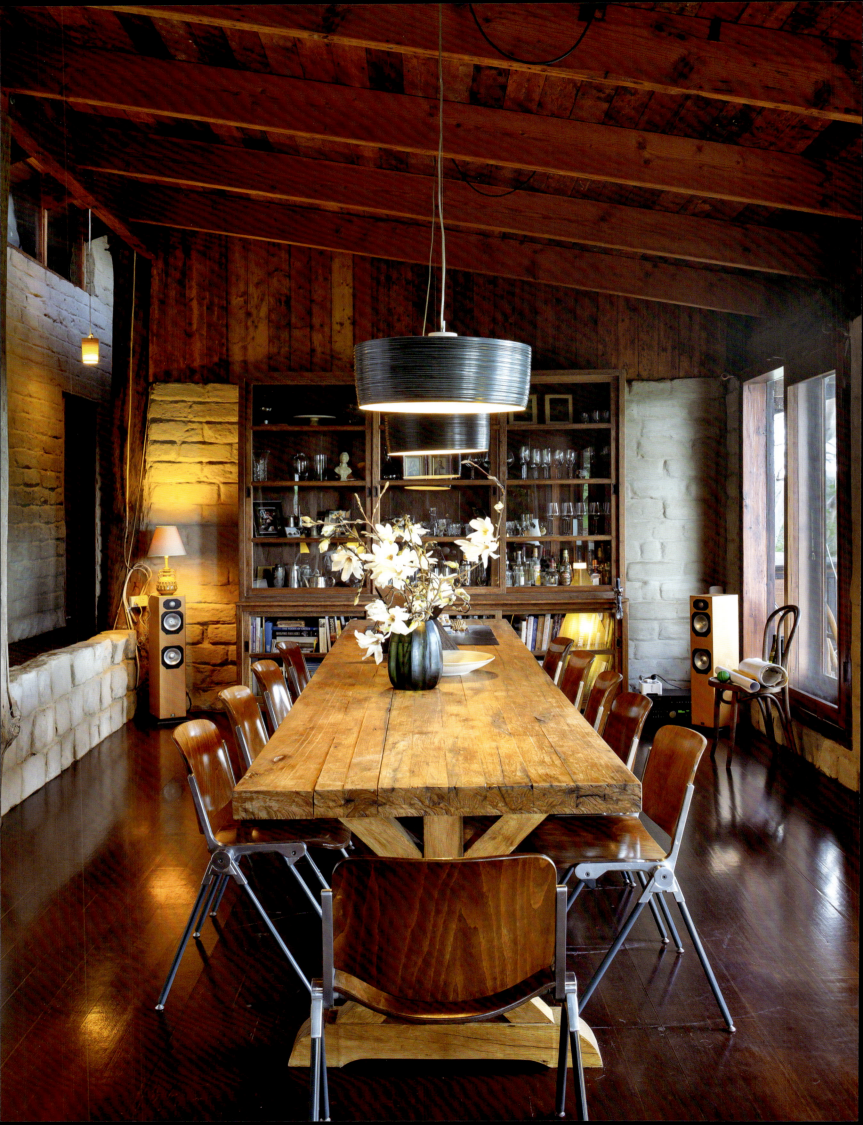

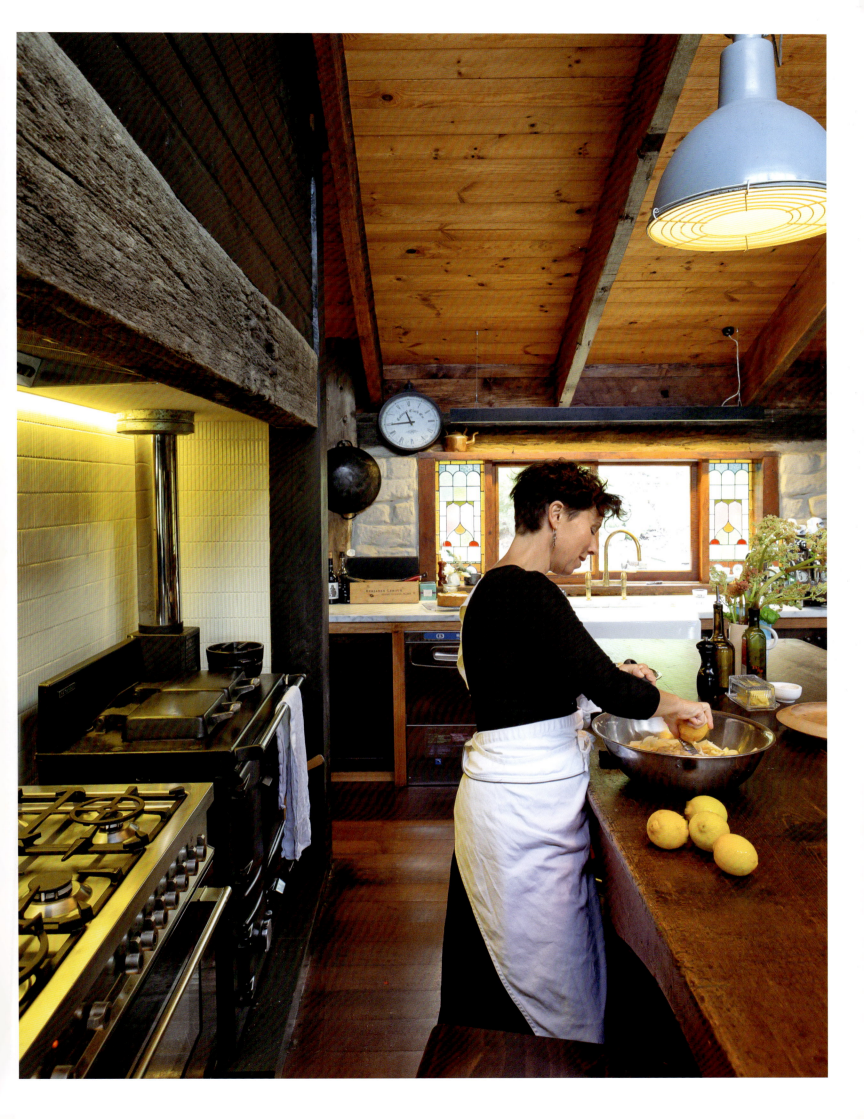

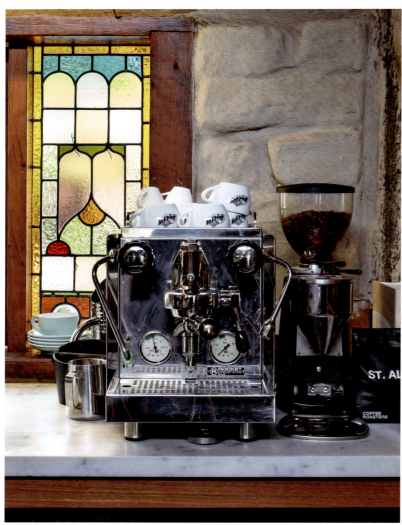

The long marble bench, approximately 7 metres in length, is key to how she prepares her pastries, including the German apple cake (Apfelkuchen) she makes on this occasion. "I love rolling pastry on marble. The temperature is cool, but not too cold like granite. The Carrara here is also honed, as opposed to being polished," says Hafner, who likens her extended bench to having a great tool bench in a workshop (Ness's workshop on the property is an example). "I need to be able to put everything out on display during preparation," she says. With her experience of operating a food and wine bar for over fifteen years, Hafner is also mindful of the importance of having the right dishwasher. As in her restaurant, she has a Bracton dishwasher, perfect for washing glasses. "The washing cycle is exactly 1 minute and 20 seconds as opposed to the usual time of 50 minutes."

The Rocket coffee machine sits nearby, with a good supply of St. Ali coffee beans. And across the front entrance, immediately inside the front door, is a 1920s armoire from Ness's family, who lived in Jakarta for a number of years. Here, crockery and glasses are kept. And outside, is the Alan Scott wood oven that is now the first thing one sees upon arrival to the home. "When Brigitte saw that stove (when we first inspected the place), it certainly tugged at her heart strings. The house and land were seen as secondary," says Ness, who extended this outdoor dining area and built a woodfire stove next to it; adding the timber battens to create a greater sense of enclosure during more inclement weather.

For Hafner, a great kitchen includes a large open space, quality ovens and generous benches to work from. It's also about being close to the elements, whether it's the warmth of the stove (where their short-haired Collie named Sonny likes to gravitate) or from the French steel fireplace in the living room, there's a sense of nurturing both from the food and this home. Although informal meals are served in the kitchen, when entertaining larger groups, meals are served around the 200-year-old oak table in the dining area, a few steps below. There, the indigenous name for the property 'Yurara' holds up to its name, being the place from where friends and family literally take in the eastern view.

German apple cake (Apfelkuchen)

Filling
8 large cooking apples, such as Cox's Orange Pippins or Granny Smith
Finely grated rind & juice of 2 lemons
Finely grated rind of half an orange
75 g caster sugar
1 heaped tsp ground cinnamon
Pinch of salt

Pastry
450 g cold butter, cut into small cubes
250 g plain flour
250 g self-raising flour
80 g caster sugar
2 eggs, whisked

Icing
1½ tbsp stewed apple juice
Icing sugar, sifted
Whipped cream, to serve

Peel, core and finely slice the apples, then place in a bowl with citrus rinds, lemon juice, sugar and cinnamon, toss to combine and set aside to macerate (1 hour minimum – this can also be left overnight). When ready to use, drain the apples but reserve the leftover liquid for the icing.

Meanwhile, for the pastry, process butter, flours, sugar and a pinch of salt in a food processor until fine crumbs form. Add egg and process until mixture just comes together. Turn out onto a lightly floured surface and knead until smooth. Cover with plastic wrap and rest in the fridge for 1 hour.

Preheat oven to 165°C. Prepare a 26–28 centimetre springform tin. Roll two-thirds of the pastry to just under 1-centimetre thick on a lightly floured surface and line the base and sides of the cake tin. Fill pastry case with the drained apple mixture. Roll out remaining pastry, roll the pastry over the rolling pin and lift it over the apple in the cake tin. Press and crimp edges with your fingers to seal, then bake until deep golden brown (1 hour). Set aside in tin to cool for 20 minutes, then release sides of springform tin and set aside to cool completely.

To make icing
Meanwhile, place 1½ tablespoons of reserved apple liquid in a bowl and gradually stir in the sifted icing sugar until a thick glazed consistency forms.

Drizzle over cake and serve with whipped cream.

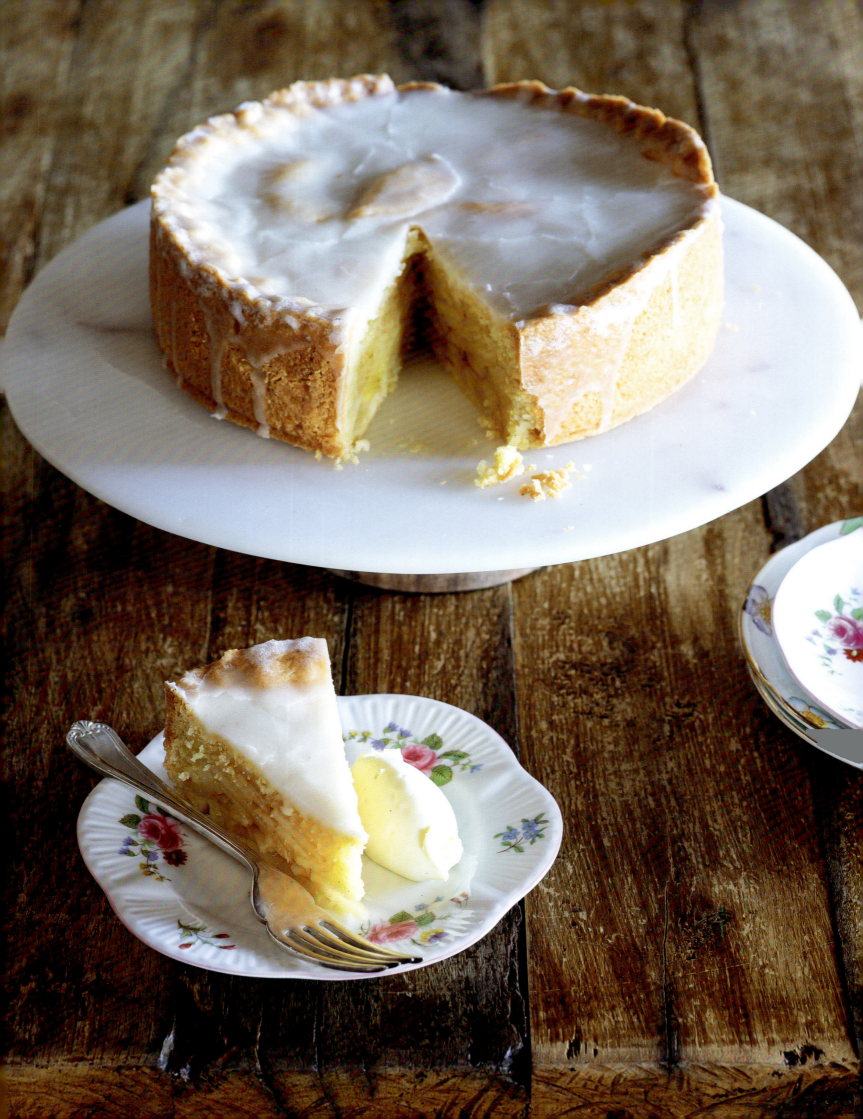

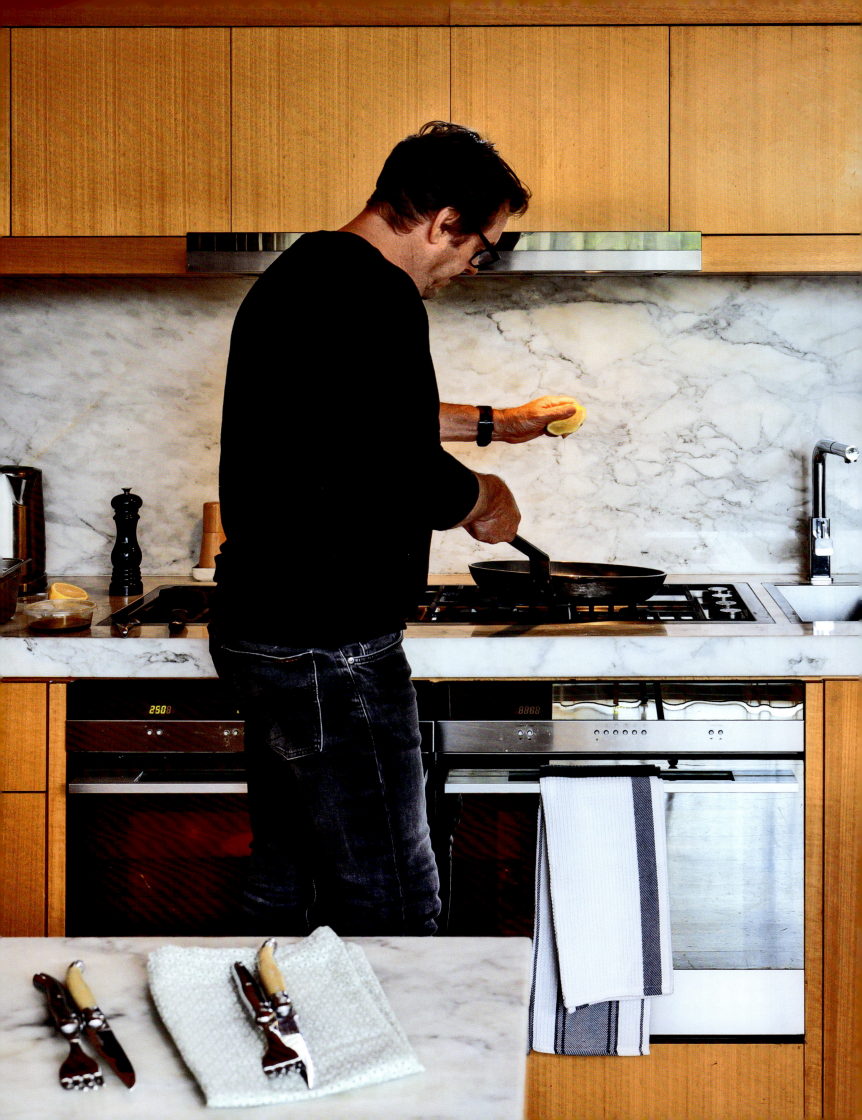

Daniel Vaughan
Having Grown up with Great Food

Daniel Vaughan started to cook as a child. His mother has a passion for cooking and his entire family appreciated her culinary delights, both as children and now, as adults. "The children in our family never bought their school lunches. It was always beautifully prepared in our lunch boxes," says Vaughan, who operates a number of restaurants and cafés, including The Pantry and The Royale Brothers, in bayside Brighton. He is also a partner at Hugo's in Manly, Sydney. Although The Pantry was established thirty years ago, there doesn't seem to be a time when Vaughan hasn't had a hand in preparing food. Vaughan spent a lot of time on the farms of extended family outside Geelong, and his first paid position as a chef was at the Chevron Hotel on St Kilda Road, Melbourne.

Having a house nearby his string of restaurants and cafés was important for Vaughan and his wife, Narelle, given the hours spent at work. Living in the same suburb would afford him more time to spend with his three teenage daughters and two whippets. The couple's early 1960s house ticked all the boxes, including being tucked away in a leafy enclave. "It has that feeling of Palm Springs," says Vaughan, pointing out the split levels, large picture windows and feature stone walls.

While the house was lightly touched when the family moved in, the original kitchen was completely reworked. Originally presenting as a series of small enclosed rooms, with walls dissecting the kitchen and dining area, the appliances were fairly outmoded, with a small wall-mounted oven and rudimentary hotplates below. The benches were also extremely narrow, both for preparing meals and for sitting at. "We rarely use the dining table, even though it's now been opened up to the kitchen. Nearly all meals are served at the bar, with my wife and three daughters sitting on one side, and me preparing on the other," says Vaughan.

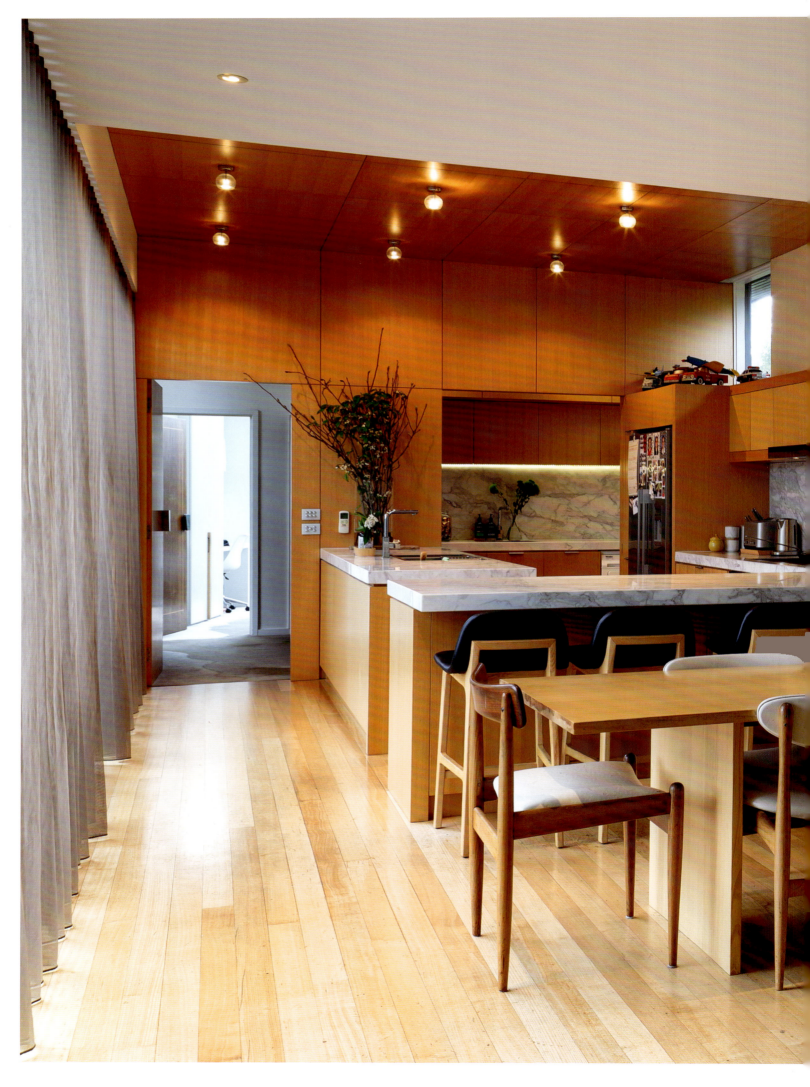

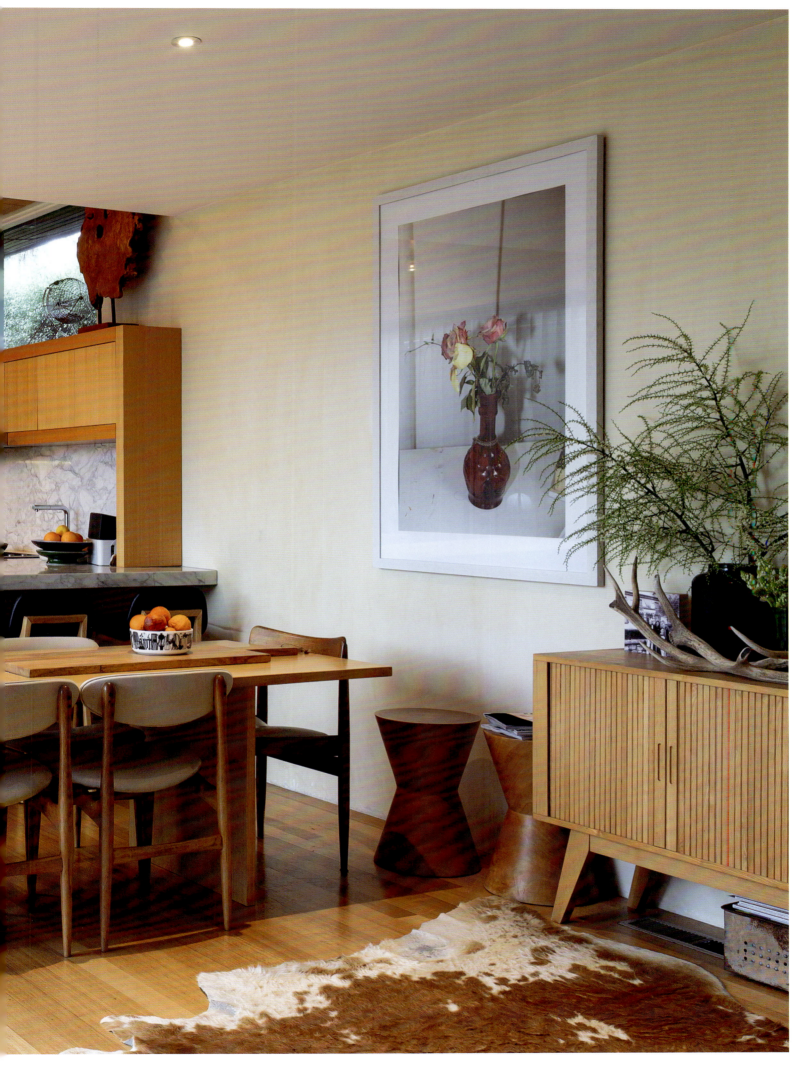

The open-plan kitchen now features two marble-clad island benches: one predominantly used for plating up meals, the other with a double sink for the preparation of food. The third bench, with the Barazza four-burner hotplate, comes with a small sink alongside, ensuring that hot pans are not carried across the kitchen. Two ovens sit below, as it's Vaughan's belief that one can't cook a roast for the family with just one oven. Vaughan was also mindful of safety when designing the kitchen. "When you have children, you need to eliminate potential spillages, transporting hot water in a pan across a kitchen," he says.

Tasmanian oak joinery in the kitchen extends to the adjacent laundry and across the ceiling, with sliding doors that allow this area to be screened off. "We keep a lot of kitchen equipment in the laundry, and things like cereal," says Vaughan, who admits that this kitchen is perhaps a little lean when it comes to storage. "We tend to buy fresh food rather than store or freeze things," he adds. There is a double fridge and also an additional bench oven in the laundry. Apart from a toaster and a few appliances, everything else is concealed, including a dishwasher and a microwave set into one of the shelves below the kitchen bench.

However, what's missing in the storage area is certainly made up for in the bench department, with generously wide marble surfaces allowing him to appeal to the entire family. One of the children currently insists on having individual food groups on separate plates, so this can sometimes result in five plates in front of her. Another is vegetarian, and Vaughan tends to eat his serve while dishing out the various requests. One of the dogs sits at the end of the bench waiting to be fed any leftovers. "I get enormous pleasure from seeing the family come together for meals. It's something that I grew up with and treasured."

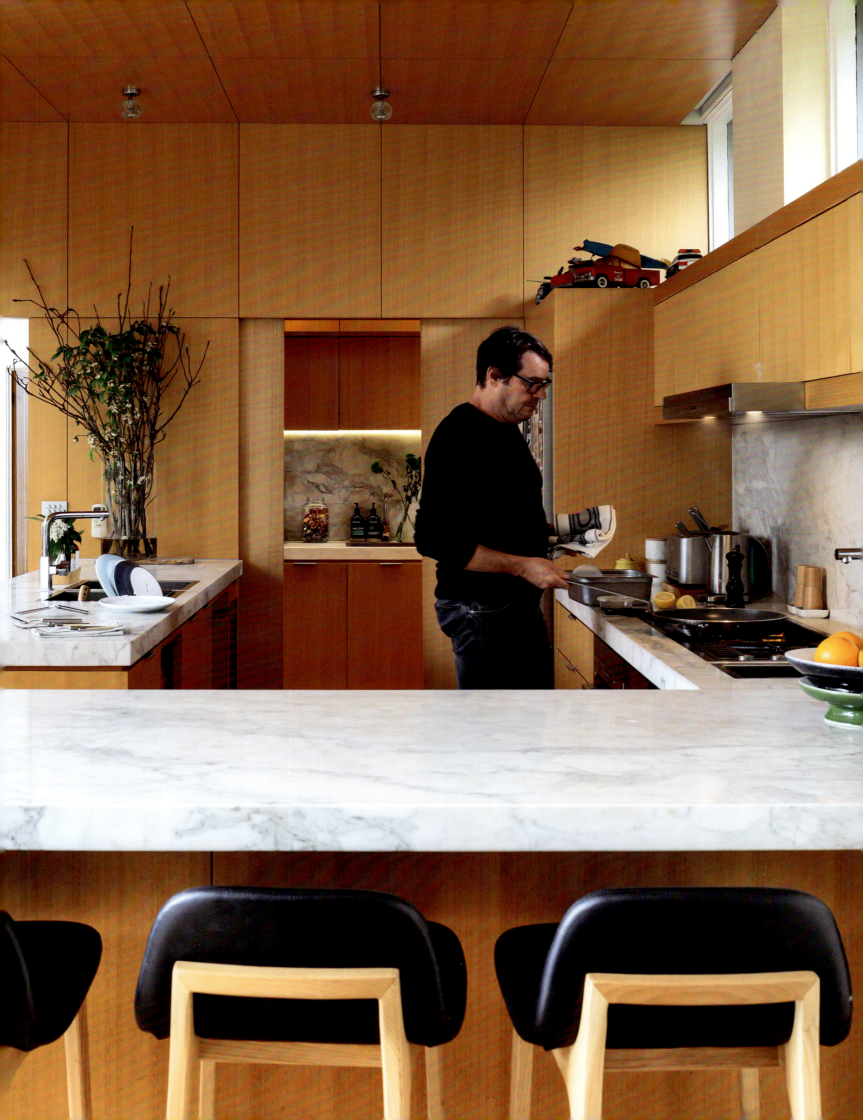

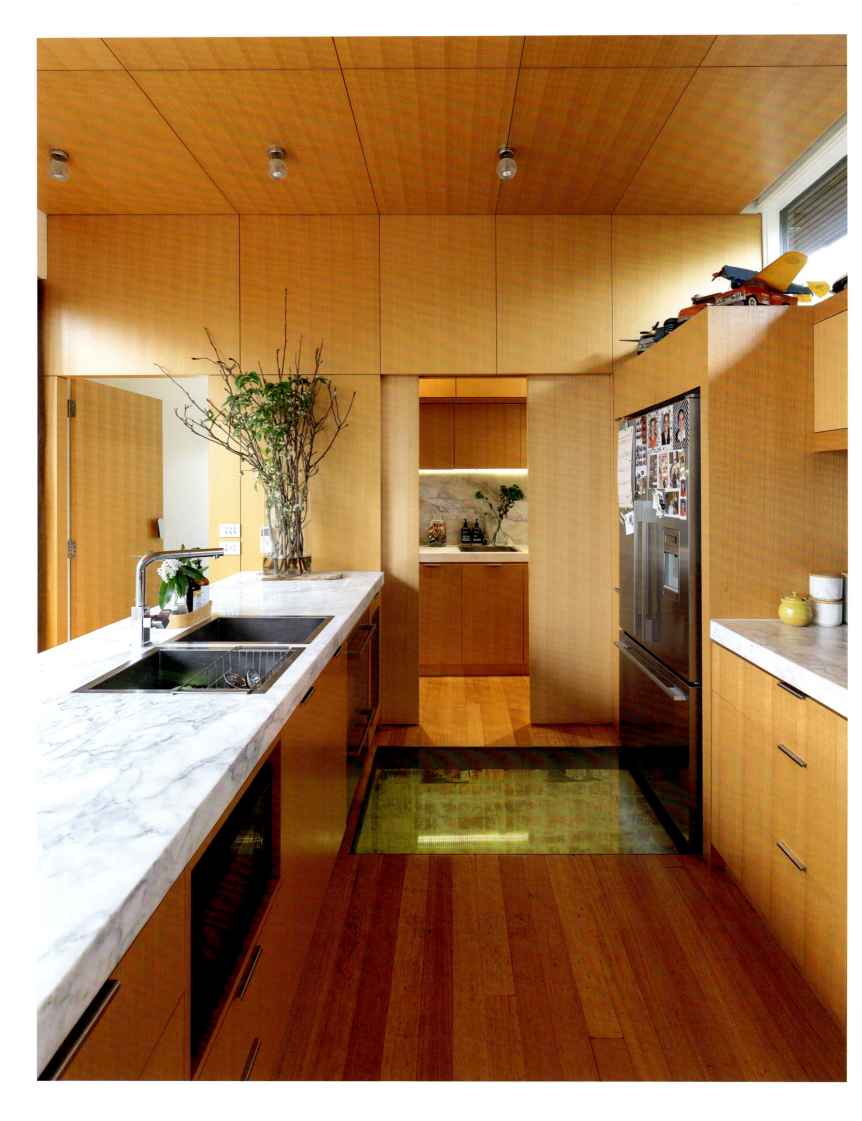

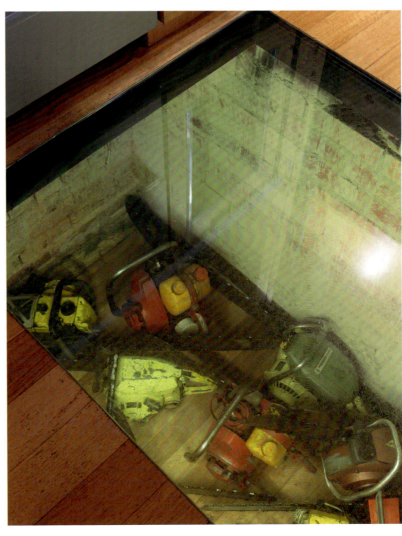

One of the most unusual features in the Vaughans' kitchen is the toughened glass floor inserted into part of the timber floors (adjacent to the laundry). The Vaughans discovered this subterranean space when they first purchased the home. Given the importance of food and wine in this household, one would think a wine cellar would have eventuated. However, as Vaughan says, "If it was there, I would simply drink it." So instead of wine bottles, the glass floor, comprising three sheets of glass, reveals numerous chainsaws dating from the mid-twentieth century. "We both love agriculture equipment, having grown up around farms," says Vaughan, who also drives his vintage tractor along the quiet suburban streets. "I think the locals think that I'm Forrest Gump," he adds.

Fortunately, the chainsaws are for display only, along with his collection of vintage tin trucks and cars from the 1950s and '60s on top of the kitchen cupboards. "It's just a reminder of where we were raised, around farms, surrounded by machinery."

The swimming pool dominates the home's internal courtyard, which is framed by a timber deck, but during the warmer months, the large sliding doors to that terrace can be pulled right back to allow a seamless connection to the outdoors. "There's no need to eat outside. When the doors are fully retracted, you literally feel the breeze on your face," says Vaughan, who appreciates the cross-ventilation offered in this home, as well as the light entering the kitchen from both the east and west.

Although the dining table is mainly used for the children's homework, the kitchen benches are where family and friends gravitate. When entertaining friends, there's a glass of wine within reach while Vaughan focuses on preparing the meal. "I always enjoy my time in the kitchen, even when the family can request very prescriptive meals. You could say that one of my daughters has highly sensitive tastebuds. Where could she possibly have developed these?"

Whole baby snapper with burnt butter sauce and crispy sage

200 g butter
½ tsp garlic, diced
2 tbsp capers
2 tbsp Kalamata olives, chopped
4 cherry tomatoes, halved
1 lemon, half juiced, half wedges

50 ml oil for frying
1 bunch sage leaves, picked
1 baby snapper
Flour for coating
Salt & pepper, to season

In a small pot, melt butter over a medium heat with garlic and cook out until the white foam begins to turn brown. Quickly add the capers, olives and cherry tomatoes, then remove from the heat and squeeze in the lemon juice to stop the cooking process. Set aside in a warm place.

Fill another small pot with about 1 centimetre of oil and heat over a medium heat. To test if it is the right temperature (180°C) and if you don't have a thermometer, add a sage leaf. It should bubble vigorously and turn the leaf a darker translucent green. Fry the sage leaves in batches. When ready, remove from oil with a slotted spoon and transfer to a dish lined with paper towel to absorb excess oil.

Toss the baby snapper in the flour and shake off any excess. Heat 50 millilitres olive oil in a large nonstick pan and add baby snapper, season with salt and pepper and reduce to a medium heat and cook for 7 minutes. Gently flip the baby snapper and cook for a further 7 minutes or until cooked through.

To serve

Place the baby snapper in the centre of the plate and spoon over the burnt butter sauce generously. Finish with crispy sage leaves and a wedge of lemon.

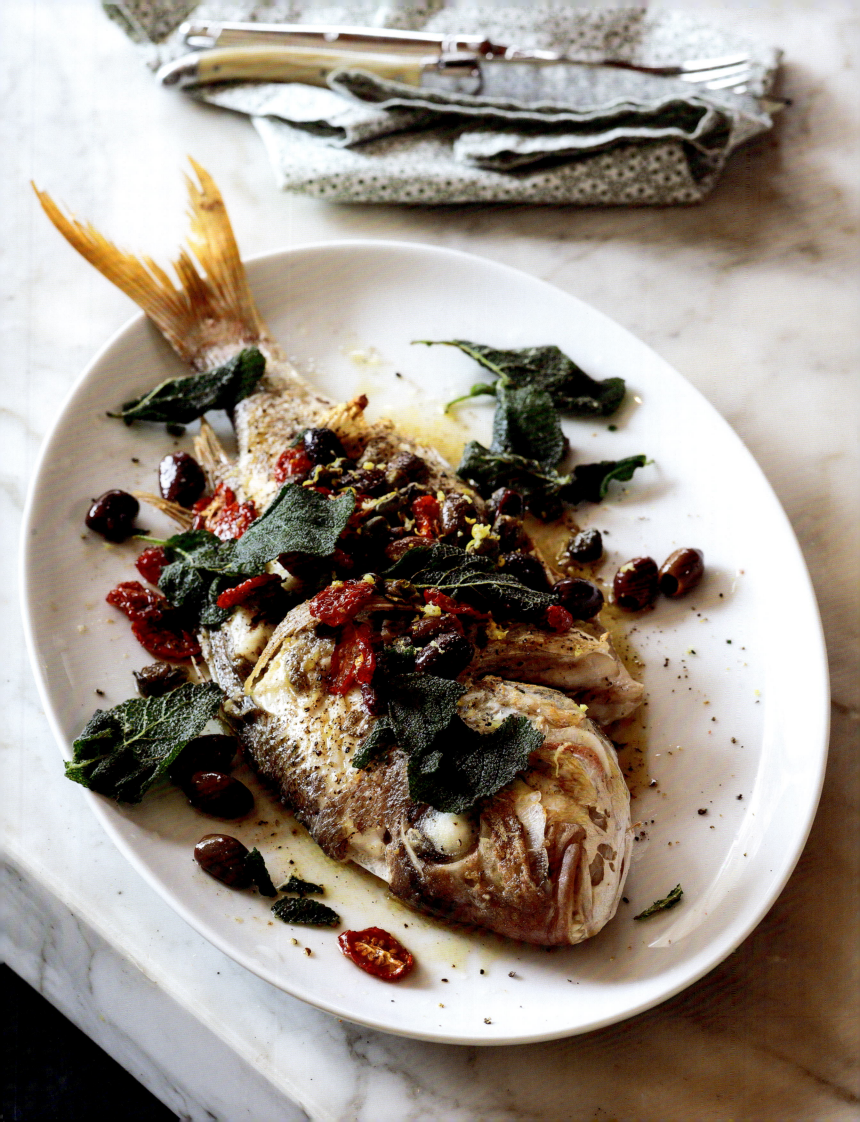

Frank Camorra
Bringing a Taste of Spain Down Under

MoVida has become a household name in Melbourne, due to owner and chef Frank Camorra. First there was MoVida in Hosier Lane, followed by MoVida Next Door, also in the graffiti-covered laneway. Then there was Bar Tini, which was replaced during the pandemic with Tres a Cinco, headed by one of Frank's MoVida chefs, who hails from Mexico. There's also MoVida Aqui at the rear of 500 Bourke Street, along with venues at both Melbourne and Sydney airports. He has just opened his first MoVida in Auckland, New Zealand. Frank was raised in Barcelona, so there's a strong Spanish feel to his bars and restaurants, many of which have been designed by architect Adam Dettrick. Both have a leaning towards authentic food and architecture, steering away from tricking up either area. "Having worked on several of Frank's commercial kitchens, I felt comfortable taking on the brief to renovate his home," says Dettrick.

Camorra's house, located on the edge of Melbourne's CBD, accommodates a relatively large family, with his wife, Emily, and their blended family of two sons and two daughters. Initially a worker's cottage on a relatively modest plot (approximately 260 square metres), the place was originally 2.5-terraces (including a storage area that forms the half). "It had been renovated in the 1980s creating two apartments, one on either level," says Dettrick, pointing at the fall of the land (approximately 3 metres) from the street.

As well as reworking the disparate floors to create a home, Dettrick redesigned the kitchen and dining areas, also adding a casual living area at the rear of the ground floor (with bedrooms below). What was formerly a living area at the front of the house has been transformed into the kitchen, allowing for direct northern light. "Natural light is paramount for the chef. It adds to the enjoyment of preparing food," says Camorra, who enjoys seeing the family's cat, Charlie, sitting on the windowsill.

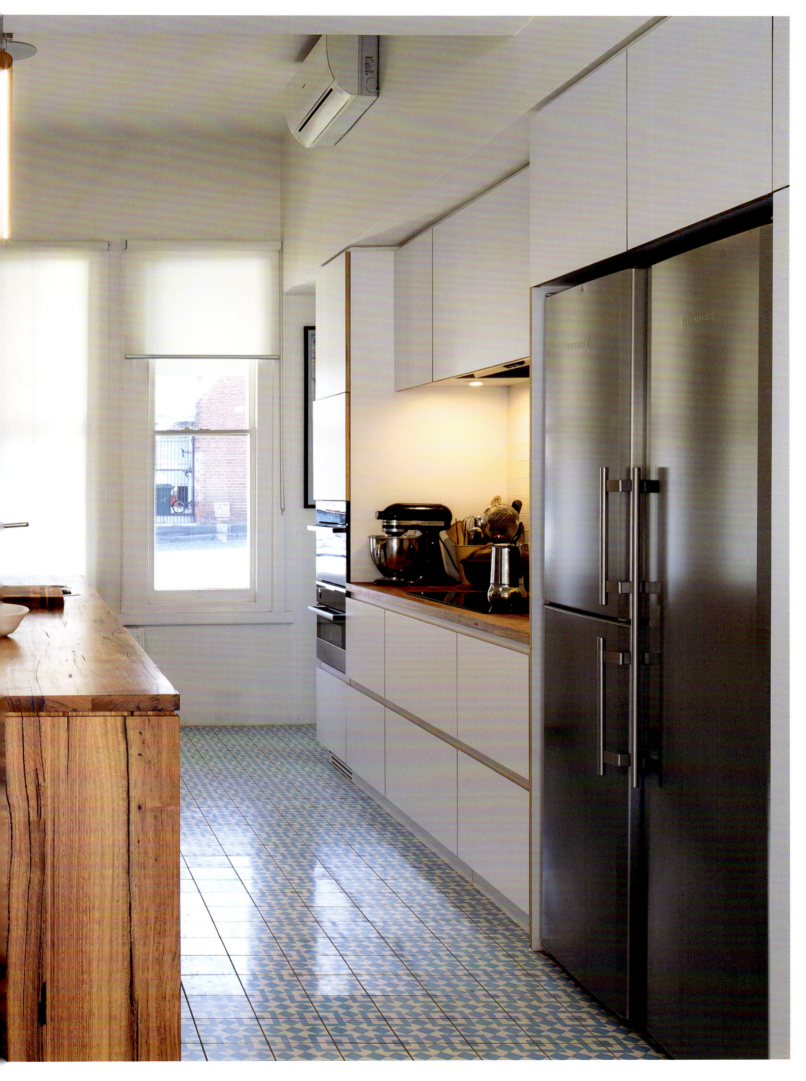

The brief for Dettrick was to create a kitchen with a Spanish feel with a touch of Australia. One of the strongest influences from Spain comes from the blue and white tiles that run through from the kitchen to the dining area. Pivotal to the design is a galley-style kitchen with an island bench almost 4 metres in length. On one side of this bench are blackbutt shelves for displaying wine and glass decanters, along with cooking books and family photographs. The other side is Camorra's domain, with deep drawers below the island bench, filled with crockery and appliances. Although MoVida's commercial kitchens feature commercial appliances and stainless-steel benches, here the surfaces are blackbutt and there are two modest-sized ovens, one above the other. "People think that the larger the better, which isn't the case. As long as there's sufficient room for a roast," says Camorra. One of the ovens is a steamer and the other one also functions as a microwave.

For Camorra, working in a kitchen is about efficiency, almost 'machine-like', with everything being at one's fingertips. Generous storage is also paramount. In this kitchen, there are wall-to-wall cupboards made from Decoply, a composite between laminate and plywood. "Frank and I like to see a few raw edges, adding a certain texture," says Dettrick, stroking his hand along the timber island bench.

The timber benches already show a slightly worn patina, with one bench showing the outlines of where a few hot pans left their marks. "It gives a certain history to the place," says Camorra. There are also a few watermarks around the sink in the island bench, something that naturally occurs from time to time. "I generally wipe up any spills. And in a year or two, it may need a little sanding back and oiling," he adds.

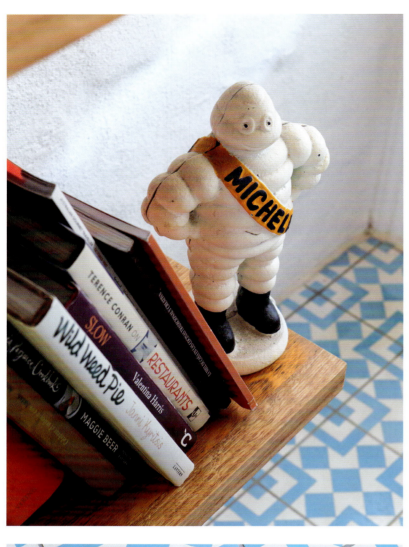

The island bench includes one-and-a-half sinks with a timber chopping block fitting into the top to create a uniform surface. Family and friends pull up one of the Thonet bar stools, are served glasses of wine, and can chat to Camorra while he's preparing the meal, something that occurs during the week, as well as on weekends. "I tend to cook quite simply at home, such as meat balls or chicken curry. There are six of us living here, with the children's ages ranging from ten to twenty, so I need to please everyone." Although Camorra likes to cook simply at home, he has a repertoire of approximately ten to twelve dishes that end up on the table. Being so close to Victoria Market also means that everything is fresh. "I don't have 'green thumbs'. The reality is that many chefs don't," he adds. Fortunately, Camorra doesn't have to worry about a garden, with a modest courtyard to the east and a small balcony leading from the informal living area to the south.

Hence, most of the dining is carried out indoors, although there's an outdoor table in the eastern courtyard, accessed from a set of stairs. Most of the time, meals are served on the island bench, but with a large family, the informal dining area adjacent to the kitchen is the primary gathering spot. Thonet chairs and a built-in banquet-style bench, designed by Dettrick, allow this relatively narrow space (less than 3 metres in width) to feel relatively spacious.

Stucco-rendered, white-painted walls create a Spanish feel to these spaces, with a sense of rawness seen in both the materials used and in some of the art displayed. As well as an Ansett Airlines advertising billboard from the late 1970s of an airline stewardess with a bouffant do, there are works from graffiti artists who made their mark in Hosier Lane, where MoVida is located. Pride of place on the kitchen wall is a framed saucepan, engraved with Camorra's name as 'Chef of the Year' in 2009, for The Age Good Food Guide Awards. "It's quite a simple affair. But really all you need in a kitchen is what you see here, with perhaps some music and light coming through the windows." Having a long suspended pendant light over the island bench is also seen as a necessity, creating 'even light' across the surface.

Although this kitchen meets all of Camorra's needs, there's a small storage room adjacent to the kitchen that will serve as his 'man cave' down the track. But instead of tools, there will be benches to prepare preserves and meats. "It's my next project," adds Camorra.

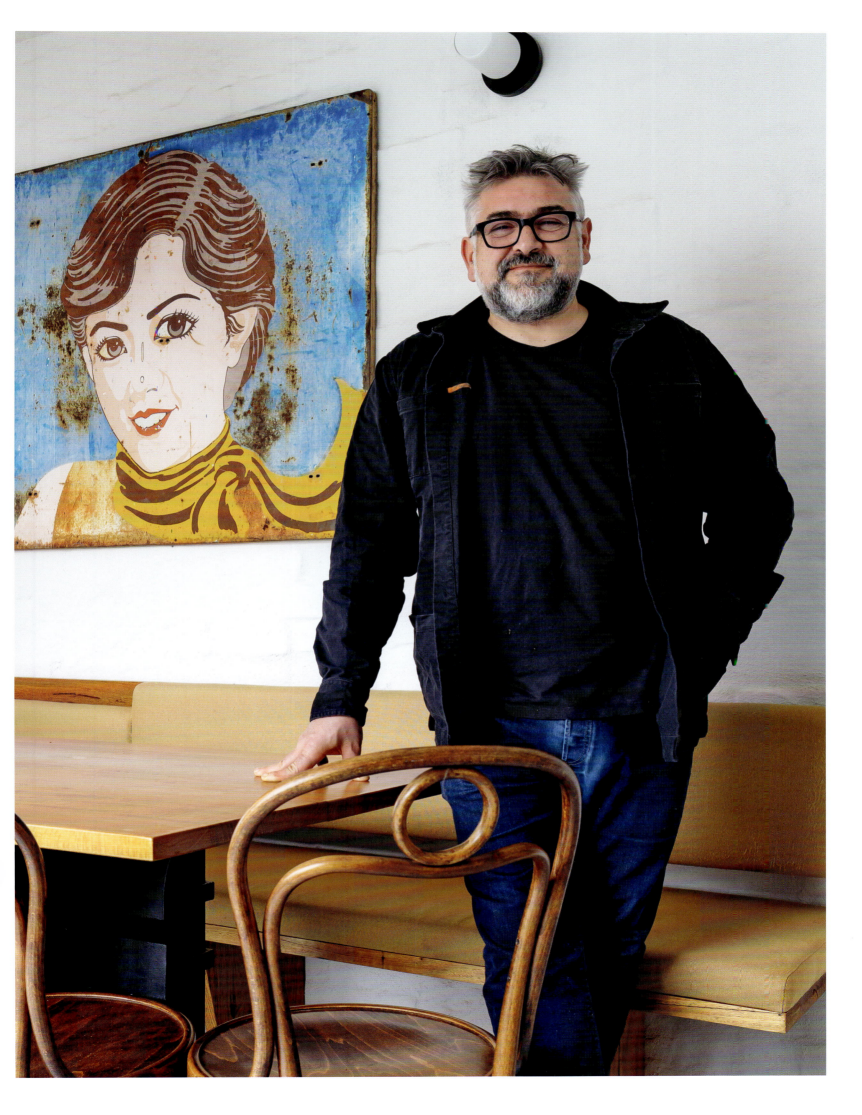

Paella

60 ml extra virgin olive oil
100 g cleaned calamari
300 g free-range chicken thighs, skin on
½ brown onion, finely diced
1 garlic clove, finely diced
Pinch of saffron threads
3 fresh bay leaves
½ red capsicum, finely diced
900 ml MoVida shellfish fumet
2 red tomatoes, peeled, finely diced
60 ml white wine
200 g bomba rice
200 g rockling fillets
4 fresh whole raw prawns
300 g fresh mussels
60 g broad beans
1 lemon
Salt & pepper, to season

Place the paella pan over high heat and add half of the olive oil. Add the calamari and season with a good pinch of salt and pepper. Cook, stirring continuously, for 2 minutes or until firm and caramelised. Remove from the pan, cover and set aside.

Add the chicken, season with salt and pepper and cook, stirring continuously, for 4 minutes or until lightly browned.

Push the chicken to one side, reduce the heat to medium-low, add the remaining oil, the onion, garlic, saffron and bay leaves. Season with a little salt and cook, stirring continuously, for 5 minutes or until the onion is golden. Add the capsicum and cook for 10 minutes or until you have a soft jammy consistency. Mix the chicken in with the onion and capsicum.

In a separate pan, warm the shellfish fumet to a gentle simmer.

Drain any liquid off the tomatoes and add to the pan. Add the wine, increase the heat to medium-high, season with salt and pepper and cook, stirring occasionally, for 15–20 minutes, scraping the base of the pan to deglaze as the *soffritto* cooks.

At this stage, any liquid should have been reduced and the paella should look like a thick, chunky jam. Sprinkle in the rice and stir evenly through. Return the calamari to the pan and stir well.

Add the warmed fumet to the paella pan, stir and continue cooking until it comes to a simmer. From this point on do not stir the paella again. Add the portioned rockling and continue cooking for 10–15 minutes, then add the prawns. Remove the paella pan from the heat after 10 minutes and let sit.

Steam the mussels in a pot on the stove top. Open and discard any mussel beards.

To serve
Place the mussels on top of the paella, serve with lemon wedges.

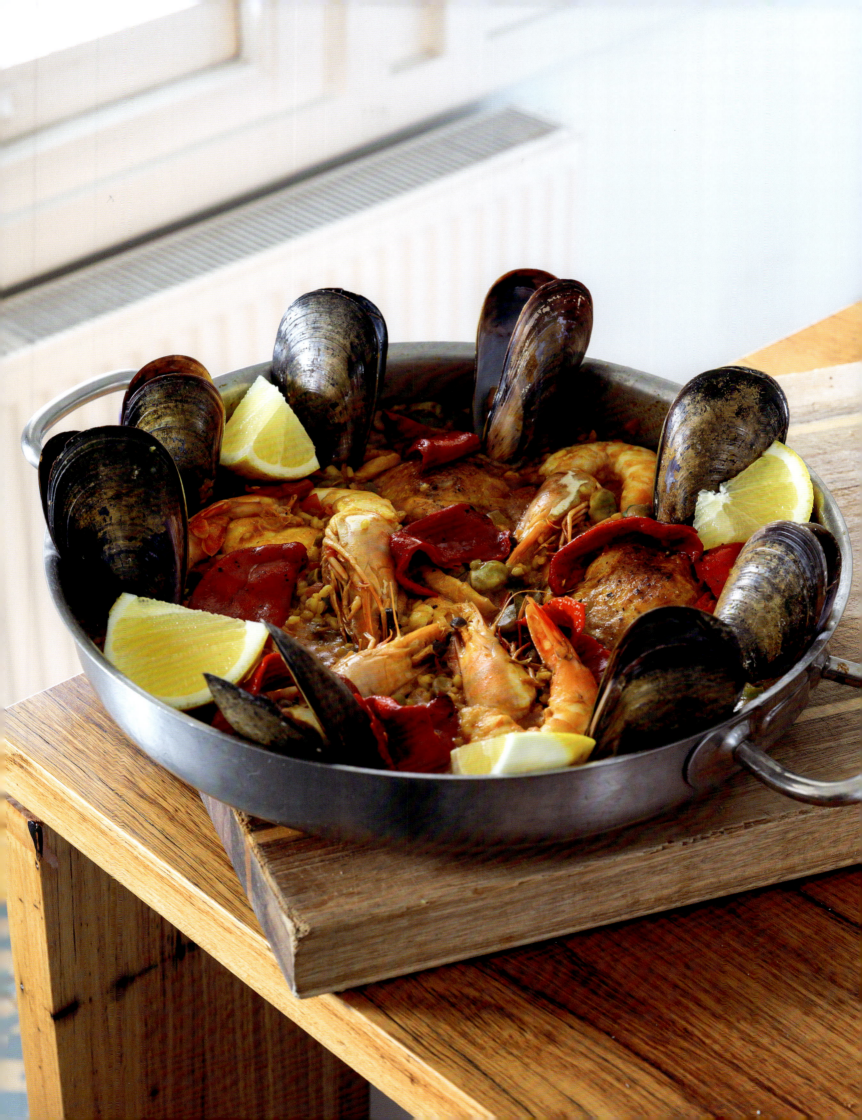

Ian Curley
An Oasis

High brick walls fence in chef Ian Curley's home in Brighton. After forty years in the food industry, starting with the Grand Hyatt in London, he can reflect on his trajectory, while overlooking his swimming pool. Now owner of The French Saloon and Kirk's Wine Bar in Melbourne's Hardware Lane, Curley also consults for a number of restaurants and catering institutions around Australia. Regularly on the road, he appreciates coming home and cooking for family and friends. Having three young children explains some of the scattered toys in the living room. However, the pristine all-white kitchen is void of any toys or general clutter. "I like to be able to wipe everything down after cooking and putting everything away," says Curley.

Curley and his wife purchased what were then two homes, side by side. One was a 1980s townhouse, while the other was a fairly rudimentary cottage, over 100 years old. Curley engaged Finnis Architects and interior designer Carole Whiting to rework both properties (the cottage was completely replaced with a new building), including the kitchen, formerly a composition in shades of brown. "It didn't really work for how I like to cook. The living areas also needed to be opened up, both to the kitchen and the garden," says Curley.

The former kitchen (in the same position) was extensively reworked, with a new butler's pantry and a window overlooking the swimming pool. The kitchen itself was also completely redesigned with a new granite island bench and generous deep drawers below. The mission brown cupboards along one entire wall were removed to make way for additional space around the island bench. The grey ceramic tiles that ran throughout the entire ground floor were replaced with in situ terrazzo. "The process was like pouring milk," says Curley, delighted to see the 'vanilla and chocolate chips' appearing in the floor as it was grounded and polished. Tongue-and-groove wall panels were also added to give the house a distinctively

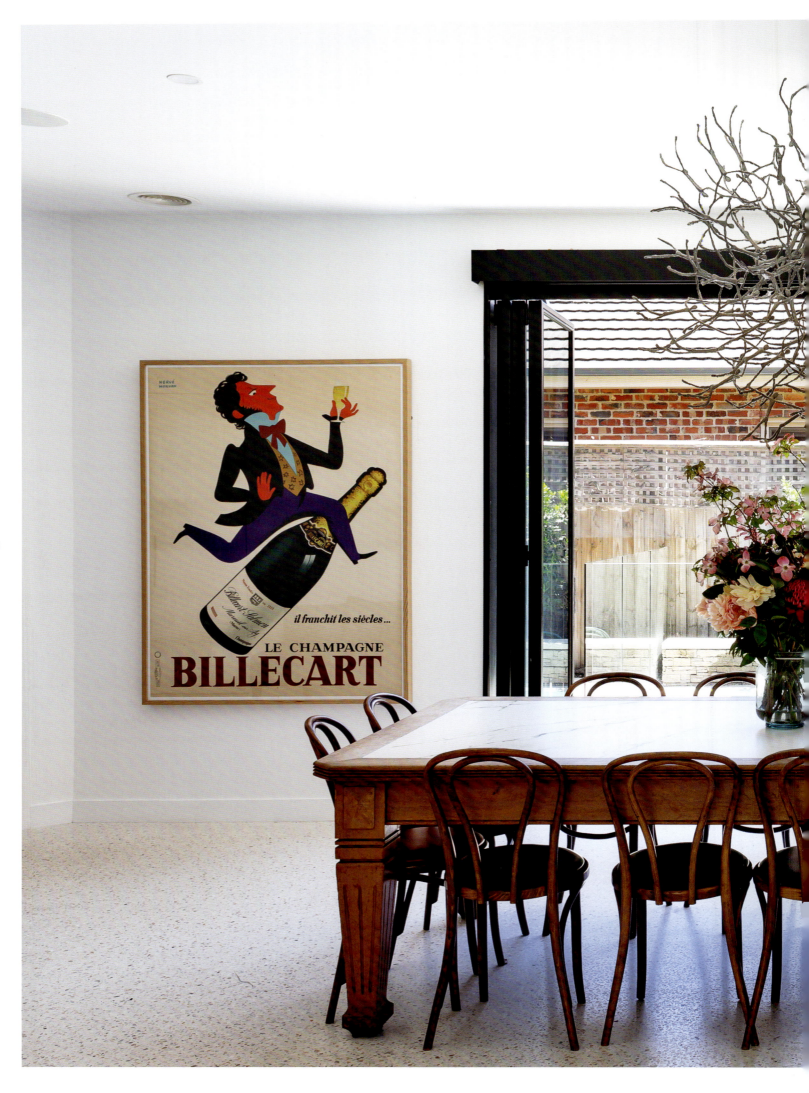

beach feel. "I love hearing the sound of water (a fountain appears at one end of the pool) and leaving the doors open, particularly during the warmer months of the year," he adds.

In both the kitchen and butler's pantry, the material of choice was Dekton (a Spanish product), made from compressed sand. "It can't burn and it doesn't leave marks even if you put a hot saucepan on it," says Curley. The large drawers are also finished in Dekton, some of which accommodate a toaster, while others display crockery. Creating a neutral backdrop allowed Curley to include stainless-steel shelves, formerly in one of his commercial kitchens, and a stainless-steel flue. The kitchen's white subway wall tiles create a recessive backdrop to Curley's culinary delights. "I like kitchens to be extremely clean, low maintenance and, above all, extremely functional. You'll notice in this kitchen, there are simply no nooks that can't be cleaned." The idea of including wall-to-wall stainless steel was never going to occur in this kitchen, given the material's association with commercial kitchens. "Why would I want all that noise and work involved?"

Unlike some kitchens that are wall-to-wall appliances, here, there are relatively few, but all thoughtfully considered. Induction hotplates and a convection oven by V-Zug are adjacent to a deep sink. "I like surfaces that can be easily wiped down and to be able to have everything at arm's reach," says Curley. The commercial steel racks above the kitchen bench are full of pots and pans, including two prized copper pans that need an 'army' to lift them. In spite of their weight, Curley has engraved his name into the side of each one so that they can't go missing. "They're the same ones, Mauviel, as in this poster," he adds, pointing to a late-twentieth-century advertisement for polishing copper.

Curley also has two sets of knives displayed in the kitchen: one being a set of treasured Japanese knives attached to a wall, the other being stored in a timber block. "When you have young children, you need to make sure certain knives are kept beyond reach," says Curley, who insists on sharpening his knives. Spices and condiments are as easily found, emerging from a pop-out pantry concealed behind one of the kitchen cupboards.

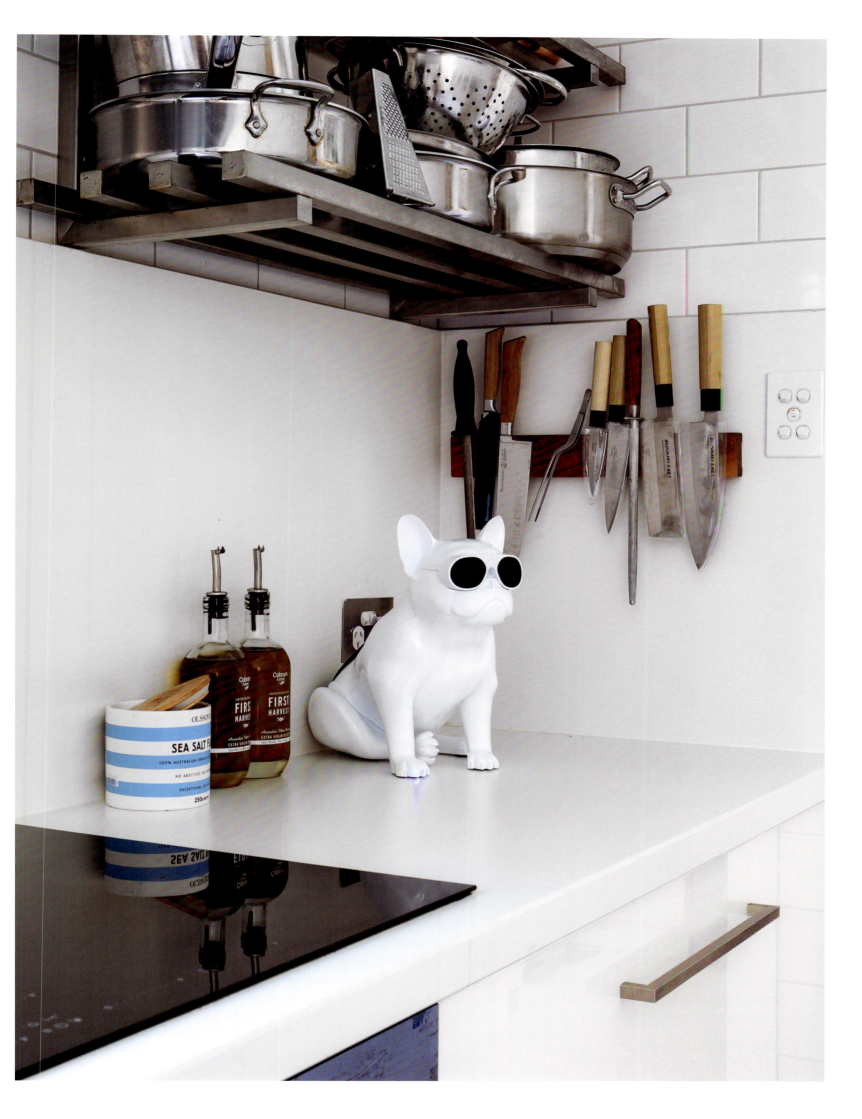

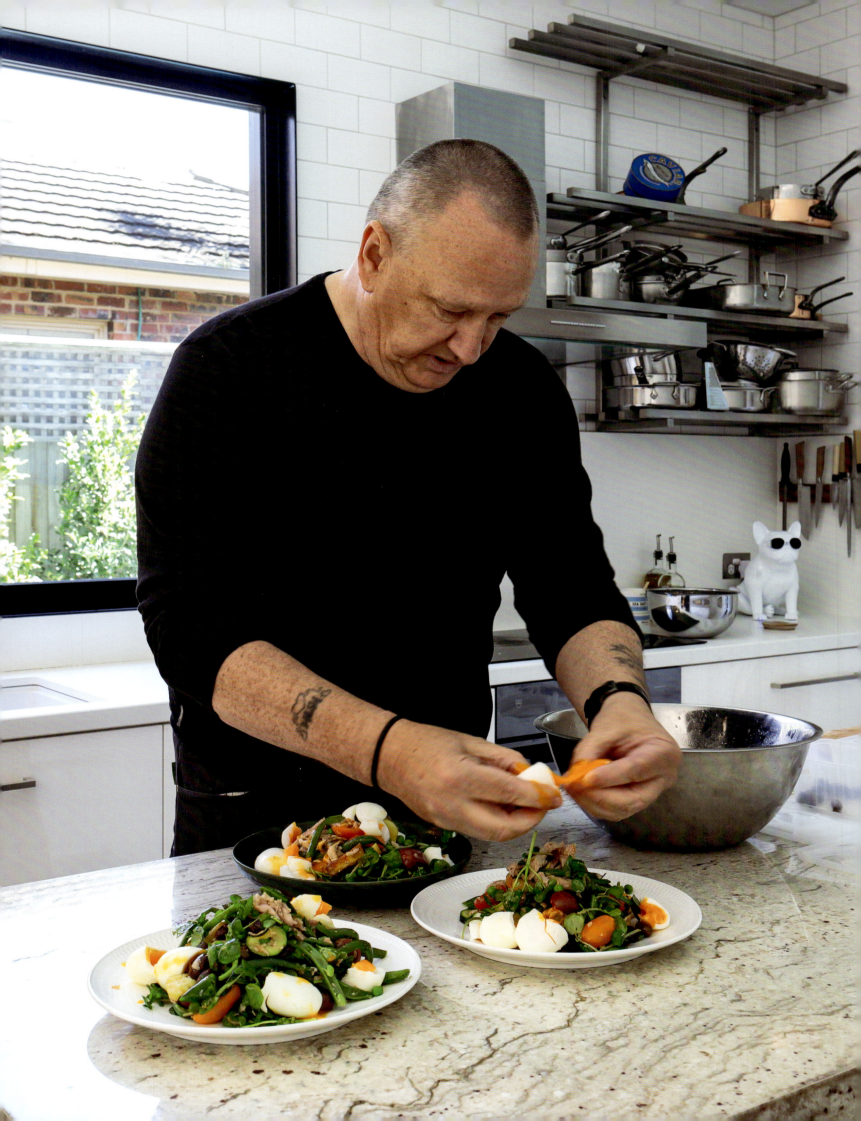

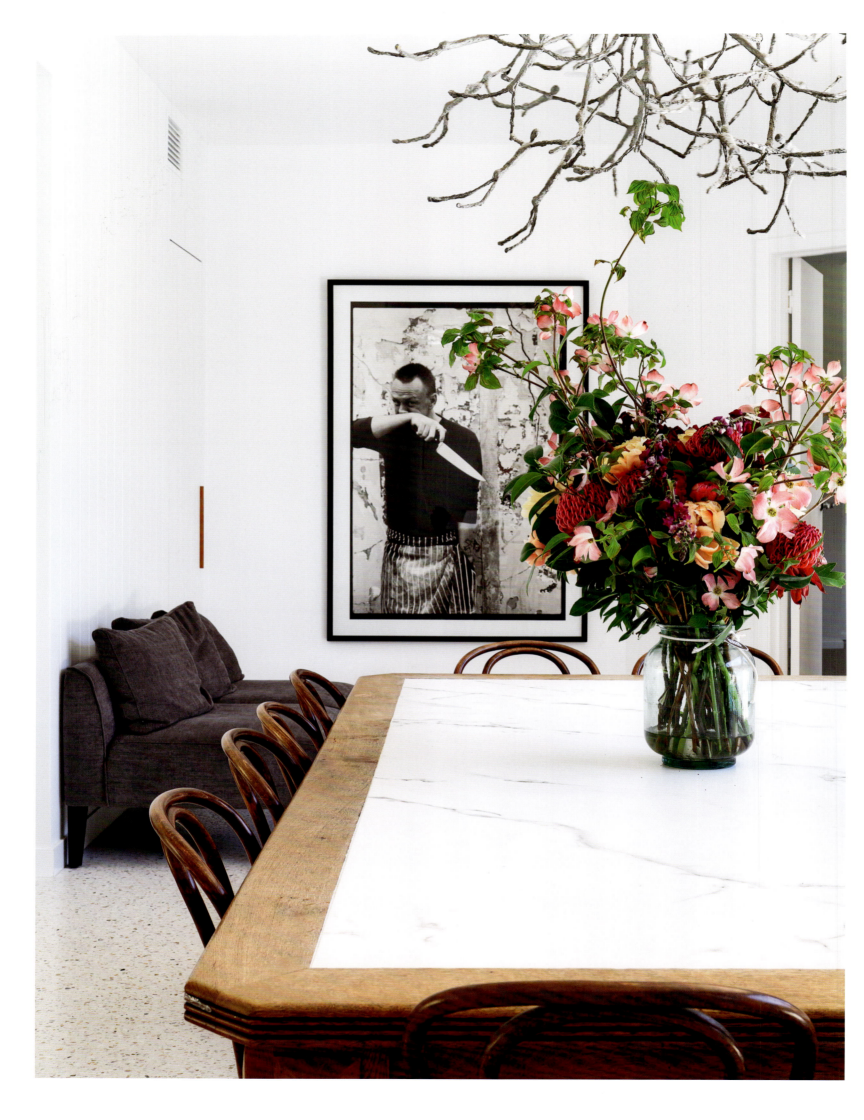

One of the reasons for redoing the kitchen was to create a more open-plan arrangement of the dining and living areas. Pivotal to the space is an old timber table, once located in barristers' chambers and resurfaced using Dekton. The table surrounded by twelve Thonet chairs (the same as in The French Saloon) is used for entertaining friends, but equally appreciated first thing in the morning with a newspaper spread across the table. A black-and-white portrait of Curley taken by photographer Julian Kingma, posing with a knife, was formerly displayed in the kitchen. "I needed a little distance from myself when I'm preparing food."

Lighting is also important for Curley, whether he's preparing a meal during the day or checking emails from his laptop on the corner of the kitchen bench. "I don't need much space for office work, but it's important to have good lighting, particularly at night when I'm catching up on things," says Curley, pointing out the industrial-style pendant light that illuminates the bench after dark.

For Curley, it's the simplicity of the kitchen that makes it so pleasurable to work in. "Life is complex enough, so the last thing that I needed were loud tiles and orange taps," says Curley, who generally prefers to prepare simple meals at home, whether it's pasta or fish, and of course with a glass of wine from the store in his compact cellar, within the base of the staircase. Having the north and south elevations completely open to the garden is also important, along with the deep window seat, orientated to the north, located at the front of the house. "I love being able to follow the sun and feel part of its trajectory," he says.

"It's about making work in the kitchen that much easier. After all, I love cooking, but I also value time spent with my family," says Curley.

Tuna niçoise

6 small kipfler potatoes
Pinch of salt
30–40 green beans
6 eggs
2 bunches watercress
1 bunch basil
20–30 cherry medley or heirloom tomatoes
Mixed olives (about 36)
Peas (a few per person)
Baby zucchini
12 white marinated anchovy fillets
Lemon juice
Olive oil
6 tuna steaks from the loin
Bottarga
Zucchini flowers, if in season

This can all be prepared in advance, apart form the tuna, which should be done just before serving.

Set up an ice bath and leave aside. Fill a pot with cold water and place on the stove. Add the kipflers and cook them until just soft. Set aside to cool in the same water (it keeps the flavour of the potatoes) and, when cool enough to handle, then peel. Boil the same water in the pot with a pinch of salt, blanch green beans until they just change colour and then place them in the ice bath.

Boil the water again and place eggs in gently. Cook for exactly 8 minutes and then refresh in ice or run under cold water. Peel eggs when cool.

Chop medley tomatoes in half. Chop olives and potatoes into small pieces. Chop watercress and basil, and combine in a bowl with potatoes, beans, olives, peas and tomatoes. Chop baby zucchini into small rounds and add to bowl. Add anchovy fillets. Dress with lemon juice and olive oil and taste (usually 1 part lemon juice to 2 parts oil). Separate into six serving plates.

Cut one egg on each plate (into three or so pieces each; yolk should be runny so it adds to the dressing on the salad). Season tuna and grill quickly on both sides. Place one on each plate. Grate bottarga over the top. (Decorate with zucchini flowers, if in season.)

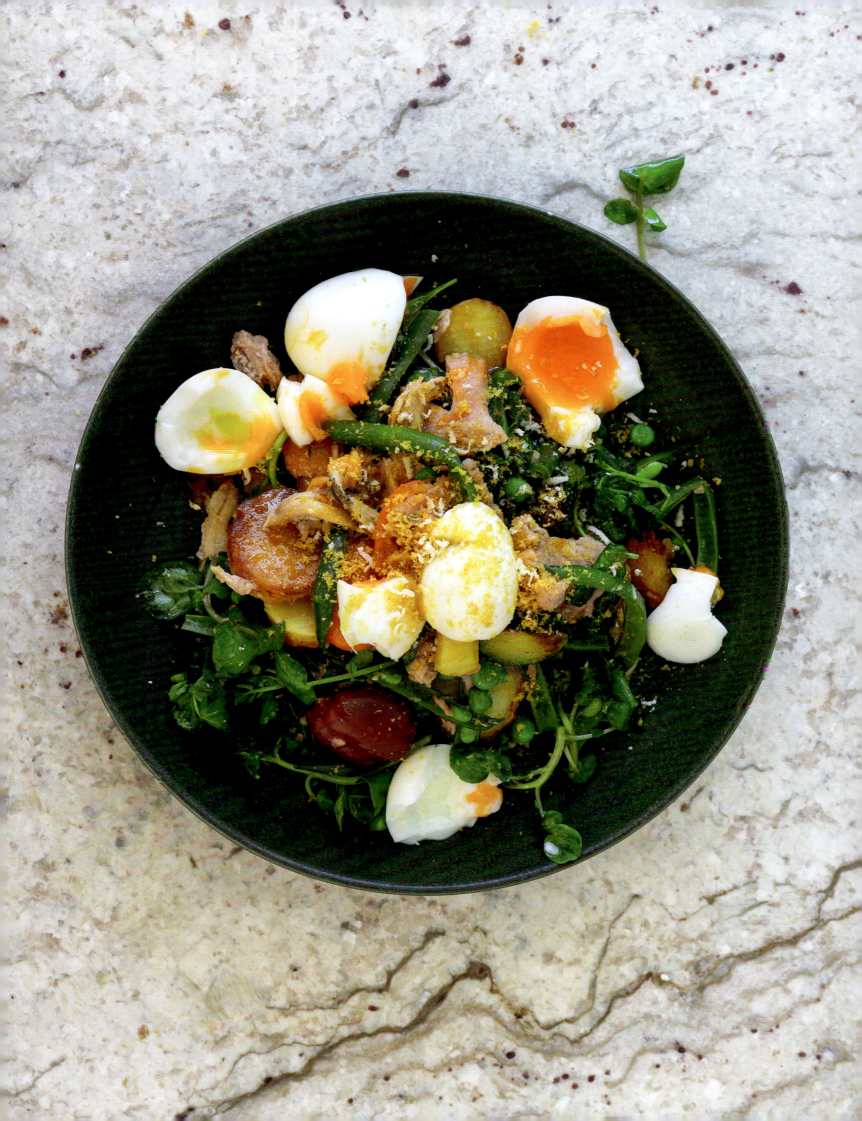

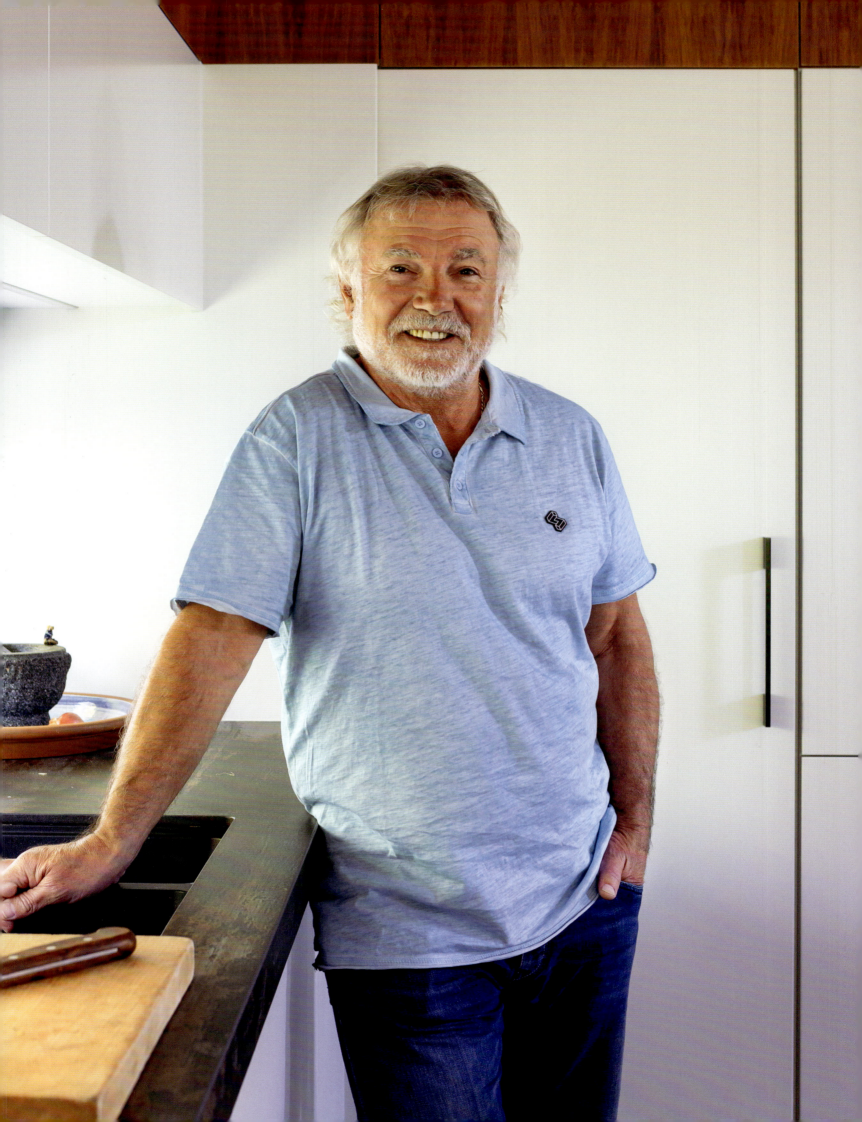

Jacques Reymond
Keeping it Simple

After fifty years preparing memorable dishes, chef Jacques Reymond's name has become synonymous with fine dining. Although he's not spending as many hours at his restaurants, Bistro Gitan, L'Hotel Gitan and the recently opened Frédéric, he still gets involved, when he's not spending time in Bresse, France. "I grew up there. Each time we visit, I always purchase a chicken, whether it's made from steel or ceramic," says Reymond, who shares his bayside home in Melbourne with his wife, Kathy. "I've been in the restaurant business since I was a teenager." Reymond enrolled in a specialist hospitality school in Nice.

Fast forward several decades and the Reymonds have scaled down from their family home in the suburbs and moved closer to the beach and the city. Although the townhouse was relatively new when they purchased it a few years ago, the kitchen was not fit for a chef, at least for Jacques and Kathy, who enjoys cooking pastries. "The kitchen just wasn't practical. It felt like a steam train when you switched on the oven," says Kathy, recalling the rattling noise that it made. "The Italian oven looked great, but there was always something going wrong with it," she adds.

While the townhouse was left largely unchanged, the kitchen and courtyard-style garden, orientated to the north, was reworked. Designer Chris Arnold from Complete Kitchens worked closely with the Reymonds to address how they like to cook and accommodate their specific requirements. "The brief was for a clean and contemporary feel, with generous storage. A chef generally comes with more equipment than the average person," says Arnold, pulling out the deep drawers in the Reymond's kitchen, which contain everything from an extensive knife collection to pots and pans and crockery. The other words of wisdom coming from Arnold are to take into account a client's age when designing a kitchen. "Knees, hips and backs tend to play up more as you get older, so having to get down on your knees to fossick through cupboards is far from ideal."

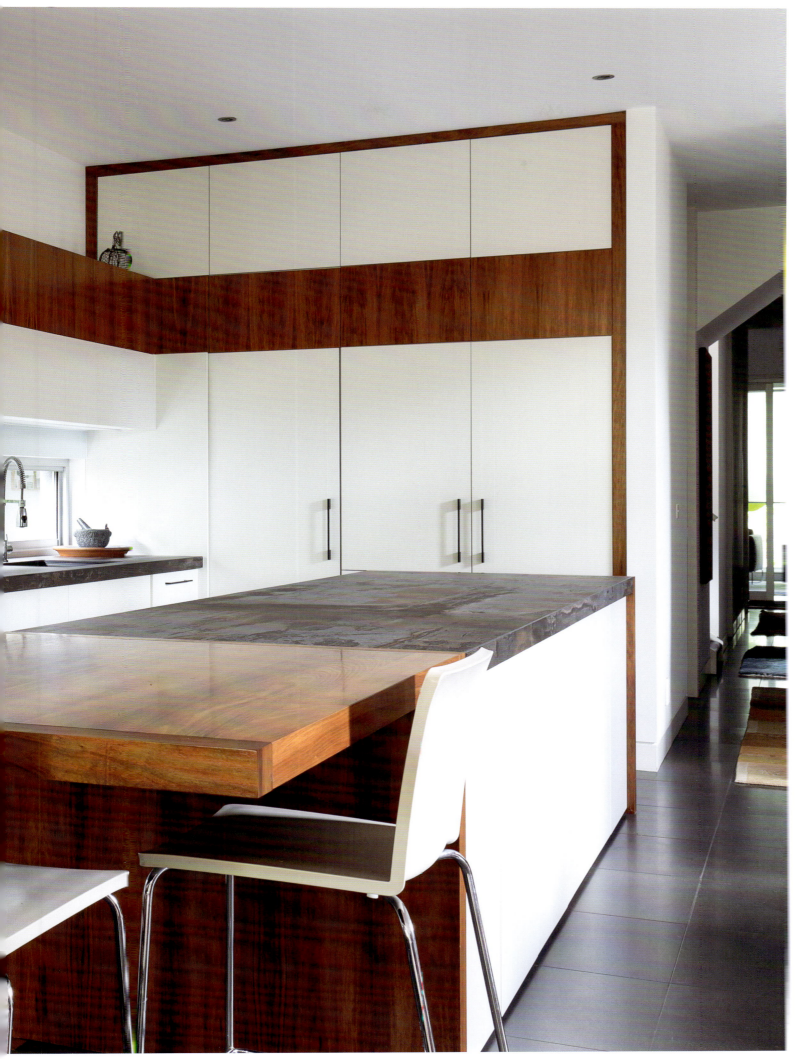

Placing less emphasis on cupboards was certainly on the Reymonds' minds, as were surfaces that could be easily wiped down. The Italian oven, part of the original design, was removed and replaced by two sleek V-Zug ovens, one for steam. And unlike the former oven, these are located at waist height so that there isn't a need to bend down. For Jacques, a priority in the new kitchen was for good cross-ventilation and, in particular, the ability to extract kitchen odours. A Qasair extractor is concealed at the base of the kitchen joinery, directly above the bench. In keeping with the brief, almost everything in the kitchen is concealed, including the fridge and dishwasher (appearing as joinery). "I really don't want to look at pots and pans when I'm cooking," says Jacques, who has stored all his French copper pots, including 'Bourjeat', in the garage. "When I switched over to an induction hotplate, all these pots became obsolete, well at least for cooking in my kitchen," says Jacques, who has been collecting copper pots and pans for many years. "Just feel the weight," he adds.

One of the more unusual features in this kitchen is the long central island bench, partially made from Dekton and the other part made from Tasmanian blackwood. "I wanted some warmth and texture in the kitchen, but I also wanted surfaces that would withstand hot pots or plates," says Jacques, who immediately warmed to the rich patina of the Dekton (a hybrid stone material), from a distance resembling mild steel. Dekton was also used for the kitchen bench.

"It's virtually impossible to mark, and the hues [blues, browns and greys] complement our timber furniture," says Kathy. While others may opt for a sink set into a kitchen bench, Jacques dislikes them intensely. "You lose all that bench space. How could you really make pasta when a sink cuts up your space?" says Jacques.

Although the timber portion at the end of the central island bench was originally designed for breakfasts and light meals, it's mainly used by Jacques for catching up on paperwork or organising his schedule. The dining area is generally where most meals are eaten, or during the warmer months, on the terrace. "At Christmas, we tend to join the two tables together, often having up to twenty people," says Kathy.

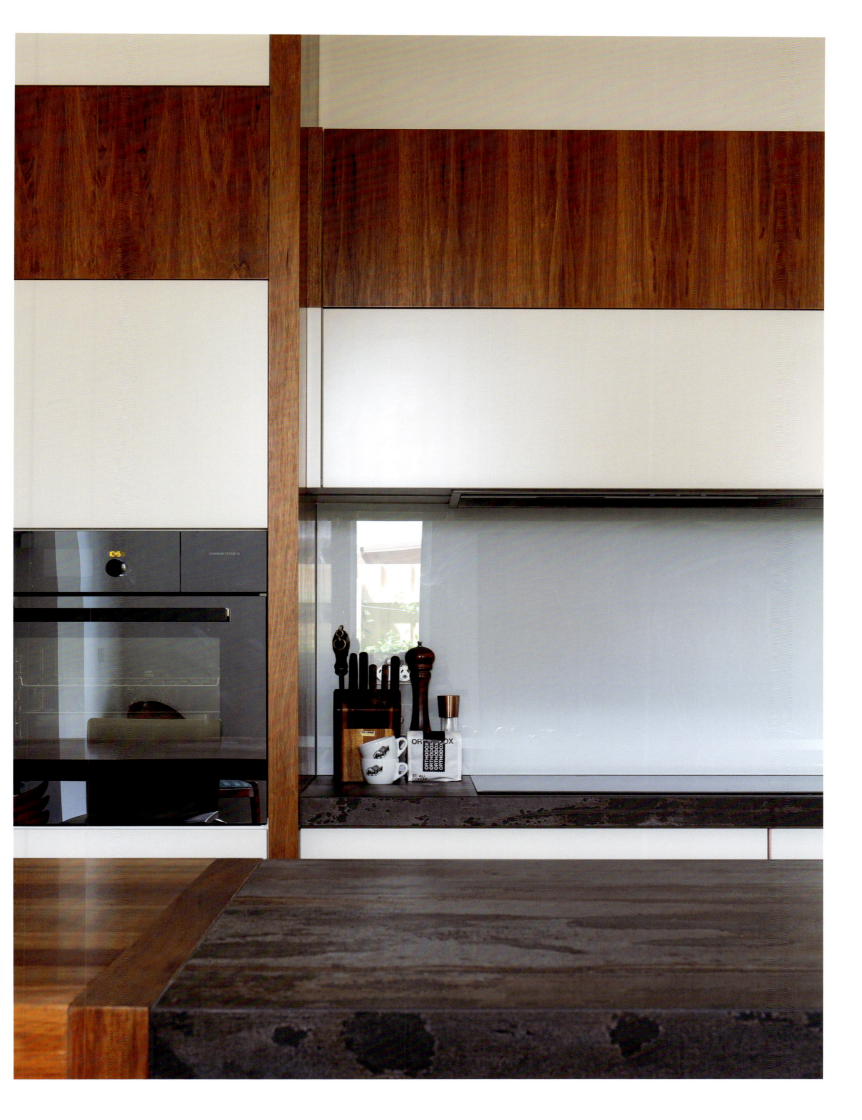

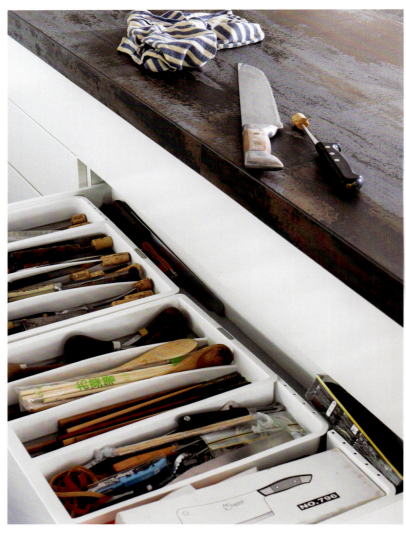

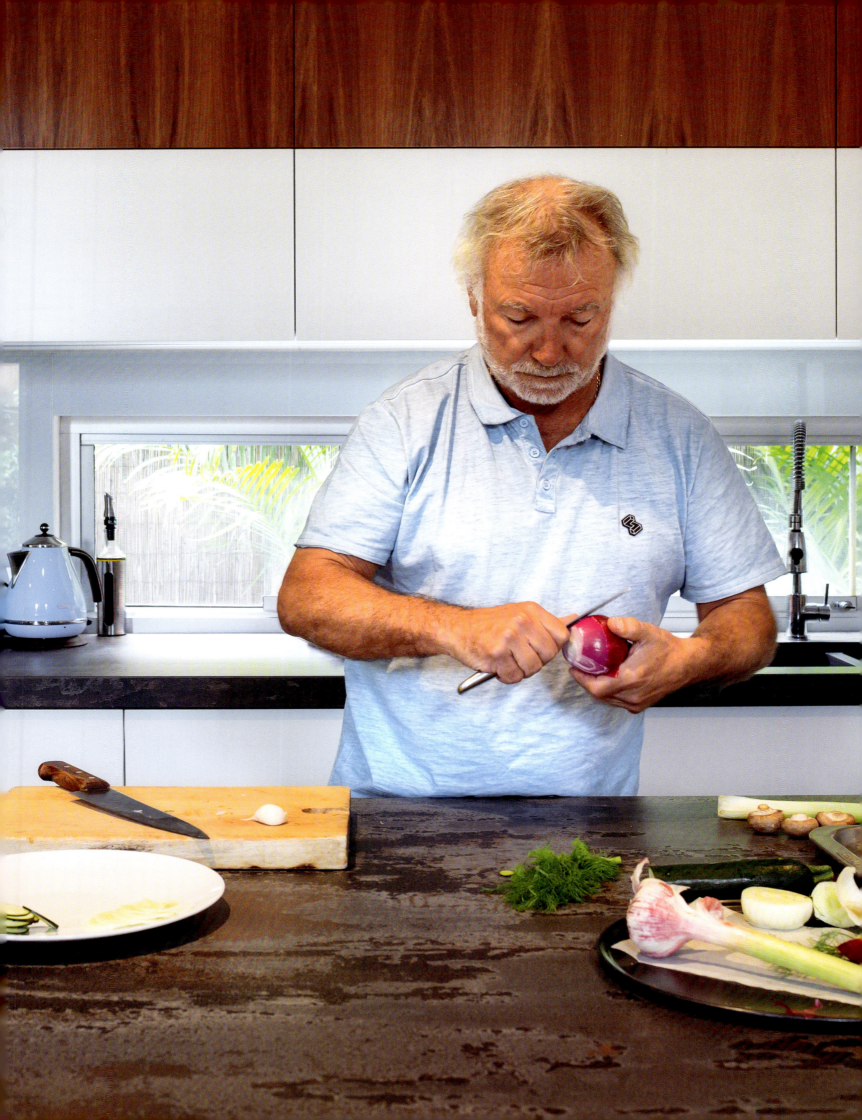

Given the experience of working in kitchens virtually his entire life, Jacques was keen to have a kitchen that was highly efficient. Rather than standard cupboard doors, here the joinery folds up with a touch of the hand. The induction hotplates are just as efficient, being easy to clean and wipe down. Everything has its place. Jacques' 200 specialist knives are kept in one drawer while Kathy's are kept in another. The joinery under the island bench (on the dining side) offers some of the few cupboards, one being to store wine, the other for cookbooks, although Jacques readily admits that most of his cooking is 'by just knowing' what's needed for each dish.

There's also a separate room leading from the sizeable garage that contains most of the Asian ingredients, along with a sizeable stainless-steel fridge to store everything from pasta to ice cream. Although the fridges are generally well endowed with fresh ingredients, the garden also provides some herbs. There's chilli and a kaffir lime tree, with the leaves rather than the fruit used for cooking. There's also a bay-leaf tree, along with a lemon and lime tree and a place to grow herbs, guarded by a number of ceramic chickens purchased on one of the couple's trips to France.

Although Jacques' fine food has been presented on starched linen tablecloths, here, the cooking is fresh and simple. "I steam a lot of fish and vegetables, just a little red meat," says Jacques, who enjoys spreading out ingredients on the 4-metre-long island bench. "We generally cook independently of each other. If he's standing next to me, he tends to take over," says Kathy, who has earnt her own stripes in the kitchen with her pastries.

Fish en Papillote

2 baby fennel, sliced very thinly
3 garlic cloves, sliced thinly
1 Spanish onion, sliced thinly
1 stick celery, sliced thinly
1 small zucchini, sliced thinly
60 g butter, cut into small cubes
400 g fillet of snapper or hapuka
3 button mushrooms, sliced thinly
1 tomato, sliced thinly
1 small piece ginger, sliced thinly
1–2 red chillies, sliced thinly
Salt & pepper, to season

Dressing
4 tsp white wine
6 tbsp good olive oil
Juice of 1 lemon

Garnish
6 fresh basil leaves
Fennel tops, chopped
Lemon slices

Line a baking tray with a large piece of aluminium foil hanging largely over the sides. Place on top a smaller sheet of baking paper. (Never cook directly on foil as your dish will taste steely; always use a sheet of baking paper.)

Preheat the oven to 200°C.

Arrange the fennel, garlic, onion, celery and two-thirds of the zucchini on the baking paper. Dot the butter cubes among and lay the fish gently on top.

Layer the remaining vegetables (mushroom, tomato, ginger, chilli and remaining zucchini) on and around the fish. Season with salt and pepper.

Mix the dressing ingredients (wine, olive oil and lemon juice) and drizzle over the lot.

Fold over the foil (you may need an additional piece) to create an air-filled capsule and seal the edges tightly.

Cook for 10–15 minutes.

To serve
Bring the whole papillote to the table and open the top with a knife.

Add the basil leaves, fennel tops and fresh lemon slices and serve with plenty of cooking juices.

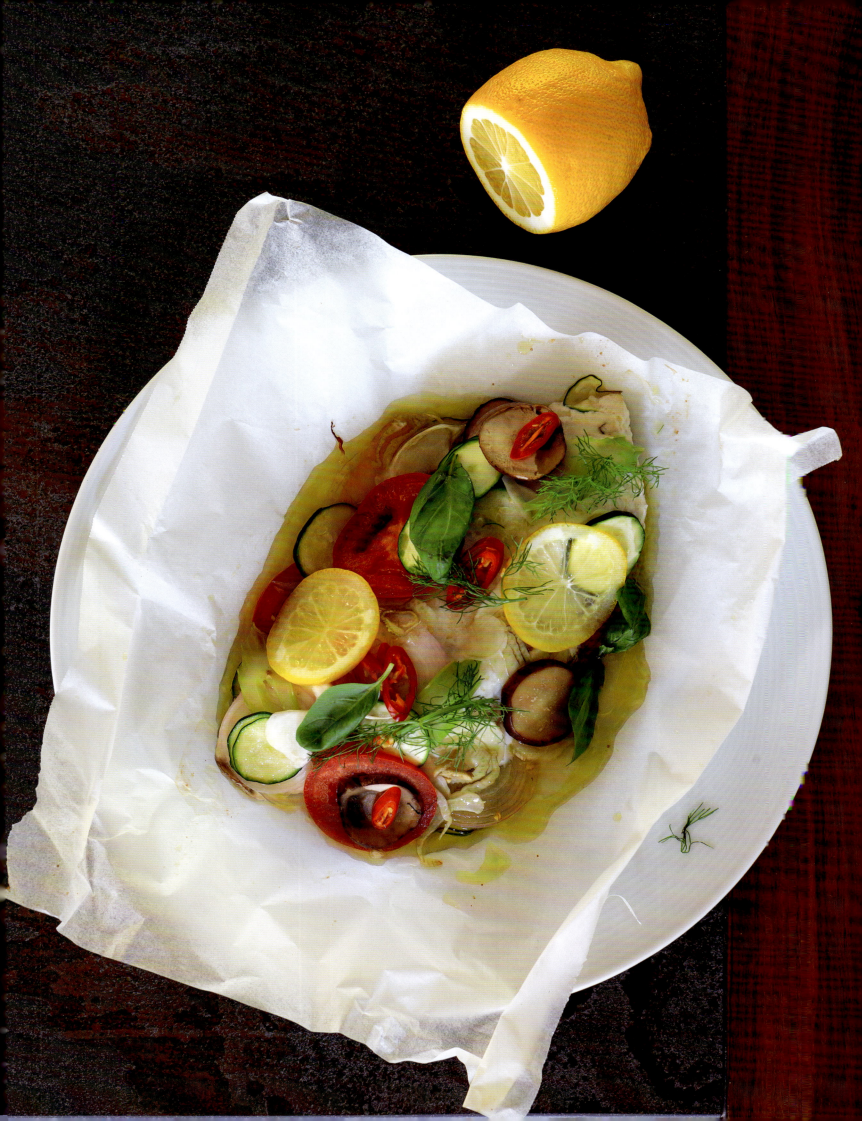

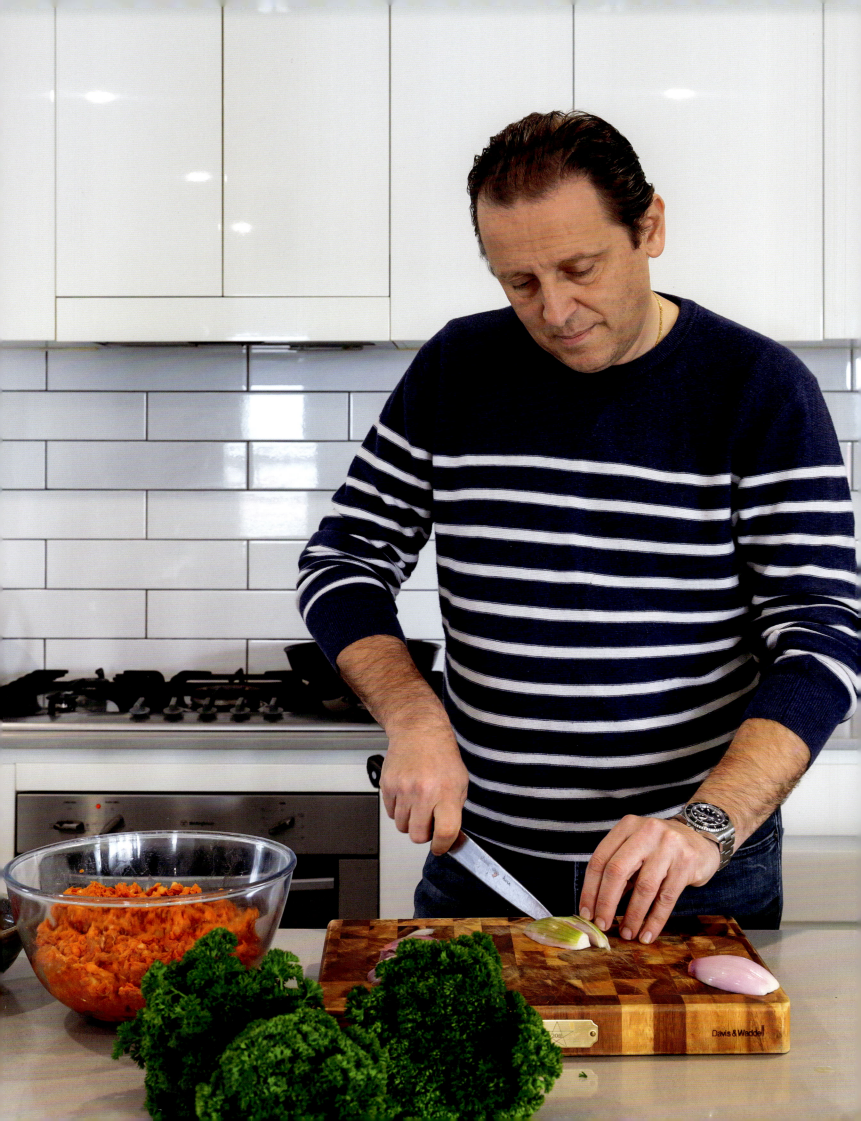

Javier Codina
A Kitchen with Space and Light

Javier Codina's kitchen in the Brisbane suburb of Camp Hill is a long way, both in distance and size, from the modest kitchen in the apartment where he grew up, in Barcelona, Spain. There, the galley-style kitchen occupied a separate room, adjacent to the dining area. "I feel extremely fortunate to be living in this house, with this great kitchen. It was the drawcard when we purchased the house seven years ago," says Codina, who lives in the 1960s timber home with his wife, Silvia Jimenez, and their three boys, Tristan, Eric and Victor. And of course, the family's cocker spaniel, Kobe, is always underfoot.

The couple, who own the Moda Brasa Tapas Bar at the Barracks in the inner-city suburb of Paddington, enjoy entertaining friends as much as eating around the table with the immediate family. "We have a rule to wait until everyone has arrived, whether that means waiting for Silvia to return after walking Kobe, Tristan returning from basketball practice or waiting until I get home from the restaurant, unless there's a need for me to stay back late," says Codina.

Located on an elevated standard-sized block, the three-bedroom house features a large open-plan kitchen and dining area at its core – with sliding glass doors that lead to a protected outdoor deck. Complete with a fan and a canvas awning, there's a need to maintain an even temperature given Brisbane's climate. "I would estimate that we eat outdoors 75 percent of the time. For family meals, it's always around a table, and breakfasts are generally perched at the bench," he adds.

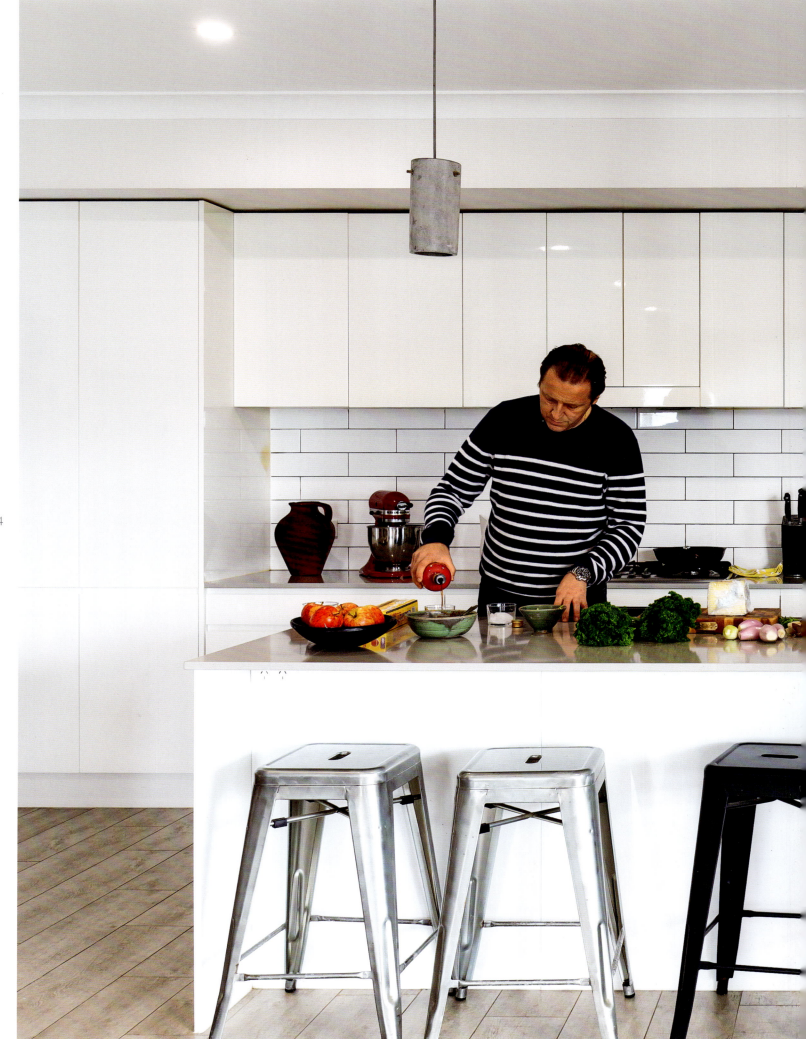

The kitchen features end-to-end extensive white-painted MDF joinery with a generous 3-metre-long island bench finished in granite. Simple, glossy white subway tiles appear on the kitchen's splashback and nearly everything is out of sight – with pans concealed in large drawers below the gas hotplates, along with crockery and glassware in the many cupboards. There are also numerous cookbooks found in the cupboards as well as thousands of recipes, some of which have been handed down by the family. And while many kitchens include a walk-in pantry or even a butler's kitchen for either storage, preparation or both, you won't find this here. "We prefer buying everything fresh from the market," says Codina, who also doesn't grow vegetables in his back garden (which has only two jacaranda trees and a lawn as well as a raised deck).

There are a few things left on the bench, adjacent to the oven and next to the gas burners – a KitchenAid, a timber block holding several knives, olive oil (a must) and on the island bench, a bowl of fruit and often tomatoes that form the basis for many of the dishes. A timber chopping board is also a permanent fixture. There's also the Cazuela/Puchero on the bench, a terracotta jug that once belonged to Silvia's mother – a pot that was used in Spain to cook everything from potatoes, lentils and beans to chickpeas and pork dishes. "No one is permitted to touch this jug," says Codina, who says that it was used in the outdoor kitchen and is a constant reminder of how their lives have changed since they came to Australia twenty-two years ago.

There are two main drawcards in the kitchen. One is the fish tank filled with goldfish that requires Silvia's immediate attention upon rising first thing in the morning. The other is a large painting by well-known Indigenous artist Sally Gabori, displayed in the dining area. Titled *Plenty of Fish*, it's both an appropriate name for the kitchen of a leading chef, as well as a way of injecting vibrant colour in the all-white kitchen. "I'm continually looking at it when I'm cooking or even just perched at the bench," says Codina, who is amazed that Gabori only started painting in her later years.

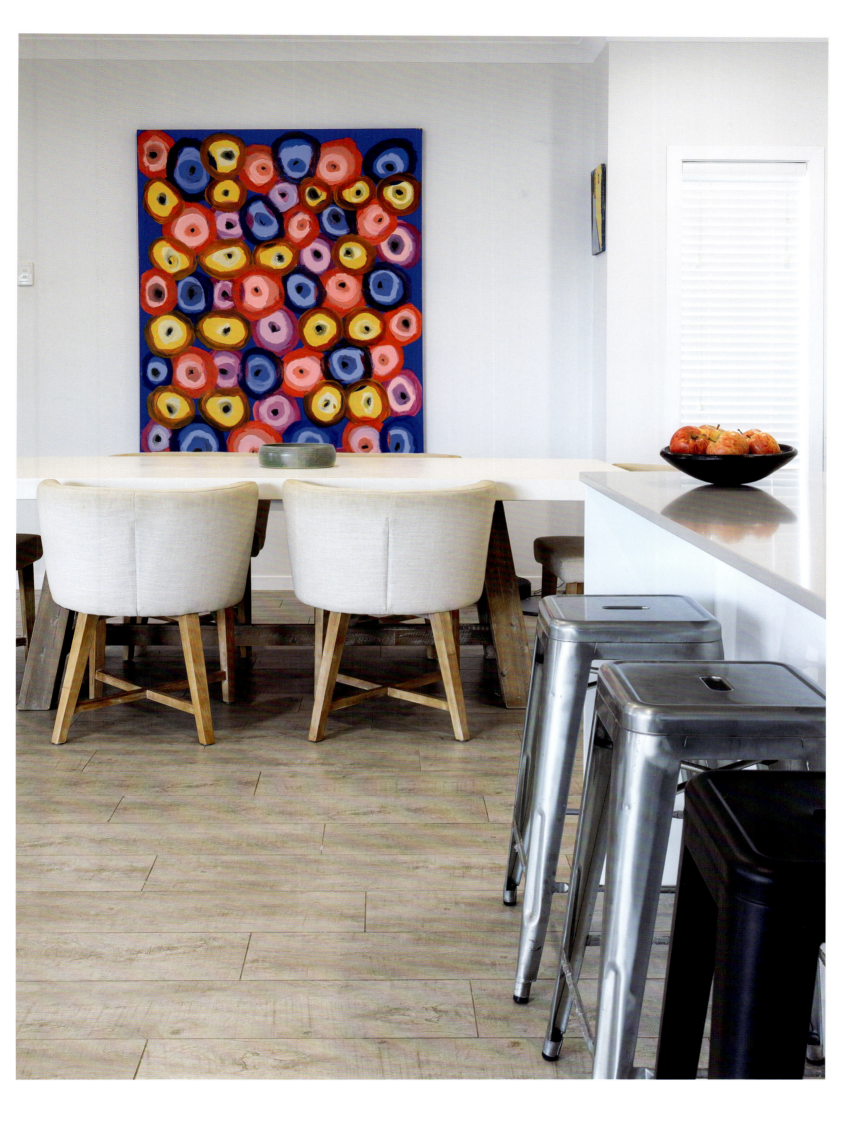

As the couple leads a busy life running their restaurant and looking after children, they were immediately drawn to the kitchen when they first inspected the house – easy to clean, low maintenance and having everything at their fingertips. "Everything is within easy reach, whether it's the stove or the microwave [located directly opposite and set into the island bench]," says Codina, who particularly enjoys eating on the deck during the warmer months, with his outdoor speakers, and of course, Spanish music!

For Codina, the success of a kitchen is the way it has been designed. "The main things such as the fridge, the oven and the sinks (a double sink is essential) and the less movement while preparing a meal, the better it is," says Codina, who admits that in his early career, he was inclined to be a tad messy, but he is getting better and more disciplined with age. He also sees natural light as being fundamental in a kitchen, even when it turns dark in winter soon after 5.30 pm and artificial lighting is required (here there are pendant lights over the island bench). Coming from fairly modest beginnings, Codina is mindful of what's required in a kitchen – a highly functional space rather than one with lavish finishes that are there more to impress than to produce great meals. "It's always about the food and how it needs to be prepared rather than simply filling your kitchen with gadgets and appliances that are rarely used," he adds. And although more complicated meals are often prepared in this kitchen, there are usually simple dishes, such as swordfish or chicken breast served with salads and lots of tomatoes! And of course, complemented with a glass of wine.

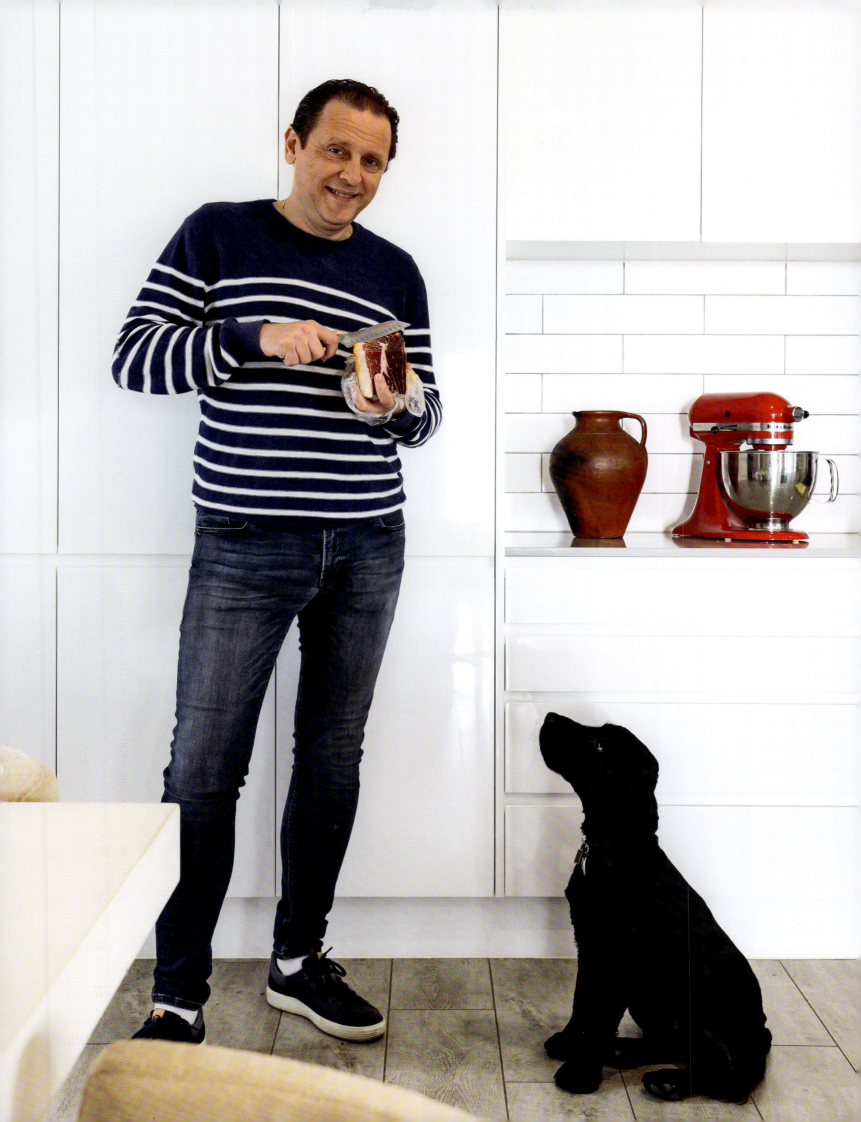

Poblano peppers stuffed with chorizo

Olive oil, for sautéing
1 small brown onion, thinly sliced
2 garlic cloves, thinly sliced
200 g king brown mushrooms, diced
400 g chorizo mince (ask your butcher)
2 sprigs Italian parsley, chopped
Sea salt & pepper, to taste
2 tbsp extra virgin olive oil
4 medium/large poblano peppers

Heat olive oil in a pan over medium heat. Sauté the onion and the garlic without colour for 4 minutes. Add the mushrooms and cook them for another 4 minutes. Place in a mixing bowl until it cools to room temperature. Add the chorizo mince, parsley, salt and pepper and oil, and mix well.

Preheat the oven to 200°C. Cut the peppers lengthways, removing all the seeds. Stuff the peppers with the mixture. Place the peppers into a tray and cook them for about 8–10 minutes.

Capsicum chutney

3 tbsp extra virgin olive oil
1 small red onion, minced
1 garlic clove, minced
1 tsp red chilli, chopped
½ tsp fennel seeds
½ tsp cumin seeds
½ tsp mustard seeds
100 g brown sugar
50 ml red wine vinegar
2 red capsicums, sliced
200 g chopped tomatoes
Sea salt & pepper to taste

Heat olive oil, onion and garlic over medium heat, and cook without colour for 4 minutes. Add the rest of the ingredients and simmer for 20 minutes.

To serve
Drizzle the capsicum chutney over the top of each stuffed pepper.

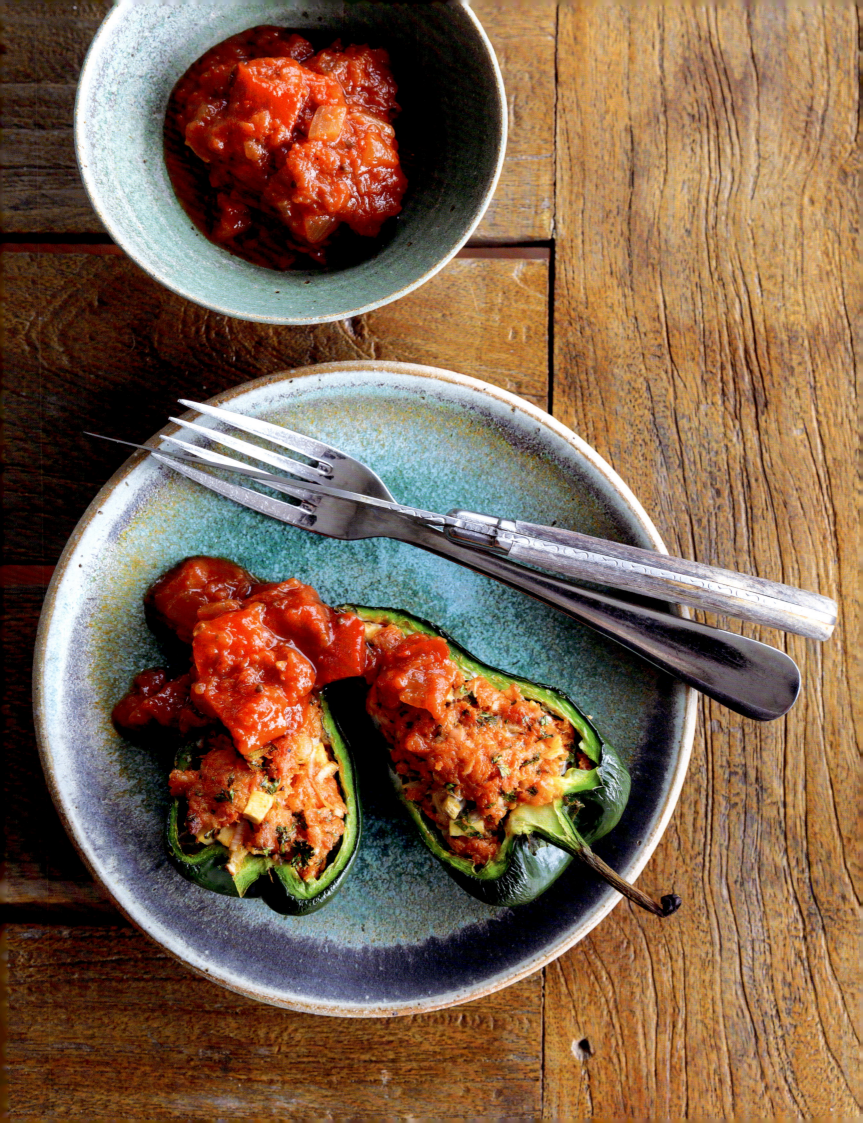

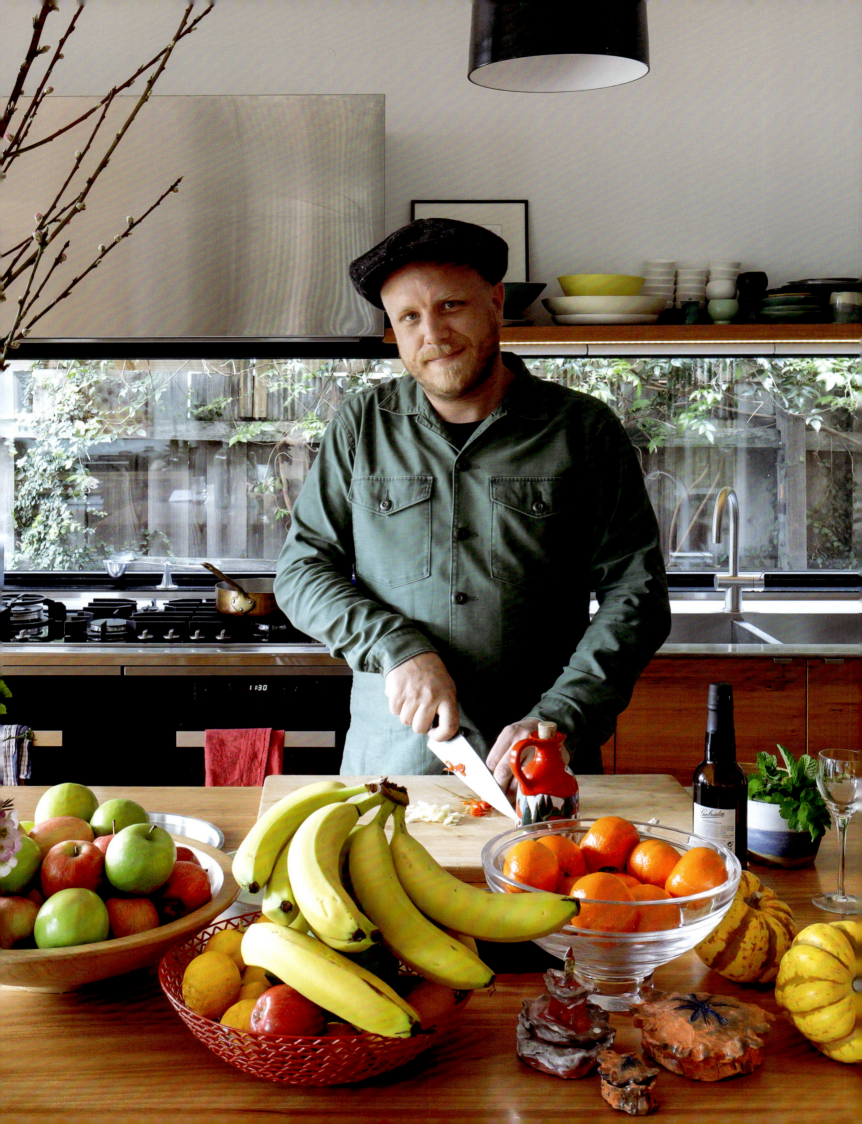

Jesse Gerner
The Garth

Chef Jesse Gerner heads a string of restaurants in Melbourne, including Bomba in the CBD and Anada in Fitzroy. There's also his café and Samuel Pepys, a wine store, just around the corner from his home in Northcote. His wife, Vanessa, and their three young boys share this sprawling house surrounded by vegetable gardens and fruit trees. The raised brick vegetable beds, filled with strawberries, artichokes and three types of beans, act as a 'welcoming mat', as do the lemon and other citrus trees dotted around the property. "There are a lot of Greeks and Italians in the neighbourhood who use their front gardens for growing vegetables," says Gerner, who dedicated one entire garden bed just to growing garlic. "The bricks (for the vegetable beds) came from the bricks that were demolished. Having them raised makes it a lot easier to garden and the bricks create a heat sink. We were still seeing tomatoes ripen at the start of winter," says Gerner.

The generous garden frames the late Italianate Victorian house (c. 1886), which has had a number of incarnations and additions to it over the decades. At one stage, it was a boarding house, with a warren of rooms added in the 1950s. "The rear portion of the house, including the kitchen, was fairly dark and dingy, with almost no connection to the garden," says architect Phil Snowdon, Director of Ola Architecture Studio. An entirely new wing was added, including a kitchen, a dining area, an informal living area and outdoor terraces orientated to the north. "We treated the new wing (clad in timber) more as a series of spaces that felt as though they were part of the garden," adds Snowdon, whose design brief from the Gerners were a 'hybrid' between Scandinavia and Japan, places they regularly travel to.

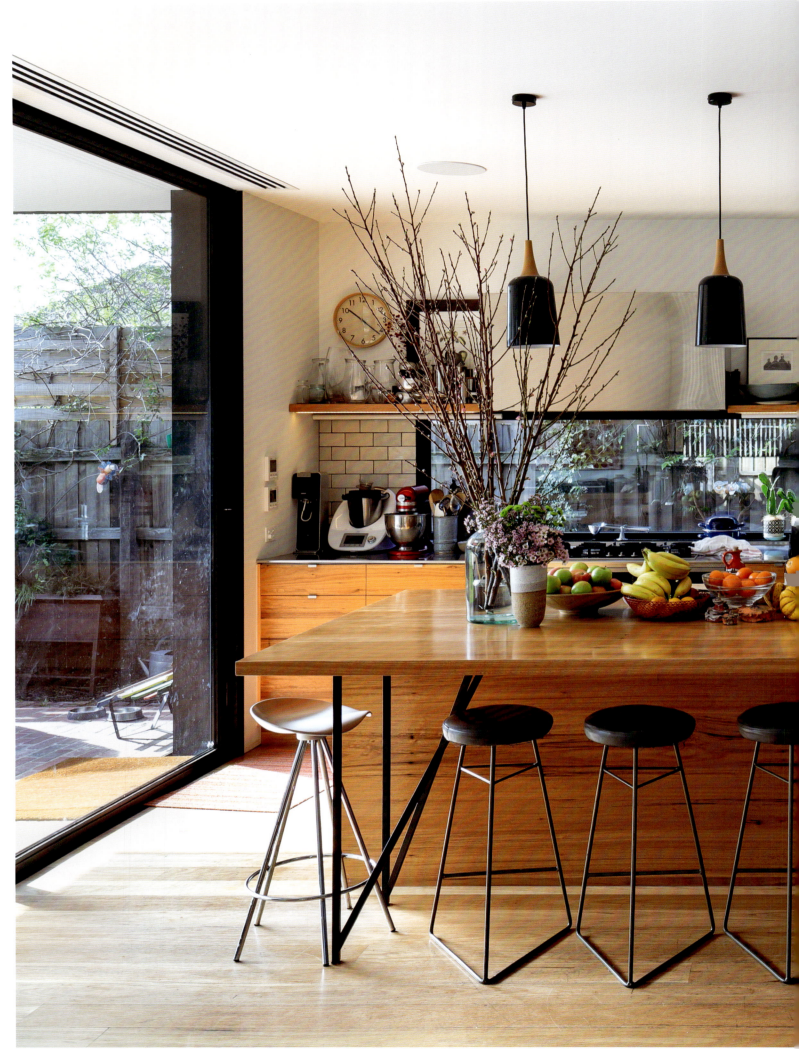

Initially the brief to Snowdon included a large detached cellar in the backyard, with a pellet lift (accessed from a rear lane). Then reality set in and the brief became more realistic. "We wanted an open-plan kitchen and living spaces, but we were also keen to have a series of more intimate nooks," says Gerner. The dining area, for example, is framed on three sides with burnt timber battened beams that create a 'veil' from the afternoon western light. In contrast, the kitchen has a more open feel, directly linked to two northern brick-paved terraces that allow for alfresco dining. "We're planning a second stage for the kitchen that includes a built-in outdoor kitchen that follows the bench lines from inside," says Gerner.

Unlike the commercial kitchens that Gerner works in, the feel of the home kitchen is more relaxed. Pivotal to the design is a 2-metre-wide island bench, made from blackbutt, and undercroft bar stools that were customised. 'It's a simple and practical design. Perhaps the only cross-over from the commercial kitchens are the stainless-steel benches. When you're cooking, it can get quite messy, so I need a surface that can be easily wiped down." However, the extensive timber joinery and open timber shelves provide a strong domestic feel. Pots, pans and crockery are concealed in the island bench's deep drawers, and the extensive shelf and bench area allows utensils and memorabilia to be left permanently on display (a KitchenAid, a Thermomix and a SodaStream together with a commercial La Marzocco Italian coffee machine). Vanessa's own ceramics are also left on the shelf, as are the children's sculptural pieces.

Although there's a substantial number of appliances, including a collection of wooden spoons left permanently on the bench, there's a substantial amount of storage. Two deep drawers appear from one nook of the kitchen, space that was found to be unused below the laundry (a few steps above the kitchen). Here you'll find numerous wine bottles that can be easily accessed to complement the meal being prepared. Other cupboards conceal brooms and general storage, together with a pantry and drawers. "I'm quite happy with a bit of clutter. I really wasn't keen to have overhead cupboards where things tend to get forgotten," says Gerner, who was keen to have everything in arm's reach (the fridge, the sink and the chopping board on the island bench).

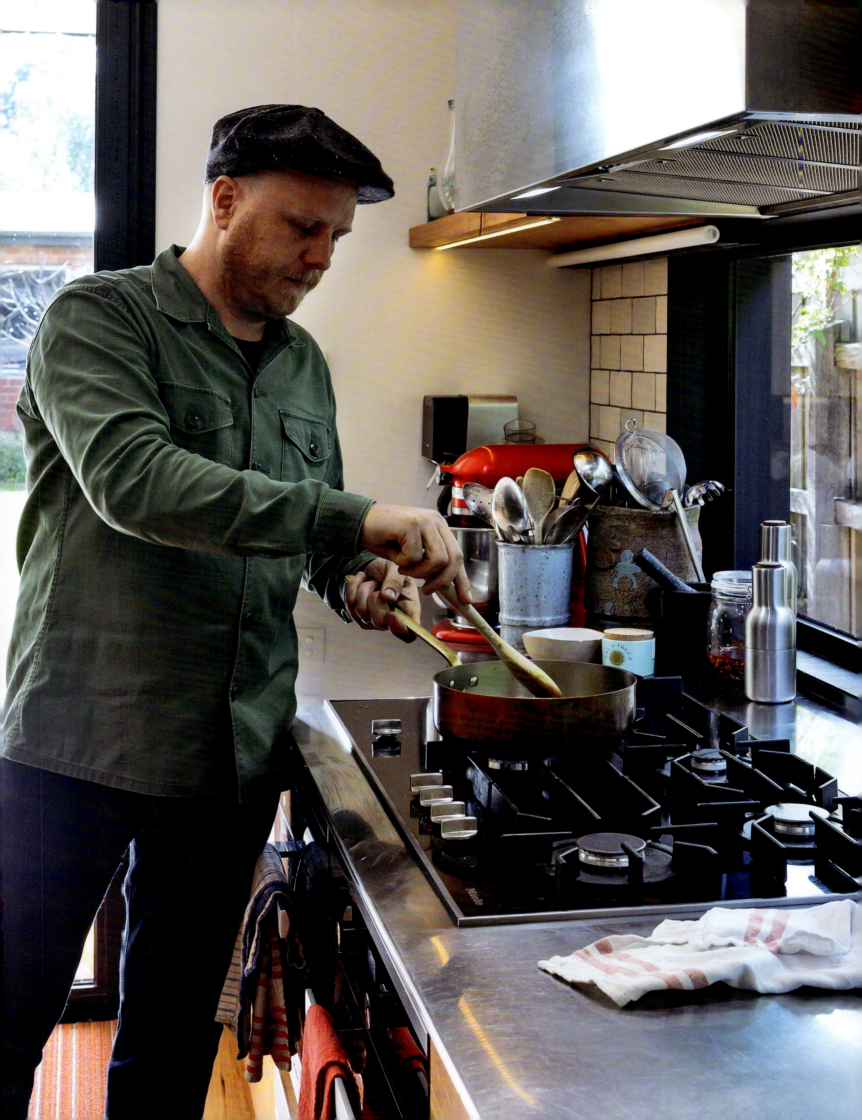

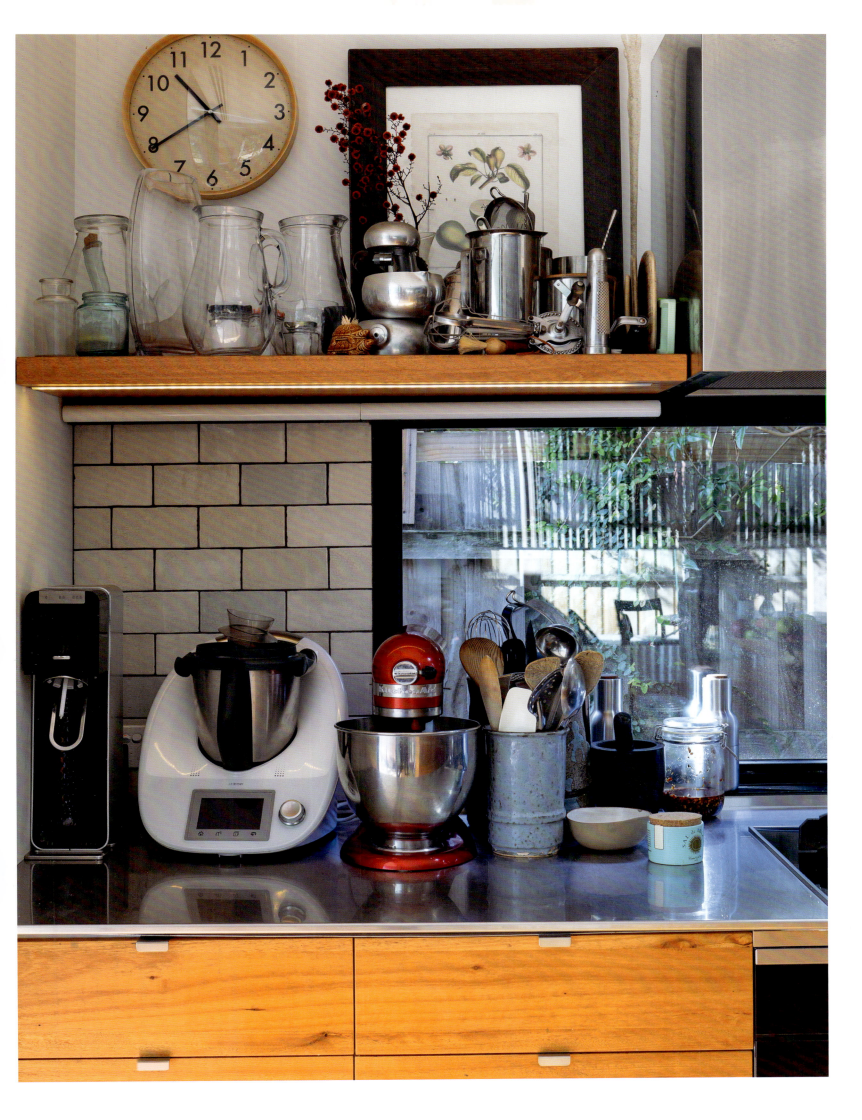

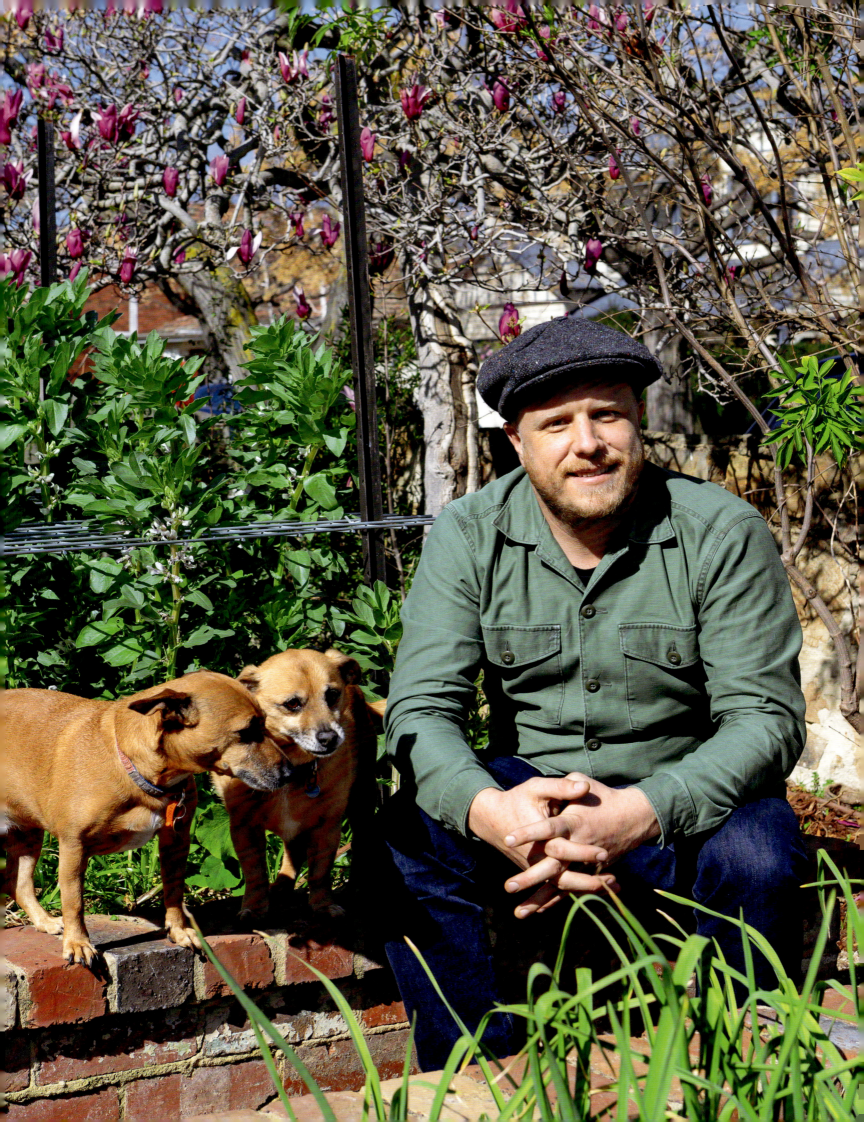

The kitchen also includes two Miele ovens, one being a regular oven while the other is a steam oven. There's also a plate warmer below. "I'll use the steam oven for vegetables and fish," he says. Snowdon also included a long slot window above the kitchen bench that allows for morning light and a backdrop that supports a climbing fig.

As Vanessa takes care of all the flower displays in the restaurants, her own kitchen includes her flower arrangements. The fresh fruit artistically displayed along the centre of the island bench, along with vegetables and apples, is a permanent fixture and is often replaced once a week. "With three young children, we find that we go through a crate of apples alone every week," says Gerner.

Although there are numerous seating areas, both indoors and out, the family, as well as friends, tend to gather around the island bench for many of the meals. When entertaining, friends can enjoy a glass of wine while Vanessa or Jesse prepares a meal. "The kitchen is practical. Visually and functionally, it forms part of the house. It certainly doesn't feel as though it has been added. We've endeavoured to use the same blackbutt throughout the home.

For Jesse, who spends long days at work in one of his restaurants, the kitchen and connecting living areas have a more relaxed ambience, without the sense of a 'clock ticking' and customers waiting to be served. "On Sundays we often like to experiment with recipes. With the boys, we might make some pastries. At this stage, they tend to prefer mixing ingredients," says Gerner. And, unlike the home prior to the renovation, which turned its back on the garden, now the garden and kitchen work as one, with herbs planted in both the front and back gardens. One of the herb gardens has been strategically placed immediately outside the back door, allowing for the right herb to be picked and placed into the nearby pot.

Clams with Manzanilla and mint

Splash of olive oil
1 garlic clove, thinly sliced
1 mild red chilli (ideally fermented)
1 kg clams, washed if sandy
100 ml of Manzanilla or Fino Sherry
1 small handful of mint, ripped up

You will need a large heavy-based saucepan with lid. Place the pan on high heat. Add olive oil and quickly cook garlic and chilli for 30 seconds, then add the clams in quick succession.

Add the Manzanilla or sherry and cover.

Shake the pan to move the clams around. They should start to open after 2–3 minutes. As soon as the majority are open, remove the lid, add mint and taste. It should not need much or any seasoning due to the clam's saltiness.

To serve

Pour clams and juice into a bowl and serve with crusty bread to mop up the juices.

Serves 4–6 people.

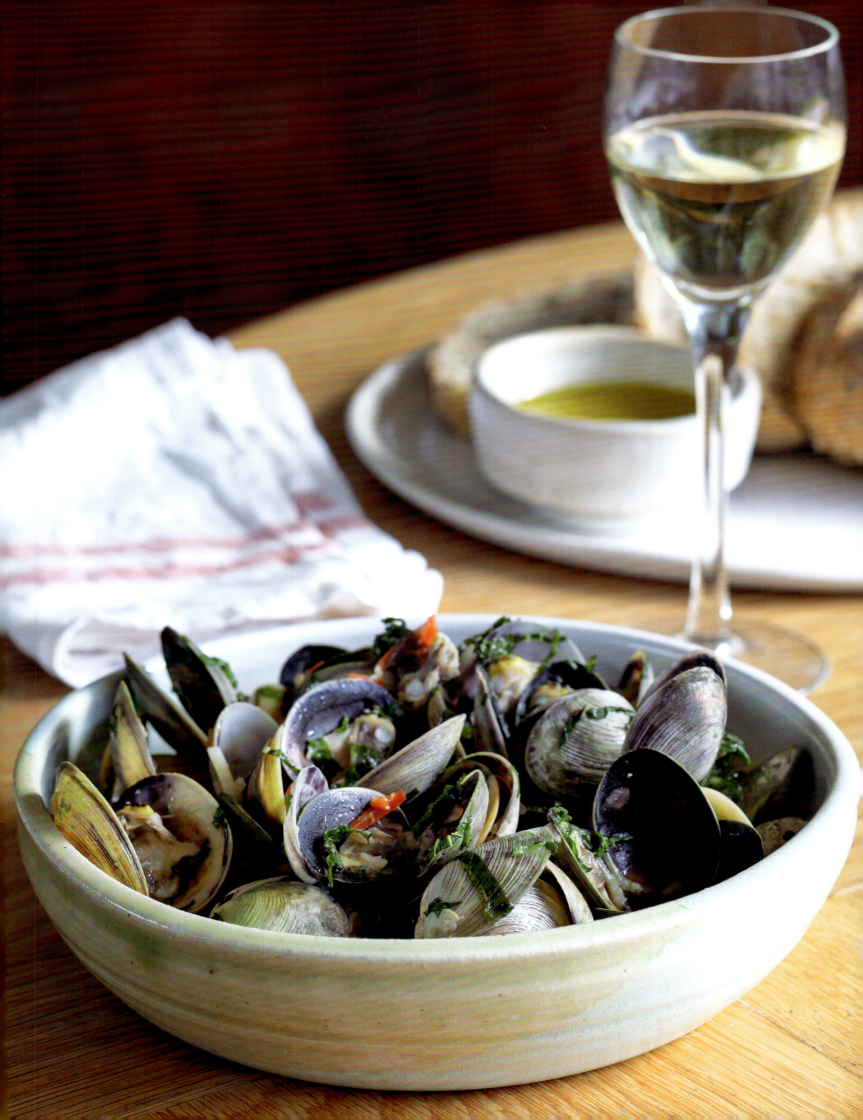

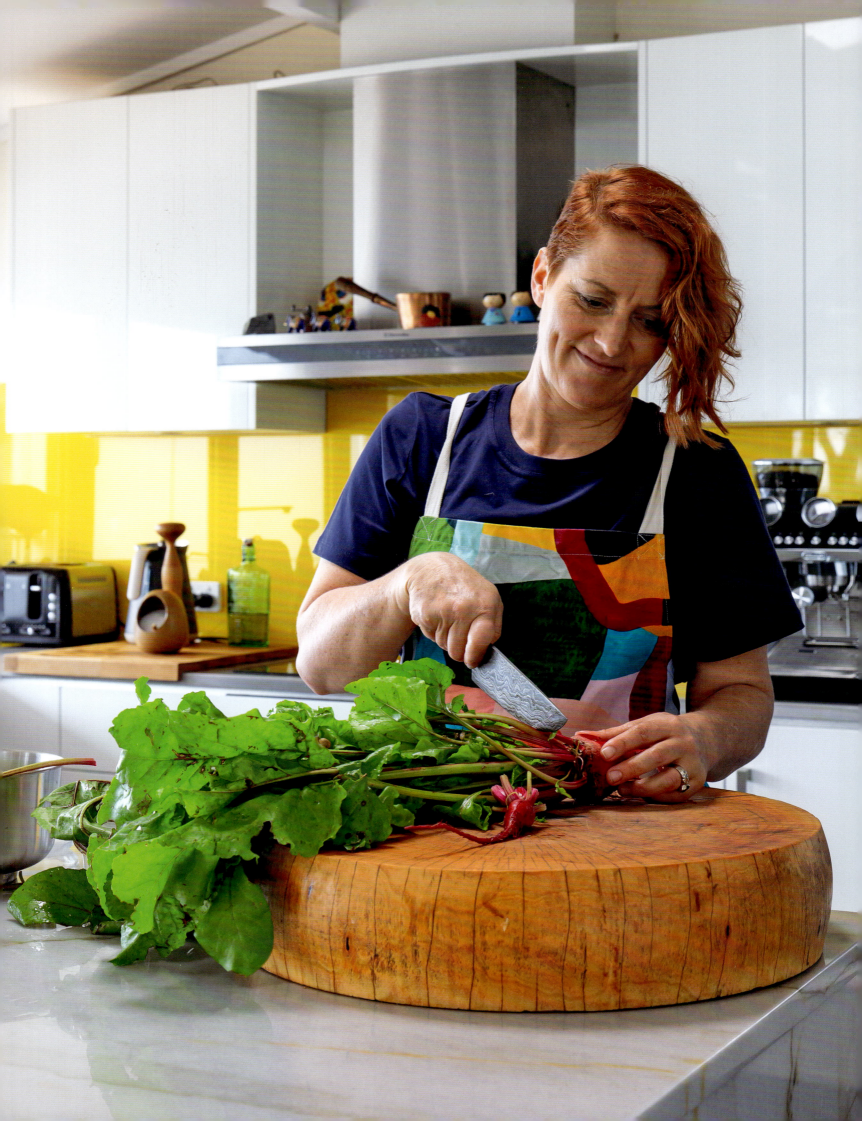

Karena Armstrong
A Kitchen to Share with Friends

Karena Armstrong, chef and owner of Salopian Inn, bubbles with enthusiasm about her industry. As co-festival director of Tasting Australia, she is also at the forefront of the culinary world down under. Based in South Australia and living in McLaren Vale, a 40-minute drive from Adelaide, she shares the large property with her husband, Michael; their three children, Harry, Sebastian and Fletcher; and their family pooch, Roger, a Staffordshire bull terrier.

When the couple purchased their 1970s solid-brick home, the kitchen was relatively small, and there was a need to create a large flexible space for the children to play pool or simply hang out with their friends. Armstrong is fairly succinct in her description of this addition, referring to it as simply "one large room with concrete floors and sliding doors". A customised wallpaper of a Koi fish is a reminder that this is a home of 'foodies' – Michael loves to cook and is quite talented in this area, too.

The new kitchen was paramount in the redesign of the home, one that offered greater space and considerably greater natural light. This new kitchen occupies the footprint of the original kitchen but has been expanded to include a meals area, doors to a terrace, and bi-fold windows above the kitchen bench – a place where family and friends gravitate. "Often, people will perch on stools outside these windows and simply watch while I'm preparing the meal," says Armstrong, who used some of the 1970s sleepers found on the property to create the outdoor deck. The outlook is towards the swimming pool, the vineyard and the native garden, as well as to the newly installed firepit, where Armstrong can truly indulge her passion for cooking. "When I'm cooking outdoors, I need that additional concentration, whether I'm cooking a lamb, a pig or a chicken. It's not the same as simply turning a switch on an oven and returning minutes later," she says. Her kitchen

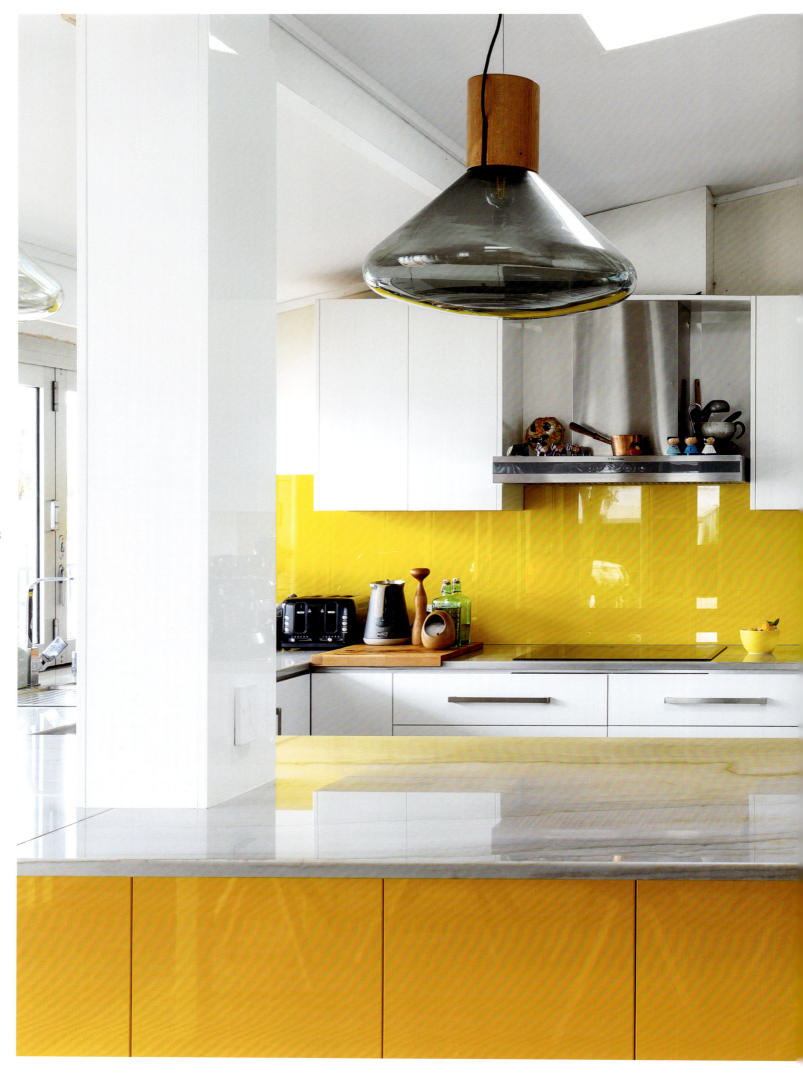

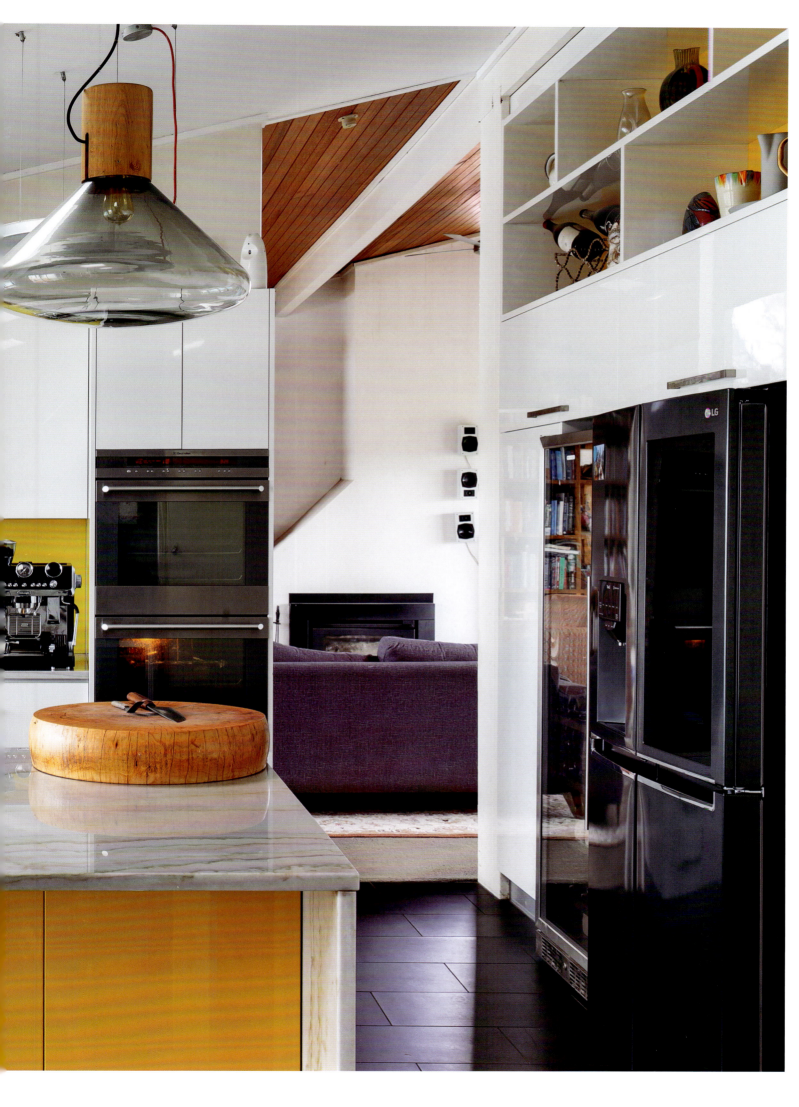

appliances are basic, and some of them quite old. "They certainly allow me to cook everything that I need. I'm not one for needing all the latest appliances and gadgets," says Armstrong, who admits that she doesn't own a Thermomix.

However, what she lacks in state-of-the-art appliances, she more than makes up for with other features in her kitchen. The U-shaped kitchen features 1.4-metre-wide marble benches (many kitchens come with 1-metre-wide benches or even less) and there's wall-to-wall joinery. Some of the cupboards are painted in white two-pack while a few others are bright yellow, as is the glass splashback. "Michael and I adore yellow. There's something quite joyous about this colour. It also appears in our restaurant [approximately 4 kilometres away]," says Armstrong.

Although there's a large dining table adjacent to the kitchen, most people gravitate to the kitchen bench, inside or out. There, they can enjoy seeing Armstrong prepare meals from her predominantly electric appliances – including two ovens, a cooktop and a built-in microwave. She has an extensive collection of appliances, with the deep drawers below the hotplates containing a large range of bowels and utensils. The middle drawers are given over to numerous steel bowls and baking trays, all of different sizes. And in the cupboards on the other side of the kitchen bench, painted in the vibrant yellow, are items that are not as regularly used, such as equipment for making chocolate, and her pasta machine. Other items can be found behind large cupboards with slide-out draws.

One of the things that Armstrong uses most is the large circular timber chopping board that is a permanent fixture on the benchtop. Made from tamarind, it can be easily washed unlike plastic, which holds remnants of ingredients. She is also reliant on her trusty set of knives; in particular, her handmade Barry Gardner knife, produced in South Australia by Karena together with Barry, and her French Opinel knives. As avid coffee drinkers, the couple also enjoy using their two coffee machines, one being the Atomic, and the other a De'Longhi that remains a permanent fixture on the kitchen bench.

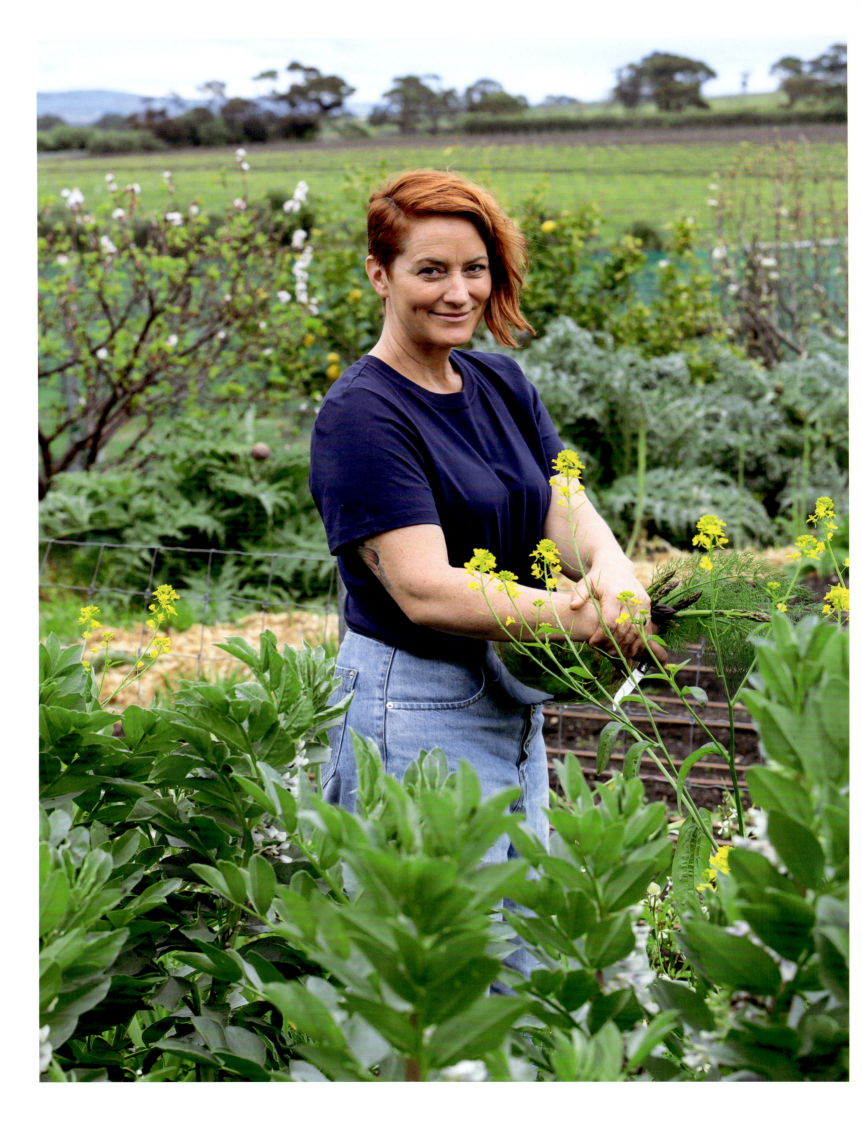

Cooking and entertaining family and friends, often up to twenty people at a time, is a regular occurrence, and brings the couple immense joy. This is beautifully captured in the couple's extensive collection of wine bottles displayed on the shelves in the kitchen, with bottles signed by friends who shared the moments when these wines were tasted. "It's a lovely space to work in, even though it's quite simple and uncomplicated," says Armstrong, who appreciates the importance of a low-maintenance yet efficient kitchen. "It might be tempting to use tiles for a kitchen splashback but this requires a considerable amount of cleaning. My glass splashback can be simply washed down in few quick actions," says Armstrong. Dark charcoal-tiled floors also can be easily cleaned.

While the kitchen is paramount in the day-to-day lives of this family, so too, is the garden, with its sixteen different fruit trees and abundant vegetable beds found on this half-acre property. Many of these beds are seasonal, producing vegetables that predominantly go to the restaurant and end up displayed on the customer's plate. Her regional restaurant that carefully follows the food produced at various times of the year, is thoughtfully complemented by the extensive wine that's served and also the restaurant's reputation for its fine gin offering. "When you're in this business, it's something you have to be passionate about," says Armstrong, whose enthusiasm for food is truly infectious.

Barbecue lamb shoulder

1 tsp smoked paprika
1 tsp ground cumin
1 tsp ground coriander
3 tsp sea salt flakes

1.5–2 kg lamb shoulder, boned
120 ml of water, stock or white wine (optional)
50 ml grapeseed oil

Combine paprika, cumin, coriander and salt into a spicy salt rub, and set aside.

Season the shoulder of lamb with the salt; rub generously and on both sides of the lamb. Rub with the oil. If using a firepit or barbecue, light and cook the lamb over a moderate or offset flame until tender. It takes around 90 minutes and the shoulder will need continuous turning. Internal temperature is 65°C. If the lamb looks a little dry, remove from the barbecue, rub with oil again and continue to cook. The meat will be tender, have a dark brown crust. It will be soft to pierce when ready.

Alternatively, to cook in the oven, put the lamb in a roasting dish and add 120 millilitres of water, stock or white wine. Cover the tray with foil and roast for 3 hours at 140°C. Remove the foil and cook on a high heat for 30 minutes.

Regardless of cooking method, rest the lamb for 20–30 minutes in a warm spot before serving. Reserve the cooking liquids from the resting meat.

Kitchen garden salad

20 ml sherry vinegar
100 ml extra virgin olive oil
Sea salt & pepper, to taste
16 asparagus spears
2 small heirloom beetroots
1 small red onion

1 small bulb fennel
150 g podded broad beans
200 g fresh salad leaves
1 bunch dill
1 bunch parsley
1 bunch coriander

Mix the sherry vinegar, olive oil and a little salt and pepper together.

Cook the asparagus on the barbecue gently and set aside. Slice the cooked asparagus and dress with some of the dressing.

Slice the beetroot, onion and fennel finely, and keep them separate. Using a mandolin is the best way to get paper thin slices. Dress each item with a little of the dressing.

To double pod the broad beans, drop them in some salted boiling water, cook for 1–2 minutes, then remove and refresh in ice water. Peel off the outer layer and discard. Dress with a little of the dressing and set aside.

Wash and prepare the salad leaves. Wash and pick the herb leaves, keeping the stems for the salsa verde.

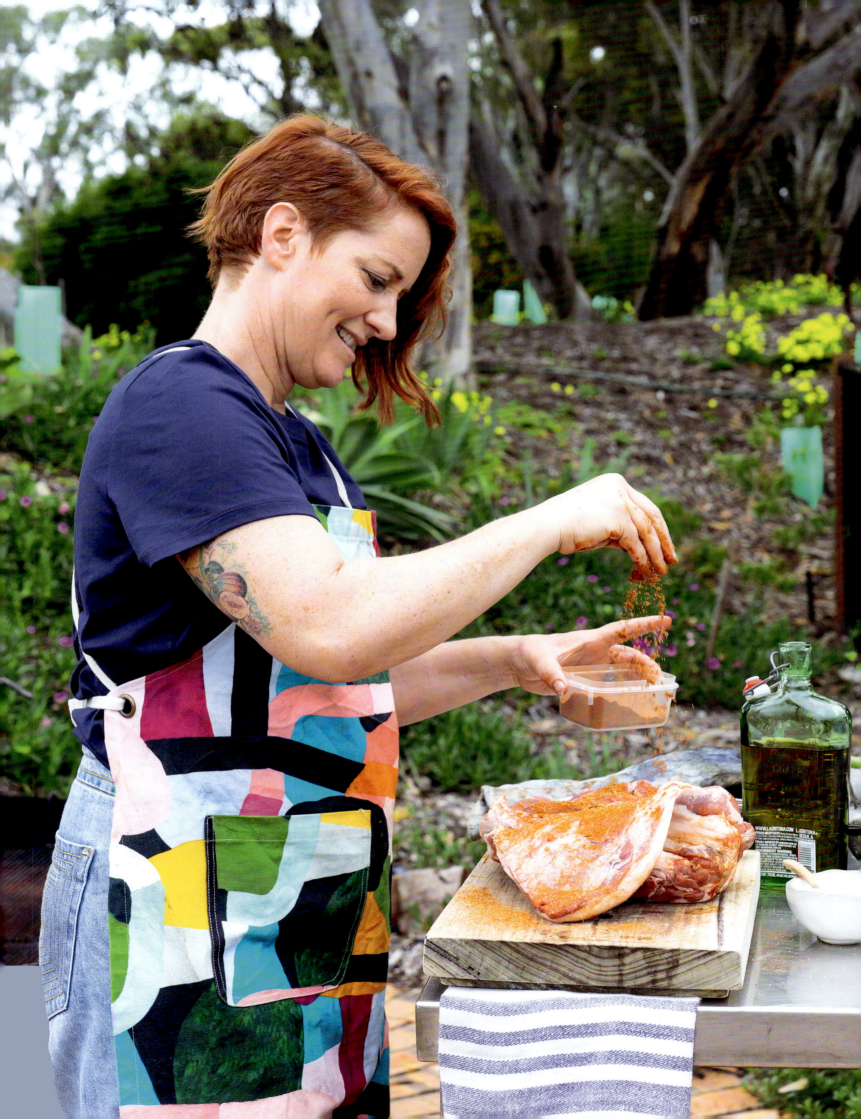

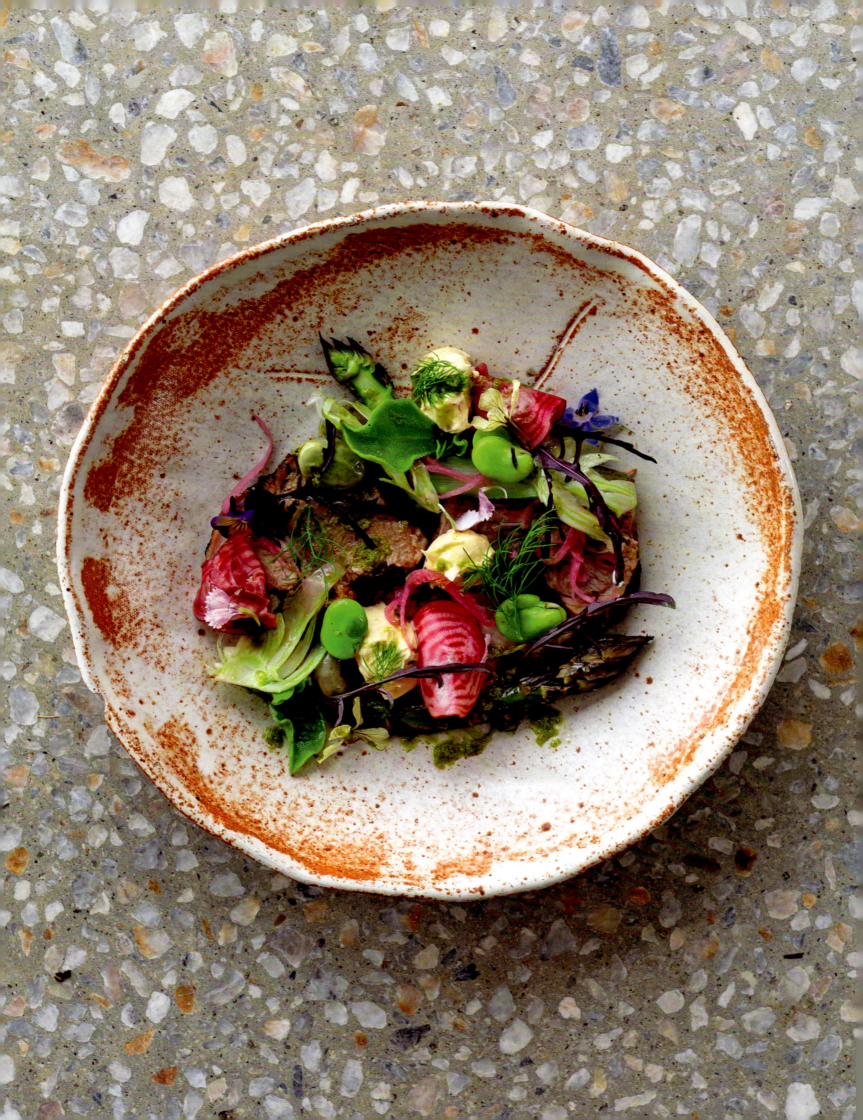

Mustard cream

600 ml double cream
1 tbsp Dijon mustard
1 tsp hot English mustard
1 tbsp roasted garlic paste
20 ml lemon juice
Sea salt, to taste

Lightly whip the cream, then fold in the mustards, the garlic paste and the lemon juice. Season to taste and set aside.

Salsa verde

stems from herbs dill, parsley & coriander
1 tbsp capers
2 garlic cloves
1 lemon, zested and juiced
150 ml extra virgin olive oil
Sea salt & black pepper, to taste

Roughly chop the herb stems. Add the herb stems, capers, garlic, lemon (zest and juice) and olive oil to a high-speed blender and blend to a smooth paste. Season with salt and pepper.

Final assembly

Carve the meat and lay onto a platter. Season with a little salt and drizzle of olive oil, spoon over any meat juices. Layer the salad components onto the meat and then dress with both the mustard cream and salsa verde.

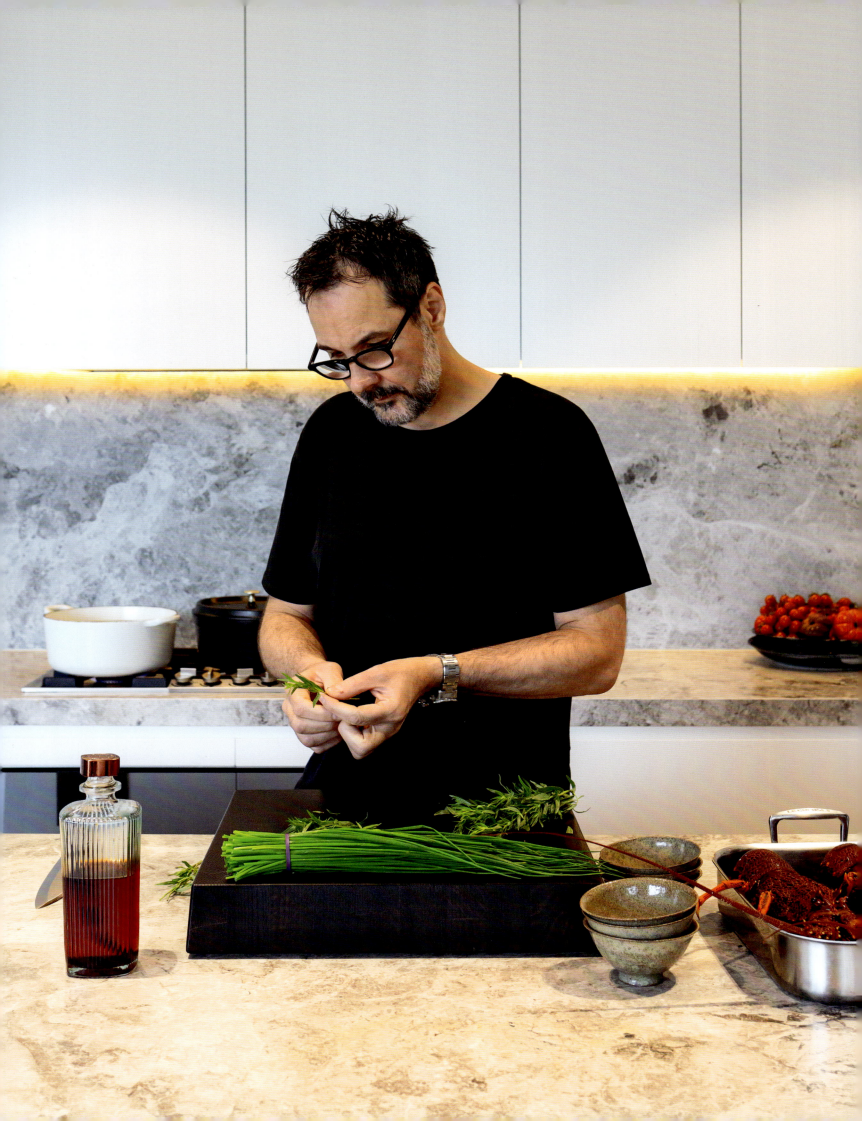

Martin Benn
A Celebrity Chef

Chef Martin Benn is known by those who aren't 'foodies'. He has appeared on television, written books, and been at the helm of a number of restaurants across the world. After working with some of the best, including rock-star chef Marco Pierre White in London in the 1990s and Tetsuya Wakuda until the early 2000s, Benn established the well-known three-hatted restaurant Sepia in Sydney, before moving to Melbourne to consult on the opening of Society.

Benn's spacious apartment in Toorak, which he shares with his life and business partner Vicki Wild and pampered feline Ducati, has simple, clean lines and is fairly minimal. "This place provided a 'blank canvas'. People often think we moved here because the marble in the kitchen mirrors Ducati's fur colour," says Wild.

There is a sense of arrival: entry to the kitchen and living room in the apartment is via a generous 12-metre-long passage, past bedrooms and a home office, which is lined with numerous cookbooks, including Benn's own, *Sepia: The Cuisine of Martin Benn*. As with other parts of the home, such as kitchen drawers and the fridge, everything is meticulously organised, whether it's food storage or food preparation, or bookshelves. Cookbooks, for example, can be found in the study, while art and architecture books are displayed in a marble nook in front of the kitchen.

As well as the simple open-plan kitchen, dining and living areas, the other appeal of this apartment was its wide oak floors. "We enjoy walking around in socks or bare feet, and obviously it's perfect for Ducati's shedding of fur," says Benn. The orientation of the apartment to the south also creates an even quality of light, with magical sunsets in summer providing a halo for the large outdoor terrace.

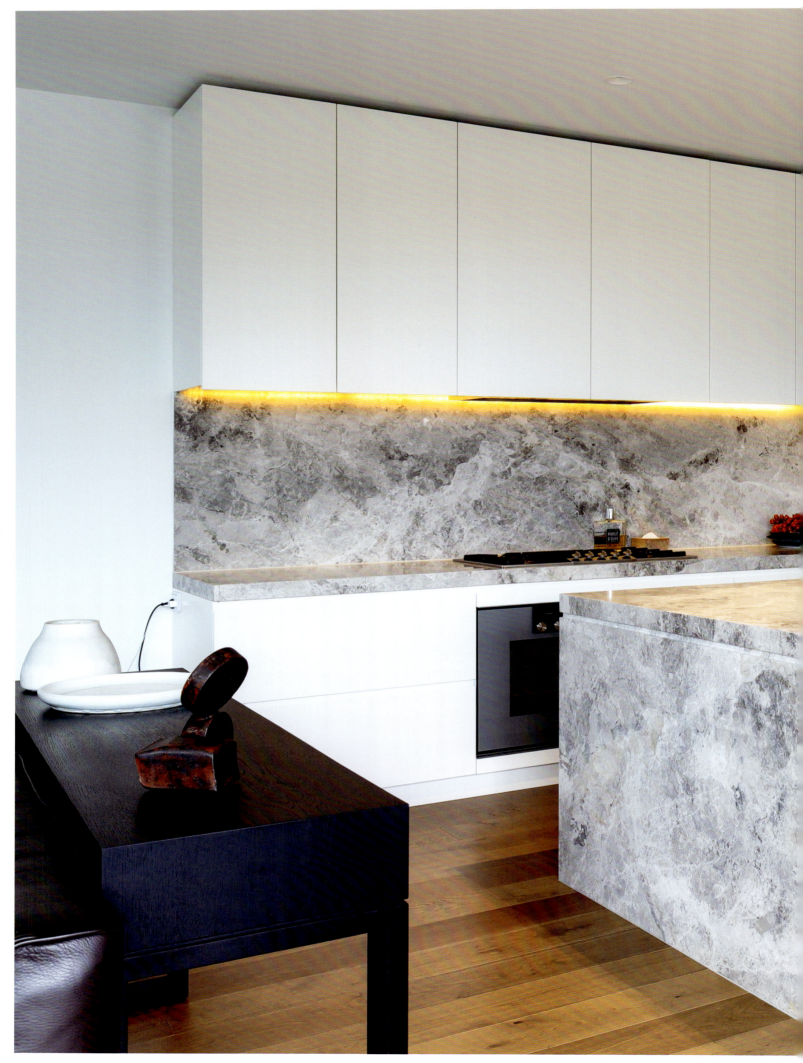

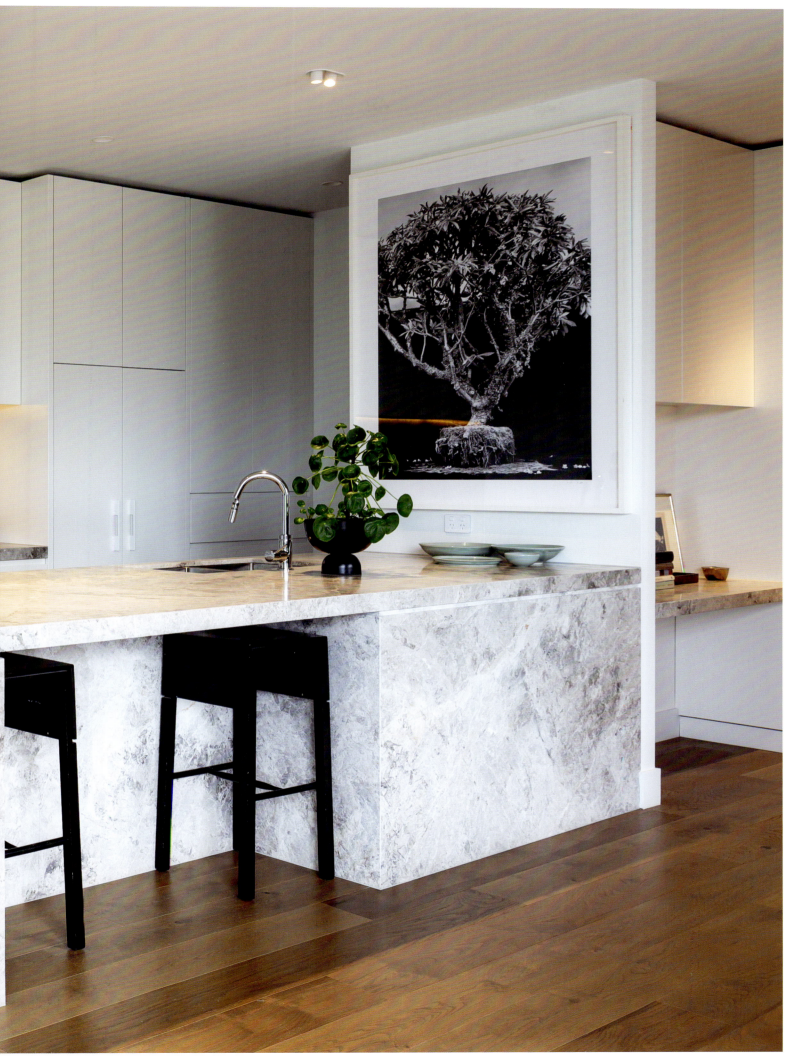

The kitchen, which forms part of the open-plan arrangement, features a wide marble island bench and a marble splashback. Painted MDF joinery, with wide drawers and a concealed fridge and dishwasher, provides a home for every imaginable kitchen appliance. "People often underestimate the amount of storage that's needed in a kitchen," says Benn. Fine Japanese kitchen knives are displayed in one drawer and utensils in another.

Some drawers in the butler's pantry include multiples of certain tinned foods, such as Mutti tomato paste. "You need to grab this when you see it," says Benn.

There's a dedicated cupboard for glasses (his favourites are the Italian crystal glasses) and another for the couple's beautiful Japanese ceramics, some of which are made from crushed scallop shells and have a luminescent glow. Benn and Wild also appreciate the butler's pantry/kitchen that includes a glass-fronted wine fridge and shelves for the Italian Rocket coffee machine, the microwave oven, a KitchenAid, a Thermomix, Magimix, and a rice cooker.

The kitchen appears relatively spartan with a few items that enrich the space, as well as Benn's cooking. A Huile D'Olive (olive oil) bottle resembling an over-scaled perfume bottle takes pride of place next to the Gaggenau gas hotplates, together with a small wooden container for cooking salts. A bowl of ripened tomatoes is artistically arranged and adds one of the few dashes of colour in the kitchen.

Although there's a Gaggenau double oven directly below the hotplates, there's only one dishwasher – sufficient for most people, but not entirely for Benn. He and Wild generally eat at home, preparing relatively simple dishes. "I tend to fill the dishwasher twice a day. We tend to cook in large quantities, then store it for the week," says Benn, whose double fridge is filled with sealed containers. The double oven is appreciated, allowing two different types of food, such as chicken and potatoes, to be cooked at different times and at different temperatures, but ready at the same time to serve on the plate.

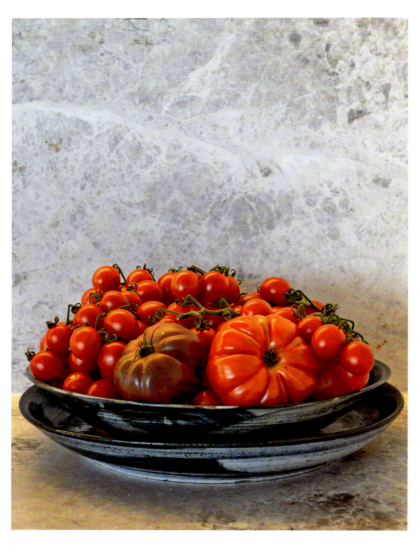

When Benn prepares food in the kitchen, he likes to spread out, hence the appeal of this island bench that measures 3.2 metres long by 1.25 metres wide. "I prefer the island bench to be free of equipment. It's the place for chopping and preparation rather than for cooking," says Benn, who feels that he doesn't need to face an audience (guests at a dining table) when preparing a meal. And while there are stools at the bench, Benn and Wild tend to eat at the walnut dining table, on Eames dining chairs, or on the terrace during warmer weather. The low-level concrete outdoor table designed by Robert Plum and 1950s-style Cape Cod chairs are ideal for a drink with friends prior to dinner. "We love looking onto the large plane trees in the street and over the rooftops," says Wild.

As with the ingredients that come to the counter, the art that surrounds the kitchen enriches the experience of dining. Artists such as Brad Munro, Darren Gannon, Matt Draper and Tara Klein grace the walls, while a photo by Gary Heery of a magnolia tree, a feature in the Sepia restaurant, frames the kitchen. Given Benn's affiliation for Japanese culture, there is a significant representation of ceramic bowls and artefacts, including two lantern-style floor lamps made from washi paper in the dining area. A steel sculpture by Russell McQuilty, in the living area, is a favourite of Ducati.

While the kitchen suits the way Benn likes to cook, there are a few small things missing that were an oversight. There are not enough power points, for example. "You can often locate these below benches so that they're out of sight and I would appreciate a spoon wash (a sink built into benches that allow spoons to be immediately washed after food tasting). They're hygienic and convenient," he adds.

Benn has established a reputation for his avant-garde offerings. And while his kitchen at home allows him time to experiment, it's simple food and often purchased in bulk that can be found in his fridge. "If I'm going to make a stew, it makes sense to make it for the week. And there's nothing wrong with reheating a pasta," he adds.

Udon noodles with southern rock lobster and kombu oil

Southern rock lobsters

2 x 1 kg southern rock lobsters

Place the lobsters into a freezer for about 30 minutes. Once the lobsters are ready, place them onto a chopping board and pierce a sharp knife between the eyes and the centre of the head to kill the lobster. Next, cut between the body and the head to remove the tail, making sure to cut right into the head cavity to collect all the meat. Bring a pot of salted water to the boil and then add the tails to the boiling water and blanch for about 30 seconds. Remove and refresh in iced water.

Once cooled, use scissors to cut along each side of the belly between where the top shell starts – it should be softer and easier to cut here. Pull away the belly shell part and then, using your thumb, push under the top shell between the meat and shell to remove the tail meat. Remove the intestinal pipe and then place on paper towel and dry off excess moisture, then wrap in fresh paper towel and then cling wrap.

Chill in the refrigerator until required.

Lobster and kombu oil

2 heads & tail shells of the rock lobsters (as above)
2 x 10 cm sticks kombu (Japanese)
2 L sunflower oil
2 brown onions, peeled and chopped
5 garlic cloves
3 bay leaves
5–6 sprigs thyme
1 bunch French tarragon stalks
20 black peppercorns
1 star anise
1 cinnamon stick
6 fennel seeds
300 ml dry white wine or rosé wine
600 g tomato paste, preferably Mutti brand

Remove the leg section from the head of the lobsters and then remove the gills and discard. Using a cleaver, chop the legs and head into small pieces. Chop the shell from the body into small pieces and add to the head pieces. Drain the excess juices from the lobster and add into a bowl with 800 millilitres water. Add the kombu to the water and lobster juices and set aside.

Heat the sunflower oil in a large pan and add in half of the shells and start to roast until fragrant and deep red in colour. Add in the remaining shells and continue to roast until all are well cooked together. Add in the onion, garlic, bay leaves, thyme, tarragon, peppercorns, anise, cinnamon and fennel seeds, and continue to cook over a medium to high heat. When the lobster starts to caramelise on the base of the pan, add in the wine to deglaze and continue to cook until the wine has evaporated. Add the tomato paste and mix well together and cook for 2–3 minutes. Add lobster and kombu water, and stir and bring to a simmer. At this stage, slowly stir in the remaining oil by drizzling it in slowly and stirring so that the mixture looks emulsified. Bring to the simmer while stirring. The mix will split the oil, but keep stirring it back together and turn the heat to low. Stir the lobster mixture from time to time, cooking slowly for around 2–3 hours. Once cooked, drain the shells from the mix and then pour all the mix into a tall container and allow to settle for about 30 minutes.

Use a ladle to remove the oil from the sediment as best possible, and pour into a small pot. Bring this to a low heat and the oil should become a clear dark red. Pass through a filter paper into a container and allow to cool. Next pour into a bottle and add a stick of kombu. (You can add the lid and refrigerate for up to 1 month or freeze.) Discard the shells and the sediment.

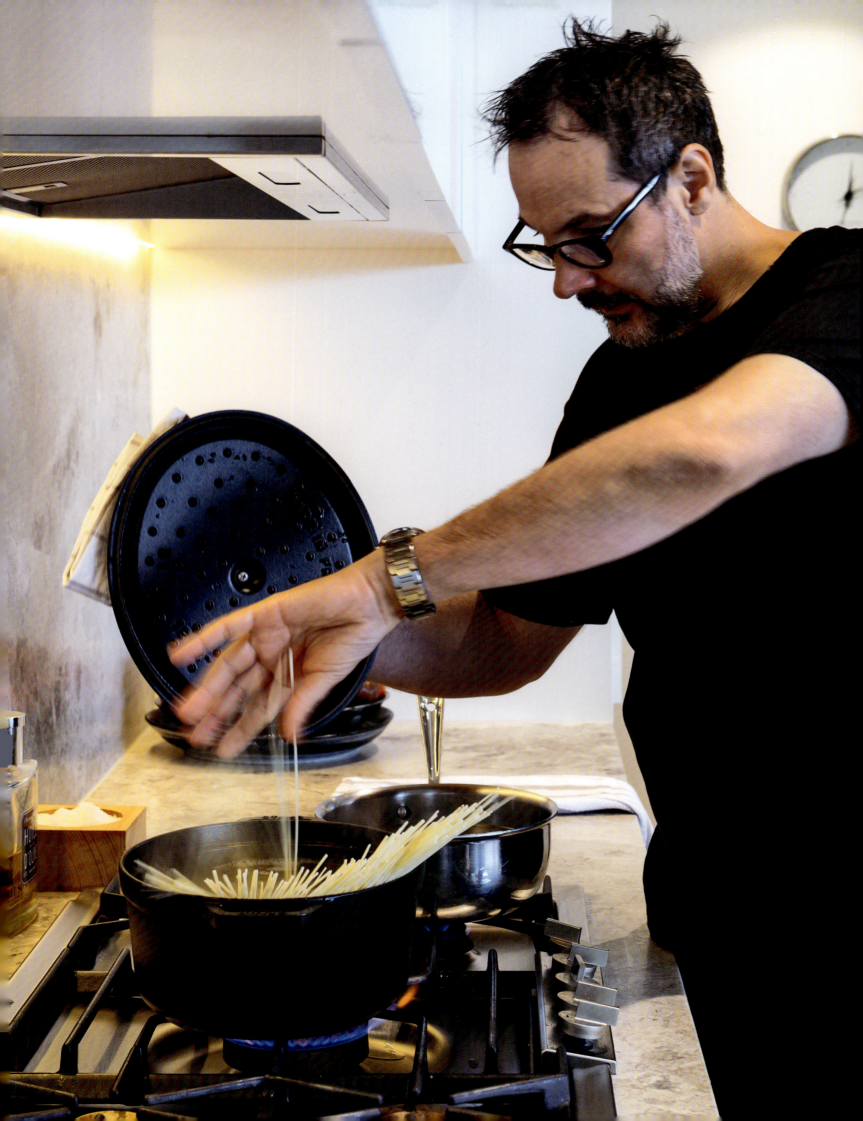

To prepare the udon noodles with rock lobster and kombu oil

180 g dried udon noodle
300 ml lobster & kombu oil (previously prepared)
2 tbsp chopped tarragon leaves
2 tbsp chopped chives
2 tsp shio kombu (salted kombu) fujcco shio (optional)
½ tsp salt
½ tsp sugar
½ tsp white pepper
½ tsp sansho pepper
1 tsp mirin
1 tsp white soy sauce
2 lobster tails (previously prepared)

You will require a large pot of around 6 litres for cooking the noodles. Bring salted water to a rolling boil then add the noodles and stir. Boil for around 4 minutes until tender but still chewy. Pass into a colander and then rinse under cold running water until cold and all the starch is washed away. Leave to drain. Add another pot of water to the stove and bring salted water to the boil – this is to reheat the noodles later.

In a separate large wide-based pan, add the lobster and kombu oil (you can add more if you wish), tarragon, chives, salted kombu, salt, sugar, pepper (white and sansho), mirin and soy sauce. Using a sharp knife, cut the lobster tails in half lengthways and then slice into large slithers. Add the lobster to the oil to coat and mix well.

Turn on the heat to a medium and slowly cook the lobster in the oil – do not fry to high. Add the noodles back into the hot water to reheat and then drain again, shaking well to remove excess water. Once the lobster is cooked in the oil and the oil is fragrant from the herbs, add in the warmed udon and toss throughout with the oil to coat.

To serve
Use tongs to place into serving dishes and serve immediately.

Matt Breen
Cooking with the Right Music

Matt Breen's hands oscillate between the kitchen knives and his beloved turntables in his 1930s home at Mt Stuart, a fifteen-minute drive from Hobart's CBD. Shared with his wife, Monique; their toddler daughter, Billie; and their greyhound, Stevie, the house is considerably larger than their previous cottage they lived in at West Hobart. Chef and owner of Sonny, a twenty-seat restaurant in the city, and Ogee, a restaurant in North Hobart, Breen was once an apprentice to leading Sydney chef Hugh Whitehouse.

There are a number of similarities between Breen's kitchen and Sonny – both slightly rustic, with a touch of the country style. While Sonny is relatively compact, Breen's home, a detached house on an 800-square-metre plot, has twenty-six fruit trees, including apples, pears, fig and passionfruit, along with raised vegetable beds, plus chickens.

When the couple purchased the art deco house (c. 1936), it had been thoughtfully restored by the previous owners after being left vacant for thirty-five years (owned by the same family). As a result of this lineage, the three-bedroom house retains its original charm, including decorative cornices in the kitchen and an open fireplace with the original timber mantle (now used to display a few bottles of wine rather than an open fire). Tasmanian oak timber joinery, with red-painted front doors, conceals generous storage, including deep drawers to hold large pots and pans. Serviceable white subway tiles, common in the 1930s, frame the Electrolux six-burner gas stove.

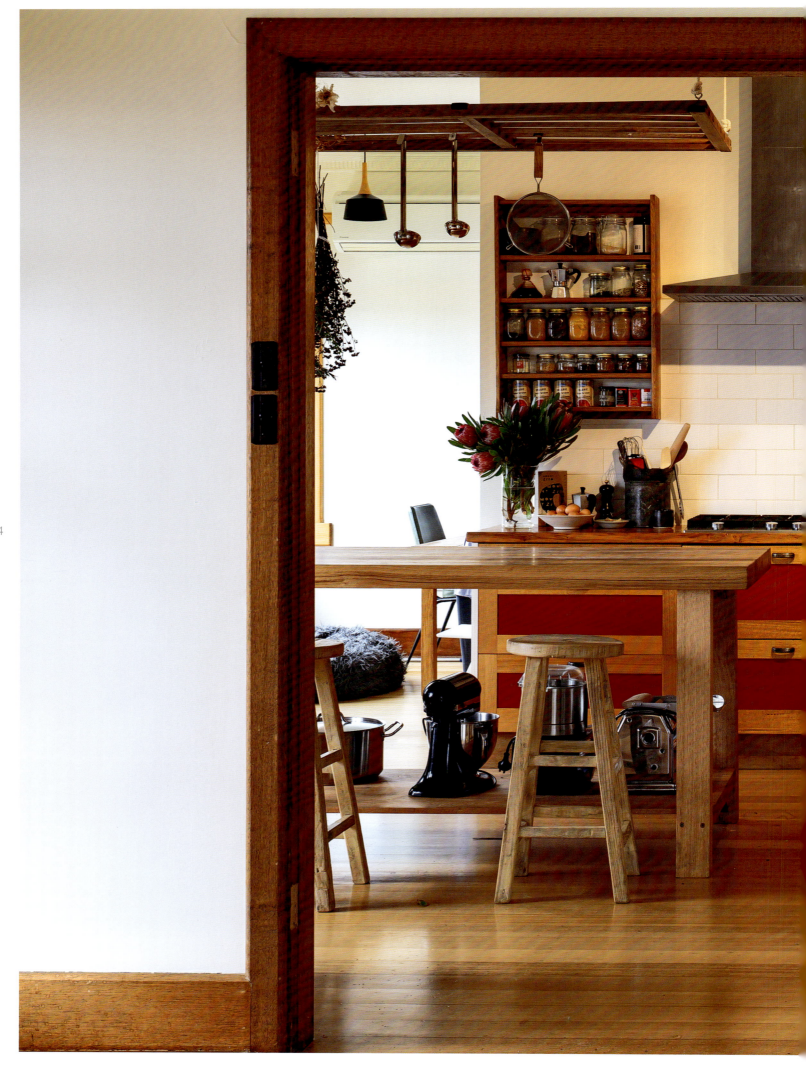

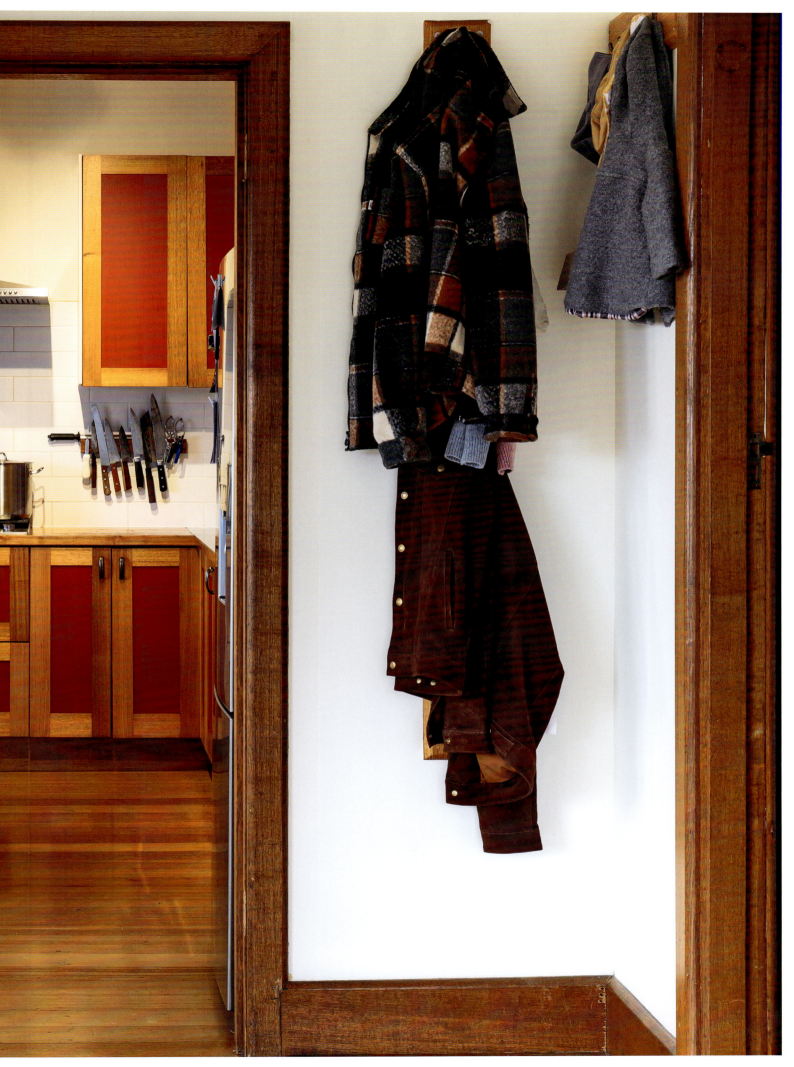

One of the main changes made by Breen was removing the double doors between the kitchen and living areas to add a seamless connection between the two rooms. The living area leads to a north-facing deck that accommodates a large eight-seater table, thoughtfully positioned below a hops vine that takes the heat out of the summer sun. What's grown in the garden, such as Romanesco broccoli, is brought into the kitchen, as well as finding its way onto the menu at Sonny's. The central bench, surrounded by eight stools, is where the family and friends gather. Also made from Tasmanian oak by a local furniture maker, the central nook includes a hanging rack that was made by Breen to suspend herbs such as garlic. And within reach, below this bench, one can find some of the key appliances used on a daily basis: a Robot-Coupe and a KitchenAid. It's here that Breen does most of his prep work when preparing meals at home. Another feature in the kitchen is a suite of Japanese knives, something that he credits as indispensable when it comes to cooking. There's a small wine fridge tucked into one corner that holds about fifty bottles of wine. "Creating a great meal starts with the right utensils, whether it's mixing bowls, pots and pans, usually of a commercial standard," says Breen.

One of the things that Breen needs to have while cooking, whether at home or in his restaurant, is the stereo system. In the adjacent living area, for example, apart from an original print of a 1980s work by Razzia depicting a fork wrapped in pasta, there's his record player and record collection, estimated to be around 200 vinyl records. When he moved here, he built the Tasmanian oak shelves to accommodate the turntables and commissioned a couple of speakers by Hobart-based company Pitt & Giblin. "I always put on a record while I'm cooking. At the moment, I'm particularly drawn to the music by Yusef Latif, a 1970s jazz flautist. Great music gets you into the mood even before what's decided for the meal," says Breen.

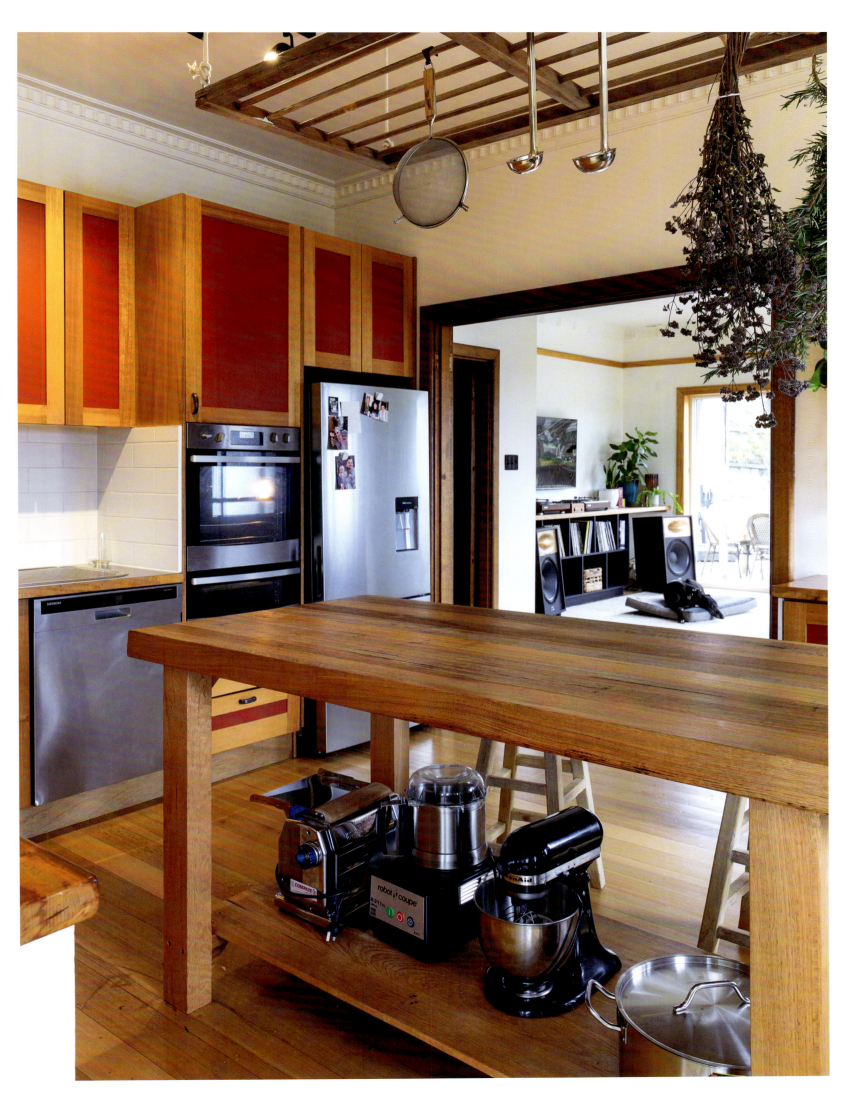

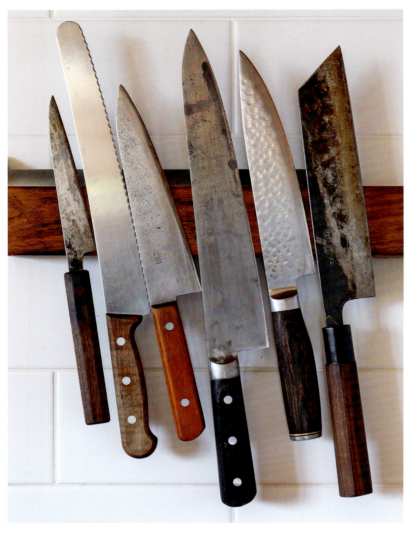
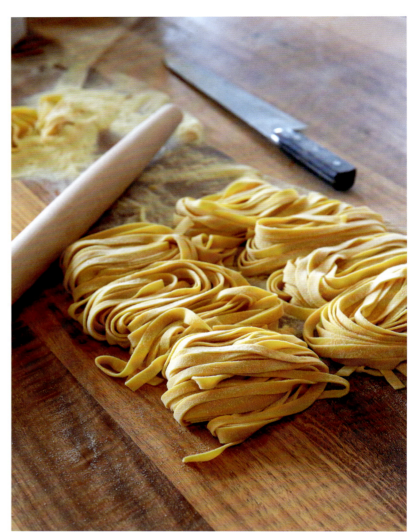

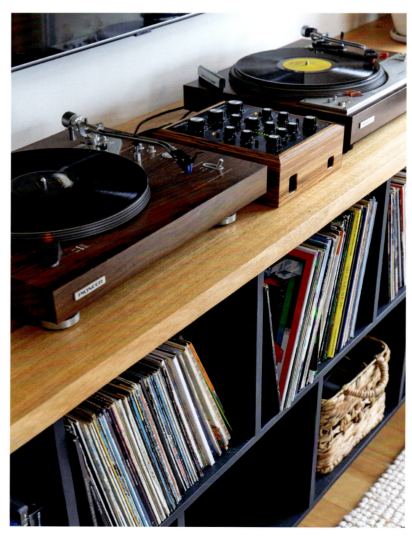

So, while the kitchen bench is where most meals are prepared and eaten (a high chair is brought out for Billie), there's also the option of eating in the living area or on the deck, the latter particularly during the warmer months. And while Breen loves his kitchen and has more than sufficient storage space, he feels there can never be too much of it. "You need generous bench space to cook comfortably," says Breen, pointing out the benches on three sides of his kitchen. A painting by Indigenous artist Linda Ngitjanka appears above the fireplace. "Eventually, we will extend the kitchen to give us just that little more space," he adds. And while some chefs fill their kitchen drawers with gadgets, Breen prefers to avoid collecting gadgets that he rarely, if ever, uses. "There are gadgets that assist in preparation. But there are those, many of which can be found in my mother's kitchen drawers, such as garlic peelers or egg boilers, that can easily be dispensed with," says Breen.

For Breen, it's not just the large plot with its established garden that appealed to him and Monique; it is the area, one where he was raised and a stone's throw from the hospital where he was born. "It's such a verdant neighborhood and the house, as well as the kitchen, just has a great feel to it. It was the kitchen that drew me to the house. And while we've made a few changes, a lot of the hard work was already done," says Breen, who was told by the previous owners that blackberry trees literally led to the front door, blocking its access.

Pasta dough

500 g tipo 00 (super fine, mid-protein flour)
200 g fine semolina, plus extra for dusting
250 g whole egg
120 g egg yolk

Mixing

Start by mixing together the flour and semolina on a clean flat work surface or in a very large mixing bowl. Whisk the whole eggs and yolk together in a bowl. Make a well in the centre of the flour and semolina mixture and, using a large kitchen spoon, start to stir the egg mix while adding the flour mixture gradually until all the flour has come off the side of the bowl or the egg mix has bound together with all the flour on the bench. If making the dough in a bowl, once the mix has started to come together, you can transfer to a clean bench.

Using a steel dough scraper, scrape underneath the mass of egg and flour and fold it onto itself. Do this a few times to clean the bench of any dough that has stuck and to help incorporate it.

Kneading

With your dominant hand, drive your palm into the dough and push it away from you, then with your other hand, fold the dough back towards you. Keep doing this while making sure to rotate the dough slightly as you go. Do this for about 5 minutes or until the dough has formed a ball with small indents in it but is still not quite smooth all over. Wrap the dough in plastic and let it rest for 15 minutes at room temperature.

Once the dough has rested, knead it another 5 minutes or until the dough has a smooth surface. Wrap the dough in plastic again, making sure that there aren't any air bubbles.

Resting

The dough will now need to rest for at least one hour at room temperature before rolling out. If you're not rolling it out right away, it can also be stored in the fridge for 48 hours before use if wrapped correctly in cling film.

Rolling

Cut the dough into four equal parts and wrap the other three back in plastic or cover with a towel if you are going to use all the dough in one go.

Set your pasta roller to its thickest setting and, with a rolling pin, flatten the dough to this thickness. Feed it through the pasta roller. Roll it through once and then decrease the setting on the machine. Keep doing this until you go down 4 steps.

Then, taking one end of the sheet, fold it onto itself and with the tips of your fingers, push down to make it stick together. Set the machine back to its thickest setting and repeat this process two more times. The dough should now look and feel smooth and relaxed. Keep rolling the dough now down to its third thinnest setting. Cut into 30-centimetre-long sheets and stack them up with plenty of semolina in between them. Roll up like a Swiss log and cut into thin noodles.

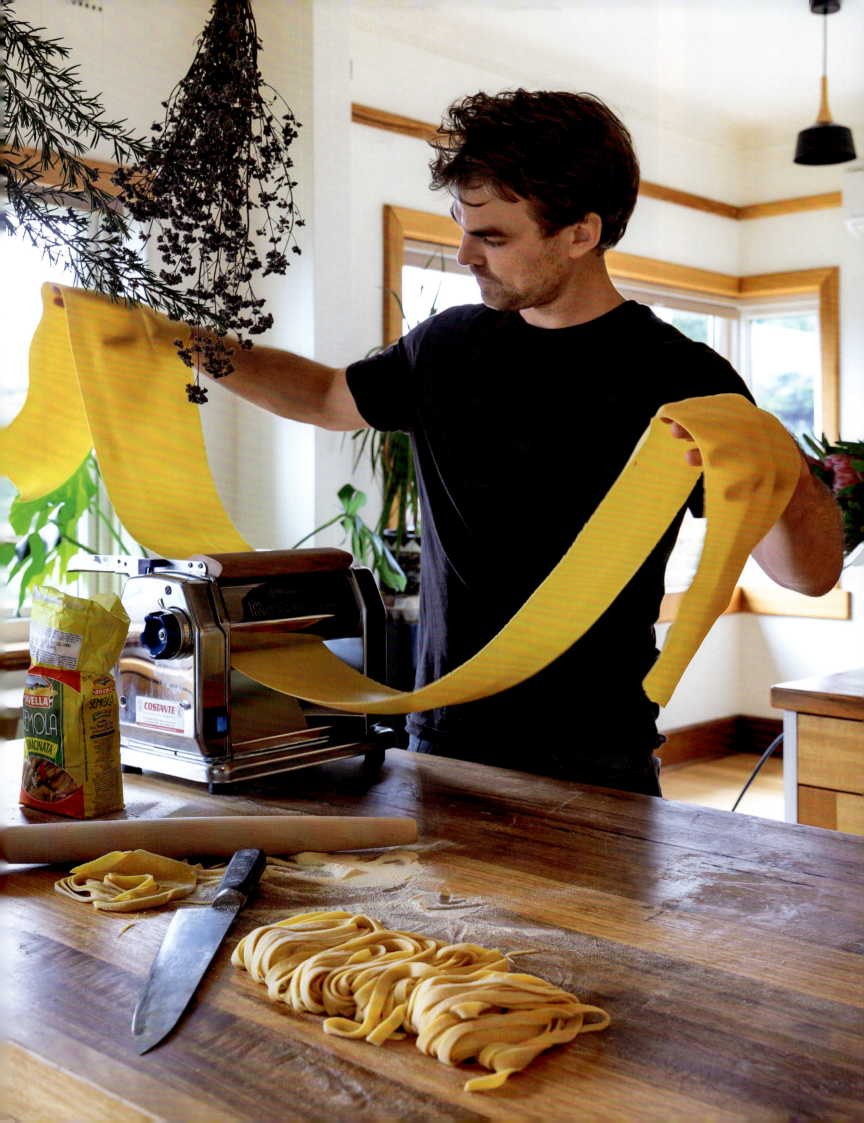

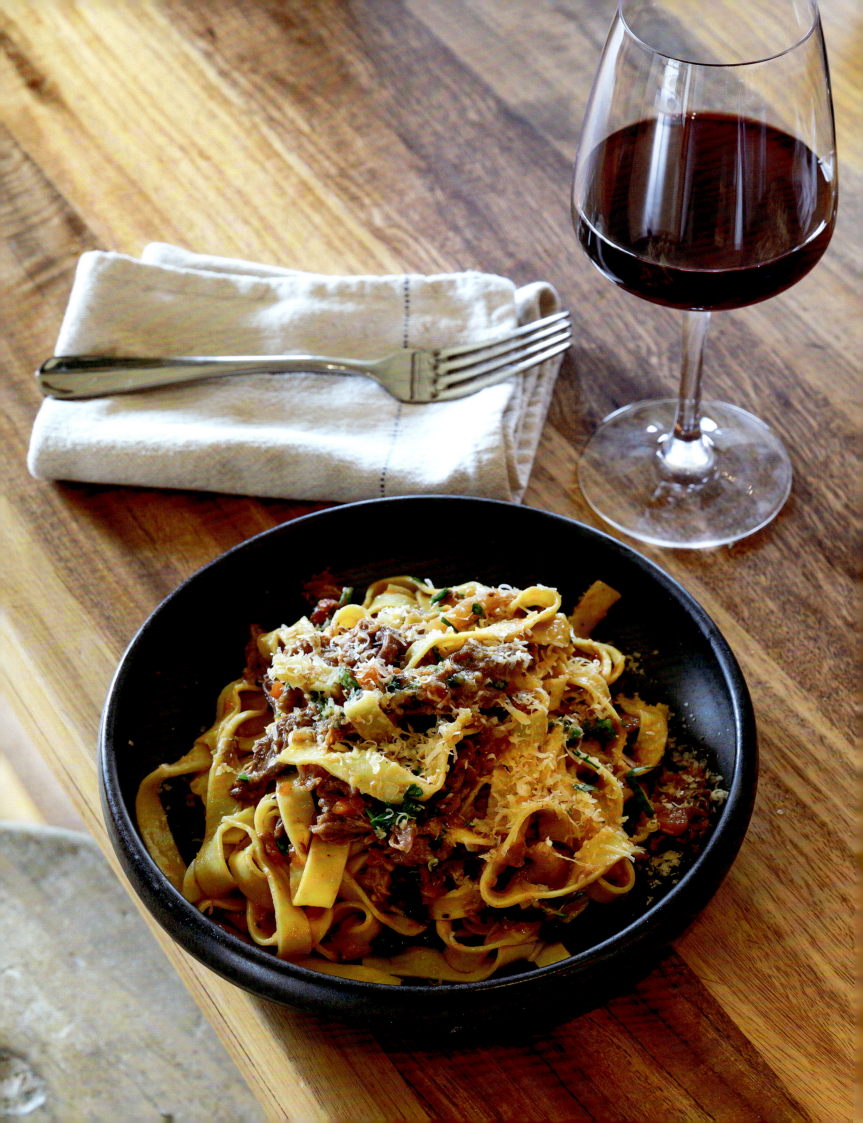

Goat ragu

1 tbsp chopped garlic

100 g onion, chopped

100 g carrot, chopped

100 g celery, chopped

250 ml red wine

1 goat shoulder or lamb shoulder (ask your butcher for a square cut shoulder)

40 g salt

1 bay leaf

4 peppercorns

1 clove

1 cinnamon stick

1 star anise

1 dried chilli

700 g tinned tomatoes

200 ml good-quality chicken stock

In a large stock pot or Dutch oven, fry the garlic, onion, carrot and celery until the onion is translucent. Deglaze with the wine and add in your shoulder. Season liberally.

Tie up the bay leaf, peppercorn, cloves, cinnamon, star anise and chilli in a clean Chux cloth and add to the pot together with the tomatoes and stock.

Transfer to the oven and roast at 165°C for 2½ hours. The bones should be easily removed by pulling on them. If not, put back into the oven until they can be.

Final assembly

Bring a large pot of water to a rolling boil. Season really well with salt. Add in your desired amount of pasta. Cooking time will depend on how fresh your dough is, somewhere between 4–8 minutes.

In a saucepan, add some of your goat and the sauce then toss through your cooked pasta and some chopped parsley.

Michael Lambie
Trained with the Finest

Chef Michael Lambie has an impressive CV. In the 1990s, he worked at the three-Michelin-star restaurant Marco Pierre White in London, as well as Harvey's, the more casual bistro affair. When he came to Melbourne a few years later, he became the executive chef at the Stokehouse in Melbourne. It's not surprising that Lambie decided on becoming a chef, given even in his teens, he was working periodically in the kitchen at his family's pub in Essex to earn an extra bob. But most associate Lambie with his successful restaurant Lucy Liu, an Asian-inspired restaurant located in Oliver Lane, in the heart of Melbourne.

When it opened in 2014, patrons waited eagerly to find a seat in the energetic establishment. "You could describe this place as eclectic Asian fare with cool cocktails. It's fast, dynamic and high energy," says Lambie, who engaged March Studio to create the fit-out. "We went to Hong Kong and to Shanghai to find inspiration," says Lambie, who moved on from Lucy Lui and recently opened Rubi Red Kitchen and Bar in Queensland.

However, his home in St Kilda is a sharp contrast to the hustle and bustle of Lucy Liu. Designed by well-known interior designer Andrew Parr, director of SJB Interiors, the sleek contemporary townhouse features generous glazing and a dramatic void (6 metres high over the living area). "As soon as I walked into this place, it just felt right. You could say that it has a sharp masculine look, but this kitchen doesn't 'read' as a kitchen," says Lambie, who does intend to make a few changes down the line. "I need more storage and probably a larger pantry," he adds.

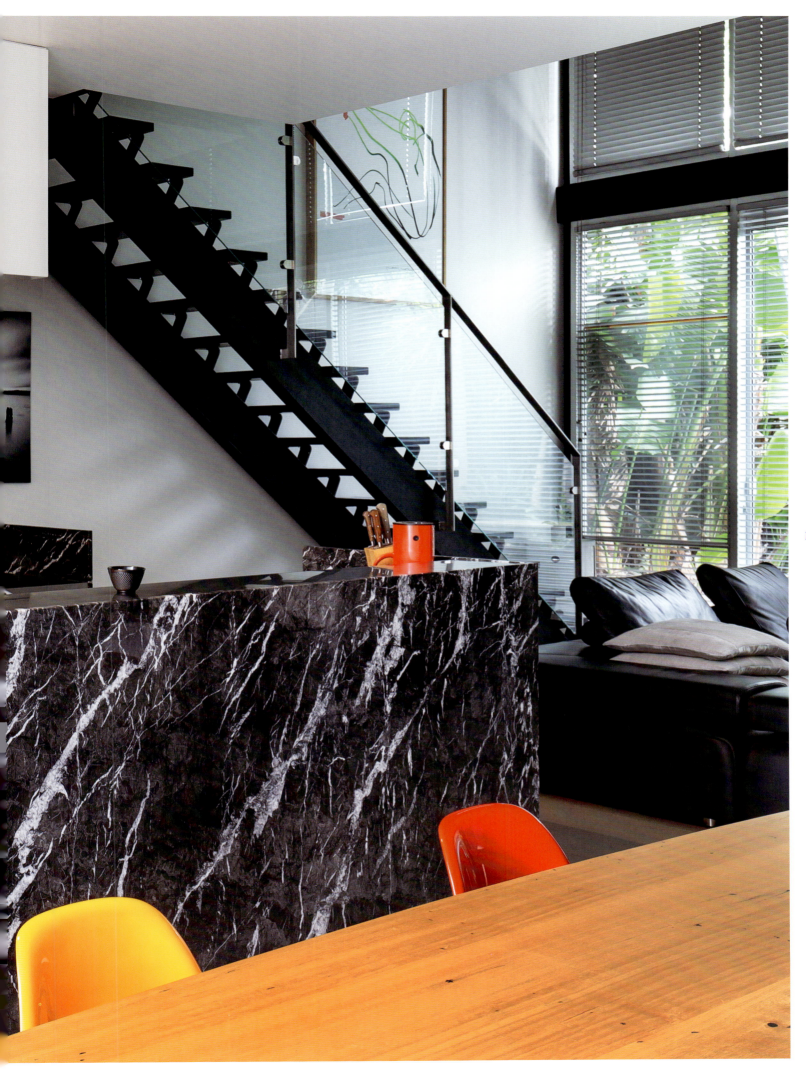

Entrance to the St Kilda home is via translucent glass doors that lead to an enclosed front courtyard. Although there's a front door nestled to one side of the courtyard, this welcoming alcove is primarily used as a nook for wine storage. Those that do use the front alcove to enter are immediately greeted with a portrait of Lambie holding a large fish and with a large knife in his mouth, anticipating the task ahead. Generally, access is via the large, sliding glass doors that open to the dining area – a timber table surrounded by a bright combination of different-coloured Eames chairs. A large framed poster depicting pasta creates a sense that this is a home of someone who appreciates food.

However, it's the kitchen, with its two black-marble island benches that catch one's eye upon arrival. These monolithic benches create a sculptural backdrop to the pared-back white interior. With each bench (finished in black laminate) having an extended lip, guests can't see the preparation going on in the kitchen from the dining room. However, often guests perch on the timber stools and watch Lambie prepare a meal.

While both benches include generous black laminate drawers, one island bench is primarily used for cutting up and washing food; the other is for cooking. One island bench includes one-and-a-half sinks with a dishwasher below, while the other includes Smeg hotplates and an oven. "When I first saw the kitchen, one of the main things that impressed me was the width of the benches [about 700 millimetres]," says Lambie. One of the other features that caught his eye was the substantial flue in the kitchen (a Qasair), concealed in plaster and treated as a sculptural object. "From experience, having a sufficiently powerful flue is fundamental in a kitchen, particularly as I cook a lot of Asian food at home," he says.

Parr also created a recessive kitchen (as opposed to a feature-style kitchen) by including one wall of kitchen joinery, finished in a pale grey, two-pack paint finish. This conceals the pantry, the integrated fridge and also storage space. And across the entire ground floor, extending from the kitchen to the living area, are wide-format, porcelain, creamy white tiles. "I am planning to change this flooring to black-stained timber. The white tiles tend to be fairly unforgiving when it comes to food spillages," says Lambie.

Although Lambie regularly cooks in the kitchen, he often gravitates to using the Weber barbecue in the lush northeastern courtyard, bordered by palm trees and birds of paradise. Unlike many chefs who have a vegie patch at home, Lambie prefers to use this space to entertain. "I love cooking out here, especially through the warmer months of the year. But I also don't really appreciate the smell of meat lingering in the house," says Lambie, who often grills either steak, legs of lamb or chicken, and even prawns. But when the sliding doors are left open on either side of the house (ground floor), any odours inside quickly dissipate. When Lambie comes home late during the week, as is generally the case, he improvises, making use of ingredients found in the fridge.

For Lambie, there are a number of factors that make a kitchen work, at least for him: generous waste facilities such as a large bin below the sink, good storage facilities (his kitchen is slightly lacking in this area) and quality appliances. "I think the choice of appliances often comes down to personal preferences, with many quality appliances offered at a similar price point. I'm attracted to quality appliances, but also ones that can be easily cleaned," he says. One feature that's often ignored when designing kitchens is both the number of power points and their placement. In this kitchen, there are two double power points, one set on each island bench. "You shouldn't feel restricted where you place items such as a kettle or a toaster. You also don't want to have electric cords traversing benchtops." On these benchtops, there's a toaster and an electric kettle. The only other permanent fixtures are a water jug, a knife block, a bottle of olive oil, black pepper and a container of Murray River pink salt – an ingredient that goes into many of Lambie's dishes.

Sufficient lighting is also singled out by Lambie as something that needs to be addressed. His kitchen includes two sets of adjustable downlights placed on either side of the island benches. But he's also fortunate to have the generous glazing to the northeast, with the soaring glass curtain wall creating a sense of being outdoors even when the sky is overcast. "It's a wonderful space to be in, even if I'm not preparing food," adds Lambie.

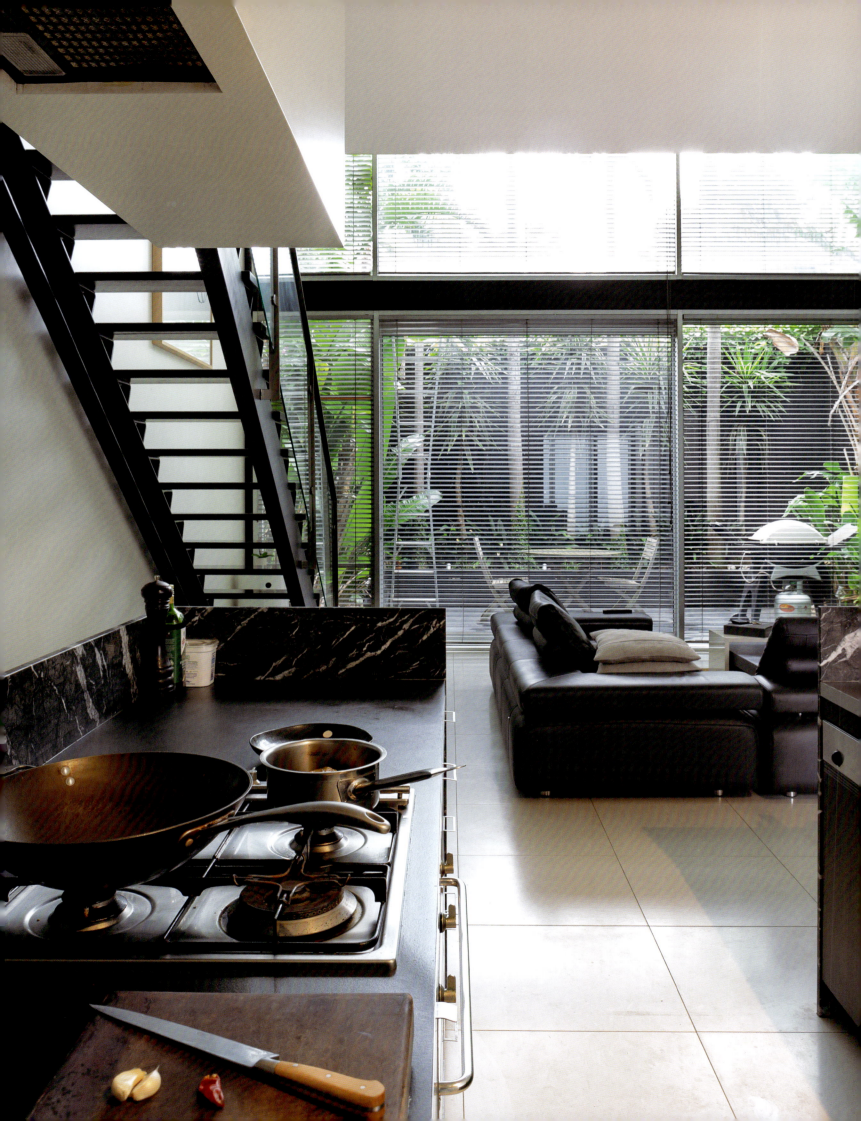

Malaysian lamb rendang

Spice paste

3 tbsp oil
10 dried red chillis, soaked in warm water & seeds removed
5 fresh red chillis, seeds removed
2 stalks lemongrass, white part only, lightly smashed
7 shallots or 1 small red onion
1 garlic clove
1 cm ginger, peeled
1 cm galangal, lengkuas, peeled
1 tsp coriander seeds
1 candlenut, lightly smashed
1 tsp tamarind paste
1 tbsp turmeric powder
1 tsp salt
1 tsp sugar

Lamb and sauce

600 g boneless leg of lamb, beef or chicken, cut into cubes
7 tbsp oil
¼ piece turmeric leaf, thinly shredded (optional)
10 kaffir lime leaves
1 stalk lemongrass, cut into 5 cm lengths
1½ cups coconut milk
2 tbsp desiccated coconut, lightly toasted
Salt & sugar, to taste
Steamed white rice or coconut rice, to serve

Plug in the crockpot/slow cooker and turn setting to high.

Blend all spice paste ingredients in a food processor until fine. Scoop out, and set aside.

Season lamb cubes with a little salt and set aside.

In a wok, heat up oil, stir-fry turmeric leaf and kaffir lime leaves until fragrant.

Turn heat to slightly medium-high, add blended spice paste. Stir-fry until fragrant, or until colour changes, for 5 minutes.

Put in lamb cubes, stir well and continue cooking for 5 minutes.

Pour in coconut milk and toasted coconut and bring to a quick boil. Turn off heat and move all pre-cooked contents from wok into crockpot and braise for 1½ hours.

Remove pot cover, stir and check to make sure the dish is not too dry and the lamb is tender enough.

Turn off heat. Unplug crockpot and allow the dish to sit for 30 minutes to 1 hour. The sauce will slowly evaporate and may appear slightly dry and thickened.

Serve with steamed white rice or coconut rice.

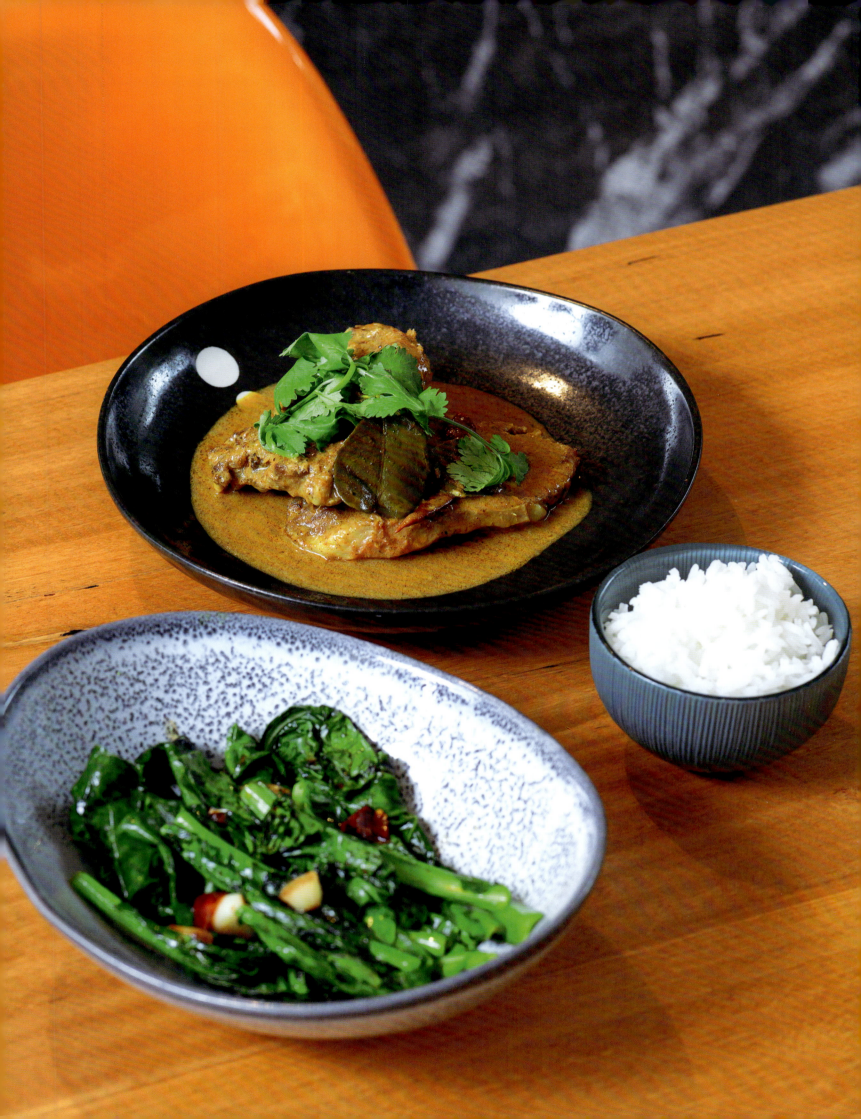

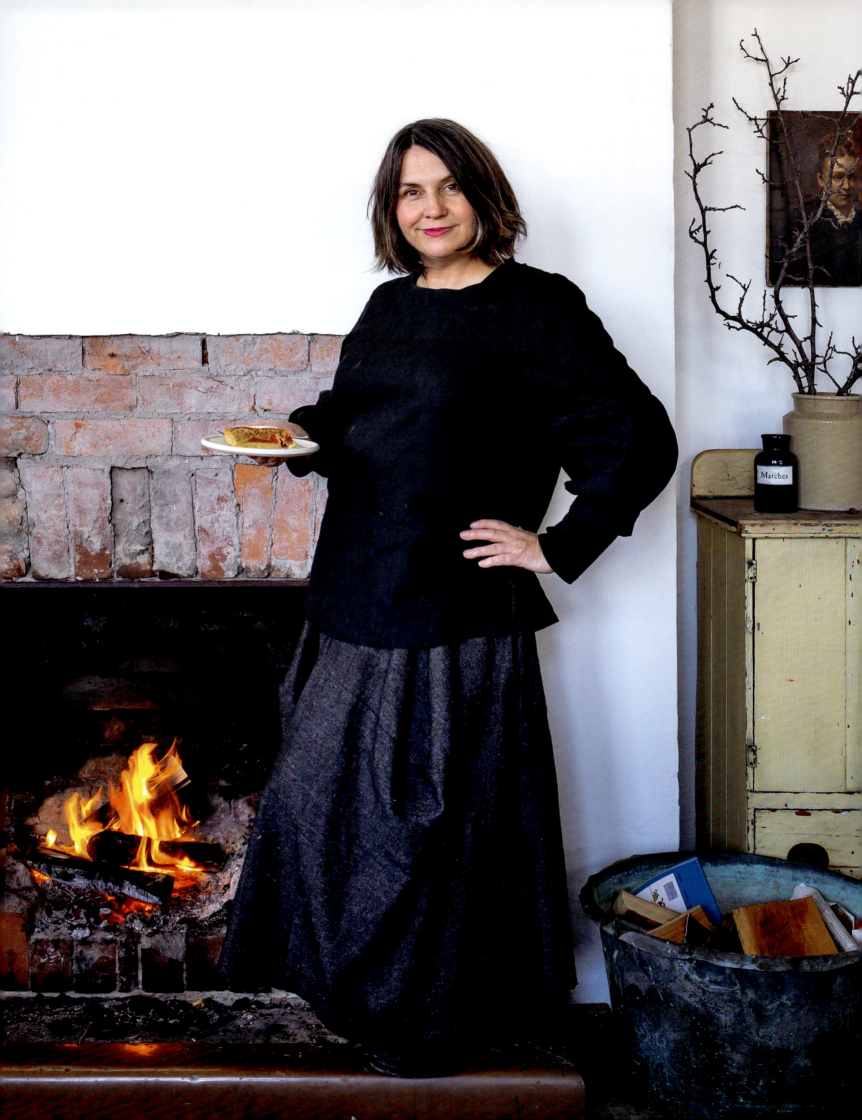

Michelle Crawford
Surrounded by Vintage Finds

Cook and food stylist Michelle Crawford is surrounded by vintage items in her kitchen and events space at Franklin, a 45-minute drive from Hobart. Located in Tasmania's Huon Valley, the former bank building (c. 1906) occupies a prominent corner site. Originally built as The Commercial Bank of Tasmania, the two-storey building was purchased by a doctor in the mid-1940s, who turned it into a hospital called The Bowmont. The building became derelict in the 1970s, and, threatened with being demolished, it was the local community who rallied to save it. "There were 3,000 babies born here while it was a hospital, until the 1960s. Many locals had their babies delivered in what's now my kitchen," says Crawford. Now The Bowmont attracts locals as well as those travelling from interstate.

With five bedrooms, including two bedrooms attached to the self-contained apartment on the first floor (once occupied by the bank manager) that has been transformed into guest accommodation, The Bowmont is a relatively new project for Crawford and her husband, Leo, and their son, Hugo. Used for everything from photographing food to preparing dishes for clients, as well as holding workshops for groups of up to eighteen people, the two adjoining spaces (the kitchen and the events space) are beautifully layered with great vintage finds, such as a French armoire that holds many of the photographic props for food styling, including glass, linen and crockery. Old oil paintings are dotted around both spaces, along with flower arrangements.

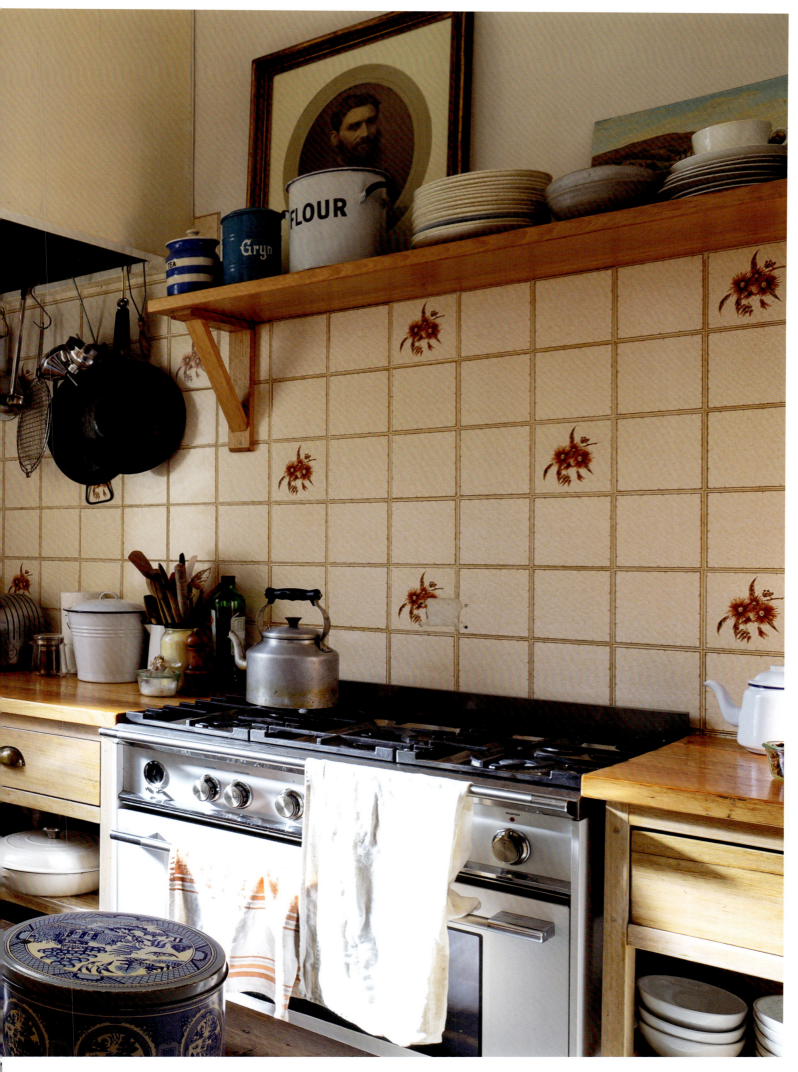

After its numerous uses, including a backpackers' hostel and an antique store, Crawford was given a fairly rudimentary 'canvas' to work with. There were damaged timber floors, now replaced, and just a hole in the brick wall that once contained an over-mantle. However, many of the features from the previous decades were retained. The 1980s tiles, with their distinctive gumnut design, were kept in the kitchen, along with the yellowed vinyl floor that would have once supported hospital beds. The massive rangehood is also a relic of the 1980s when the kitchen was used to train youths in cooking skills.

However, the past is layered with the present, including new colonial-style timber joinery designed by Crawford and built by local carpenter Michael Van Keel. Complete with drawers and open shelves, made from Tasmanian oak, it's difficult to see where the past ends and the present begins. Pivotal to the kitchen is a 900-millimetre-wide oven from Fisher & Paykel, together with the acquisition of a lab sink purchased online from Gumtree. Cooking appliances, such as pots and pans, frame the kitchen wall, and central to the kitchen is a vintage table that serves as the primary work bench for Crawford. "I made sure there was sufficient room for my Rancilio [coffee machine], the coffee grinder, wooden spoons and the Dualit toaster," says Crawford.

While the kitchen and events space benefit from a rustic charm, it's the pleasure of cooking near the window and seeing the Huon River beyond her French parterre-style back garden that brings Crawford the most joy.

Crawford oscillates between working in the kitchen and working in the events space. And when groups are expected, benches in both rooms are fully cleared. One of her prized items is her AGA cast-iron stove with its three separate ovens: one for simmering, one for baking and the other for roasting. And the adjacent room to the kitchen, which was originally the bank's safe, is now a pantry.

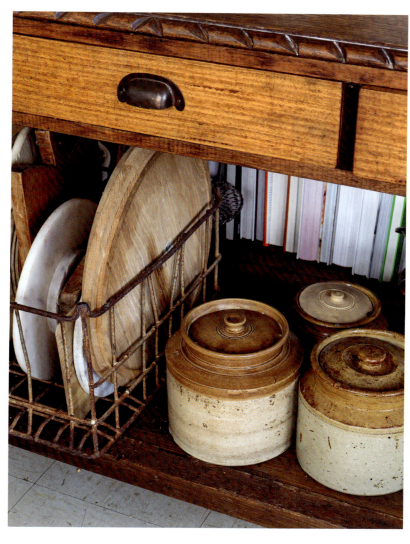

Unlike many kitchens that can't be easily altered, Crawford's kitchen and event space continually change and evolve to suit her functions and workloads. A kitchen dresser, for example, can easily be moved around, as can her prized Thonet chairs, designed around the same time the building was designed. These items, whether chairs, armoires or tables, are not only practical but, according to Crawford, unique and environmentally friendly. "I prefer sourcing furniture and objects from secondhand and vintage stores. They also come with a history rather than simply buying things off the shelf," she says. The generous northern light that enters through the large kitchen windows also makes cooking a pleasure. "We're enjoying the prevalence of light filling the space, as well as benefiting from the views of the river," says Crawford.

Crawford enjoys seeing new people visit The Bowmont, whether it's guests, clients or chefs preparing meals for her to photograph. And while this part of the house enjoys a constant stream of traffic, the remainder of the ground floor is given over to the family's home, including its own separate entrance.

As with the numerous babies born here, there will be as many meals in the course of time – and a place that will continually evolve as further renovations take place.

Marsala quinces and frangipane tart

Marsala poached quinces

4 large quinces peeled, quartered, cored
400 g sugar
1 cup sweet Marsala wine
2 cinnamon sticks, halved
1 vanilla bean, split lengthways
750 ml water

Combine ingredients in a saucepan and bring to a simmer, stirring to dissolve the sugar. Cook over low heat for about 4 hours until quinces are tender and a deep blush colour. Using a slotted spoon, transfer quinces into a medium bowl and allow to cool. Cut quince quarters in half lengthways. Bring syrup to a boil and simmer until reduced to about 350 millilitres.

Pastry

150 g plain flour
55 g almond meal
50 g icing sugar mixture
125 g chilled butter
1 egg yolk

Place the flour, almond meal, icing sugar and butter in a food processor and process until mixture resembles fine breadcrumbs. Add the egg yolk and pulse until dough just comes together.

Shape into a disc and cover with plastic wrap. Rest in the fridge for 30 minutes. Roll out pastry to 3-millimetre-thin circle. Line in a 22-centimetre-diameter tart tin. Trim the edges then put back in the fridge to rest for another hour.

Preheat oven to 200°C. Line the pastry with baking paper and pastry weights. Bake in oven for 15 minutes. Remove the paper and weights and bake for a further 10 minutes or until golden. Remove from oven and set aside to cool slightly.

Reduce oven to 180°C.

Frangipane

100 g butter, softened
100 g caster sugar
100 g ground almonds
2 eggs
50 g plain flour
Extra caster sugar, to sprinkle

Beat butter and sugar in a stand mixer until pale and fluffy. Add ground almonds, then add eggs, one at a time, beating until well combined. Fold in the flour.

Final assembly

Spread frangipane onto the base of the cooled tart case. Arrange the quince pieces on top. Sprinkle with extra caster sugar then bake for about 30–35 minutes, until frangipane is golden and cooked through and springs back when lightly pressed.

To serve

Cool slightly, then serve warm with vanilla ice cream and drizzle with extra syrup.

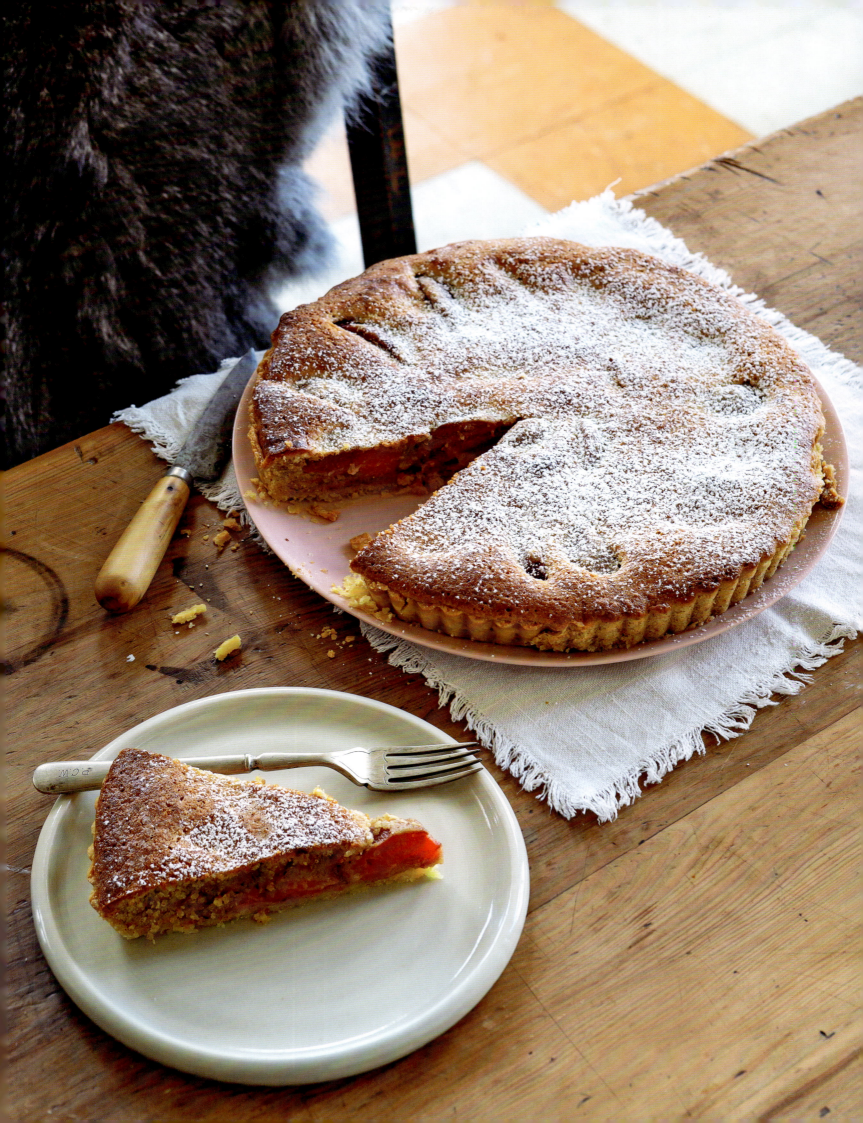

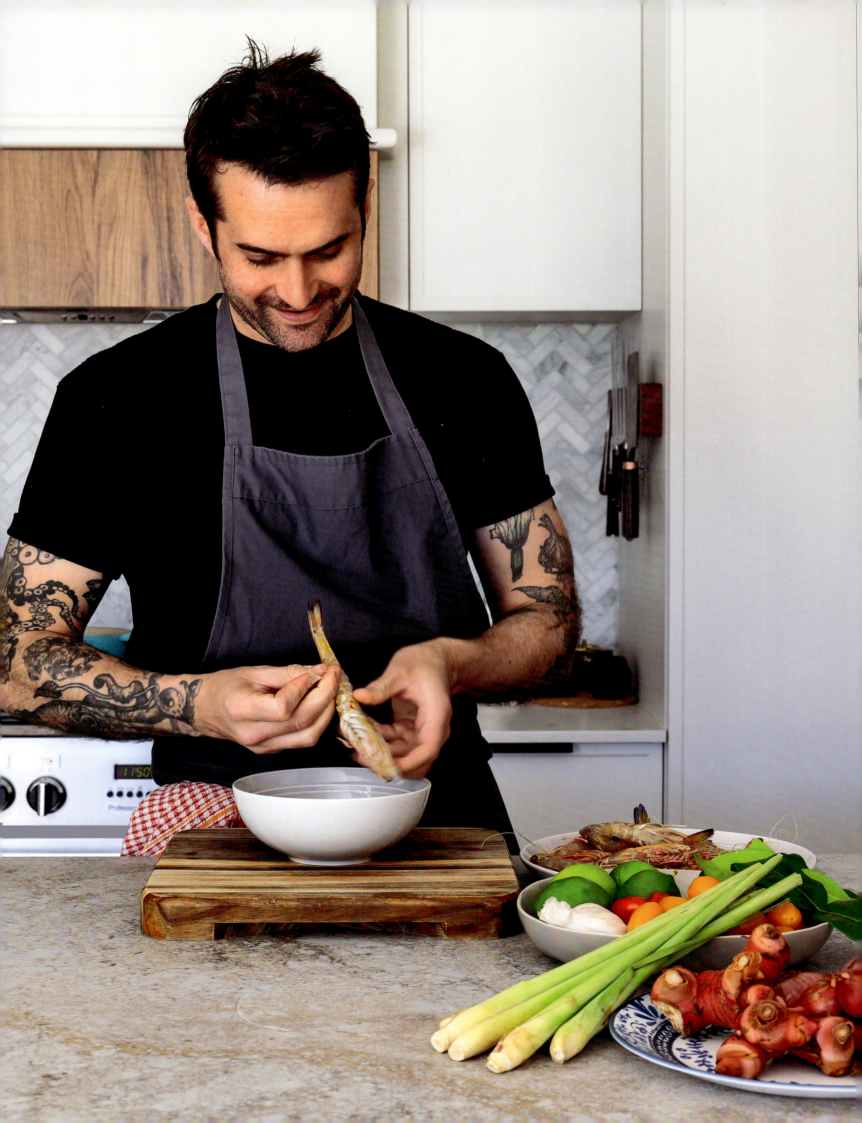

Peter Orr
At Home with His New Kitchen

Peter Orr, chef at Adelaide's Leigh Street Wine Room and Press* Food & Wine, is delighted to have his new kitchen at home. Shared with his wife, Quina, also a chef who works part-time at Leigh Street Wine Room, and their two young daughters, Alba and Evie, it's a long way from the many shared houses and kitchens that Peter lived in while living and working in Europe. He left Adelaide at just seventeen years old to start forging a career in the hospitality industry, initially working for a number of leading chefs in London. Orr met Quina while they were both working at the restaurant Au Passage in Paris.

Home is now a Californian bungalow in Westbourne Park, approximately 5 kilometres south of the city. The couple came back to Adelaide after spending seven-and-a-half years in Paris. While the house was in good condition, the kitchen and living areas were fairly small and had very little connection to the garden. "There was literally a four-burner stove and a small kidney-shaped island bench," says Orr. So, they commissioned Farquhar Kitchens to come up with a scheme.

"Our brief was a kitchen that was extremely functional. We certainly wanted a large island bench in the centre of the kitchen," says Orr, running his hands along the large stone bench that came from a single piece of stone. The other thing that was essential was a large stove (this one, a Falcon, is 900 millimetres wide, and was shipped from the United Kingdom).

Given the size of this kitchen, it's been thoughtfully zoned and includes a separate coffee station along one wall that displays a number of machines, including one to make espresso coffee and another for drip coffee. The couple's love for coffee is also shown with the number of coffee cups displayed on the timber shelves, many of which were purchased in Paris.

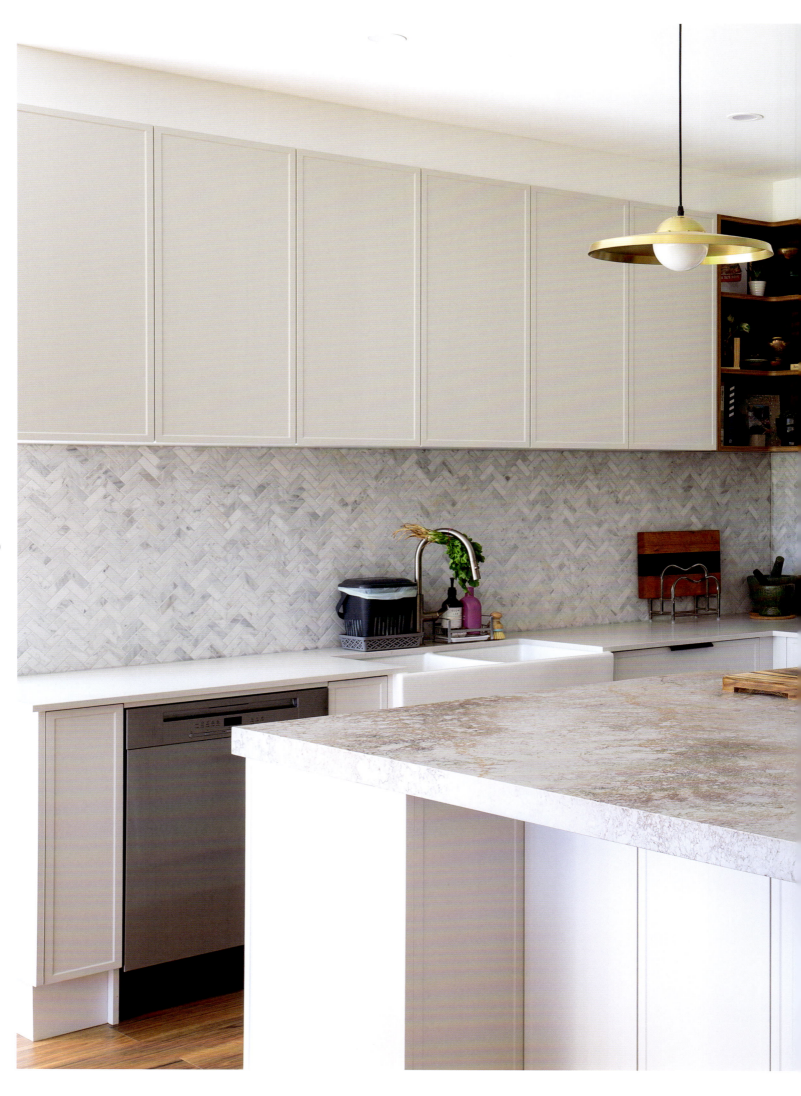

As the brief to Farquhar was for an efficient kitchen (read: low maintenance), the joinery that frames three sides of the kitchen is covered in an off-white (or as described by Peter, 'egg shell') vinyl wrap. And to complement the joinery are tiled splashbacks, laid in a herringbone pattern, that are more recessive to the stone used for the island bench, featuring brown and golden veins. "I think it would have been too intense if you used the same stone for the splashbacks," says Orr, who enjoys cooking for the family when he's not working at the restaurant. "Quina and I take it in turns cooking at home. It's generally quite a quick Asian-style meal," he adds.

As well as the size of the island bench, the couple appreciates the amount of storage in their kitchen. There are deep drawers for large pots and trays as well as a special cupboard for Quina's beloved ice-cream machine, located on the side of the bench that faces the dining area. There's also a separate pantry tucked behind the wall dedicated to making coffee, and drawers and places for literally every imaginable cooking utensil. And although Peter doesn't need to look at a recipe to come up with a great dish, he enjoys browsing through his many cookbooks, tucked in the end of the island bench and within easy reach. Given the couple work in a restaurant known for its wine offerings, it's surprising that there isn't a dedicated cellar or wine storage area to be found. "The kitchen has just been completed so we're expecting a dedicated wine fridge to arrive shortly," says Orr.

As well as the generous amount of storage, Orr enjoys using his double sink that slightly cantilevers over the joinery. Known as the farmhouse butler's sinks, they are well positioned next to the dishwasher, with cleaning products stored below. As with the wine fridge, the bar stools that will complement the island bench haven't arrived. "I think that most spaces are a work in progress," says Orr, who enjoys seeing how everything is taking shape – including the new bi-fold glass doors to the back garden that allow him to keep an eye on the children while he's in the kitchen.

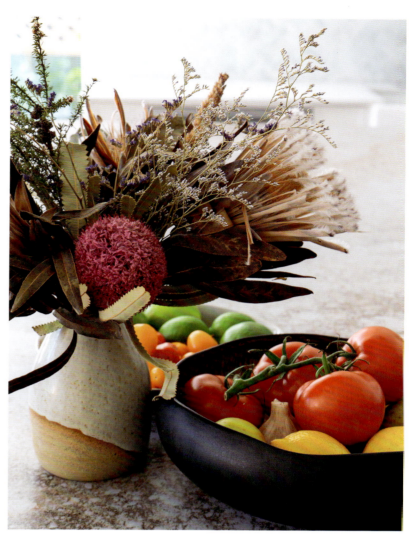
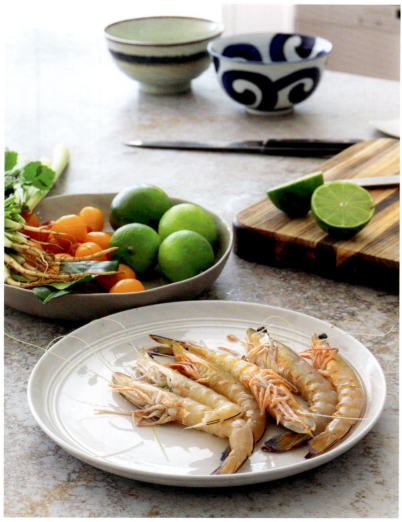

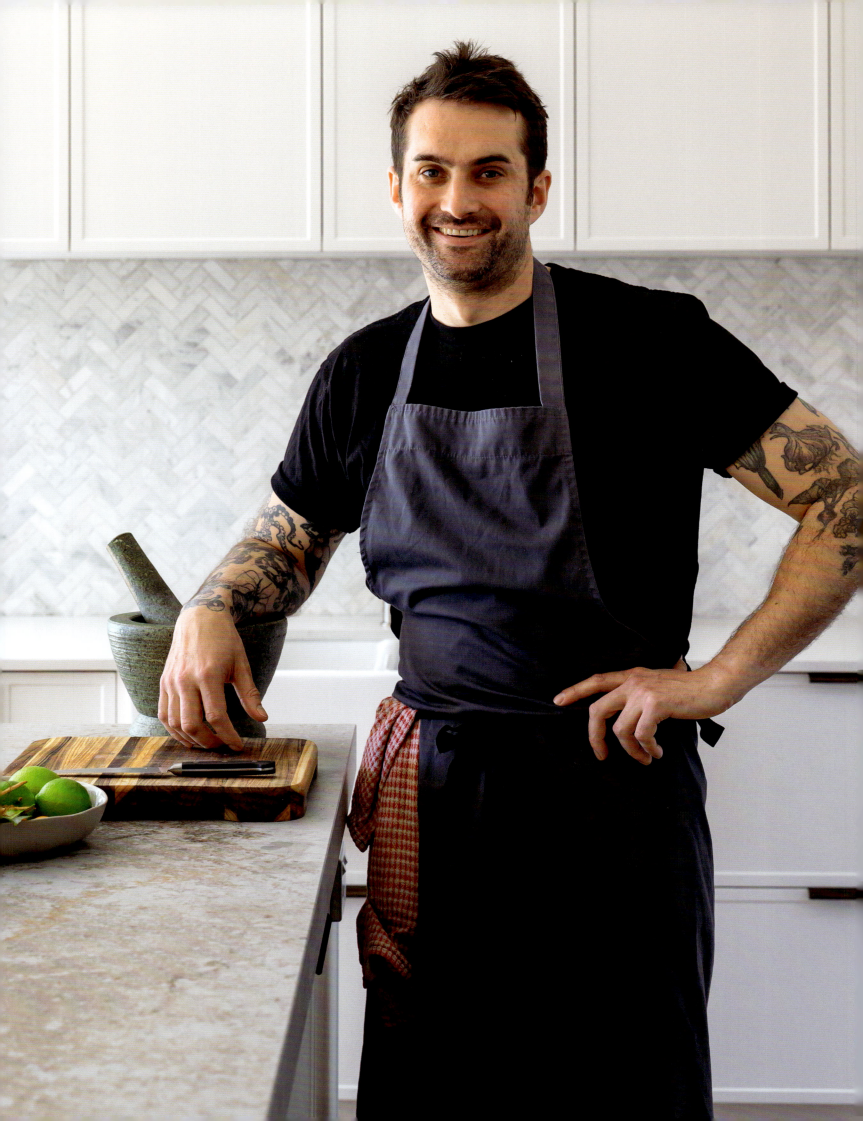

According to Orr, some features in a kitchen go beyond aesthetics. The kitchen's island bench is 950 millimetres in height, slightly higher than is found in most homes. "From years of working in restaurants, standing on your feet for up to 15 hours a day, you don't want to be continually leaning over a bench," says Orr, who also appreciates having large sinks to clean everything that can't be stacked into the dishwasher, such as large pots and pans. Peter also understands the importance of lighting in a kitchen, and being able to change it with a flick of a switch. Here, the pendant lights, including the brass light over the island bench, can be easily illuminated or dimmed, the latter when guests come over.

The kitchen is clean and contemporary, with only a few items on display, such as the timber chopping block. Likewise, the dining/meals area features provincial French-style furniture, a memory of the time the couple spent in Paris. "It's just a lovely space to be in, whether I'm preparing a meal or simply just looking out to the garden," says Orr.

Prawn hot and sour soup

500 ml fish stock

Small pinch of salt

2 tbsp fish sauce

4 Thai chillies (or as many as you can handle)

2 stalks lemongrass, 5–10 cm pieces, pounded (to break fibres but not to be eaten)

3 kaffir lime leaves, torn

3 Thai shallots, peeled & pounded (to bruise)

4 cherry tomatoes, cut in half

A few oyster mushrooms, torn

4 large raw king prawns

Juice of 1 lime

Steamed rice, to serve

Small handful of coriander leaves, chopped, to garnish

Bring the stock to the boil. Add all other ingredients except the prawns, lime juice and coriander. Turn down the heat and let simmer for a few minutes or until the shallots are soft.

Add the prawns and allow to cook gently – no more stirring.

Once the prawns are cooked, remove from the heat and add the lime juice. If needed, add more fish sauce or lime juice.

The soup should taste salty, sour and hot. Feel free to adjust the seasoning to achieve this.

To serve

Serve with lots of steamed rice, and garnish with chopped coriander.

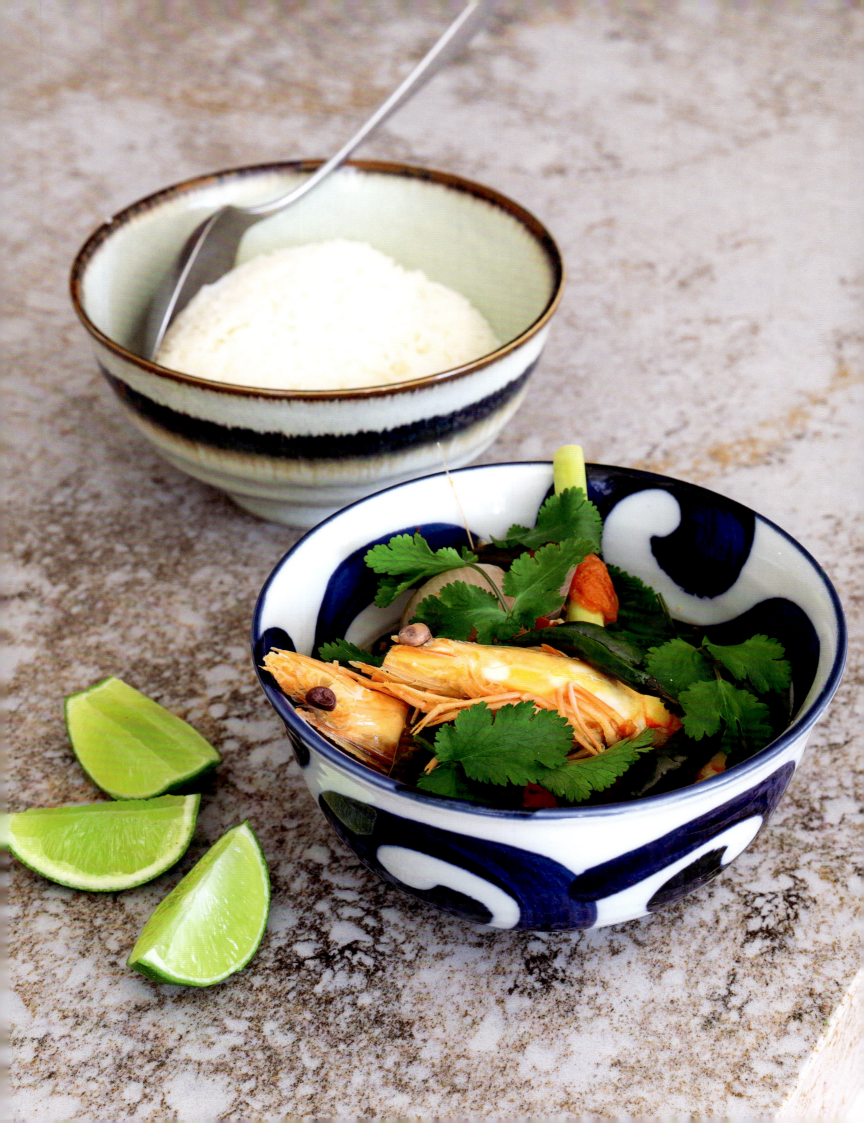

Rita Macali
From Being a Fussy Eater to a Great Chef

As a child, chef Rita Macali was a fussy eater. "If I didn't like something I just wouldn't eat it," says Macali, who formerly operated Supermaxi in North Fitzroy, with her partner Giovanni Patané doing front of house. However, during her high school years, she started to become more interested in food, making cupcakes at home. "Being in an Italian family, food takes a pivotal role," says Macali, who undertook a hospitality course at Preston TAFE. A series of part-time jobs in hotels even before graduating from TAFE cemented her future. "It just felt natural and, importantly, I really enjoyed it for the time we were there [over a decade]," says Macali, who opened Supermaxi, designed by architect Robert Simeoni, in 2010.

Opening the informal Italian-style restaurant felt right after moving on from owning a pizza restaurant. The location also seemed to work, being only a 5-minute drive from their home in West Preston. (The restaurant closed its doors in 2022.) Originally built in the 1950s, the couple's property was once the tennis court of a nearby bluestone mansion. "We inherited the change rooms," says Patané, who now uses the rudimentary shed for storage.

There's a connection to food well before one reaches the front door of the couple's home, which they share with their teenage daughter, Liliana, and their two cats, Mario and Patches. On the nature strip are numerous fruit trees, together with a couple of olive trees. The extensive fruit and vegetable garden can also be seen behind the timber picket fence. Framed by established pine trees, the front, north-facing garden includes cherry and apricot trees, tomatoes, beans, zucchini, and an extensive range of herbs: thyme, lemongrass, oregano, rosemary and sage. "There's nothing more rewarding than eating the food that you've planted with your own hands. Everything is so fresh," says Patané, whose domain is the garden, while Macali's is the kitchen.

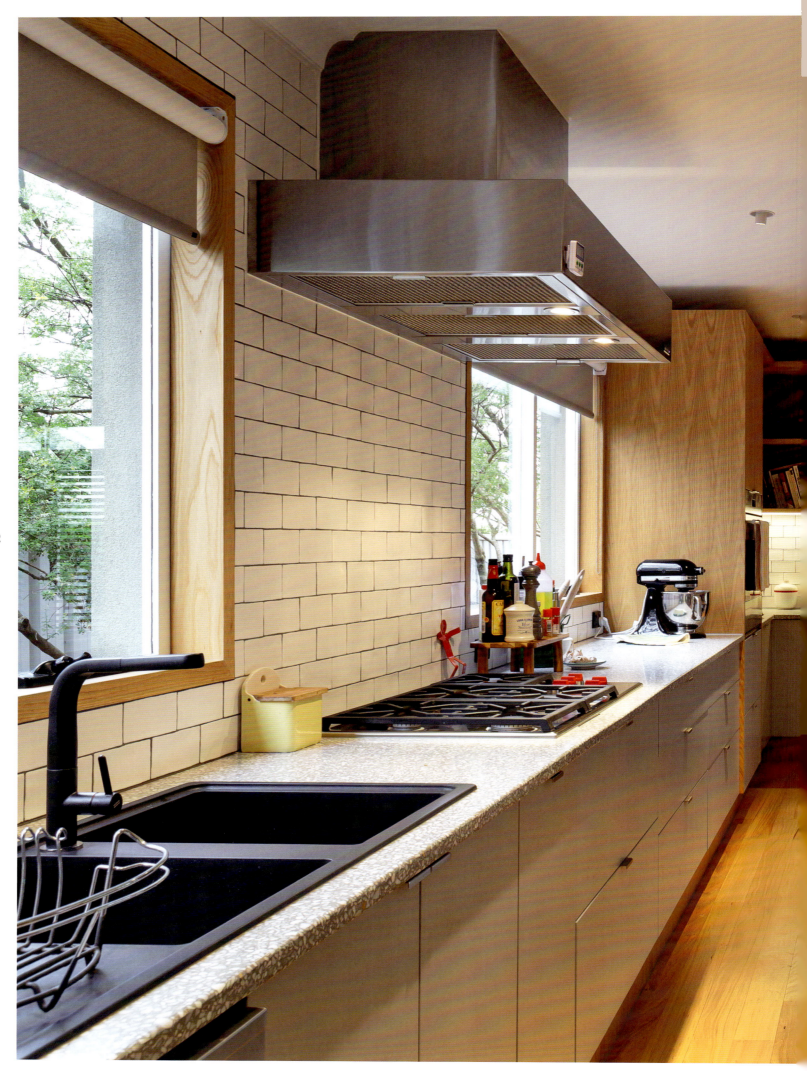

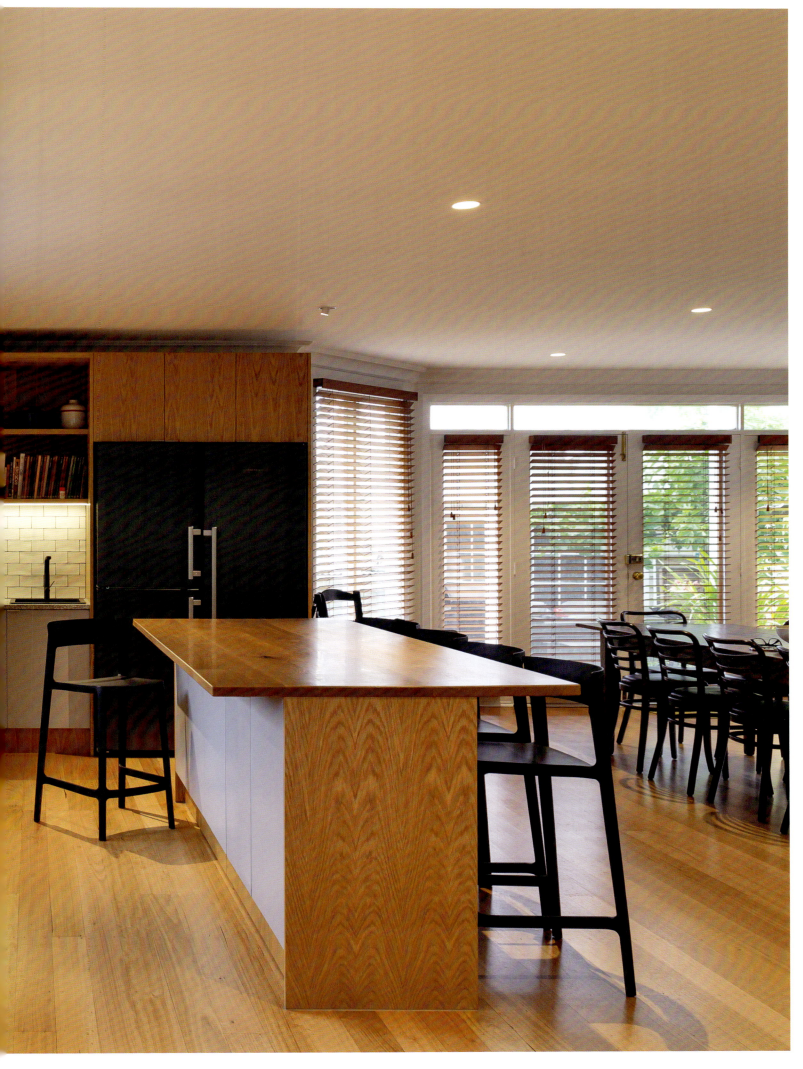

When the couple purchased the house, the kitchen was galley-style, comfortably accommodating only one or two people at most. Working with carpenter Scott 'Roopa' McCormack, they completely removed the wall between the front lounge and the kitchen. Now there's one large open-plan kitchen, dining room and informal lounge that connects to the rear garden. "Now half a dozen people can work in the kitchen at the same time, and quite comfortably at that," says Macali, who was looking for a large, open design, with fluid spaces and two separate sinks. "You shouldn't need to have to move out of someone else's way," she adds.

The new kitchen includes two sinks on either side of the benches, one being a double, the other a single sink. Terrazzo benchtops, MDF joinery and American oak shelves provide a more domestic palette than the stainless-steel finishes at Supermaxi. "I wanted a less industrial aesthetic at home," says Macali, who has included a number of semi-commercial fittings such as the customised rangehood. "I don't want to have to deal with odours, grease or with smoke."

The Wolf five-jet gas burner could also fit comfortably into a commercial kitchen. "I'm used to working with gas. You could say the way I cook is old school," says Macali. Important for the couple was that the kitchen wasn't too shiny, showing marks every time food was prepared. So the Spanish tiles used above the bench have a matt finish, easy to clean and not showing grease marks.

Macali also prefers to have a clutter-free kitchen, with many of the appliances, such as the microwave oven, tucked away in the walk-in pantry. One of the few things that takes pride of place on the kitchen bench are the condiments used for cooking: several different oils, a pepper grinder and oregano. A container of wooden spoons is always at the ready (Macali never uses plastic). The only permanent appliances are the coffee machine and the KitchenAid. The Wolf semi-commercial, twin forced-fan oven is digital, with the temperature being precise. "When I am baking, literally every second counts," says Macali, who went for a Liebherr double fridge.

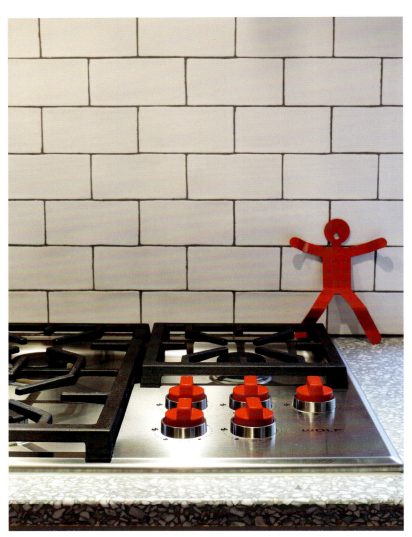
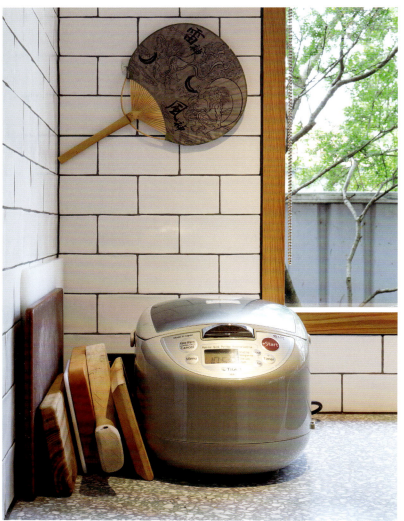
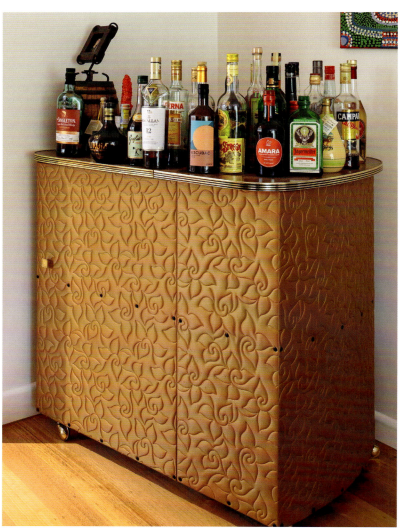

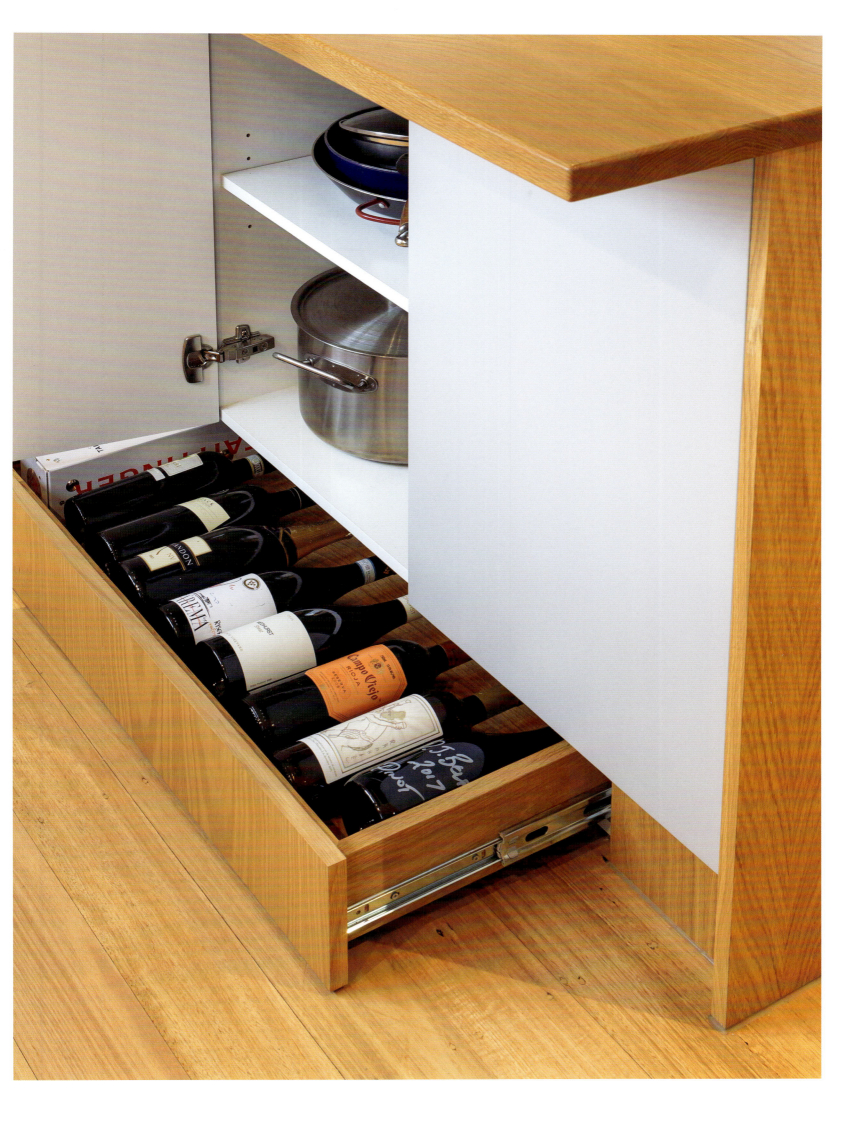

Although the couple regularly entertains at home sitting around the dining table, breakfasts and quick meals are generally eaten at the island bench. This bench also includes deep drawers on one side that accommodates large steel pots and pans, along with crockery. "Storage was a priority in this kitchen. I didn't want to have to remove everything from a drawer to get one thing and have to spend time putting everything back," says Macali, whose experience over decades has given her insight into the smallest details of kitchen design. "It's not just important to have the two sinks, but also to have a lip over the edges to reduce cleaning. There are no cracks to look out for," she says.

Even though the kitchen is minimal, there are also the memories of travels and of things found along the way. Japanese-style curtains, for example, screen the window opening to the pantry. The steel bookshelf in the front living room is crowned by an unusual Japanese-carved snapper, often the fish of the day on the Supermaxi menu. And in one corner of the lounge is a gold-quilted bar, also from the 1950s, discovered in a secondhand store. On rollers, this bar can be moved towards guests if needed. One of the unusual features in the kitchen is the kickboards located at the base of the island bench. Although appearing fixed, this can be lightly touched with one's foot and bottles of wine appear.

Most meals are served and eaten indoors. This is not only to be closer to the kitchen, but also to avoid the displeasure of flies, particularly during the warmer months. "I think if you are eating great food, the first thing that's important is to be comfortable," says Patané, who, as in the restaurant, is the perfect host!

Gnocchi bolognese

Bolognese sauce

3 tbsp extra virgin olive oil
2 garlic cloves, crushed
500 g beef mince
Salt & pepper, to season
Half a glass white wine
1 bay leaf
3 cans whole peeled tomatoes, puréed
8 fresh basil leaves

Make the sauce first. In a medium-sized pot, heat oil and crushed garlic gently. Sauté garlic.

Add the beef mince, salt and pepper, and stir for a couple of minutes until the raw meat colour disappears.

Add the wine and the bay leaf, mix and allow that wine to evaporate, then add the puréed tomatoes. Stir the sauce, add the basil leaves, gently bring to the boil, stirring constantly so sauce doesn't burn. Once it starts to boil, drop the temperature to low, cover with a lid and cook for 2 hours, stirring every now and then.

Correct the seasoning at the end.

Ricotta gnocchi

500 g fresh ricotta
2 eggs
½ cup grated Parmesan cheese
Good pinch of salt
2 cups plain flour (you may need more)
Parmesan cheese, to serve

To make the gnocchi, add the ricotta, eggs, Parmesan and salt to a large bowl. Mix together with your hands to a create smooth paste. Make a well with the flour on a flat surface then add the ricotta mixture to the flour. Knead until it all comes together.

Roll all the dough into long logs, 30 centimetres long and 2 centimetres wide. Cut into little gnocchi, adding flour so it doesn't stick.

Bring a large pot of water to the boil, add a good handful of salt to water, and gently drop gnocchi into water. Stir so gnocchi don't stick to the bottom. Allow gnocchi to boil for about 2 minutes.

To serve

Drain gnocchi once cooked and transfer to a bowl. Add some sauce and mix gently. Add some extra Parmesan on top to serve.

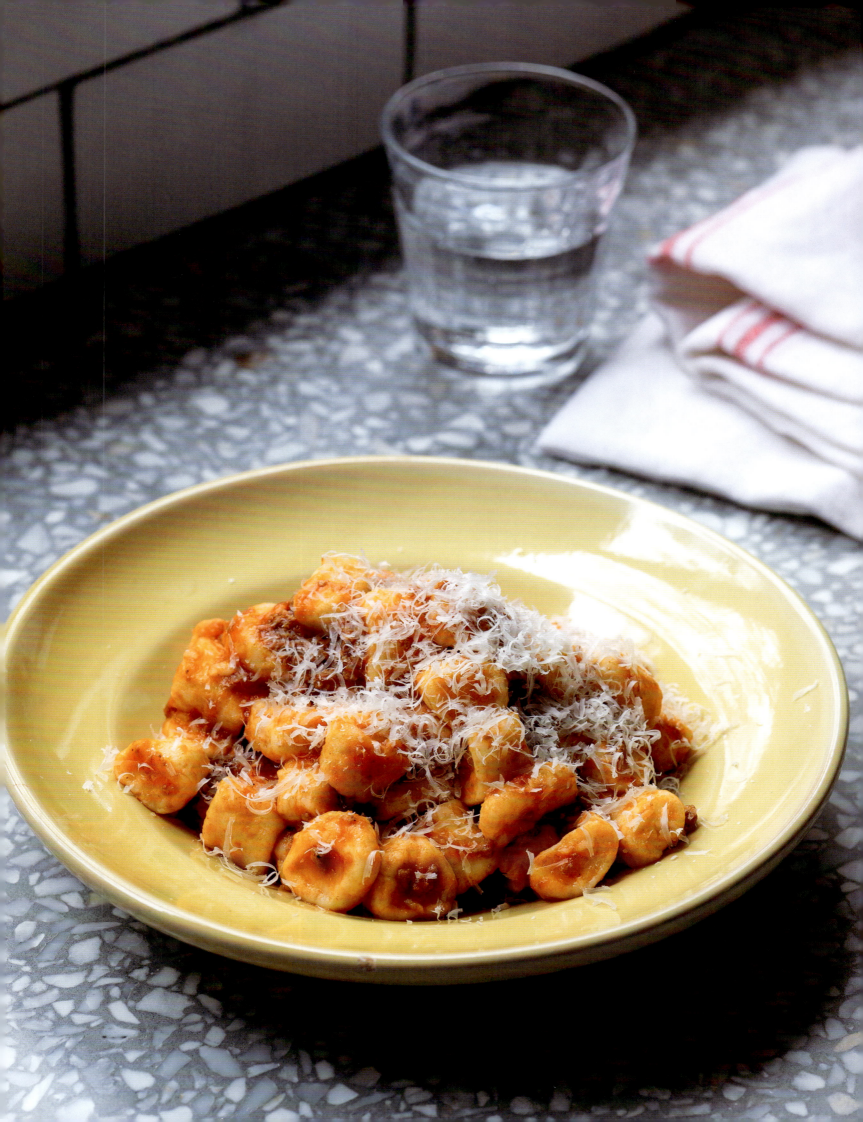

Rodney Dunn
Once a Classroom

Located in Lachlan, 7 kilometres from New Norfolk, a 40-minute drive from Hobart, sits this charming timber building. Originally built in 1887 as the town's local primary school, the place initially consisted of two large classrooms before it was expanded in the 1940s.

Home to chef and owner of The Agrarian Kitchen, Rodney Dunn; his wife, Séverine Demanet; and their two children, Tristan and Chloé, it's a befitting abode for a leading chef with its large kitchen. Dunn grew up in Griffith, southwest New South Wales, initially apprenticed as a chef in a local restaurant before moving to Sydney in the late 1990s and doing the final year of his apprenticeship at leading restaurant Tetsuya's. Many will also recall Dunn as a food editor with *Australian Gourmet Traveller* magazine before moving to Hobart in 2007.

"When I walked into this place [early in 2007] I was sold," says Dunn, pointing out the original building's large windows in the kitchen, orientated to the northern light. While the building had already been converted into a three-bedroom family home, it was tired and required new bathrooms, and in particular a kitchen designed for a chef. So, the building was virtually gutted, including the kitchen, which is located in one of the original classrooms. Dunn worked with heritage architect Paul Johnston and created a wood-fire oven and tongue-and-groove joinery clad in a durable vinyl. Tasmanian oak floors replaced the old boards and stainless-steel benchtops replaced the laminate. One of the key additions to the kitchen was a new island bench, which was assembled inside, being 2 metres wide and 3 metres long. Featuring eight drawers on each side and an open shelf below for storage, it's where Dunn does most of his food preparation. There's a built-in electrical switch, because Dunn wasn't prepared to look at dangling electrical cords.

This kitchen also features two induction cooktops, two large ceramic sinks as well as a third smaller sink for washing hands, and four ovens, a reminder of the room when it originally operated as Dunn's cooking school. "I was persuaded by AEG to trial one of their induction cooktops when I first moved here. After a while I stopped using gas altogether," says Dunn, who regularly uses two of these stoves with the other two on 'stand-by'. And on one bench proudly stands a La Marzocco coffee machine. Some items in the kitchen have also been repurposed. There's the armoire that originally formed part of a French bookcase but has been refashioned with a Carrara marble benchtop, now used for storing crockery.

Dunn's kitchen also features an open fireplace that he uses for cooking grills, though it would have originally been used in 1887 to heat the classroom for the school children. "The key to making this kitchen so pleasurable to work in is not just its size, but the abundant natural light. It's now become the heart of the home," says Dunn, who uses the adjacent classroom as a dining and living area, though at the time of writing it is being renovated. There's a small cottage-style back garden with a variety of herbs used for cooking. "I enjoy looking at the garden but also the distant views of the hills, often snow-capped in winter," he adds.

Unlike many contemporary kitchens that come with walk-in pantries and butler's kitchens, the pantry in this house can be found in the adjacent corridor where the school children once lined up before entering class. Shelves were added by Dunn. And like his commercial kitchen, he likes to keep his own kitchen at home fairly uncluttered, bringing out things when needed. "I try not to have too much on the benches, with the exception of a chopping block, utensils such as spoons and perhaps a whisk or two next to the stove while I'm cooking," says Dunn.

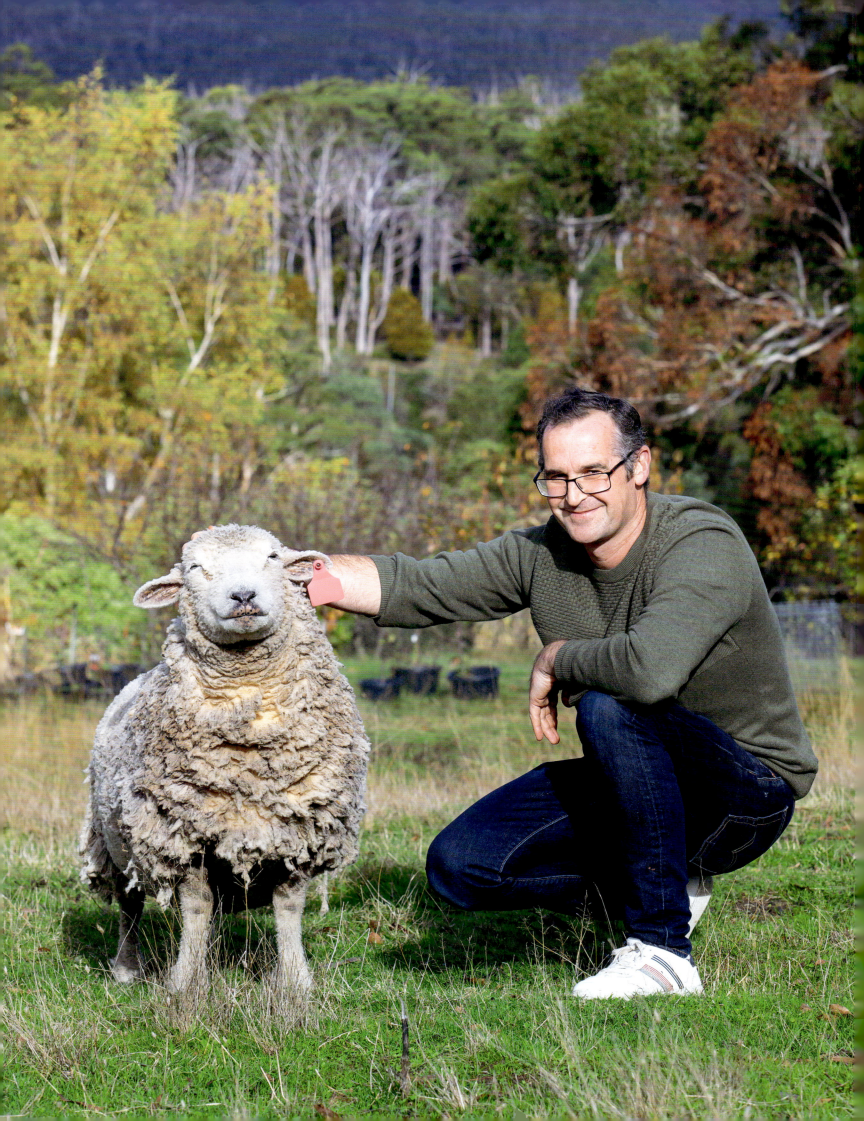

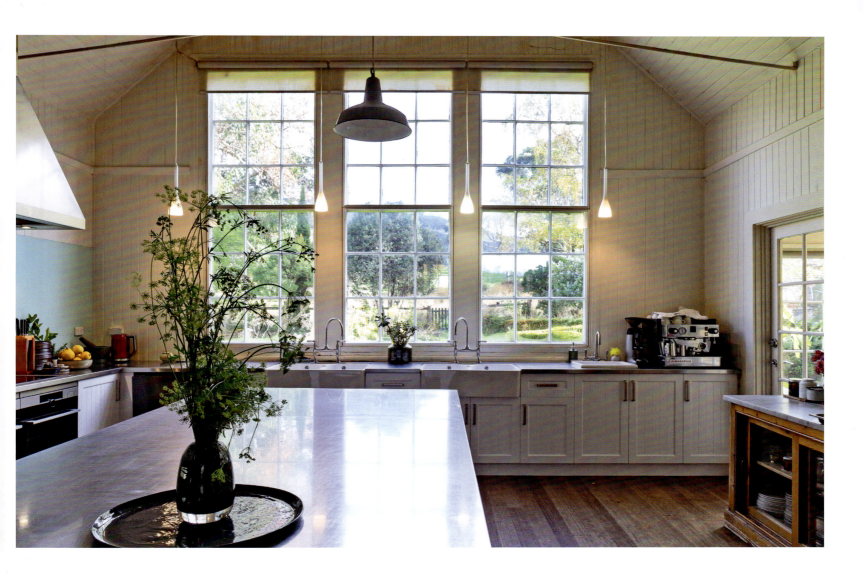

Dunn sees the success of this kitchen as not only the equipment it has, but also its layout, not having to walk too far in the 30-square-metre space. And while some Victorian buildings can be dark, his kitchen is flooded with natural light, high ceilings and large windows that frame picturesque views. While he's regularly cooking meals for the family on most days, Sunday is generally his day away from the kitchen. "Sundays are rarely planned, both in what we tend to do and what we tend to eat," says Dunn. However, when friends and family come over for a meal, they tend to perch on the stools on the central bench (which can accommodate ten people) and enjoy seeing the meal prepared and also the pleasure of partaking in a meal prepared by a chef.

Shepherd's pie

Flaky pastry

230 g plain flour	75 ml iced water
150 g butter	½ tsp vinegar
½ tsp salt	1 egg, lightly beaten with 1 tbsp water

For flaky pastry, pulse flour, butter and salt in food processor until large, even pieces of butter remain throughout flour. Combine iced water and vinegar, and drizzle into flour mixture, pulsing to bring together. Remove dough and gently press together. Halve dough and wrap in cling film to prevent oxidisation. Refrigerate for at least 2 hours. Pastry can be frozen.

On a lightly floured work surface, roll out pastry to 5 millimetres thick, and line the base and sides of a 25-centimetre-diameter pie dish. Leave overhanging pastry and refrigerate for at least 1 hour or overnight to prevent pastry shrinking when baked.

Preheat oven to 180°C. Trim excess pastry and line pie dish with baking paper or foil. Fill with baking weights or dried beans. Bake pastry until golden brown, about 20 minutes, then remove baking paper and weights, brush with beaten egg and return to the oven for another 5 minutes. Remove from oven and allow to cool.

Filling

1 tbsp olive oil	2 stalks celery, cut into 1 cm pieces
1.8 kg (about 4) lamb shanks	1 tbsp chopped rosemary
2 brown onions, unpeeled & quartered	1 tbsp tomato paste
3 carrots, coarsely chopped	1 kg potatoes, peeled
2 stalks celery, coarsely chopped	80 g butter
2 tbsp olive oil	100 ml pouring cream
1 brown onion, peeled & finely chopped	Sea salt & ground black pepper, for seasoning
2 carrots, peeled & cut into 1 cm pieces	

For braised lamb, preheat oven to 150°C. Heat olive oil in a large frying pan, add lamb shanks and brown over high heat. Remove shanks to a casserole dish, add unpeeled quartered onions, coarsely cut carrots and celery, cover with water and season with salt. Cover, place into oven and cook for 3 hours or until meat is tender and falling from the bone. Remove shanks and strip meat from bones, then refrigerate until required. Strain broth and reserve.

Pour reserved braising broth into a saucepan, bring to a simmer over medium-high heat and reduce until thickened to a light coating consistency. Heat olive oil in a large pot, add peeled and finely chopped onion, peeled and cut carrot and celery, and rosemary, then cook over low heat, stirring often until tender, about 10 minutes. Add tomato paste and cook for another 2 minutes, then add braised lamb and reduced braising liquid and stir to combine, season to taste, and refrigerate until required.

Place potatoes into a large saucepan, cover with salted water and bring to a simmer over a medium-high heat. Cook until potatoes are tender, about 15 minutes. Drain and mash potatoes, then return to saucepan with butter and cream. Stir over low heat until well combined and season to taste with sea salt and freshly ground black pepper. Spoon mashed potato into a piping bag fitted with your favourite nozzle; alternatively, the mash can be spooned over the pie.

Final assembly

Spoon lamb filling into cooked pastry base, then pipe or spoon over potato mash. Place into preheated oven and cook until potato is golden brown, about 40 minutes.

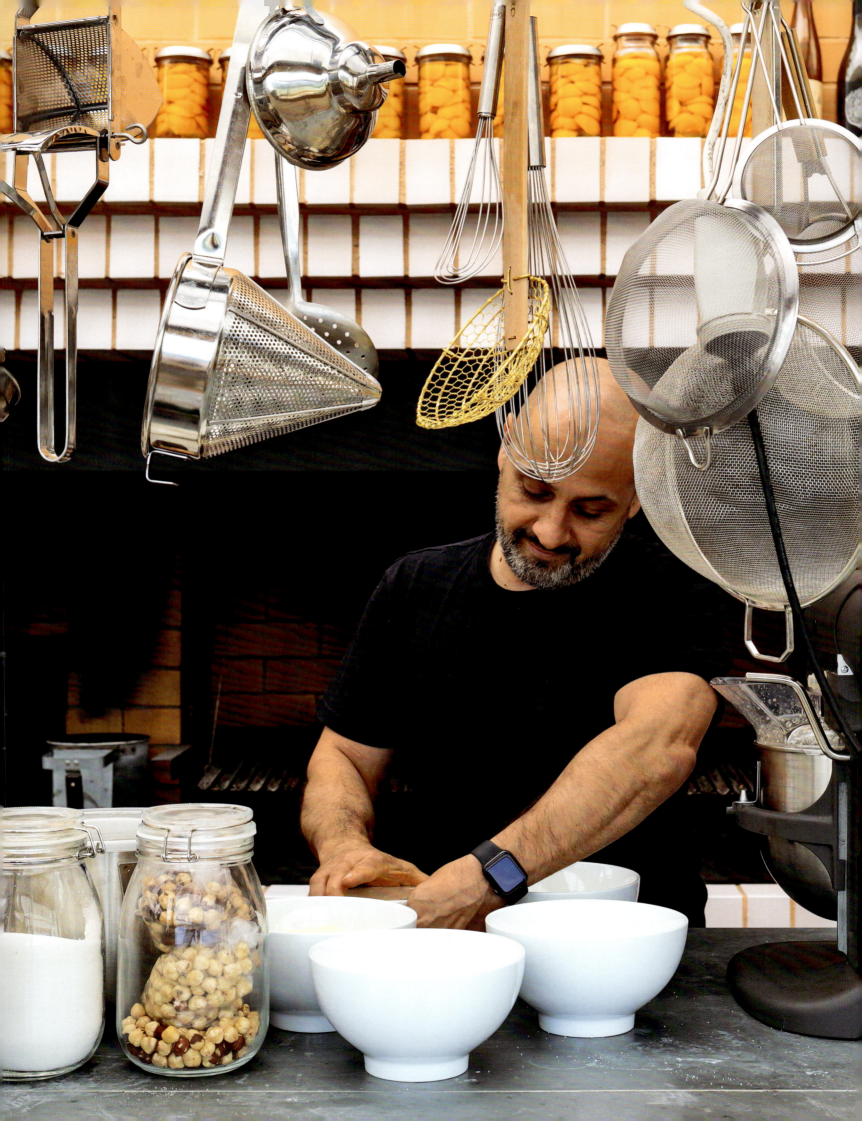

Ronnen Goren
A Sustainable Kitchen

Named the Longhouse, this award-winning house designed by architect Timothy Hill, director of Partners Hill, has a kitchen that has everything. If it can't be found in the kitchen of the property outside of Daylesford (Victoria), it can be found in the sprawling indoor garden or in the vegetable gardens on the 8.5-hectare property. "I've always been surrounded by food since childhood. It's something you experience when your parents own cafés, restaurants and pubs," says Ronnen Goren, who trained as an architect before switching to graphic design (he is a founding director of Studio Ongarato). Here, he lives with his partner, Trace Streeter, responsible for the creation of the garden (indoors and out); his two Cairn terriers, Angus and Eadie; his two sheep dogs, Koda and Parker; the pigs, cows (producing milk and cream for the table), the chickens and ducks, and two goats that are relatively new to the property.

Goren has worn many hats over his career, including operating a CBD eatery, SMXL. Now his focus is between Studio Ongarato and operating Daylesford Longhouse, which includes inviting key chefs from all around Australia and the world to partake in workshops. Then there are masterclasses in charcuterie, fermenting and cheese making, along with events and functions. For several weeks, chef Oliver Nono from Grenoble in France has been at Longhouse, assisting Goren in the kitchen. "One of the key decisions in coming to this place was being in the countryside, but of course being so close to everything that's produced here," says Nono.

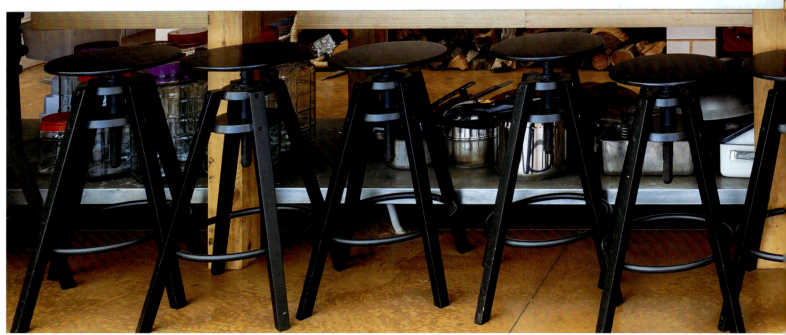

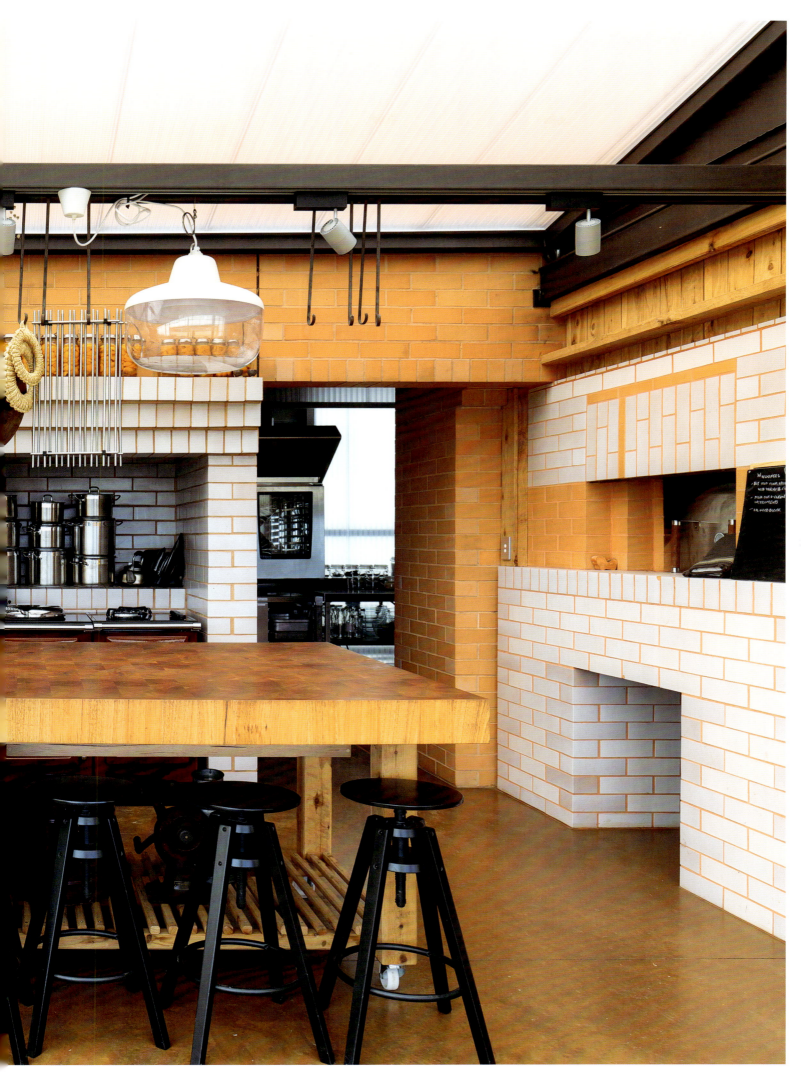

The style of house is also a world away from the traditional kitchens, commercial or domestic, that Nono has worked in. Set within a steel and polycarbonate shed that extends over 110 metres (hence its name), the kitchen was designed as a separate pod within the indoor garden. On one side is a setting under a timber arbour covered in wisteria, and on the other is a series of hay bales that could be likened to a contemporary interpretation of a module lounge suite, tailor-made for this rural setting. "It's not a permanent fixture. It's set up for an impending conference," says Goren.

The path leading to the kitchen is an experience in itself. Past the 'gatehouse', designed for keeping jams and condiments (grown on the property), one passes through raised timber garden beds planted with everything from corn and avocado, fig and almond trees, to apricot trees, passionfruit vines and myriad herbs used for the pot.

The kitchen, orientated to the north and enjoying sweeping views over the rolling hills, features a retractable roof, and steel and glass sliding doors, the latter kept open most of the time. "It's important to get cross-ventilation through, particularly during the warmer months of the year, but it's also about keeping the warmth in during winter. It can snow here," says Goren.

Hill loosely divided the kitchen into three areas. There's the main kitchen with its broad central island bench, the dining alcove that includes a built-in daybed, and the galley-style kitchen to the south that extends the entire length of the kitchen and dining area. It is framed by fixed polycarbonate walls, some with clear expanses of sliding glass windows, and the light and ventilation are perfectly controlled to suit the daily weather conditions.

The design for Goren's kitchen started with a book given to Hill called *Mrs. Beaton's Book of Household Management,* initially published in the late 1800s. The food, as with the vignette of black-and-white sketches, evokes kitchens of both French and Italian farmhouses. Large hearths, brick walls and generous bench space feature prominently.

Pivotal to Goren's kitchen is a large zinc-clad bench and sink that includes all the patina of someone who is passionate about food. And at one end is a large timber chopping block (1.5 x 1.5 metres) that can allow for an entire

animal to be butchered (a steel beam running across the entire kitchen supports the weight of animals as well as heavy pots and pans and lighter kitchen appliances). "[The chopping block] is on wheels that allows me to move it away, for occasions when I'm having more people," says Goren. Also prominent in the kitchen is the Esse wood stove, partly fuelled by wood and partly by gas. The stove's rich brown doors, and the burnished concrete floor throughout the kitchen and dining areas, evoke the colour of the surrounding dirt. As well as the Esse, there's the adjacent Tuscan grill often used for smoking meats, and nearby is the Alan Scott wood oven, used for making everything from bread to delicate pastries. "I start with the oven at 400°C, with the heat slowly reducing to 200°C for my roasts. By the end of the week, it's perfect for making the more delicate pastries," says Goren.

The kitchen's back of house is as well decked out. There's a meat-aging fridge at one end, a commercial dishwasher and a delightful old armoire used for wine glasses and piles of crockery (from pale yellow through to creamsand white, arranged with an art director's fine eye). There's also a pantry with open shelves. It seems nothing has been omitted, including a separate washing station in the main kitchen dedicated to the washing and drying of vegetables.

The dining area is as considered, with timber shelves set into glazed brick walls to display everything from books (not all are about cooking) through to jars of condiments. Central to this space is a cork table edged in brass, designed by Hill, framed by Thonet chairs from the 1970s. And for guests who prefer to take in the panoramic view over the rolling hills, there are ottomans made from tents or the edge of the indoor garden beds that double as seating. "I think it's important that you feel part of the entertaining process when you're preparing food, not shunned off to one side," says Goren, who is not only continually surrounded by friends, guests or chefs, but by things that speak of the place such as jars of preserved apricots on the kitchen shelves. According to Goren, a kitchen should also include the right 'flow' or movement, and not be too prescriptive or follow a trend. "Tim and I often talk about 'KIDLI', with the open-plan kitchen, dining and living areas being a natural given arrangement. But sure, we have evolved. Kitchens and meals areas should not be that prescriptive, irrespective of the context," adds Goren.

Daylesford Longhouse peach melba misu madeira cake

Madeira cake

240 g unsalted butter (softened)	Grated zest of 1 unwaxed lemon
240 g caster sugar (plus 2 tbsp for sprinkling)	3 large eggs
240 g self-raising flour	Dash of milk (as needed)
50 g plain flour	Extra butter, for greasing

Preheat the oven to 170°C/160°C fan forced. You will need a loaf tin (23 x 13 x 7 centimetres), buttered and lined. Cream the butter, sugar and flours until you have crumbs; then add the lemon zest. Combine and lightly beat the eggs in a cup. Add it to the flour mixture. Mix with the mixer, until a batter forms. Add a dash of milk to the mixture so that you have a drop consistency (when the mixture slowly hangs on to the spatula or mixing paddle). Spoon mixture into the loaf tin, using a spatula to smooth it out. Sprinkle with caster sugar as it goes into the oven, and bake for 1 hour or until a cake tester comes out clean. Cool in the tin for 10 minutes before turning out onto a wire rack. Store in an airtight container until needed.

Misu cream filling (Zabaione)

2 egg yolks	500 g mascarpone
60 g caster sugar	250 g crème fraîche
25 ml Marsala	2 egg whites
1 tbsp water	

For Zabaione, whisk yolks, sugar, Marsala and 1 tablespoon water in a heatproof bowl over a saucepan of simmering water until pale and thick (2–4 minutes); set aside to cool. Whisk mascarpone and crème fraîche to combine, then fold through Zabaione. Whisk egg whites in a separate bowl until soft peaks form, then fold through mascarpone mixture until well combined. Refrigerate until needed. This can be made a day ahead.

Final assembly

180 g roasted hazelnuts, skins off	6–8 stemless glasses or 1 medium-size trifle bowl
250 g white chocolate buttons	Caster sugar
8–12 peaches	Marsala, for sprinkling

Ensure hazelnuts are fresh and well roasted. If preroasted, flash them quickly in a 180°C oven to refresh. Set aside and allow to cool; then coarsely chop. Run the white chocolate buttons through a food processor to a coarse medium-grained texture. Set aside. Cut the peaches in half and destone them. Then cut them into quarters or sixths; dip each piece into caster sugar on both sides. Heat a nonstick pan until very hot and place each sugared peach face-side down until caramelised, then turn over to complete. Set the peaches aside on a rack to cool.

Take your glass or bowl and break up a layer of Madeira cake into chunks, spreading evenly across the bottom. Then sprinkle some Marsala over the top to moisten the cake. Top the cake layer with a healthy amount of misu cream filling and place in the fridge for at least 4 hours (or overnight). This will allow the cake to moisten. If you are making an entire dessert in a trifle bowl, you can do this in layers if you like. To serve, place the grilled peaches on top. Finish with the white chocolate and hazelnut mixtures.

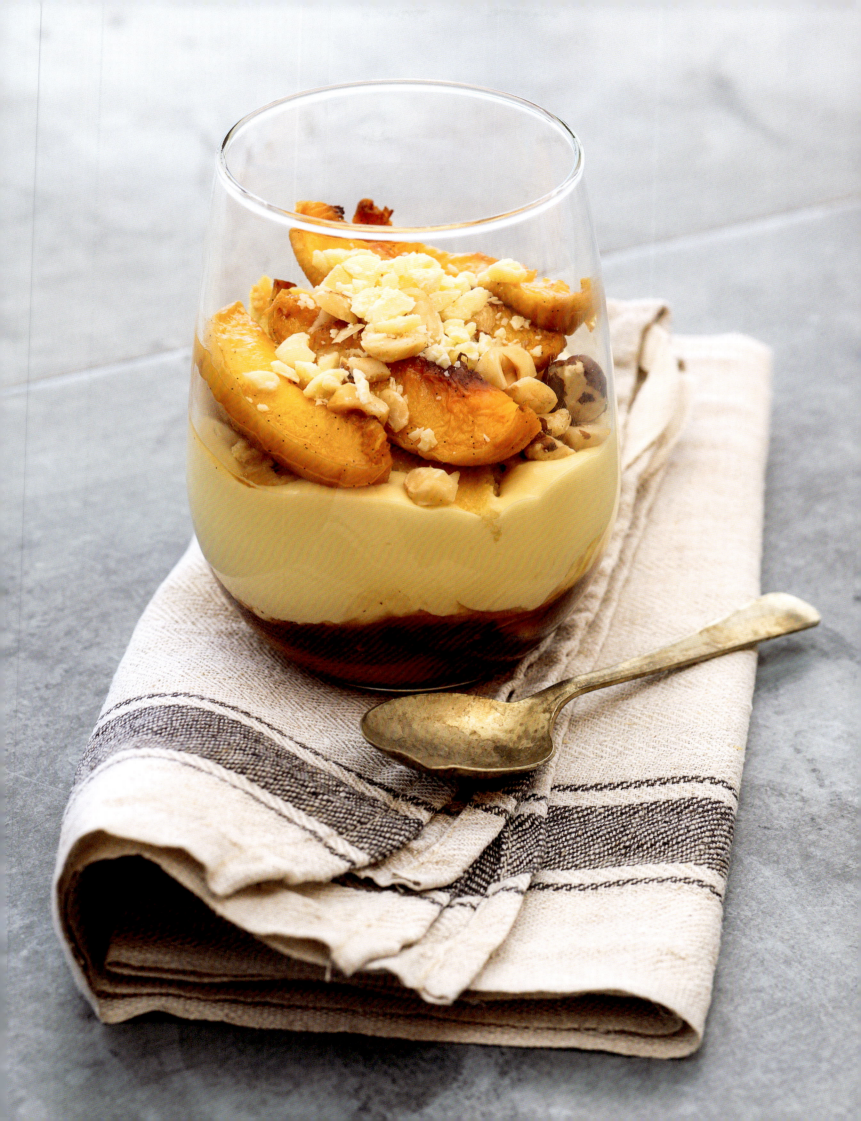

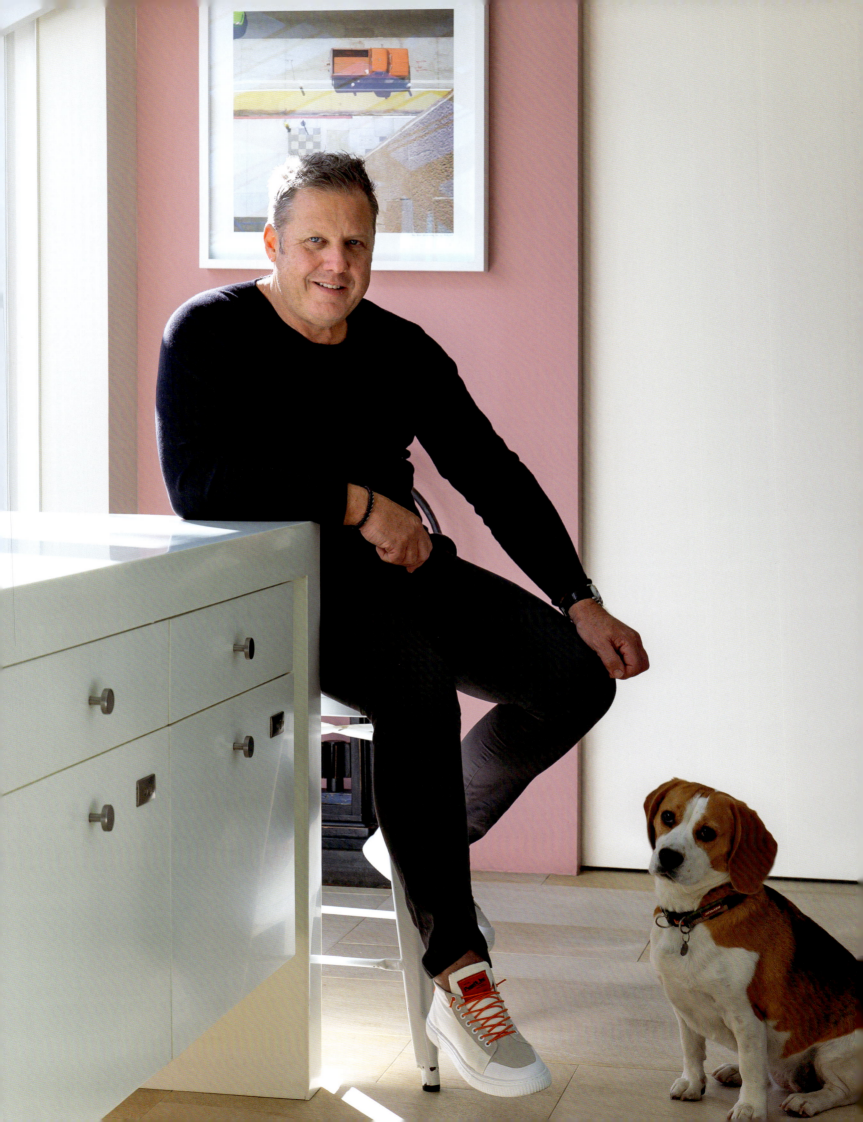

Ross Lusted
Multifaceted

Chef and owner of Woodcut, Ross Lusted demonstrates his talents on a number of fronts. As well as being a chef of a leading Sydney restaurant that he operates with his wife, Sunny, and their partners at Crown Casino, he is also an accomplished sculptor (with a number of works displayed at home) and in his former career, opened fifteen hotels worldwide for the Aman resorts. The couple, who have a daughter, Bronte, and a beagle called Poppy, were regularly in and out of planes before they settled in Sydney, purchasing a three-level terrace in Paddington.

While some people buy homes and madly renovate them to suit their requirements, Ross and Sunny loved the renovation from the outset. Only a few changes were made: an orange wall was painted pink, and they added a rooftop garden. Unlike the former owners, who kept the large industrial-style garage door to the front courtyard closed, the Lusted family keep it open for eight to nine months of the year, at least when they're home. Given it's orientated to the west, it becomes a suntrap if the door is continually closed. "As we travelled so much during our time with the hotels, particularly throughout Asia, we were always either cooking or eating outdoors," says Ross, who cooks with solid fuel in his restaurant, which has established a reputation for the type of food that's served.

While the kitchen in his Paddington terrace is relatively modest in scale, approximately 4 metres wide and 5 metres long, it is extremely efficient. Integrated into the dining area with a cast Corian 'floating' bench, there are six chairs at one end and two circular sinks at the other – one has an InSinkErator. Below these sinks are two dishwashers set into the joinery, with each operating on a 15-minute cycle to ensure dishes can be whisked away and returned to the shelves behind the extensive bank of MDF joinery.

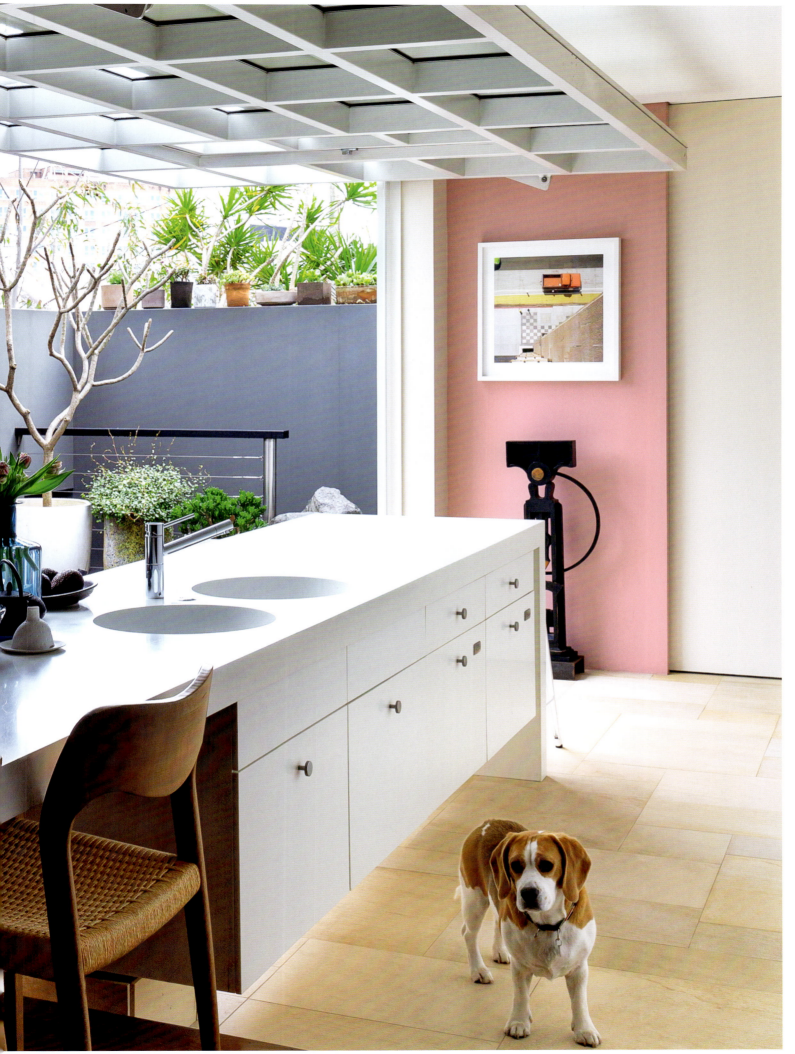

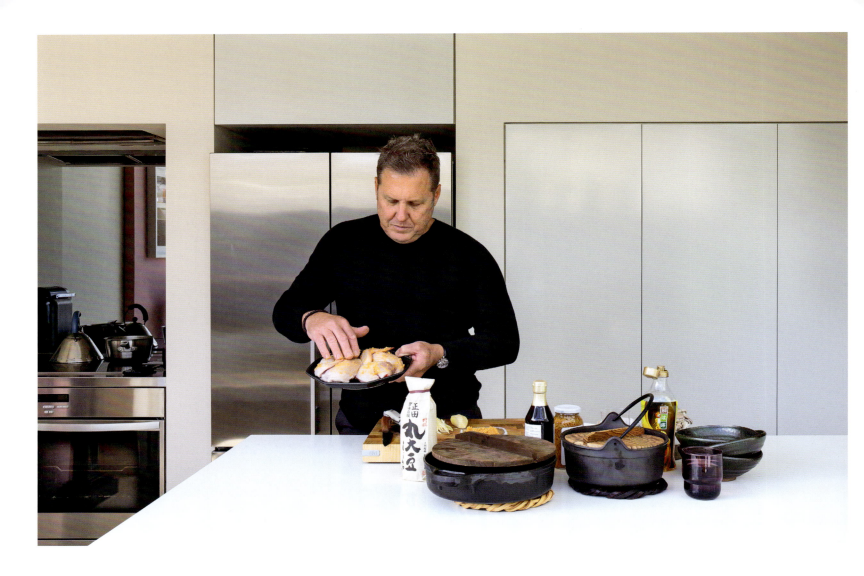

When Ross moved into the house, one of the changes he was keen to make was to change all the Miele induction appliances to gas. But the challenge and expense in excavating to reach the gas main was prohibitive, and progressively he started to enjoy the induction appliances put in by the previous owners (he's also installed induction appliances at Woodcut). Although the kitchen/dining area is relatively modest in scale, it has been beautifully curated with art, photography and Ross's own work. He salvages industrial fittings and refashions them, as seen with the work displayed in front of the pink feature wall with a photograph by George Burn above. Other pieces include Michelle Aboud's huskie series of photos.

It's the perfect backdrop for Ross to cook, often Asian-style fare, with friends sitting on the timber bench opposite to watch. Often, his daughter Bronte sits here doing her homework. And when this bench isn't being used, it's simply slid under the counter to create more space on the sandstone floors that lead to the timber deck. The built-in outdoor bench is continually used as are the Hay outdoor chairs when Ross cooks outdoors.

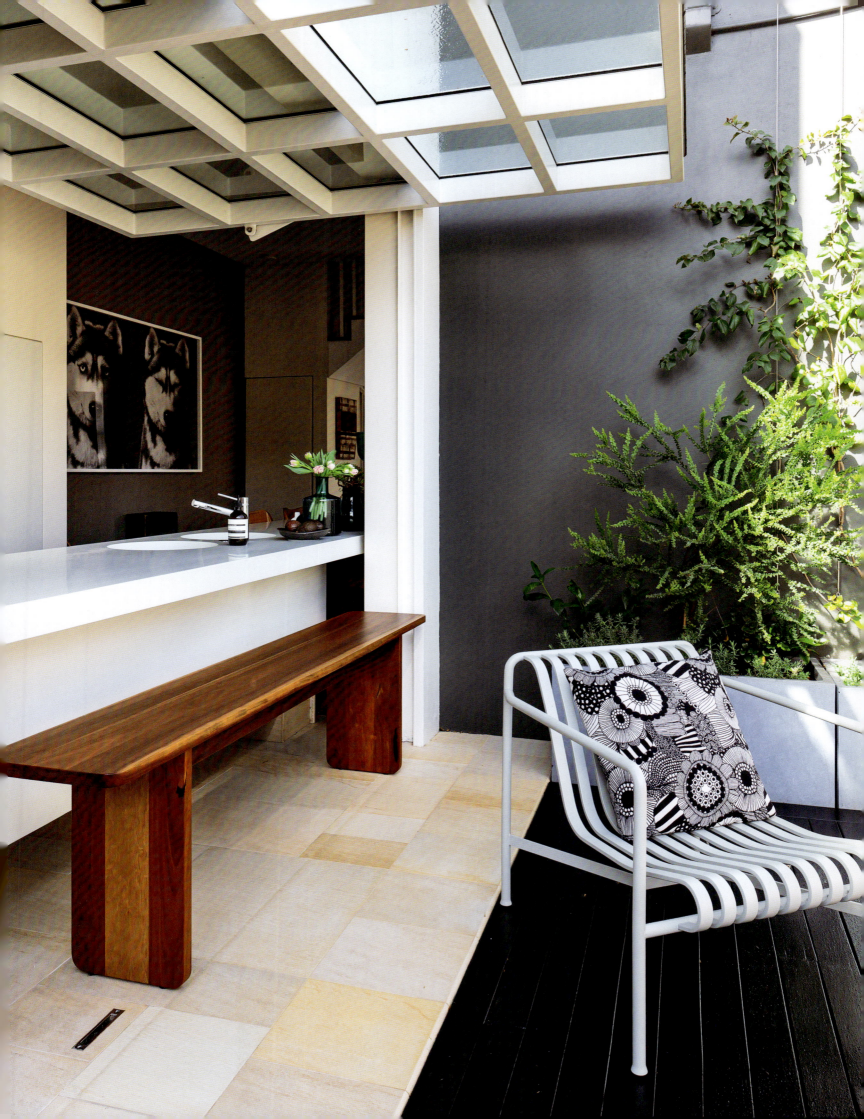

Ross describes his kitchen as almost the opposite of a farmhouse-style kitchen – one that comes with extra-wide benches akin to a large country-style table. However, there are certainly sufficient appliances to be found, including two stoves framed by a mirrored splashback that reflects the plane trees in the street. There's also a stainless-steel double fridge with a generous freezer drawer, and a large walk-in pantry that forms part of the concealed joinery. Behind this bank of cupboards is the couple's collection of Japanese ceramics. "I prefer a clean and minimal aesthetic. You rarely see anything on the kitchen bench. As soon as things are removed from the dishwashers they're put away," he says. Poppy also regularly vanishes, disappearing under the floating bench and enjoying the underfloor heating, particularly during the colder months of the year.

One of the things Ross found to be odd was the location of the bathroom, directly next to the kitchen. However, when Bronte was little, he would read to her from the kitchen while she took a bath. Ross also appreciates the way all the kitchen appliances have been thoughtfully placed, ensuring that everything is at his fingertips. "There's no need to walk around to find things – all the appliances are in the correct spot," he says.

Although the elongated bench includes six chairs on the dining side of the space, the family is generally drawn to the kitchen side – where the outdoor courtyard forms part of the kitchen, particularly during the warmer months. And while the family doesn't travel as much as it used to, this is the type of house that can be easily locked up and left.

Pot-roasted chicken

1 x 1 kg good-quality chicken
60 g organic white miso or shiro miso
100 ml light Japanese soy sauce
100 ml olive oil
30 g young ginger, juiced or pounded finely in a mortar & pestle
4 green shallots, for roasting

Split the chicken in half and remove the backbone. Pat dry the chicken all over with kitchen paper.

Combine all the other ingredients in a bowl and mix well. Rub the marinade all over the chicken and place in a tray, skin side up. Place in the fridge, uncovered, to dry out. Leave overnight if possible.

Remove the chicken and allow to come to room temperature. Preheat the oven to 180°C. Place the shallots in a heavy-based cast iron pan, place the chicken on top of the shallots and roast in the oven for about 40 minutes. Remove from the oven and allow to rest.

Savoury rice with mushrooms and bonito furikake

50 ml peanut oil
30 ml sesame oil
2 garlic cloves, chopped
60 g shiitake mushrooms, chopped
60 g shimeji mushrooms, chopped
250 g koshikari rice, washed 3 times to remove the starch
50 g pickled enoki mushrooms
2 green spring onions
Bonito furikake

Heat the oils in a heavy-based cast iron pot and fry the chopped garlic until golden. Add the shiitake and shimeji mushrooms and continue to cook. When soft, add the rice and cover with water to about 1 centimetre, bring to the boil and cover with a lid.

Reduce the heat and continue to cook for about 10 minutes or until the water has all been absorbed by the rice.

Fluff the rice with a spoon and mix in the pickled enoki mushrooms. Let the rice stand for another 10 minutes.

Before serving the rice, cover with sliced green shallots and bonito furikake.

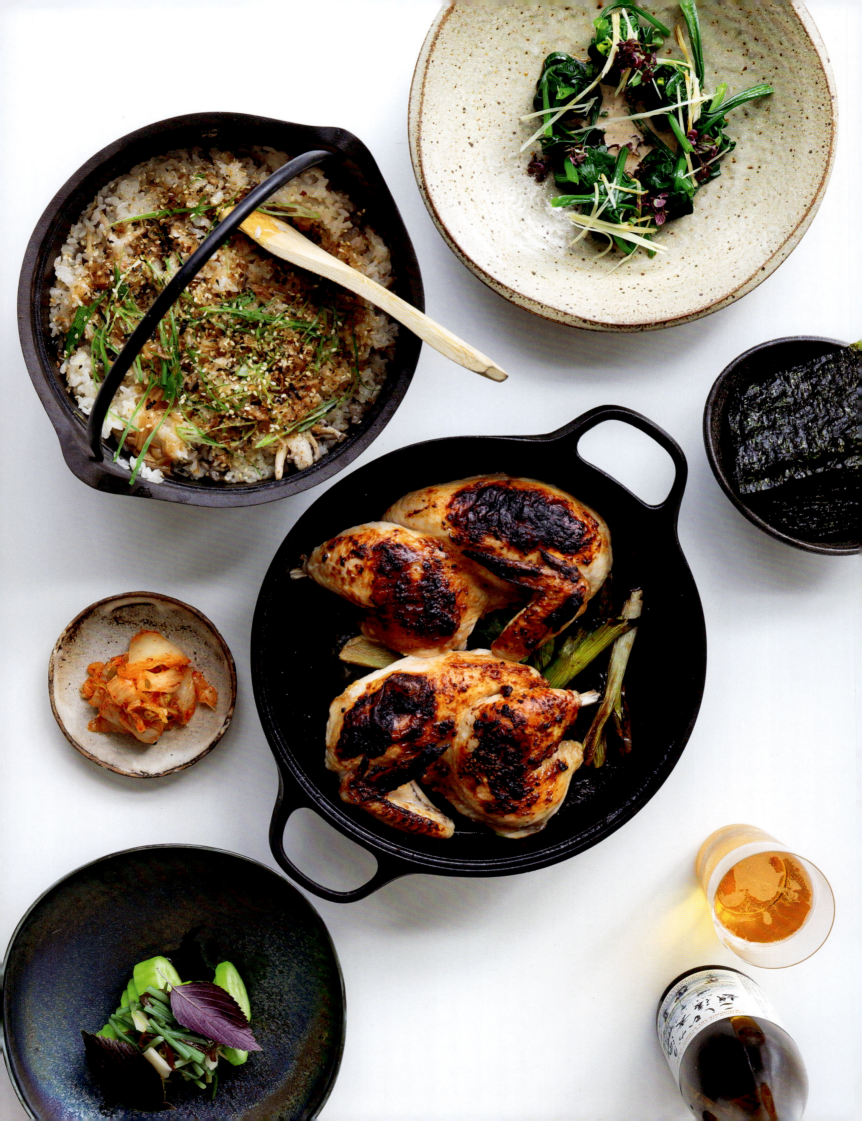

Cold spinach salad

2 bunches young English spinach, washed & roots removed
100 ml sesame dressing (Gyomo is good)
1 large knob of young ginger, peeled & finely sliced
1 punnet baby shiso leaves

Heat a pot of salted water and blanch the washed spinach for 5 seconds. Remove and refresh in ice water. Remove the cold spinach and press between 2 tea towels. Roll the spinach into small balls and place in a bowl.

Dress with the sesame dressing and finish with sliced ginger and shiso leaves.

Cucumber, Japanese pickles, ponzu

1 Lebanese cucumber, peeled & sliced
200 g prepared burdock & vegetable pickles, available from Asian grocery stores
60 ml ponzu sauce
60 ml olive oil
1 bunch large perilla leaves

Place the sliced cucumber in a deep bowl and add the burdock and vegetable pickle. Dress with the ponzu and olive oil and finish with perilla leaves.

To serve
Serve with kimchi, toasted laver sheets and Echigo Koshikari rice lager.

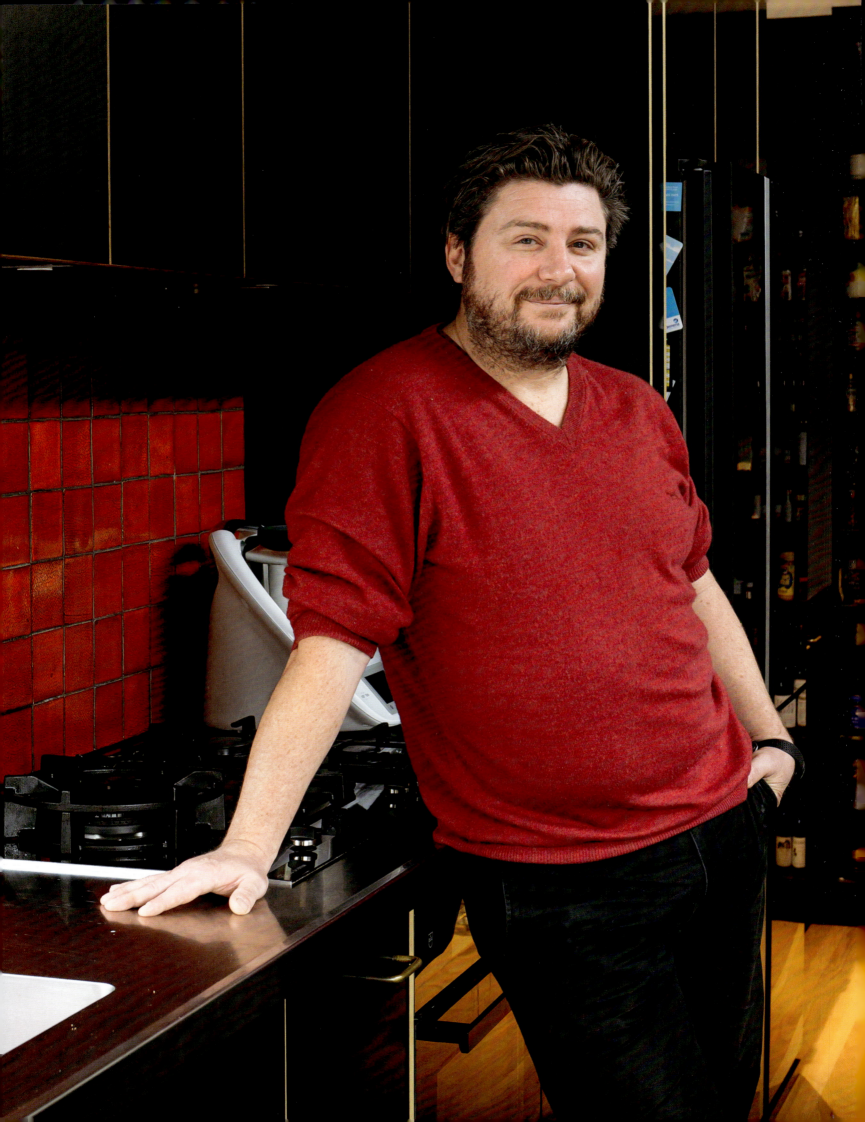

Scott Pickett
Fit for a Chef

Chef and restaurateur Scott Pickett has left an indelible mark on Melbourne's food scene with his many restaurants, including Estelle, Matilda, Chancery Lane, Le Shoppe, Longrain, Smith St Bistrot and the recently opened Audrey's at The Continental Sorrento. Pickett, who shares his time between all his restaurants, works six days every week, enjoying Sundays off with family, cooking at home, often something that's simple to prepare. "It's often a roast chicken. We tend to eat simply at home, and it's often 'comfort' food," says Pickett, who lives in his Edwardian home with his family. "My wife tends to cook during the week, but hands it over to me on weekends, particularly on Sunday," he adds.

Pickett engaged architect Antony Martin, director of MRTN Architects, to renovate the period home, creating a new kitchen and living area that would connect to the rear garden. Loosely evocative of the 1970s, the extension features a raked ceiling and an outdoor terrace made from recycled bricks (using bricks that once framed the fireplaces in the bedrooms). Glazed orange tiles sourced from Italy are used for the kitchen's splashback, also suggesting the 1970s.

According to Martin, the brief was for a dual-purpose kitchen. "Firstly, it had to operate as a family kitchen and gathering space, with the usual demands of preparing family meals and school lunches. The second was for Scott to entertain and cook for people at home," says Martin, who created two kitchens within the one, although this is not obvious. The back bench with its sink, cooktop and ovens (from V-Zug) is seen as the everyday kitchen, while the second is the kitchen island bench, with its concealed sink (referred to as the secret sink) located below a customised built-in lid or chopping board and an induction cooktop embedded within the spotted gum benchtop. "Antony and I must have looked at over 150 different timbers in

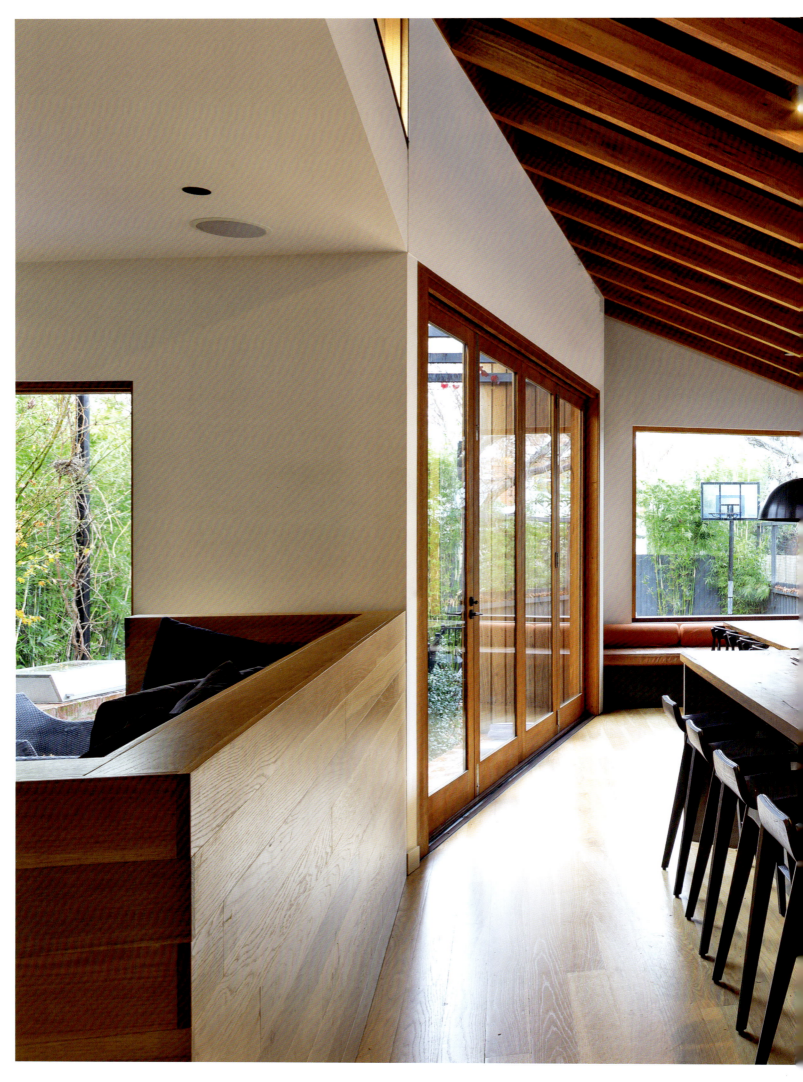

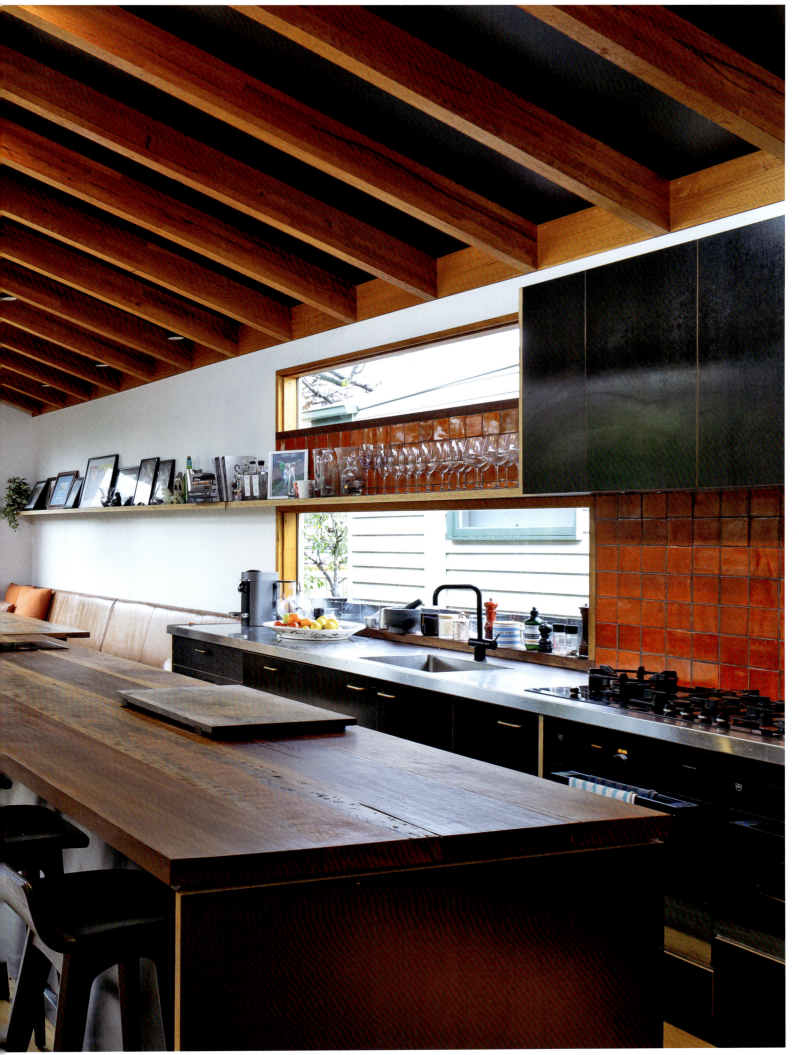

the recycling yard until we discovered four special logs. I love the colour, the grain and the width of the timber," says Pickett, stroking his fingers on the 40-millimetre-thick slabs of spotted gum that stretch over 3 metres in length. "The timber does mark and shows cuts. But Scott was comfortable in giving the benchtop a slight sand and re-oil every couple of years," says Martin.

As well as an extensive use of timber, the kitchen includes generous built-in cupboards, made from formply, stainless-steel benches and a modest-sized butler's kitchen, which includes a deep stainless-steel sink (approximately 500 millimetres in depth) for washing large pots and pans. Pickett's extensive range of spices and herbs can also be found here. "I wanted a space where I can put all these ingredients so that the kitchen is streamlined," says Pickett. Pots and cooking utensils supported on a steel rack in the butler's kitchen/pantry also screen the view into a neighbouring window, as does the shelf in the main kitchen, filled with glasses, cooking books (some produced by Pickett) and family portraits.

Pivotal to MRTN Architects' design is the built-in banquette-style dining arrangement, complete with a customised timber table, a collaboration between Pickett and Neele Dey Furniture. Set into the tabletop are the timber lids that once protected Grand Cru burgundies, the first of which were purchased for Pickett's restaurant Estelle. Leather-padded chairs by Carl Hansen and bar stools complement the built-in furniture. "I believe in buying original designs. But any seating has to be comfortable," says Pickett, who enjoys relaxing on weekends with a newspaper spread out and his own produced 'Native Gin' on the table.

Although this kitchen appears streamlined and minimal, there are a lot of built-in and loose appliances to be found: three sinks, two cooktops, two ovens (one being a steamer and the other a convection oven) and importantly large drawers below the island bench for easy access of equipment and appliances. While having great appliances certainly elevates this kitchen several notches, according to Pickett, it's paramount to understand how a kitchen needs to function and where everything should 'live'. "I don't

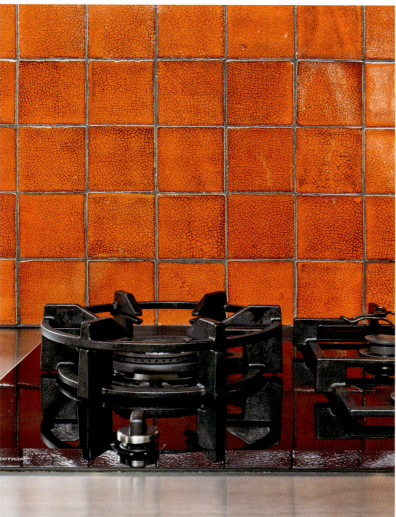

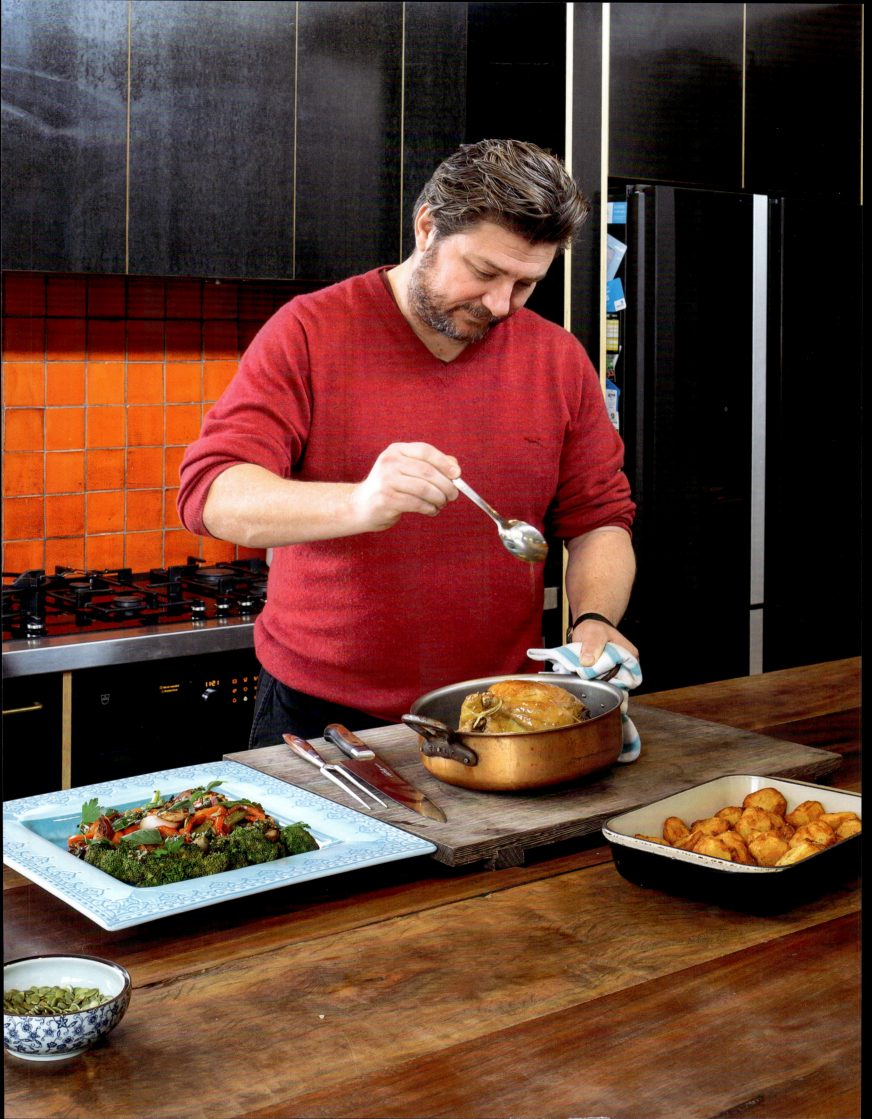

want to have to be continually moving around the kitchen every time I need something. I can stand at the sink, chopping or washing vegetables and turn around to the stove, with minimal effort." Pickett also made an extensive list of where everything would go before Martin even started to prepare schematics.

Other features such as the treatment of the windows and doors were also discussed. The window in the butler's pantry, for example, is shugg-style for ventilation. Highlight windows in the new wing also bring additional northern light into the kitchen, aligned to the island bench. The timber and glass doors to the outdoor terrace can also be completely pulled back into the cavity walls during the warmer months of the year, allowing the terrace to function as an outdoor dining area. The pergola, covered with ornamental grapes, diffuses the northern sunlight. "While entertaining on the outdoor terrace, I generally cook a rib of beef on the barbecue, again keeping things quite simple," says Pickett.

When at home, the front door is often left open, allowing not only for cross-ventilation, but also access to the herbs that are grown in the front garden. There's parsley, thyme and lemon verbena, all used to prepare meals. In contrast, the back garden is low maintenance, with a swimming pool and minimal planting, albeit a Japanese maple and bamboo around the perimeter to create privacy. The steps, fashioned from the recycled bricks, provide additional seating.

For Pickett, who has been decades in the business, people often fail to appreciate the amount of bench space required to allow cooking to be fully enjoyed. "Often, there's simply not enough, either for storage or sufficient bench space for preparation. You need to be able to lay everything out, *mise en place*, 'put in place' as the French would say," says Pickett. Entertaining at home is still quite special, given his hectic work schedule, often from 9.00 am to midnight, six days a week.

Roasted chicken with herbs

1 whole organic chicken (size No. 18)
½ bunch thyme
4 sprigs rosemary
⅓ bunch marjoram
1 head of garlic, cut in two
Vegetable oil
Salt & pepper, to season
Butcher's twine

Preheat the oven to 180°C. Wash and dry the herbs and place them with the garlic into the chicken. Tie the chicken with butcher's twine. Brush the chicken with some oil, then salt and pepper. Place the chicken in the oven for 15 minutes, then crank it up to 190°C and cook for another 15 minutes. Then increase the temperature to 200°C, turn the tray, and cook for 10 minutes (at this point, best to check with a temperature probe to ensure the chicken has reached a steady temperature of 75°C throughout). Let it rest for 15 minutes.

Duck fat roasted potato

500 g Désirée potatoes
150 g duck fat
Rosemary salt, to season

Peel and cut the potatoes. Place them in a large pot of salted water. Boil the potatoes for 15 to 20 minutes. Place the potatoes in a strainer and toss them in order to create a fluffy coating around the potato. Place them on a tray and into the fridge to cool down for 2 hours.

Heat the duck fat in a large pot, bringing the fat to between 150°C and 160°C. Shallow-fry the potatoes. Once coloured, place them on a paper-lined tray and season with rosemary salt.

Pumpkin seed pesto

20 g pepitas
50 g pecorino
½ bunch parsley
⅓ bunch basil
Extra virgin olive oil
Pumpkin seed oil
Lemon juice
Sherry vinegar
Salt & pepper, to taste

In a food processor, place the pepitas, pecorino, parsley and basil, and pulse until smooth. Emulsify with olive oil and pumpkin seed oil. Season with the lemon juice and sherry vinegar, and salt and pepper to taste.

Enjoy the pesto as an accompaniment to the roast chicken, though it's also excellent on the potatoes!

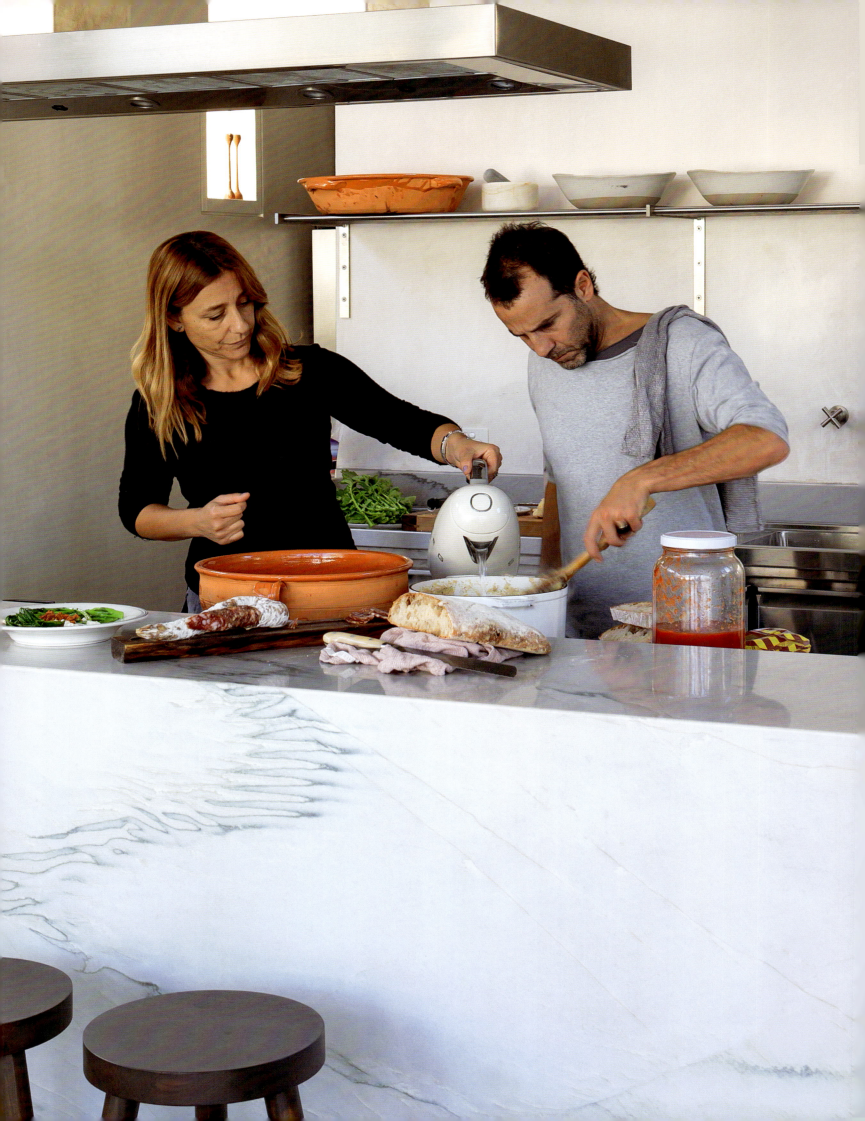

Tony Nicolini
The Italian Touch

Entertaining friends and family was at the top of Tony and his wife Marcella's brief when they commissioned architect Domenic (Dom) Ridolfi to transform their 1930s art deco home into a family abode. Previous generations of Tony's family were instrumental in bringing Italian fare to Melbourne; he has continued this legacy with his restaurant Italian Artisans.

Given his longevity in the food and hospitality arena, Nicolini was clear in what he wanted to achieve in his kitchen at home, with some features overlapping at Italian Artisans. "The design had to cater for large numbers, so the spaces, particularly in the kitchen and living areas, had to be fluid." The designated areas within the kitchen had to respond to preparation, cooking and what he refers to as 'pack down' (putting things away) and cleaning up afterwards. "In kitchen design, flow is everything," says Tony, who was at ease in briefing Ridolfi given that both families came from the same region in Italy. So it's not surprising the renovation has a strong Italian touch, with virtually every item, be it furniture or the handmade knives used in the kitchen, being traced to Italy in some fashion.

Polished concrete floors, raw plaster-finished walls (referred to as *stucco lustro*) and marble-clad island benches create a sophisticated Italian palette. "Our brief to Dom was that the kitchen had to be beautiful but also highly functional, not dissimilar to a well-planned restaurant," says Nicolini. "Our initial discussions for this renovation started by browsing through images of Italian farmhouses featured in books, many with a raw and honest sensibility," explains Ridolfi, who extended the exposed steel beams from the open-plan kitchen and living areas out to the courtyard to frame the swimming pool.

Although the kitchen appears sleek and minimal when not being used, it has been designed to ensure everything can be screened from view, except the large clay pots displayed on a steel drying rack above the station dedicated to the preparation of fruit and vegetables. "These clay pots are typical of European kitchens, ideal to make fish stews or *pasta e fagioli* (pasta and bean soup)," says Nicolini. Each of the three benches includes stainless-steel fridge drawers or doors, as well as stainless-steel sinks to ensure everything is washed during the various stages of food preparation.

The main island bench, loosely dividing the dining area, features a semi-commercial 1.5-metre-long Smeg oven and hotplates with seven burners along with a semi-commercial dishwasher. And although food, both prepared and unprepared, is artfully arranged, there's a marble lip and serving counter that discretely conceals any unwashed dishes. "The idea is that partaking in a meal here is a two-way process, often with my daughters, Simona and Mara, collaborating," says Marcella, who tends to get more involved in the kitchen during the week, while weekends are given over to Tony. Many items are double here, including the twin flu to allow for heavy-duty cooking without lingering odours.

The third key element in the Nicolinis' kitchen is the marble-clad station dedicated to making coffee and aperitifs. Atop a stainless-steel benchtop with a fridge below, the emphasis is on the 1967 Faema E61 coffee machine, now fully restored. When entertaining is required, the bespoke timber-and-glass drinks trolley, designed by Orio Randi from Arteveneta, is aligned next to this bench.

One of the most delightful nooks in this kitchen, and one of the few fully concealed, is the butler's pantry, complete with a bespoke steel wine cabinet that holds up to 130 bottles of wine. The array of handmade pepper grinders, crockery handed down by the families, coffee grinders, copper utensils and even the fridge, creates a place to explore. Timber chopping boards are neatly stacked, many of which are handmade and find their way into Italian Artisans. "Look at these Italian Berti knives," says Nicolini, who regularly has these propped against a wall, like art pieces.

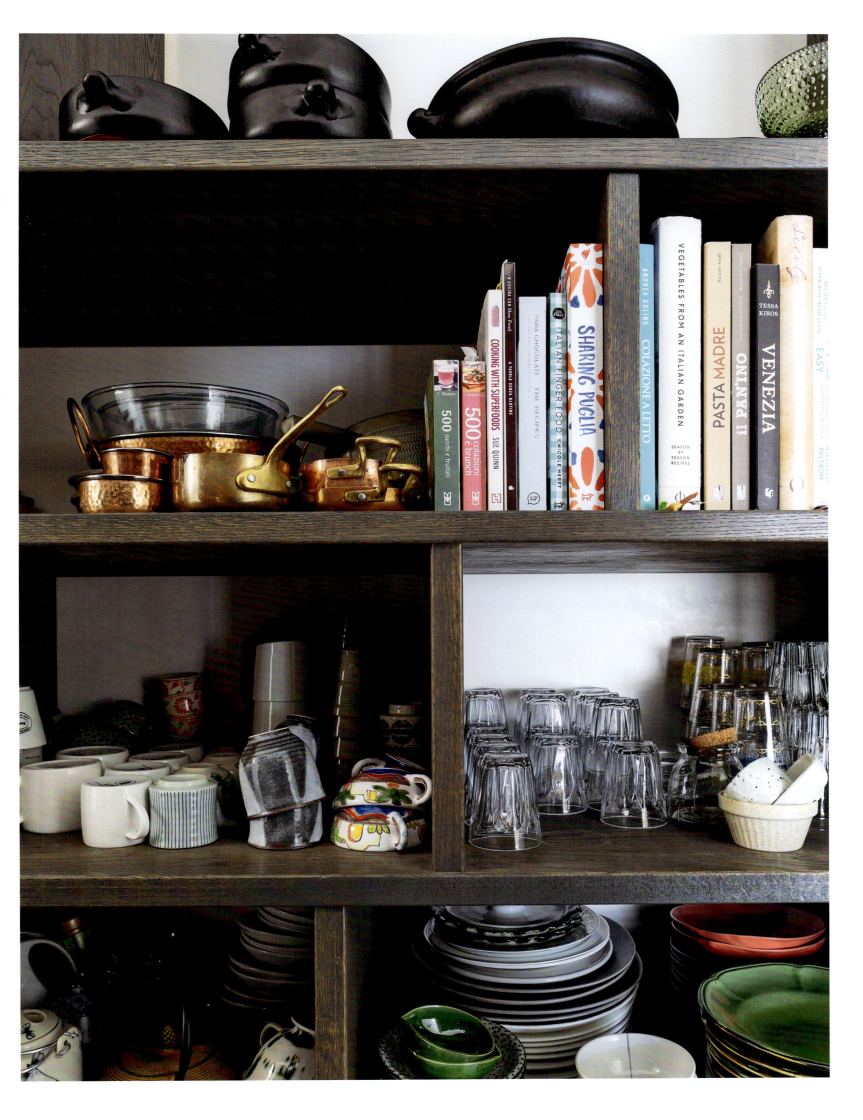

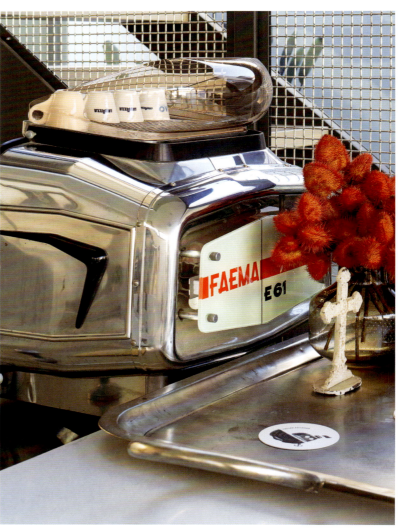

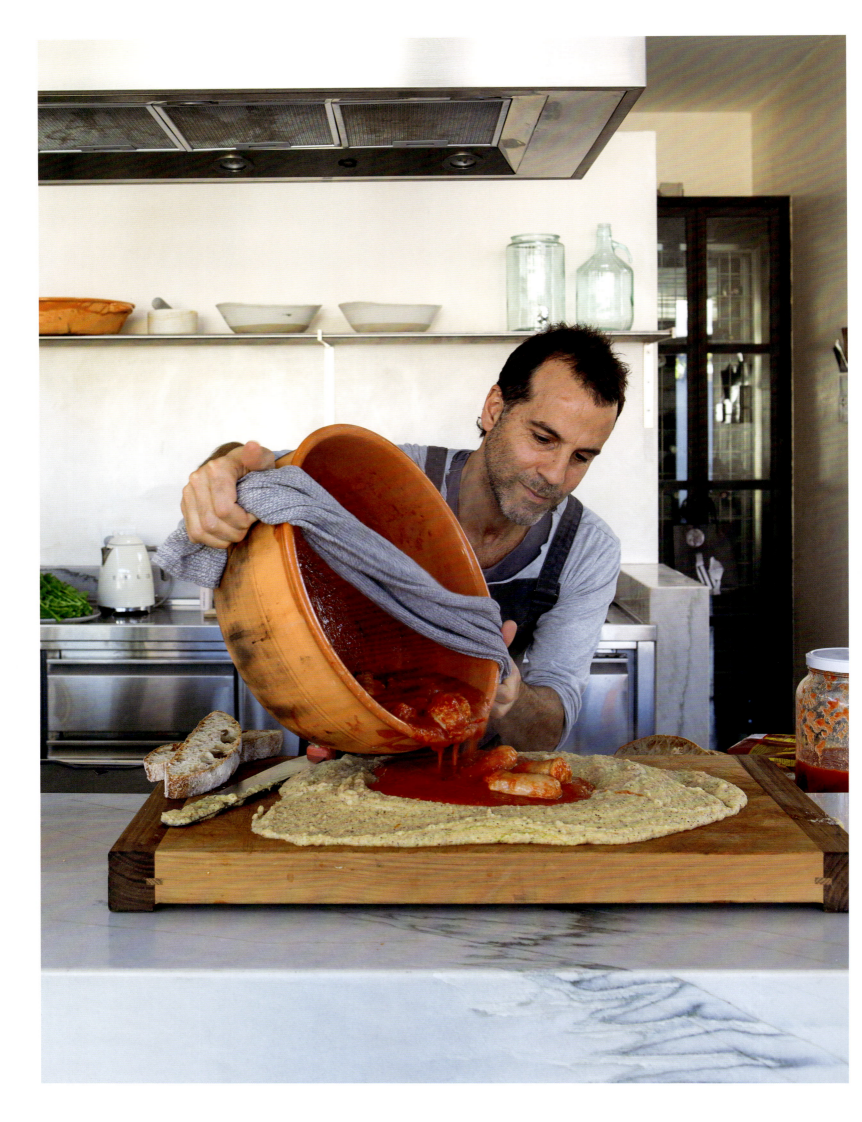

"Our children enjoy cooking, at least at this stage. We want to expose them to food and the art of preparation as much as possible," says Marcella, who, as with Tony, uses the outdoor courtyard, with its wood-fire oven (that once belonged to Tony's late father) as an outdoor room during the warmer months of the year. Although the courtyard garden is compact, there is more than enough space for their pampered pooch Moet to roam, as well as a few planter beds to grow herbs, such as rosemary, thyme and sage. Grapes grown on a vine are always brought to the table when in season, as is the chinotto. Although the wood-fire oven is severely cracked, it's still regularly used, with the cracks creating a 'dialogue' with the finer cracks in the concrete floor in the kitchen, dining and living areas. And although some may be content with a roll-out barbecue, here, you'll find a commercial Smeg barbecue set into a concrete form.

Unlike many who start with an overall design and select appliances once counters and benchtops have been drawn up, here the choice of appliances was paramount from the start. "We chose the appliances first. The dishwasher, for example, had to clean dishes in 10 minutes not a couple of hours," says Nicolini, who was also mindful of allowing the cuisine to shine in his kitchen, rather than being bombarded with excessive materials and finishes. "The kitchen needs to be a simple backdrop," he says. As important was for everything to be at one's fingertips and easily accessed (read: 'no cupboard doors'). "I want to be able to see everything at a glance." Natural light was also important in making the kitchen feel a pleasure to work in. Ridolfi brought in northern light from a skylight from the second level, as well as highlight windows to the west.

And when the food is fully prepared, it is beautifully arranged on the dining table, which is designed by Orio Randi using recycled sleepers that mimic the wheel of an old flourmill. "I can't think of a more important place than the kitchen. It's where we spend most of our time. It's the place that binds the entire family. But it's also a place to share with friends, whether it's the extended family or entertaining on a larger scale," adds Nicolini.

Polenta e salsiccia (polenta and sausage), with wild greens

Sugo (sauce)

2 garlic cloves, peeled & smashed

Extra virgin olive oil

750 g Leo Donati Fine Meat's pork sausages

1 kg Pera D'Abruzzo tomato or San Marzano tomato passata *[tomato varieties, not brands]*

Handful of fresh basil

Pinch of sea salt

Touch of ground pepper

Fry off garlic (do not burn) in the olive oil and discard garlic. Add the sausages to the pan and allow them to gain a light colouring to seal in the goodness. Add the tomato passata, basil, sea salt and pepper. Cook on very low heat for 90 to 100 minutes. Check sausages are cooked through with a fork.

Polenta

1 tbsp Sicilian sea salt

1.8 L water

500 g polenta (Taragna-style polenta made with cornmeal & buckwheat flour)

170 g butter, diced

120 g Reggiano Parmigiano (Parmesan), grated

Pecorino (optional)

Boil water with the Sicilian sea salt. Slowly sprinkle in the polenta flour and be sure to mix in the same direction so as to avoid forming lumps. Cook on low heat for 5 to 6 minutes, gradually adding in butter and Parmesan. You can add in a small amount of pecorino for some extra bite. Pour the mixture over a big timber cutting board for best results and gently pour over the tomato sugo and sausages.

Serve with a generous grating of Parmesan.

Wild greens, Burrata and 'Nduja

This dish is served alongside a bed of steamed and/or charred wild greens, such as rape leaves, accompanied with a beautiful local Burrata from La Stella Latticini, spread with Princi's Calabrese 'Nduja (a spicy, fermented pork *salumi*). Finish the greens with an exceptional olive oil, such as Ardoino Liguria extra virgin olive oil.

Buon appetito.

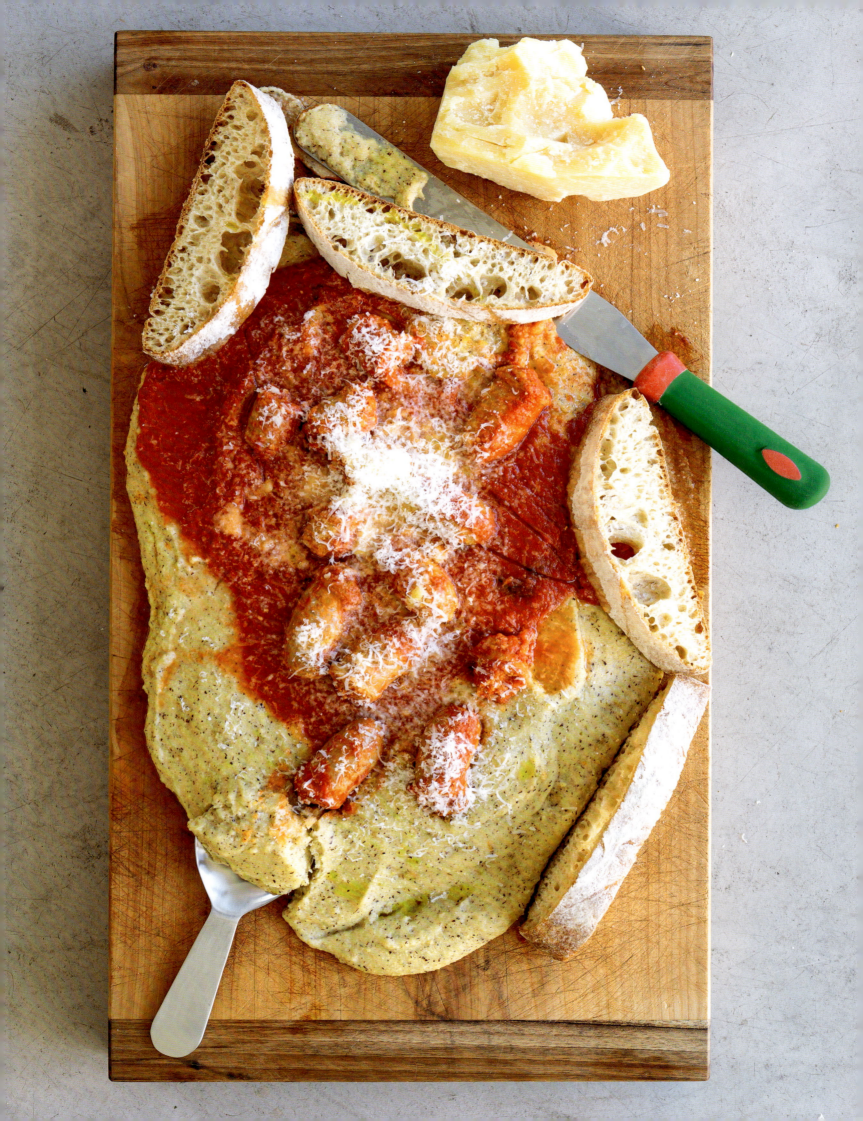

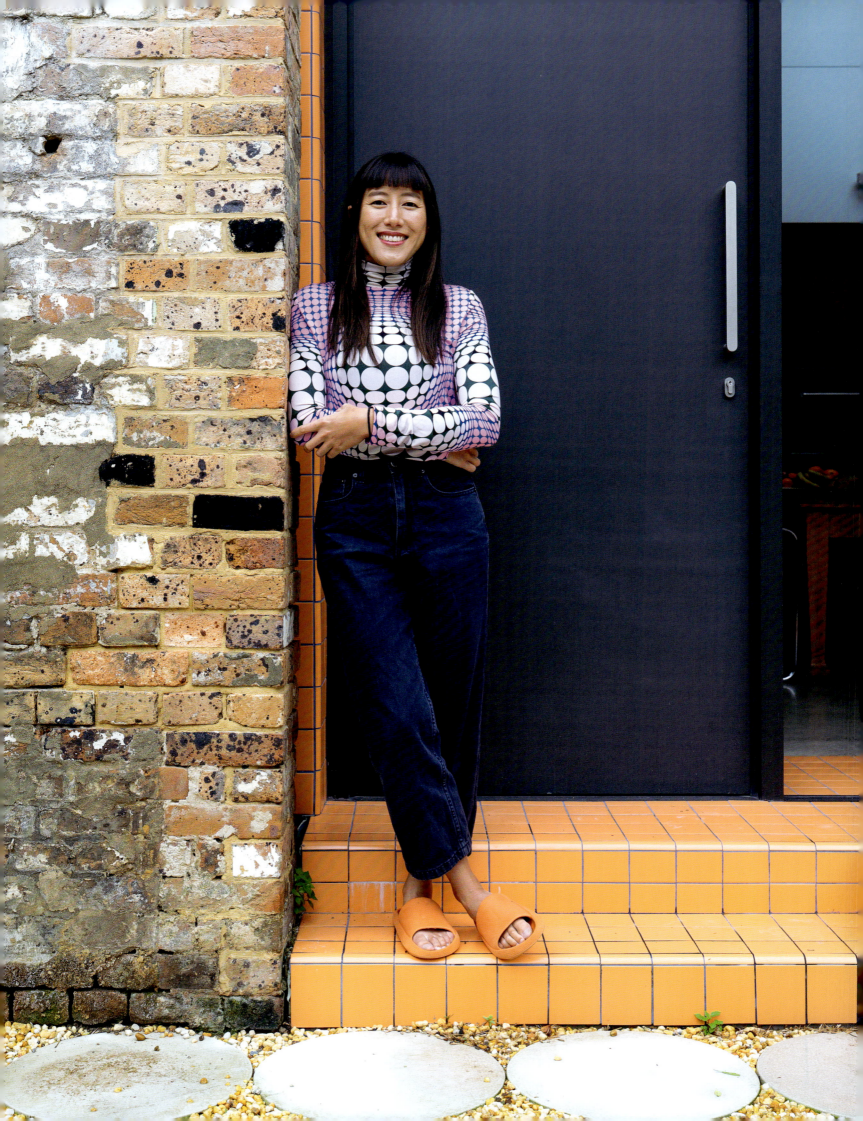

Xinyi Lim
A Love of Cooking

Self-taught chef Xinyi Lim originally trained and practised as a lawyer, working in cities such as Hong Kong, the Hague and Sydney. However, her career as a chef started eight years ago in New York. Upon her return to Sydney in 2020, she opened Cafe Freda's with the owners and more recently worked as a chef at Firedoor, in Sydney's Surry Hills. She also operates as a freelance chef, food consultant and stylist. "Coming from a Chinese/Malaysian family has also made me interested in different food styles, culture and the broader world," says Xinyi, who has not only created a name in the food and hospitality industry, but also works in a kitchen in an award-winning house, designed by her sister, Qianyi Lim, a director of Sibling Architecture (the house received the prestigious Wilkinson Award from the Australian Institute of Architects).

Located in the inner-western suburb of Forest Lodge, the site includes the Stables, where Xinyi and her partner live, with a detached cottage at the front of the property, where her sister, her husband and their child will live (it's currently being renovated by Qianyi). However, rather than feeling like an inner-city pad, the view from Xinyi's kitchen is of an adjacent bush reserve. "You feel like you're in the bush even though you're just minutes from the city," says Xinyi.

Originally a stable, and now just over 120 square metres in area, a substantial portion of the building was restored. Even the brick walls that once enclosed the horses have been retained, along with the building's few windows and now with a new raked ceiling. "I didn't want the neighbours living in the Victorian house next door to have their outlook diminished," says Qianyi, who worked closely with architect and landscape architect Nicholas Braun, one of Sibling Architecture's directors.

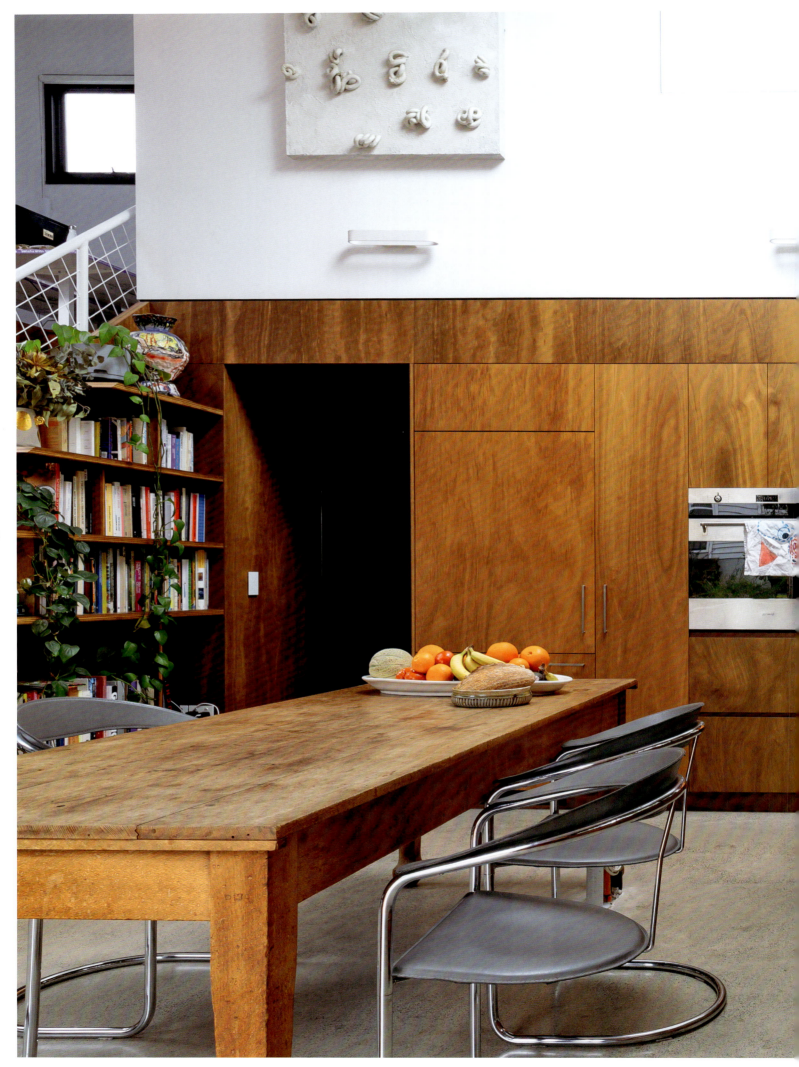

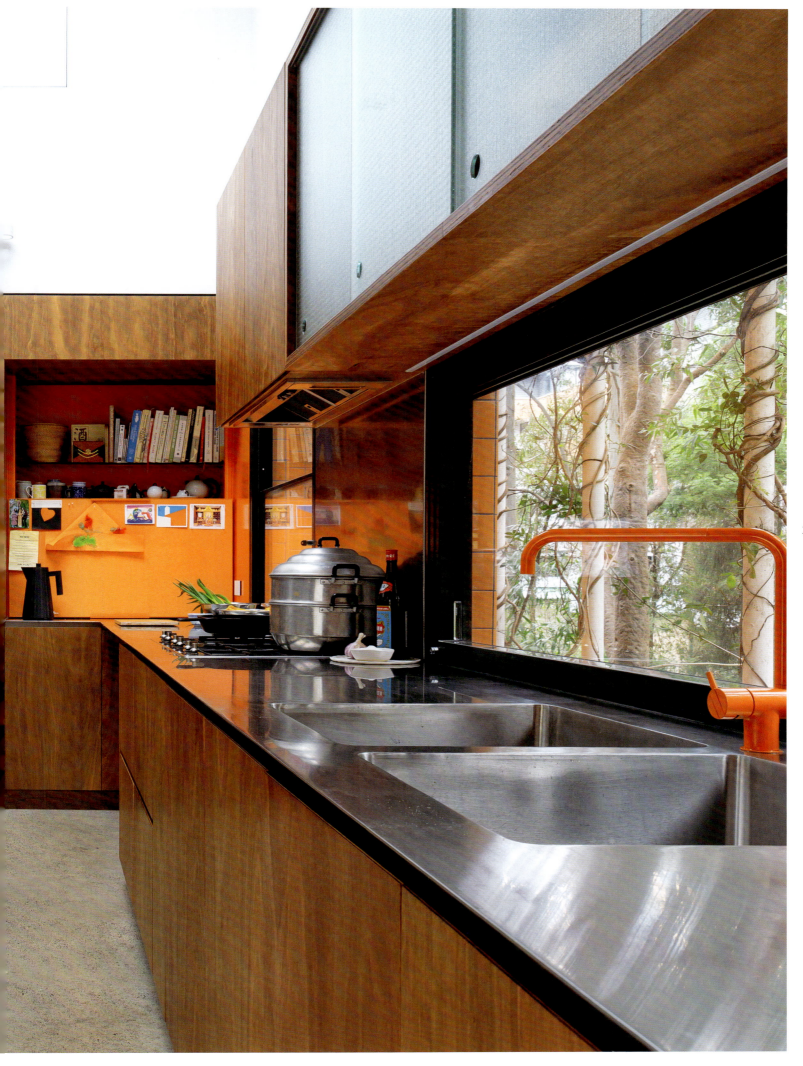

What was originally a stable is now a home with a generous open-plan kitchen, dining room and living area that opens via large glass doors to a shared courtyard that connects to the cottage. And to the rear of the floor plan, on each of the two levels, are two rooms with a shared bathroom. Pivotal to the design are the vibrant bolts of colour, including cobalt blue for an inner courtyard garden planted with ferns, and accents of vibrant orange in the kitchen, including orange tiled walls and moments of orange joinery.

However, it's the kitchen that is pivotal to the design, taking up virtually half the ground floor and loosely delineated from the living area by the staircase. The raked and angled ceiling accentuates this space. It's here that Xinyi prepares food, sometimes on the large timber dining table, approximately 2.5 metres long. Instead of a traditional island bench for food preparation, Xinyi uses the dining table or, more often, the extensive stainless-steel benches that extend across the kitchen. "These benches [the splashback is also stainless steel] are extremely easy to wipe down and are extremely practical in my industry," says Xinyi, who enjoys preparing food at the bench and looking at the reserve through the window. The large gap under this window also allows large bags of ingredients to be brought in and stored before using.

While the benches are stainless steel, the timber joinery is made from spotted gum, concealing a pantry and a fridge. The only appliances that can be seen are a large oven, gas hotplates and a rangehood (a Qasair) that's of a commercial rather than a domestic grade. And while the appliance cupboard generally remains open, it can be easily closed with a bright orange sliding pin-board panel when guests come over.

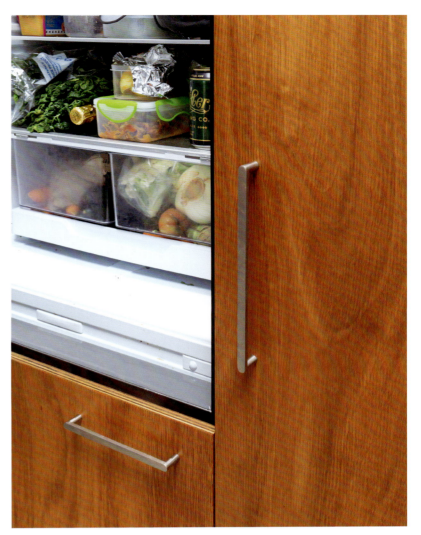

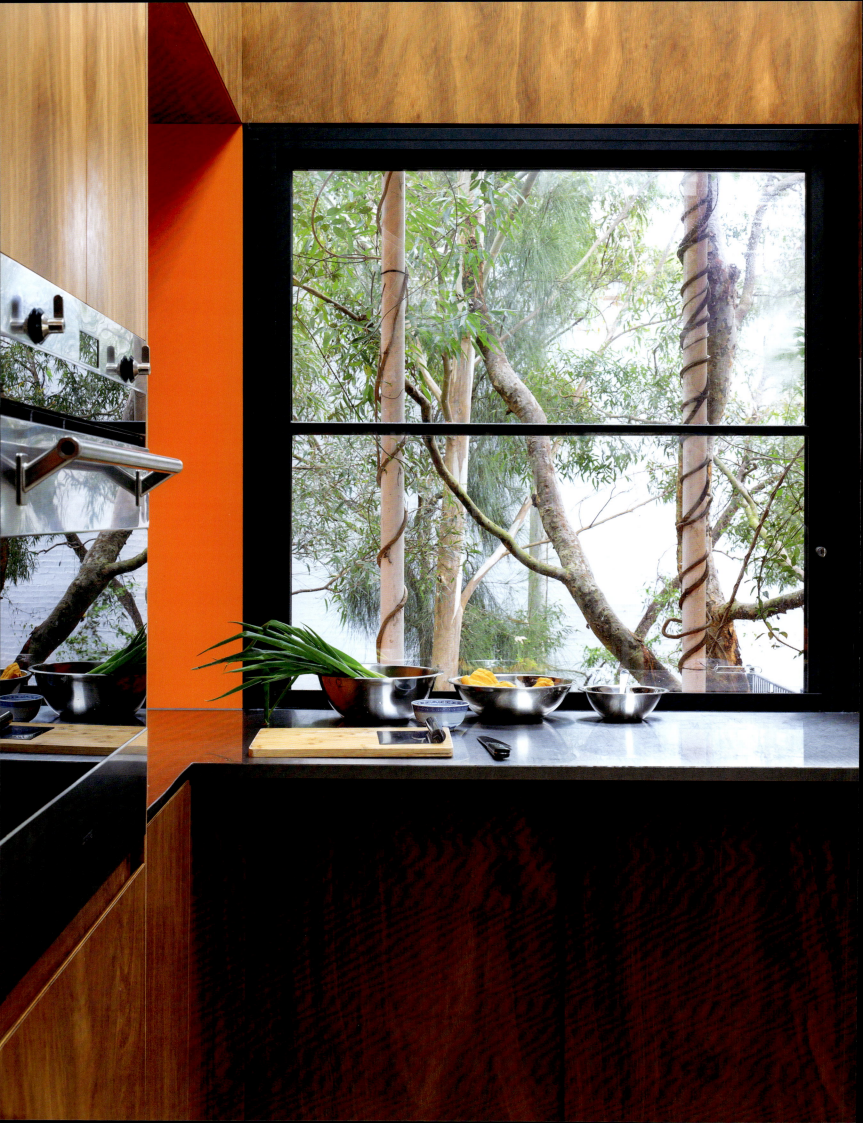

Although there are few overhead cupboards in this kitchen, albeit cupboards with industrial wired glass doors, there's more than sufficient storage in the cupboards below – including large drawers for pots and pans, and areas for crockery and cutlery. Xinyi also appreciates the way the kitchen has been laid out, working closely with her sister to ensure the design responds to the way she works. The large wall oven, for example, is placed at waist height so that she can easily take something heavy from the oven directly to the nearby bench. "You shouldn't have to bend over all the time when you're cooking," she says. The double stainless-steel sink is also appreciated, considerably larger than most domestic sinks, where large pots and pans can be easily washed. And of course, there's the benefit of having a polished concrete floor that can be easily swept. The floors include the odd horse shoe found in the process of the build when some of the brick floors were removed.

While there isn't a strict regime, the family, including Xinyi's sister and her family, and their extended family and friends, all eat at the dining table. They sometimes also assist with preparation, sometimes from the dining table while Xinyi is preparing food on the bench. "I love being part of the event, whether I am making a simple dish or creating more complex meals."

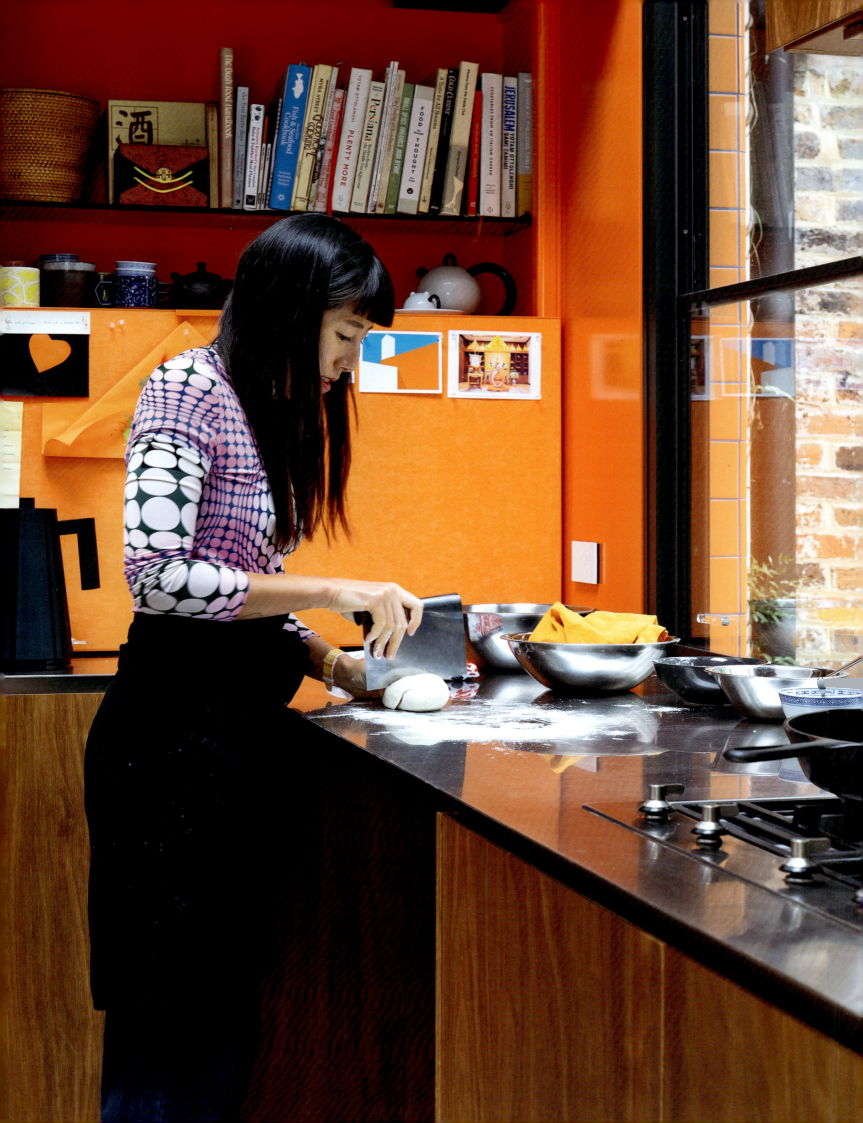

Spring onion and nigella flatbread (Cong You Bing)

Dough
300 g plain flour
½ tsp salt
½ cup boiling water
¼ cup + 1–2 tbsp cool water

Filling
¼ cup + 2 tbsp plain flour
¼ cup oil (canola, sunflower or even olive oil or melted butter is fine, too)
¾ tsp salt
12–15 spring onions, halved lengthways & finely chopped (both green & white parts, about ½ cup)
6 tsp nigella seeds (optional)
Vegetable oil for pan frying

For the dough, mix the flour and salt together in a large bowl. Slowly drizzle in the boiling water, while stirring with a pair of chopsticks until the hot water is fully absorbed. Slowly drizzle in the ¼ cup of cool water, continuing to mix until the water is fully absorbed and the dough has started to flake and clump together. Set aside the chopsticks and use your hands to press the warm dough together, gathering any dry flour in the bowl with the wet dough.

Drizzle in a little extra water if needed to bring the dough together. Cover and rest at room temperature for 20 minutes to let the gluten relax.

While the dough is resting, for the filling combine the flour, oil, and salt in a small bowl. Mix until a smooth paste is formed. After dough has rested, knead for 3–5 minutes until very smooth. Roll dough into a thick log and cut into 6 even pieces. Roll each piece between your palms to form balls.

Lightly flour your work surface. Working with one piece at a time (ensuring the rest of the pieces are covered with plastic wrap or a damp tea towel to prevent drying), roll each ball into a thin rectangle about 15 x 25 centimetres using a rolling pin. Lift and turn the dough regularly to prevent it sticking to your work surface.

With the long edge of the rectangle closest to you, evenly spread about 1 tablespoon of the flour paste onto the dough, leaving around 2.5 centimetres on the top and left side (this will help the filling stay contained within the flatbread). Sprinkle 2–3 heaped tablespoons of spring onions and 1 teaspoon of nigella seeds evenly onto the paste.

Beginning from the long edge closest to you, roll the dough up until you have a long tube. Lightly flatten the tube and pinch the right end of it to seal in the filling. Take this sealed end of the tube and gently roll it towards the other end, using your hands to smooth out the dough and push out any large air bubbles. Tuck the loose end under the roll and turn on its side so the spiral is facing up. Gently press down on the spiral with your hand. Set aside and cover while you repeat this same step with each piece of dough.

Very lightly dust your work surface with flour again and, using a rolling pin, gently roll out each flatbread into an 18- to 20-centimetre-wide circle. Flip and move the flatbread as you do to prevent sticking. Handle gently but it's fine if some air bubbles burst through or spring onion pieces fall out.

Heat a large cast-iron or non-stick frying pan with a lid over medium-high heat and add enough oil to liberally coat the surface. Once the oil is hot (but before it starts smoking), gently place a flatbread into the pan.

Use a spatula to swirl the flatbread around in the oil for a few seconds to prevent sticking. Cover, turn the heat down to medium and let cook for 1 minute. Flip the bread over, cover and cook on the other side for 1 minute. Remove the lid and continue to cook, flipping regularly, until both sides of the bread are crisped and golden brown, around 3 minutes. Adjust the heat if the pan gets too hot and flatbreads are darkening too quickly.

Transfer flatbread to a rack or plate lined with paper towels to absorb excess oil and cool slightly. Repeat with remaining flatbreads. (Note: If you do not wish to cook all the flatbreads at once, they can be frozen before cooking. Separate each with a piece of baking paper and store together in a ziplock bag for up to 3 months.)

Dipping sauce

3 tbsp light soy sauce

2 tbsp Chinkiang vinegar (or rice vinegar)

½ tsp sugar

½ tsp sesame oil

2 tbsp water

Fresh red chilli, thinly sliced (optional)

Combine all ingredients in a small bowl and mix until the sugar is dissolved.

To serve

Cut each flatbread into 6 pieces (or leave whole for your guests to tear apart excitedly) and transfer to a serving platter. Serve hot alongside dipping sauce.

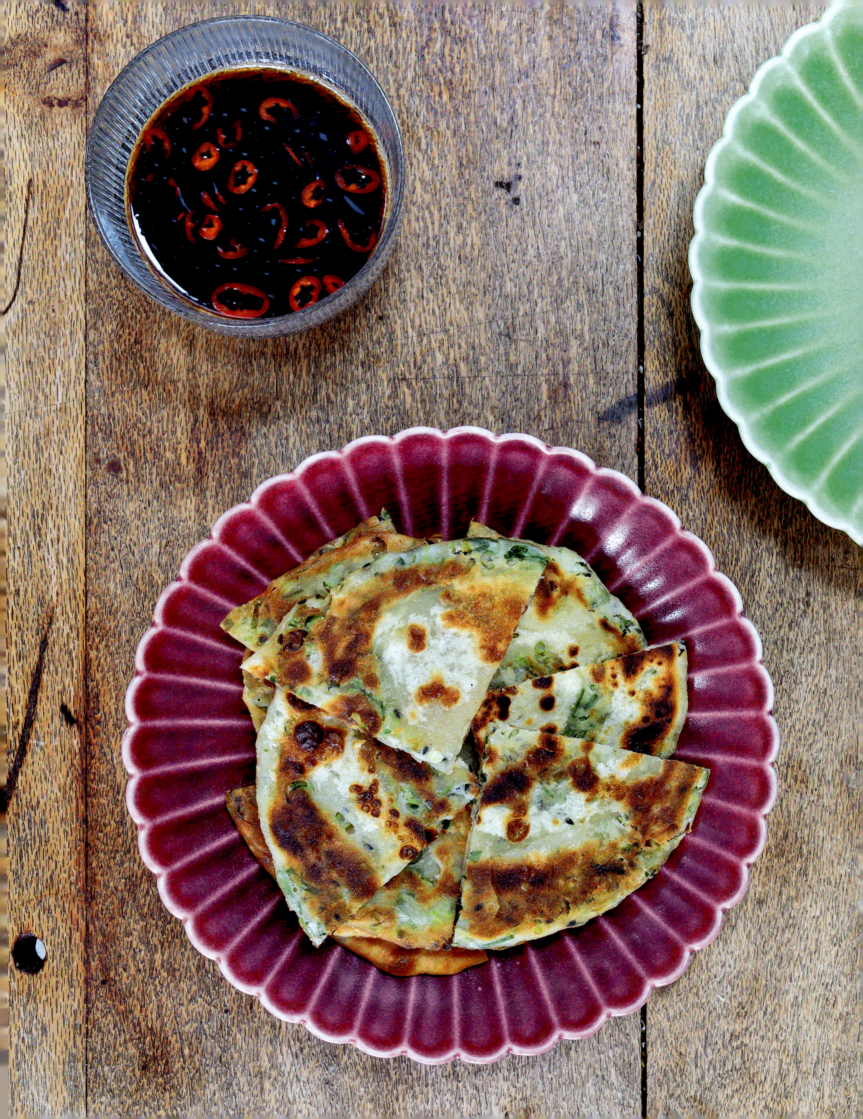

Author & Photographer

Stephen Crafti and his cat Harvey in his own home renovated by architect Robert Simeoni.

Image courtesy Armelle Habib and the *Sunday Life* magazine, *The Age/Sydney Morning Herald*

Stephen Crafti

Stephen Crafti started writing on architecture and design in the early 1990s after purchasing a modernist 1950s house designed by Montgomery King & Trengove. He has produced many books with the Images Publishing Group as well as writing for leading newspapers and magazines. Stephen also leads tours interstate and in Europe with leading cultural tour company Australians Studying Abroad.

Stephen would like to thank all the chefs featured in this book. He also thanks Catherine Sutherland who worked with him on this unique book – her energy and enthusiasm were greatly appreciated. His thanks also go to St. Ali for its support, e&s, together with Jaci Foti-Lowe from the Front Gallery. His thanks extend to Georgia (Gina) Tsarouhas from the Images Publishing Group.

Catherine Sutherland at home.

Catherine Sutherland

Catherine Sutherland is a Melbourne-based photographer, specialising in editorial and lifestyle photography with a portfolio that is particularly strong in food, interiors and travel.

Catherine would like to thank the chefs, for all the years of cooking and for the warm welcome into their kitchens. Thanks to Stephen for all the fun, stories and inspiration along the way. And thanks to Georgia (Gina) Tsarouhas and everyone at Images Publishing for their support and the beautiful book design.

Credits

Adam D'Sylva [venue] Boca (bocagelato.com.au)

Annie Smithers [venue] du Fermier (anniesmithers.com.au/du-fermier)

Brigitte Hafner [venue] Graceburn House & Tedesca Osteria (tedesca.com.au);
[architect] Cox Architecture (coxarchitecture.com.au)

Daniel Vaughan [venues] Hugo's (hugos.com.au); The Pantry (pantry.com.au);
The Royale Brothers (pantry.com.au)

Frank Camorra [venues] MoVida Aqui (sevenrooms.com); MoVida Auckland (savor.co.nz);
MoVida Next Door (sevenrooms.com); MoVida Original (sevenrooms.com); MoVida Providor (providor.com.au);
Tres a Cinco (tresacinco.com.au); [architect] Adam Dettrick Architects (adamdettrickarchitects.com.au)

Ian Curley [venues] The French Saloon (frenchsaloon.com); Kirk's Wine Bar (kirkswinebar.com);
[architect] Finnis Architects (finnis.com.au); (designer) Carole Whiting Studio (carolewhiting.com)

Jacques Reymond [venues] Bistro Gitan (bistrogitan.com.au); L'Hotel Gitan (lhotelgitan.com.au);
Frédéric (frederic.com.au); [designer] Chris Arnold, Complete Kitchens (complete-kitchens.com.au)

Javier Codina [venue] Moda Brasa Tapas Bar (modarestaurant.com.au)

Jesse Gerner [venues] Anada (anada.com.au); Bomba (bombabar.com.au);
Samuel Pepys (samuelpepys.com.au); [architect] Ola Architecture Studio (olastudio.com.au)

Karena Armstrong [venue] Salopian Inn (salopian.com.au)

Martin Benn (martinbenn.com)

Matt Breen [venues] Sonny (sonny.com.au); Ogee (ogeehobart.com.au)

Michael Lambie [venues] Rubi Red Kitchen and Bar (rubiredkitchenandbar.com.au); Lucy Liu (lucylius.com.au);
[interior designer] Andrew Parr, SJB Interiors (sjb.com.au)

Michelle Crawford (michellecrawford.com.au); [venue] The Bowmont (thebowmont.com.au)

Peter Orr [venues] Leigh Street Wine Room (leighstreetwineroom.com);
Press* Food & Wine (pressfoodandwine.com.au); [designer] Farquhar Kitchens (farquhar.kitchen)

Rita Macali [venue] Supermaxi (closed 2022)

Rodney Dunn [venue] The Agrarian Kitchen (theagrariankitchen.com);
[architect] Paul Johnston Architects (pauljohnstonarchitects.com)

Ronnen Goren [venue] Daylesford Longhouse (daylesfordlonghouse.com.au); [architect] Timothy Hill,
Partners Hill (partnershill.com); [designer] Studio Ongarato (studioongarato.com.au)

Ross Lusted [venue] Woodcut (woodcutrestaurant.com)

Scott Pickett [venues] Estelle (theestelle.com.au); Matilda (matilda159.com); Chancery Lane (chancerylane.com.au);
Le Shoppe (leshoppe.com.au); Longrain Melbourne (longrainmelbourne.com);
Smith St Bistrot (smithstbistrot.com.au); Audrey's (thecontinentalsorrento.com.au/audreys);
[architect] Antony Martin, MRTN Architects (mrtn.com.au)

Tony Nicolini [venue] Italian Artisans (italianartisans.com.au); [architect] Ridolfi Architects (ridolfi.net.au)

Xinyi Lim [venue] Firedoor (firedoor.com.au); [architect] Qianyi Lim, Sibling Architecture (siblingarchitecture.com)

Index

Page numbers in **bold** refer to images

A

Aboud, Michelle 240
Adam Dettrick Architects 12, 67, 70, 74, 285
AEG 216
AGA 27, 180
The Agrarian Kitchen 213, 285
Anada 115, 285
apple purée (by Annie Smithers) 38, **39**
appliances & cookware, *see also* artisans, manufacturers & product design; light fittings
 AEG 216
 AGA 27, 180
 Atomic 130
 Barazza 58
 Bertazzoni 44
 Big Green Egg 23
 Bracton 49
 De Dietrich 18
 De'Longhi 130
 Dualit 180
 Electrolux 153
 Esse 233
 Everdure Churrosco 23
 Faema E61 264
 Falcon 12, 189
 Fisher & Paykel 180
 Gaggenau 142
 InSinkErator 237
 KitchenAid 30, 44, 106, 118, 142, 156, 204
 La Marzocco 118, 216
 Liebherr 204
 Magimix 142
 Mauviel 30, 82
 Miele 123, 240
 Qasair 94, 168, 276
 Rancilio 180
 Rayburn 44
 Robot-Coupe 156
 Rocket coffee machine 49, 142
 Salt & Pepper 18
 Scott, Alan 49, 233
 Siemens 18
 Smeg 264, 269
 SodaStream 118
 Thermomix 118, 130, 142
 V-Zug 82, 94, 249
 Wolf 204
architects & designers, *see also* appliances & cookware; artisans, manufacturers & product design; light fittings
 Adam Dettrick Architects 12, 67, 70, 74, 285
 Arnold, Chris 91, 285
 Carole Whiting Studio 79, 285
 Complete Kitchens 91, 285
 Cox Architecture 41, 285
 Farquhar Kitchens 189, 192, 285
 Finnis Architects 79, 285
 Hill, Timothy 225, 228, 233, 285
 Lim, Qianyi 12, 273, 285
 Martin, Antony 249, 252, 257, 285
 MRTN Architects 249, 252, 285
 Ola Architecture Studio 115, 285
 Parr, Andrew 165, 168, 285
 Partners Hill 225, 228, 233, 285
 Paul Johnston Architects 213, 285
 Ridolfi Architects 10, 261, 269, 285
 Sibling Architecture 12, 273, 285
 Simeoni, Robert 201, 284
 SJB Interiors 165, 285
 Studio Ongarato 225, 285
Armstrong, Karena 8, 126–137, 285, **126, 128–129, 131, 132, 135, 136**
Arnold, Chris 91, 285
Arteveneta 264
artisans, manufacturers & product design, *see also* appliances & cookware; architects & designers; light fittings
 Aboud, Michelle 240
 Arteveneta 264
 Berti 264
 Burn, George 240
 Catalani, Enzo 27
 Dekton 82, 87, 94
 Draper, Matt 147
 Eames 147, 168
 English Tapware Company 44
 Gabori, Sally 106
 Gannon, Darren 147
 Gardner, Barry 130
 Hansen, Carl 252
 Hay 240
 Heery, Gary 147
 Hilditch, Georgina 35
 Ibride 35
 Kingma, Julian 87
 Klein, Tara 147
 Latif, Yusef 156
 McCormack, Scott 'Roopa' 204
 McQuilty, Russell 147
 Munro, Brad 147
 Neele Dey Furniture 252
 Ngitjanka, Linda 159
 Opinel 130
 Pitt & Giblin 156
 Plum, Robert 147
 Randi, Orio 264, 269
 Razzia 156
 Scott, Alan 49, 233
 Thonet 74, 87, 185, 233
 Van Keel, Michael 180
artists, *see* artisans, manufacturers & product design
Atomic 130
Audrey's 249, 285

B

Barazza 58
barbecue lamb shoulder (by Karena Armstrong) 134, **135, 136**
bars & cafés, *see* venues
Benn, Martin 138–151, 285, **138, 140–141, 143, 144, 145, 146, 149, 150**
Bertazzoni 44
Berti 264
Big Green Egg 23
Bistro Gitan 91, 285
Boca 15, 285
Bomba 115, 285
The Bowmont 177, 185, 285
Bracton 49
Breen, Matt 8, 13, 152–163, 285, **152, 154–155, 157, 158, 161, 162**
Burn, George 240

C

Cafe Freda's 273
Camorra, Frank 8, 10, 12, 66–77, 285, **66, 68–69, 71, 72, 73, 75, 77**
capsicum chutney (by Javier Codina) 112, **113**
Carole Whiting Studio 79, 285
Catalani, Enzo 27
Chancery Lane 249, 285
chefs
 Armstrong, Karena 8, 126–137, 285, **126, 128–129, 131, 132, 135, 136**
 Benn, Martin 138–151, 285, **138, 140–141, 143, 144, 145, 146, 149, 150**
 Breen, Matt 8, 13, 152–163, 285, **152, 154–155, 157, 158, 161, 162**
 Camorra, Frank 8, 10, 12, 66–77, 285, **66, 68–69, 71, 72, 73, 75, 77**
 Codina, Javier 102–113, 285, **102, 103–104, 107, 108, 110, 111, 113**
 Crawford, Michelle 176–187, 285, **176, 178–179, 181, 182, 183, 184, 187**
 Curley, Ian 78–89, 285, **78, 80–81, 83, 84, 85, 86, 89**
 D'Sylva, Adam 12, 14–25, 285, **14, 16–17, 19, 20, 21, 22, 25**
 Dunn, Rodney 8, 212–223, 285, **212, 214–215, 217, 218, 219, 220, 221, 223**
 Gerner, Jesse 12, 114–125, 285, **114, 116–117, 119, 120, 121, 122, 125**
 Goren, Ronnen 224–235, 285, **224, 226–227, 229, 230–231, 232, 235**
 Hafner, Brigitte 8, 40–53, 285, **40, 42–43, 45, 46, 47, 48, 50, 51, 53**
 Lambie, Michael 164–175, 285, **164, 166–167, 169, 170, 172, 173, 175**
 Lim, Xinyi 8, 12, 272–283, 285, **272, 274–275, 277, 278, 280, 283**
 Lusted, Ross 12, 236–247, 285, **236, 238–239, 240, 241, 242, 245, 246**
 Macali, Rita 8, 200–211, 285, **200, 202–203, 205, 206, 207, 208, 211**
 Nicolini, Tony 8, 10, 260–271, 285, **260, 262–263, 265, 266, 267, 268, 271**
 Orr, Peter 12, 188–199, 285, **188, 190–191, 193, 194, 195, 196, 199**
 Pickett, Scott 8, 248–259, 285, **248, 250–251, 253, 254, 255, 256, 259**
 Reymond, Jacques 90–101, 285, **90, 92–93, 95, 96, 97, 98, 101**
 Smithers, Annie 8, 12, 26–39, 285, **26, 28–29, 31, 32, 33, 34, 36, 37, 39**
 Vaughan, Daniel 13, 54–65, 285, **54, 56–57, 59, 60, 61, 62, 65**
clams with Manzanilla and mint (by Jesse Gerner) 124, **125**
Coda 15
Codina, Javier 102–113, 285, **102, 103–104, 107, 108, 110, 111, 113**
cold spinach salad (by Ross Lusted) 247, **245, 246**
Complete Kitchens 91, 285
cookware, *see* appliances & cookware
Cox Architecture 41, 285
Crawford, Michelle 176–187, 285, **176, 178–179, 181, 182, 183, 184, 187**

cucumber, Japanese pickles, ponzu (by Ross Lusted) 247, **245, 246**
Curley, Ian 78–89, 285, **78, 80–81, 83, 84, 85, 86, 89**

D

Daylesford Longhouse 225, 285
Daylesford Longhouse peach melba misu madeira cake (by Ronnen Goren) 234, **235**
De Dietrich 18
Dekton 82, 87, 94
De'Longhi 130
designers, *see* architects & designers; artisans, manufacturers & product design; appliances & cookware; light fittings
Draper, Matt 147
D'Sylva, Adam 12, 14–25, 285, **14, 16–17, 19, 20, 21, 22, 25**
Dualit 180
duck fat roasted potato (by Scott Pickett) 258, **259**
duck legs braised with cider and prunes (by Annie Smithers) 38, **39**
du Fermier 12, 27, 285
Dunn, Rodney 8, 212–223, 285, **212, 214–215, 217, 218, 219, 220, 221, 223**

E

Eames 147, 168
Electrolux 153
English Tapware Company 44
Esse 233
Estelle 249, 252, 285
Everdure Churrosco 23

F

Faema E61 264
Falcon 12, 189
Farquhar Kitchens 189, 192, 285
Finnis Architects 79, 285
Firedoor 273, 285
fish en Papillote (by Jacques Reymond) 100, **101**
Fisher & Paykel 180
Frédéric 91, 285
The French Saloon 79, 87, 285

G

Gabori, Sally 106
Gaggenau 142
Gannon, Darren 147
Gardner, Barry 130
George Nelson 23
German apple cake (Apfelkuchen) (by Brigitte Hafner) 52, **53**
Gerner, Jesse 12, 114–125, 285, **114, 116–117, 119, 120, 121, 122, 125**
gnocchi bolognese (by Rita Macali) 210, **211**
goat ragu (by Matt Breen) 163, **162**
Goren, Ronnen 224–235, 285, **224, 226–227, 229, 230–231, 232, 235**
Graceburn House & Tedesca Osteria 41, 285

H

Hafner, Brigitte 8, 40–53, 285, **40, 42–43, 45, 46, 47, 48, 50, 51, 53**
Hansen, Carl 252
Hay 240
Heery, Gary 147
Hilditch, Georgina 35
Hill, Timothy 225, 228, 233, 285
Hugo's 55, 285

I

Ibride 35
InSinkErator 237
Italian Artisans 261, 264, 285

K

Kingma, Julian 87
Kirk's Wine Bar 79, 285
KitchenAid 30, 44, 106, 118, 142, 156, 204
kitchen garden salad (by Karena Armstrong) 134, **136**
Klein, Tara 147

L

La Marzocco 118, 216
Lambie, Michael 164–175, 285, **164, 166–167, 169, 170, 172, 173, 175**
Latif, Yusef 156
Le Shoppe 249, 285
Leigh Street Wine Room 12, 189, 285
L'Hotel Gitan 91, 285
Liebherr 204
light fittings
 Camorra's kitchen, Frank 74
 Codina's kitchen, Javier 109
 Curley's kitchen, Ian 87
 D'Sylva's kitchen, Adam 23
 Lambie's kitchen, Michael 171
 Orr's kitchen, Peter 197
 Smither's kitchen, Annie 27
Lim, Qianyi 12, 273, 285
Lim, Xinyi 8, 12, 272–283, 285, **272, 274–275, 277, 278, 280, 283**
Longrain Melbourne 249, 285
Lucy Liu 165, 285
Lusted, Ross 12, 236–247, 285, **236, 238–239, 240, 241, 242, 245, 246**

M

Macali, Rita 8, 200–211, 285, **200, 202–203, 205, 206, 207, 208, 211**
Magimix 142
Malaysian lamb rendang (by Michael Lambie) 174, **175**
manufacturers, *see* architects & designers; artisans, manufacturers & product design; appliances & cookware; light fittings
Marsala quinces and frangipane tart (by Michelle Crawford) 186, **187**
Martin, Antony 249, 252, 257, 285
Matilda 249, 285
Mauviel 30, 82
McCormack, Scott 'Roopa' 204
McQuilty, Russell 147
Miele 123, 240
Moda Brasa Tapas Bar 103, 285
MoVida 10, 67, 70, 74, 285
MRTN Architects 249, 252, 285
Munro, Brad 147
mustard cream (by Karena Armstrong) 137, **136**

N

Neele Dey Furniture 252
Ngitjanka, Linda 159
Nicolini, Tony 8, 10, 260–271, 285, **260, 262–263, 265, 266, 267, 268, 271**
Nono, Oliver 225, 228

O

Ogee 153, 285
Ola Architecture Studio 115, 285
Opinel 130
Orr, Peter 12, 188–199, 285, **188, 190–191, 193, 194, 195, 196, 199**

P

paella (by Frank Camorra) 76, **77**
The Pantry 55, 285
Parr, Andrew 168, 168, 285
Partners Hill 225, 228, 233, 285
pasta dough (by Matt Breen) 160, **161, 162**
Paul Johnston Architects 213, 285
Pickett, Scott 8, 248–259, 285, **248, 250–251, 253, 254, 255, 256, 259**
Pitt & Giblin 156
Plum, Robert 147
poblano peppers stuffed with chorizo (by Javier Codina) 112, **113**
polenta e salsiccia (polenta and sausage), with wild greens (by Tony Nicolini) 270, **271**
pot-roasted chicken (by Ross Lusted) 244, **245, 246**
prawn and zucchini spaghettini (by Adam D'Sylva) 24, **25**
prawn hot and sour soup (by Peter Orr) 198, **199**
Press* Food & Wine 189, 285
product design, *see* architects & designers; artisans, manufacturers & product design; appliances & cookware; light fittings
pumpkin seed pesto (by Scott Pickett) 258, **259**

Q

Qasair 94, 168, 276

R

Rancilio 180
Randi, Orio 264, 269
Rayburn 44
Razzia 156
recipes
 apple purée 38, **39**
 barbecue lamb shoulder 134, **135, 136**
 capsicum chutney 112, **113**
 clams with Manzanilla and mint 124, **125**
 cold spinach salad 247, **245, 246**
 cucumber, Japanese pickles, ponzu 247, **245, 246**
 Daylesford Longhouse peach melba misu madeira cake 234, **235**
 duck fat roasted potato 258, **259**
 duck legs braised with cider and prunes 38, **39**
 fish en Papillote 100, **101**
 German apple cake (Apfelkuchen) 52, **53**
 gnocchi bolognese 210, **211**
 goat ragu 163, **162**
 kitchen garden salad 134, **136**
 Malaysian lamb rendang 174, **175**
 Marsala quinces and frangipane tart 186, **187**
 mustard cream 137, **136**
 paella 76, **77**
 pasta dough 160, **161, 162**
 poblano peppers stuffed with chorizo 112, **113**
 polenta e salsiccia (polenta and sausage), with wild greens 270, **271**
 pot-roasted chicken 244, **245, 246**
 prawn and zucchini spaghettini 24, **25**
 prawn hot and sour soup 198, **199**
 pumpkin seed pesto 258, **259**
 roasted chicken with herbs 258, **259**
 salsa verde 137, **136**
 savoury rice with mushrooms and bonito furikake 244, **245, 246**
 shepherd's pie 222, **223**
 spring onion and nigella flatbread (Cong You Bing) 281–283, **283**
 tuna niçoise 88, **89**
 udon noodles with southern rock lobster and kombu oil 148–151, **149, 150**
 whole baby snapper with burnt butter sauce and crispy sage 64, **65**

restaurants, *see* venues
Reymond, Jacques 90–101, 285, **90, 92–93, 95, 96, 97, 98, 101**
Ridolfi Architects 10, 261, 269, 285
roasted chicken with herbs (by Scott Pickett) 258, **259**
Robot-Coupe 156
Rocket coffee machine 49, 142
The Royale Brothers 55, 285
Rubi Red Kitchen and Bar 165, 285

S
Salopian Inn 127, 285
salsa verde (by Karena Armstrong) 137, **136**
Salt & Pepper 18
Samuel Pepys 115, 285
savoury rice with mushrooms and bonito furikake (by Ross Lusted) 244, **245, 246**
Scott, Alan 49, 233
Sepia 139, 147
shepherd's pie (by Rodney Dunn) 222, **223**
Sibling Architecture 12, 273, 285
Siemens 18
Simeoni, Robert 201, 284
SJB Interiors 165, 285
Smeg 264, 269
Smithers, Annie 8, 12, 26–39, 285, **26, 28–29, 31, 32, 33, 34, 36, 37, 39**
Smith St Bistrot 249, 285
SMXL 225
Snaidero 18
Society 139
SodaStream 118
Sonny 153, 156, 285
spring onion and nigella flatbread (Cong You Bing) (by Xinyi Lim) 281–283, **283**

St. Ali 49
Studio Ongarato 225, 285
Supermaxi 201, 204, 209, 285

T
Thermomix 118, 130, 142
Thonet 74, 87, 185, 233
Tonka 15
Tres a Cinco 67, 285
tuna niçoise (by Ian Curley) 88, **89**

U
udon noodles with southern rock lobster and kombu oil (by Martin Benn) 148–151, **149, 150**

V
Van Keel, Michael 180
Vaughan, Daniel 13, 54–65, 285, **54, 56–57, 59, 60, 61, 62, 65**
venues
 The Agrarian Kitchen 213, 285
 Anada 115, 285
 Audrey's 249, 285
 Bistro Gitan 91, 285
 Boca 15, 285
 Bomba 115, 285
 The Bowmont 177, 185, 285
 Cafe Freda's 273
 Chancery Lane 249, 285
 Coda 15
 Daylesford Longhouse 225, 285
 du Fermier 12, 27, 285
 Estelle 249, 252, 285
 Firedoor 273, 285
 Frédéric 91, 285
 The French Saloon 79, 87, 285
 Graceburn House & Tedesca Osteria 41, 285
 Hugo's 55, 285
 Italian Artisans 261, 264, 285
 Kirk's Wine Bar 79, 285
 Le Shoppe 249, 285
 Leigh Street Wine Room 12, 189, 285
 L'Hotel Gitan 91, 285
 Longrain Melbourne 249, 285
 Lucy Liu 165, 285
 Matilda 249, 285
 Moda Brasa Tapas Bar 103, 285
 MoVida 10, 67, 70, 74, 285
 Ogee 153, 285
 The Pantry 55, 285
 Press* Food & Wine 189, 285
 The Royale Brothers 55, 285
 Rubi Red Kitchen and Bar 165, 285
 Salopian Inn 127, 285
 Samuel Pepys 115, 285
 Sepia 139, 147
 Smith St Bistrot 249, 285
 Society 139
 Sonny 153, 156, 285
 Supermaxi 201, 204, 209, 285
 Tonka 15
 Tres a Cinco 67, 285
 Woodcut 12, 237, 240, 285
V-Zug 82, 94, 249

W
Wakuda, Tetsuya 139
White, Marco Pierre 139, 165
whole baby snapper with burnt butter sauce and crispy sage (by Daniel Vaughan) 64, **65**
Wolf 204
Woodcut 12, 237, 240, 285

Weights & Measurement Conversions

Weight
20 g (1½ tbsp/0.7 oz)
30 g (2 tbsp/1 oz)
40 g (2½ tbsp/1⅓ oz)
50 g (3½ tbsp/1¾ oz)
55 g (3¾ tbsp/2 oz)
60 g (4 tbsp/2¼ oz)
75 g (5 tbsp/2⅔ oz)
80 g (5½ tbsp/2¾ oz)
100 g (7 tbsp/3½ oz)
120 g (8½ tbsp/4¼ oz)
125 g (5¾ tbsp/4⅓ oz)
150 g (1 cup/5⅓ oz)
170 g (1 cup, 2½ tbsp/6 oz)
180 g (1 cup, 1¼ tbsp/6⅓ oz)
200 g (1 cup, 3½ tbsp/7 oz)
230 g (1 cup, 3¾ tbsp/8¼ oz)
240 g (8½ oz)
250 g (8¾ oz)
300 g (½ lb)
400 g (14 oz)
450 g (15¾ oz)
500 g (1 lb)
600 g (1⅓ lb)
700 g (1 lb, 8¼ oz)
750 g (1½ lb)

1 kg (2¼ lb)
1.5 kg (3¼ lb)
1.8 kg (3¾ lb)
2 kg (4½ lb)

Volume
20 ml (¾ fl oz)
30 ml (1 fl oz)
50 ml (1¾ fl oz)
60 ml (2 fl oz)
75 ml (2⅓ fl oz)
100 ml (3½ fl oz)
120 ml (4 fl oz)
150 ml (5 fl oz)
200 ml (7 fl oz)
250 ml (8 fl oz)
300 ml (½ pt)
350 ml (11¾ fl oz)
500 ml (¾ pt)
600 ml (1 pt)
750 ml (1½ pt)
800 ml (1⅔ pt)
900 ml (1¾ pt)

1.8 L (3¾ pt)
2 L (4¼ pt)
6 L (12¾ pt)

Length & Distance
3 mm (⅛ in)
5 mm (¼ in)
40 mm (½ in)
50 mm (2 in)
500 mm (19½ in)
700 mm (27½ in)
900 mm (35½ in)
950 mm (37½ in)

1 cm (⅓ in)
2 cm (¾ in)
2.5 cm (1 in)
5 cm (2 in)
7 cm (2¾ in)
10 cm (4 in)
13 cm (5 in)
15 cm (6 in)
18 cm (7 in)
20 cm (8 in)
22 cm (8⅔ in)
23 cm (9 in)
25 cm (9¾ in)
26 cm (10¼ in)
28 cm (11 in)
30 cm (11¾ in)

1.2 m (3.9 ft)
1.25 m (4.1 ft)
1.4 m (4.6 ft)
1.5 m (4.9 ft)
2 m (6.5 ft)
2.5 m (8.2 ft)
3 m (9.84 ft)
3.2 m (10.5 ft)
4 m (13.1 ft)
5 m (16.4 ft)
6 m (19.7 ft)
7 m (23 ft)
12 m (39.4 ft)
110 m (360.9 ft)
760 m (2,493.4 ft)

4 km (2.48 miles)
5 km (3.1 miles)
7 km (4.3 miles)

Area
30 sq m (322.9 sq ft)
120 sq m (1,292 sq ft)
260 sq m (2,798.6 sq ft)
800 sq m (8,611 sq ft)

0.2 ha (0.5 acres)
8.5 ha (21 acres)
9 ha (22 acres)
12 ha (30 acres)

Temperature
65°C (149°F)
140°C (284°F)
150°C (302°F)
160°C (320°F)
165°C (329°F)
170°C (338°F)
180°C (356°F)
190°C (374°F)
200°C (392°F)
400°C (752°F)

Published in Australia in 2023 by
The Images Publishing Group Pty Ltd
ABN 89 059 734 431

Offices

Melbourne
Waterman Business Centre
Suite 64, Level 2 UL40
1341 Dandenong Road
Chadstone, VIC 3148
Australia
Tel: +61 3 8564 8122

New York
6 West 18th Street 4B
New York, NY 10011
United States
Tel: +1 212 645 1111

Shanghai
6F, Building C, 838 Guangji Road
Hongkou District, Shanghai 200434
China
Tel: +86 021 31260822

books@imagespublishing.com
www.imagespublishing.com

The Images Publishing Group Reference Number: 1567

Copyright © Stephen Crafti 2023 [text]; Matt Preston 2023 [foreword];
© Catherine Sutherland 2023 [photography]

All rights reserved. Apart from any fair dealing for the purposes of private study, research, criticism or review as permitted under the Copyright Act, no part of this publication may be reproduced, stored in a retrieval system or transmitted in any form by any means, electronic, mechanical, photocopying, recording or otherwise, without the written permission of the publisher.

 A catalogue record for this book is available from the National Library of Australia

Title: Chefs' Kitchens: Inside the Homes of Australia's Culinary Connoisseurs || Stephen Crafti with Catherine Sutherland

ISBN: 9781864708769 (Australia/New Zealand edition)

ISBN: 9781864709902 (International edition)

This title was commissioned in IMAGES' Melbourne office and produced as follows:
Senior editorial Georgia (Gina) Tsarouhas; *Editing* Helen Koehne; *Proofing* Danielle Hampshire;
Graphic design Ryan Marshall; *Production* Nicole Boehringer

Printed on 157gsm Chinese OJI matt art paper (FSC®) by Artron Art (Group) Co., Ltd, in China

IMAGES has included on its website a page for special notices in relation to this and its other publications. Please visit www.imagespublishing.com

Every effort has been made to trace the original source of copyright material contained in this book. The publishers would be pleased to hear from copyright holders to rectify any errors or omissions.

The information and illustrations in this publication have been prepared and supplied by the author, photographer, and the contributors. While all reasonable efforts have been made to ensure accuracy, the publishers do not, under any circumstances, accept responsibility for errors, omissions and representations, express or implied.